Thailand

Nine Days in the Kingdom by 55 great photographers

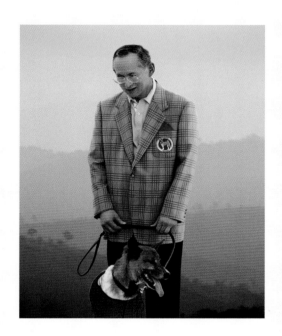

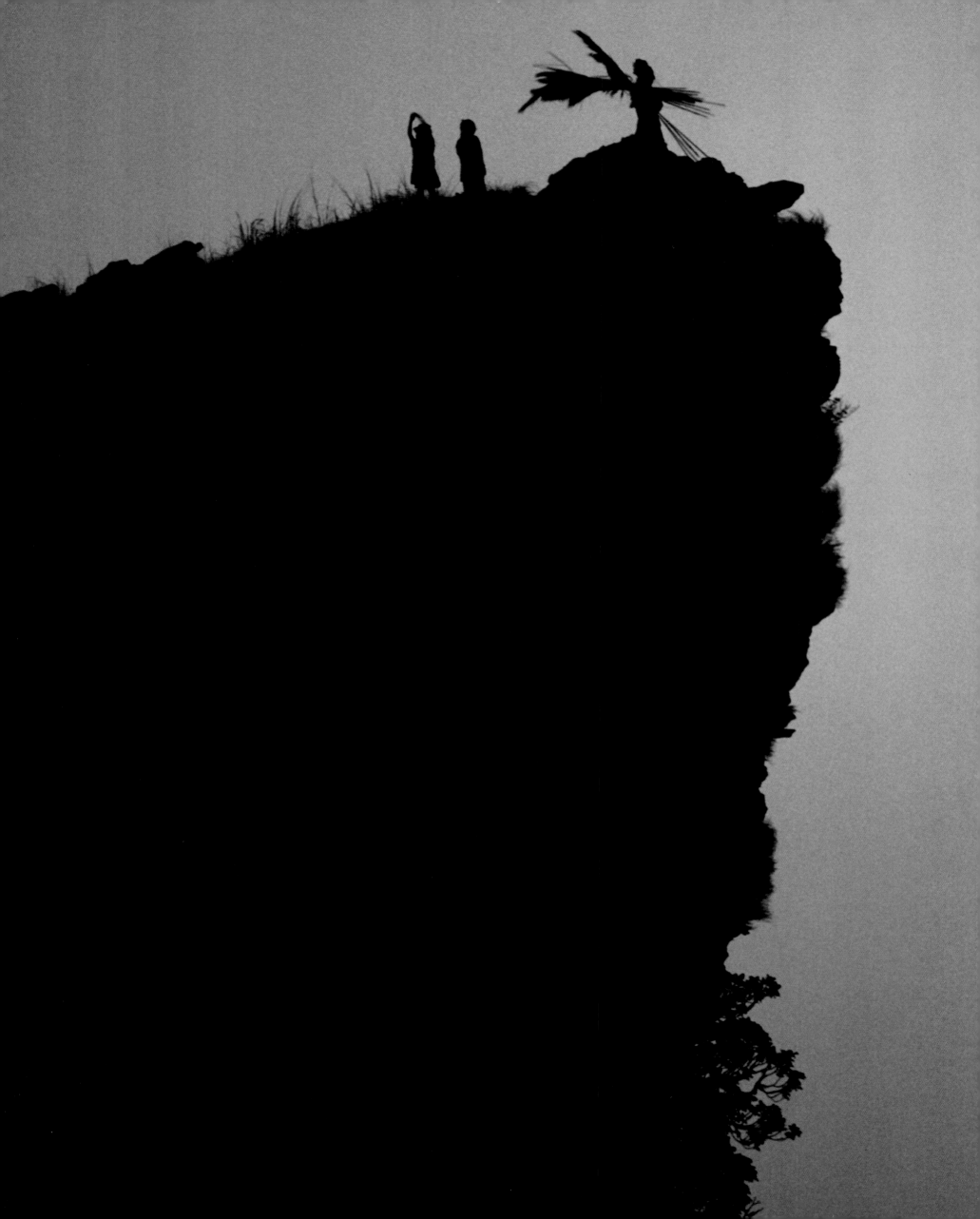

Thailand

Nine Days in the Kingdom by 55 great photographers

Editions Didier Millet

SINGAPORE · KUALA LUMPUR · PARIS

9 THAILAND
Days in the Kingdom
by 55 of the world's great photographers

Designed and published by
Editions Didier Millet Pte Ltd
121 Telok Ayer Street #03-01
Singapore 068590

www.edmbooks.com

www.9days-inthekingdom.com

THE PROJECT TEAM

Singapore

Publisher	: Didier Millet
General Manager	: Charles Orwin
Editorial Director	: Timothy Auger
Project Coordinator	: Laura Jeanne Gobal
Picture Editor	: Marie Claude Millet
Executive Editor	: Melisa Teo
Studio Manager	: Annie Teo
Creative Designer	: Pascal Chan
Production Manager	: Sin Kam Cheong

Bangkok

Project Director	: Yvan Van Outrive
Project Coordinator	: Tanya Asavatesanuphab (Bee)
Chief Editorial Consultant	: William Warren
Editorial Consultant	: Philip Cornwel-Smith
Assignment Editors	: Nicholas Grossman
	Korakot Punlopruksa (Nym)
	Puchara Sandford (Am)
Chief Photographers	: Robert McLeod
	Kraipit Phanvut
Digital Consultant	: Michael Freeman
Technical Assistants	: Wittaya Wiangsima (Num)
	Siriwipha Wongchinda (Noyna)
	Yien Li Yap

Colour separation by
SC Graphic Singapore

Printed by
Tien Wah Press, Singapore
on 157gsm Japanese super kote matt art

First published 2007. Reprinted 2008.

© Editions Didier Millet 2007

ISBN 978-981-4217-18-7

FRONT COVER: A monk hangs his robe out to dry at a temple located on the Chao Phraya River in Bangkok. (**Dominic Sansoni**, Sri Lanka)

PAGE 1: His Majesty King Bhumibol Adulyadej pictured with his dog Tongdaeng. (**Kraipit Phanvut**, Thailand)

PAGE 2–3: Villagers stand on the peak of Phu Chi Fa in Chiang Rai province in northern Thailand, near the Laos border. (**Olivier Föllmi**, France)

PAGE 5: Visitors to Wat Maheyon in Ayutthaya have lit and placed incense sticks in front of the Buddha images housed there, a typical offering at all temples in Thailand. (**Kaku Suzuki**, Japan)

PAGE 6–7: A mahout cares for his elephant in the early hours of the morning in Umphang district, near the Myanmar border. (**Palani Mohan**, Australia)

PAGE 8: A sculpture in the shape of a coin honours His Majesty the King at the Royal Flora Ratchaphruek, a flower festival that was held in Chiang Mai to commemorate His Majesty's 60th anniversary on the throne. (**Jörg Sundermann**, Germany)

PAGE 9: A bird sculpture catches the light of sunrise at the Bangkok Metropolitan Garden section of the Royal Flora Ratchaphruek. (**Jörg Sundermann**, Germany)

PAGE 10–11: A flock of birds flies over the rice fields surrounding the massive Buddha statue of Wat Muang in Ang Thong province. (**Romeo Gacad**, Philippines)

PAGE 12–13: A solitary fisherman tries for an early catch as the sun rises over the Mun River in northeast Thailand, near the Laos border. (**Bohnchang Koo**, South Korea)

PAGE 14–15: Wat Chedi Luang, in the centre of Chiang Mai, once housed the Emerald Buddha. (**Jörg Sundermann**, Germany)

PAGE 278–279: Backstage at Mambo Cabaret in Bangkok. (**Gueorgui Pinkhassov**, France)

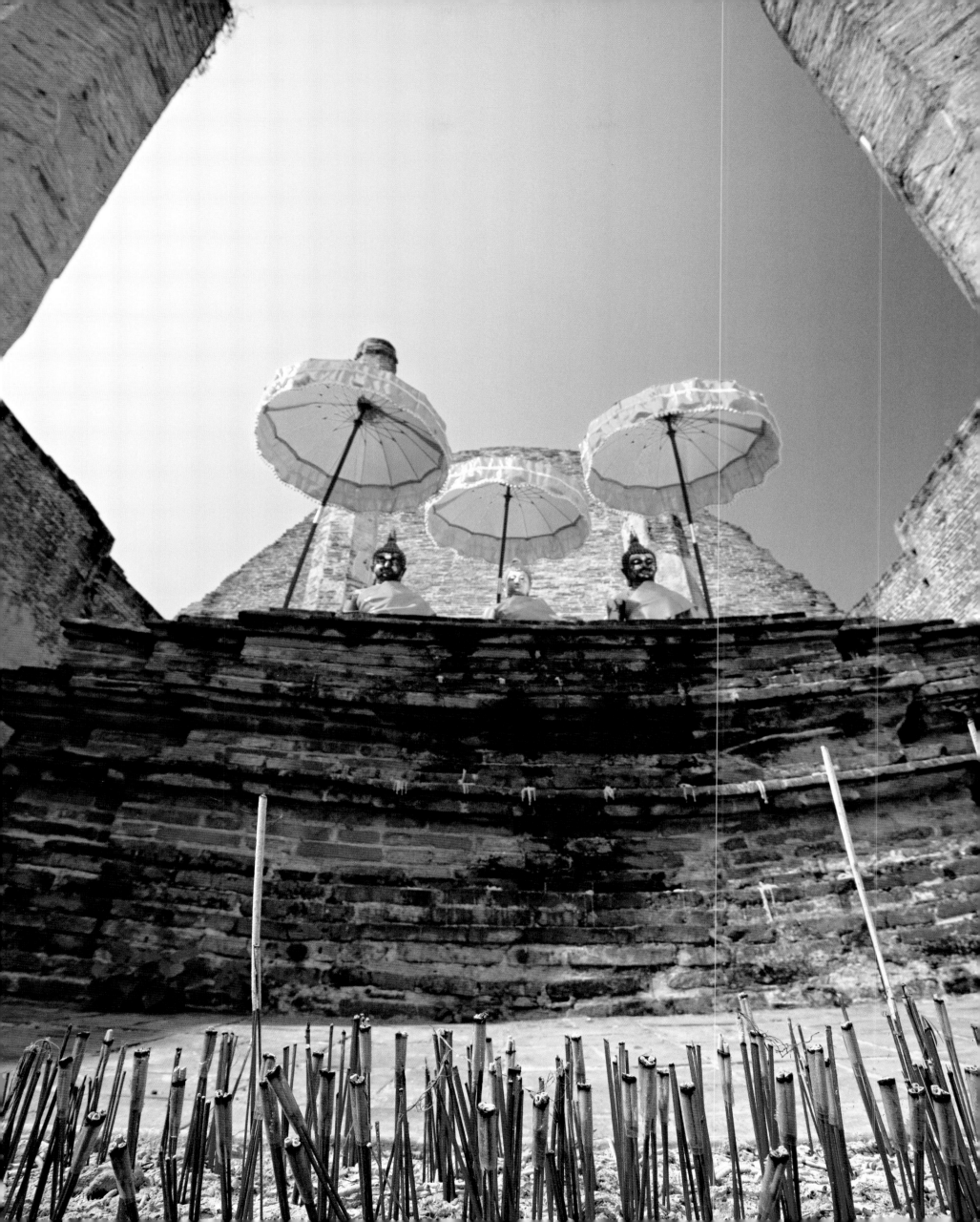

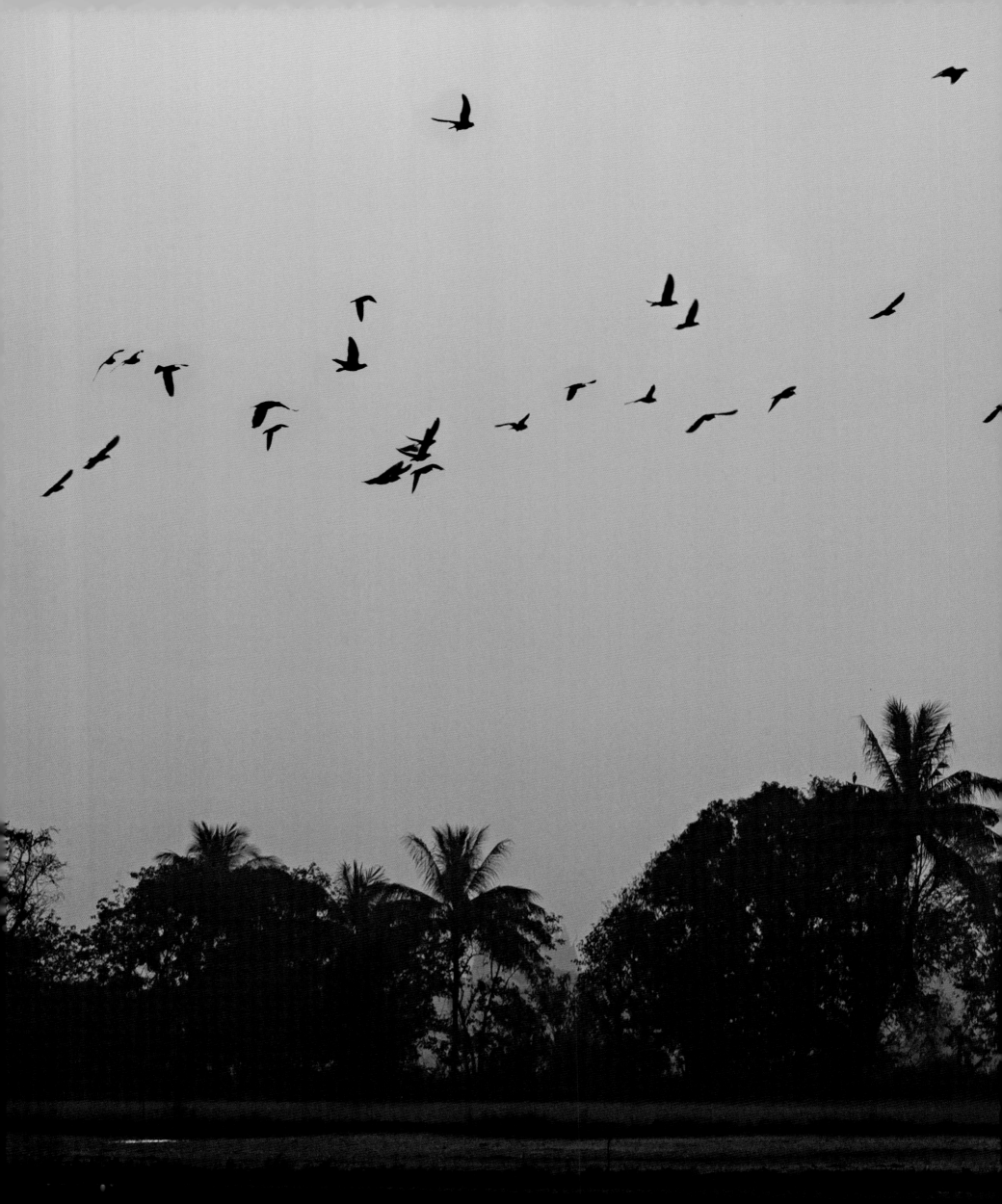

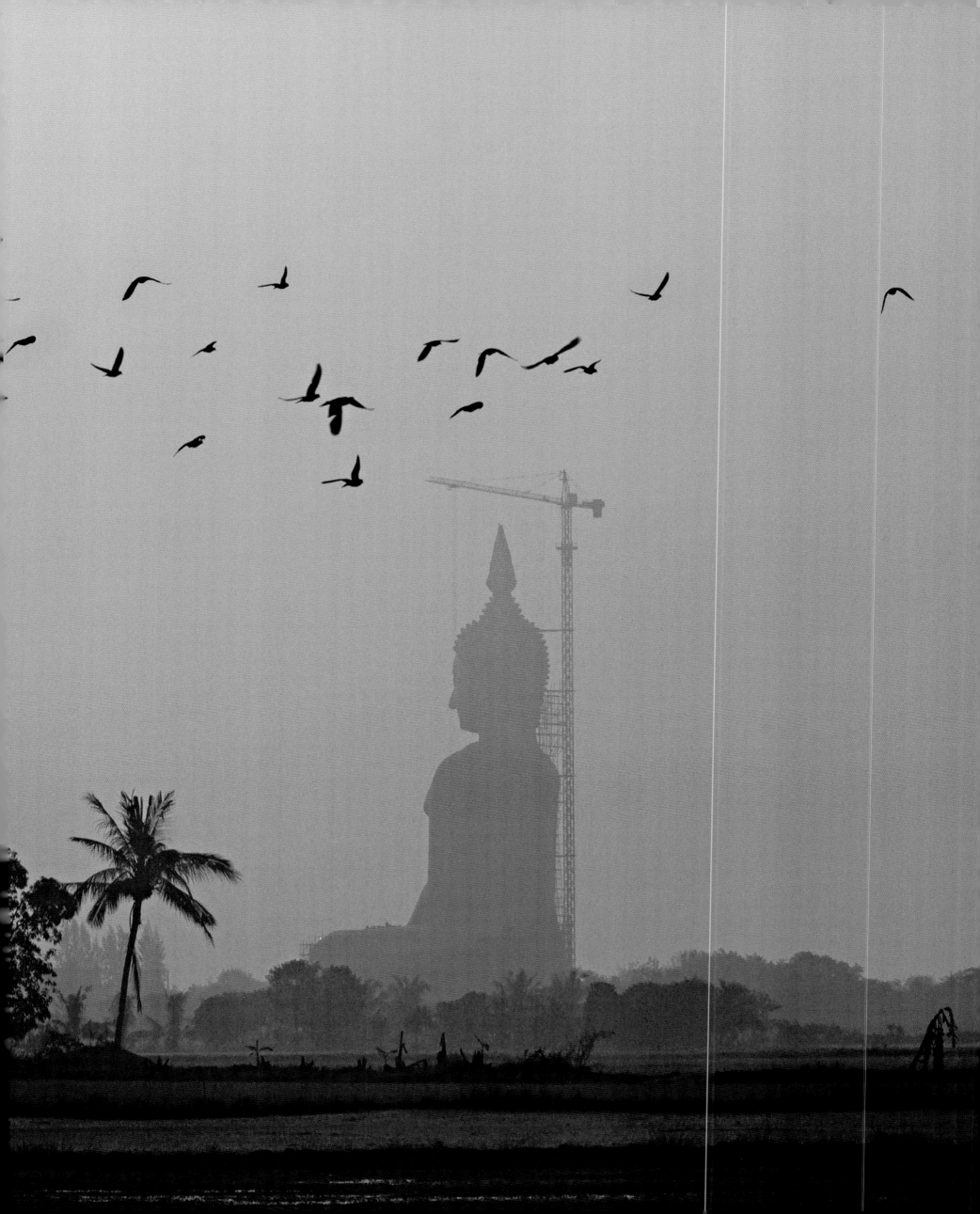

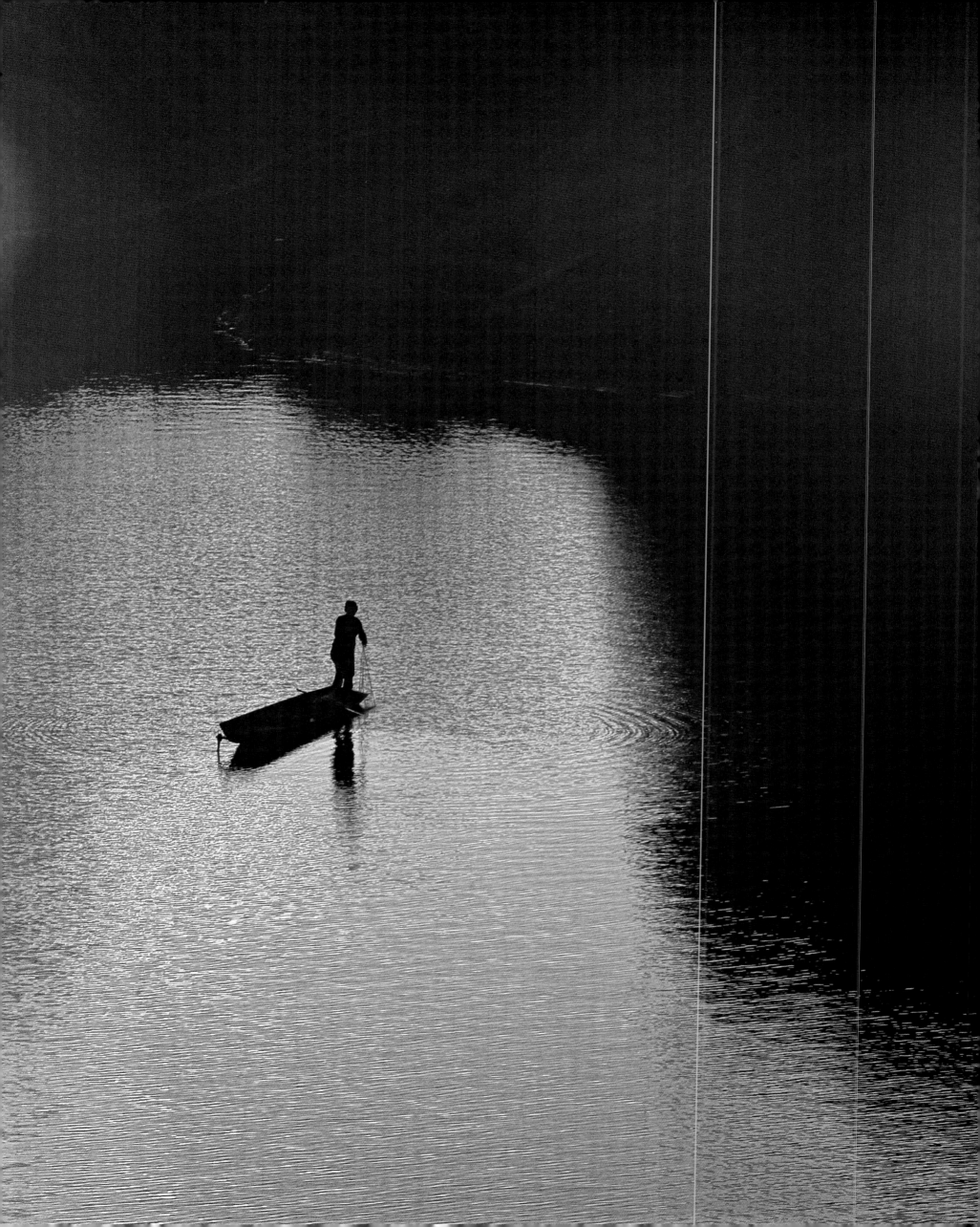

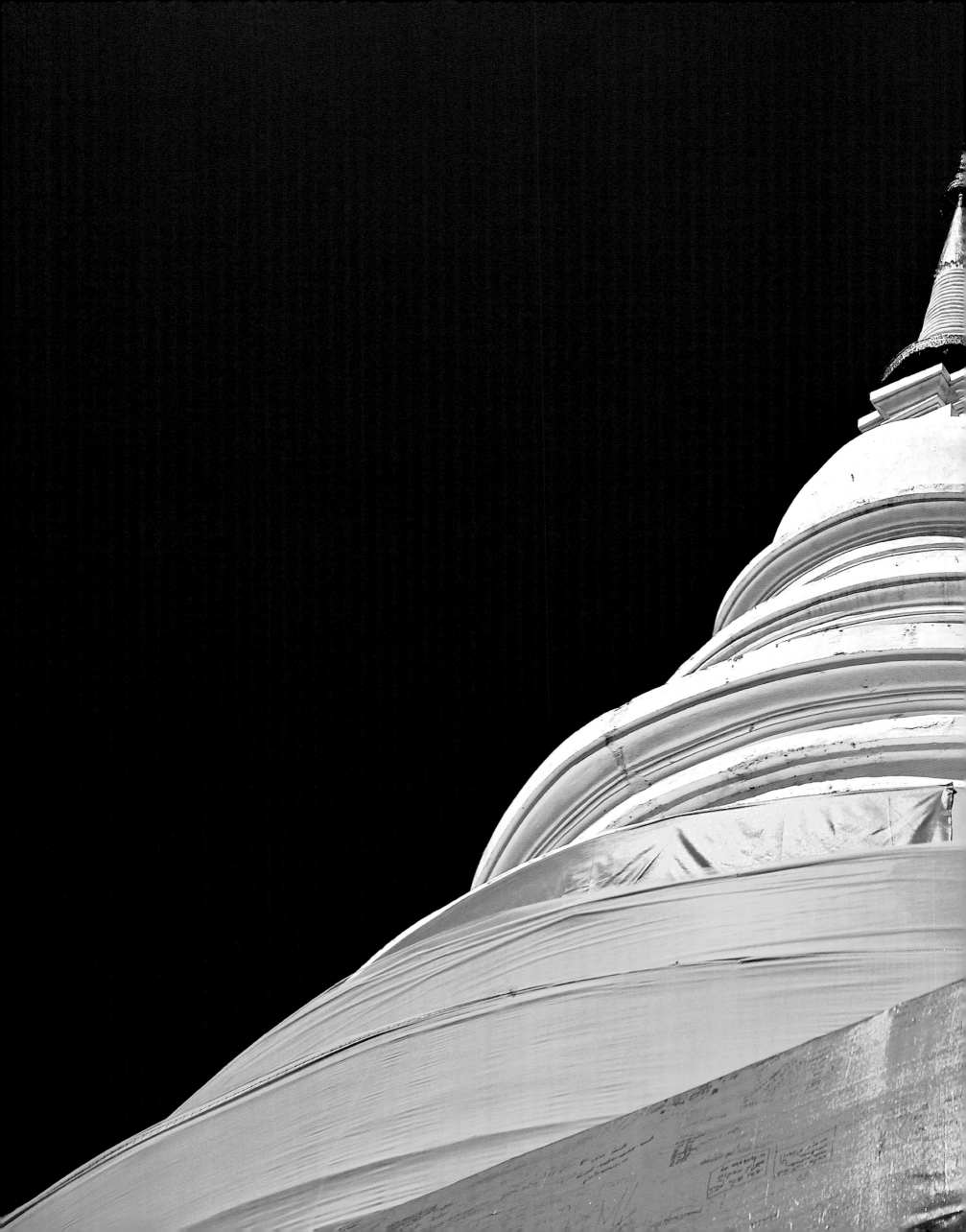

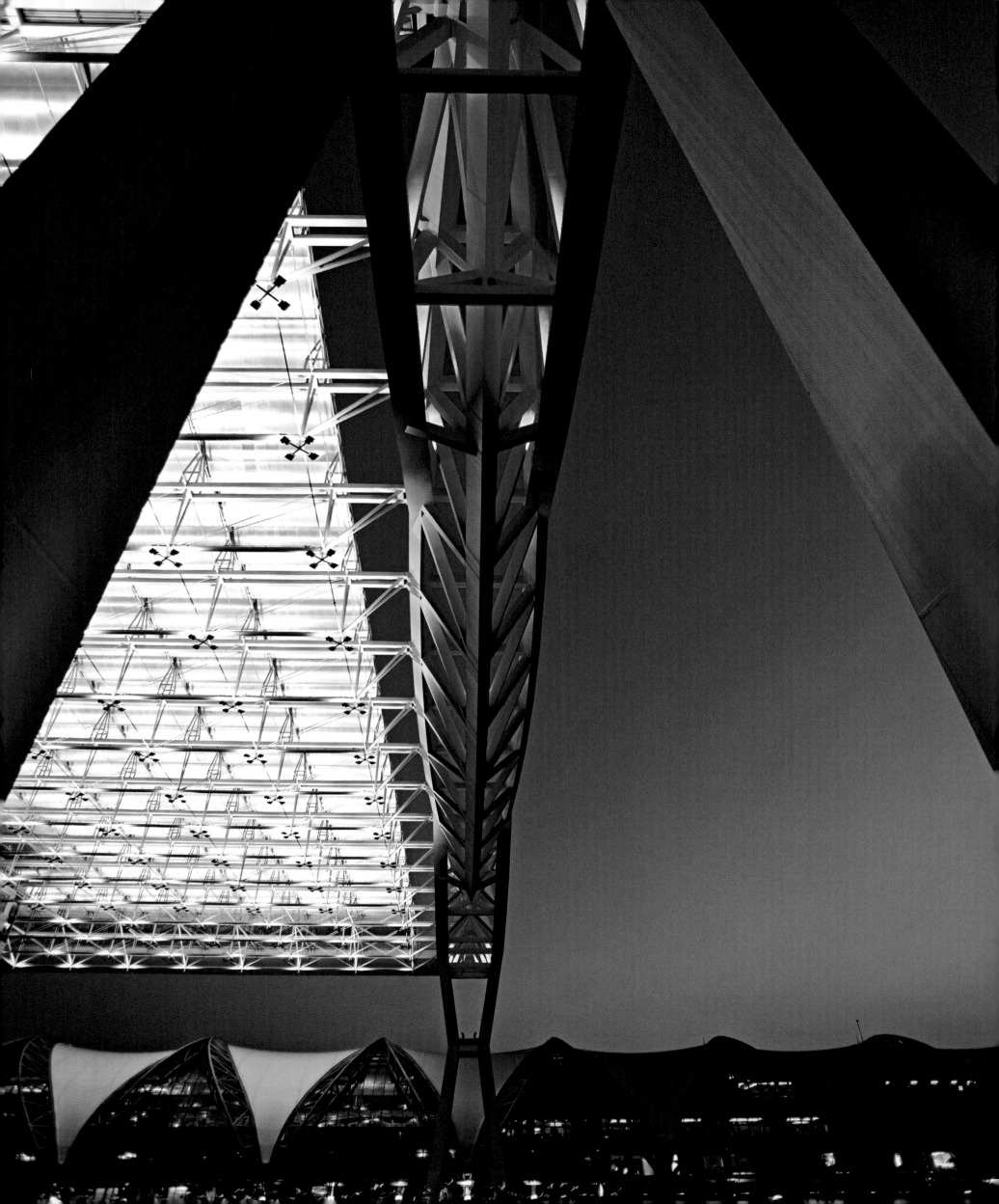

A Modern Kingdom

In January 2007, 55 of the world's leading photographers assembled in Bangkok and then scattered to spend nine days all over Thailand. Their quest was to capture the various faces, ways of living and atmosphere of the country today, from the rolling mountains of the far north to the long southern peninsula that stretches down to Malaysia. The team included specialists in such areas as aerial, underwater and wildlife photography, and others renowned for their ability to capture intimate and revealing views of everyday life.

Twenty years ago, in March 1987, 50 photographers had embarked on a similar mission—to preserve, through a memorable collection of images, what Thailand was like at a particular moment in its history. But though the basic aim was similar, the team of 2007 discovered fresh and innovative ways of achieving it and, in the process, reveal a very different Thailand from that of two decades earlier.

The timing of both explorations was not random. Each celebrated a significant landmark in the life of His Majesty King Bhumibol Adulyadej; in the first case his auspicious 60th birthday and in the second his 80th. The longest-reigning monarch in the world, the King occupies a unique personal position in Thai life, one probably unequalled anywhere else. He also embodies a centuries-old institution.

Some of the photographs in this book reveal the physical remains of Thailand's past and its cultural components. There are, for instance, massive stone temples in the northeast that remind us that the Khmers were once the dominant power in what is today Thailand, and left a legacy that can still be seen in numerous rituals and architectural features. In the north are other structures dating back to the Lanna kingdom, a loose collection of city states founded by some of the first Thai-speaking people to migrate down from the southern provinces of China.

Far more evocative are the ruins of Sukhothai, founded in the latter part of the 13th century and viewed by most Thais as the true birthplace of their culture. Here, it is said, the Thai alphabet was devised, distinctive styles of Thai art and architecture first appeared on palaces and Buddhist temples, and a system of paternalistic monarchs evolved to replace that of the god-like Khmer rulers.

Following the decline of Sukhothai, the great capital of Ayutthaya was the seat of power for some 400 years in the fertile Chao Phraya River valley. This glittering, cosmopolitan city, which attracted commerce from all over the world, was almost completely destroyed by Burmese invaders in the mid-18th century, leaving only a few remnants of its once extensive buildings. Most of its population fled or were carried off as prisoners and, over the next century or so, jungle creepers clambered over streets where a succession of kings had impressively paraded on royal elephants, wealth had been proclaimed through ornate temples and enormous gilded images, and a diversity of ambitious merchants from China, Japan, Persia, Holland, Britain and France, to mention only some, had competed for the wealth of Thailand's fields, forests and mines.

Meanwhile, however, the Thais had recovered their strength and, in 1782, commenced construction of a new capital further down the broad, winding Chao Phraya. Given an immensely long, honorific royal title—the longest of any capital city in the world according to the *Guinness Book of Records*, it was commonly known within the kingdom as Krung Thep, 'city of angels', though foreigners (and Western map-makers) persisted in calling it Bangkok, the name of a small trading town that had originally stood on the site. It was fairly close to the Gulf of Thailand, easily accessible to trading vessels, and soon began to prosper.

OPPOSITE: The soaring exterior supports and neon-blue lighting reveal the sculptural beauty of Bangkok's new international airport.
Ben Simmons, USA

BELOW: Private investors check their stocks in the trading room at Sicco Securities in Sindhorn Tower on Wireless Road in Bangkok.
Ben Simmons, USA

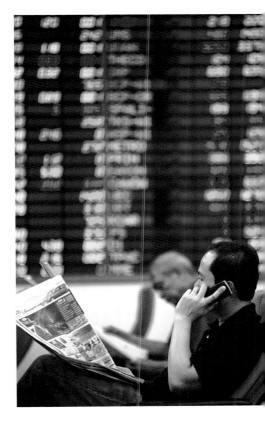

The city was founded by King Rama I, who also established the Chakri Dynasty that still occupies the Thai throne. Nine kings have ruled thus far, and Bangkok—first laid out in conscious emulation of the lost Ayutthaya, complete with a network of Venice-like canals and near-replicas of buildings in the old capital—has expanded in all directions to become one of the great cities of the region. Its ever-changing face—futuristic in some aspects, timeless in others, reflecting both the best and the worst of contemporary Thailand—is vividly captured in one section of this book.

As members of the photographic team fanned out across the country on their assignments, alert for any serendipitous discoveries that might come their way, they encountered both geographical and cultural variety. The northern landscape is characterised by mountains that rise in places to considerable heights, and narrow but fertile valleys, watered by a number of small rivers that eventually meet to form the all-important Chao Phraya, while the mighty Mekong forms the border with Laos. A century or so ago it was densely forested with hardwood trees, providing a haven for wild elephants and nearly a thousand species of indigenous orchids. Due to its inaccessibility, the north remained a semi-autonomous region well into the late 19th century, with its own ruling families and its own customs and cuisine—some influenced by Burma (now Myanmar) and Laos, many of which survive to give the area a particular flavour even today. In more recent times, assorted tribal groups in colourful costumes have

An aerial view of the Temple of the Emerald Buddha and the Grand Palace, two of Thailand's most important landmarks and the seat of power of the Chakri Dynasty for more than 200 years. Behind the temple (on the left) lies the Ministry of Defence (the square building).
Yann Arthus-Bertrand, France

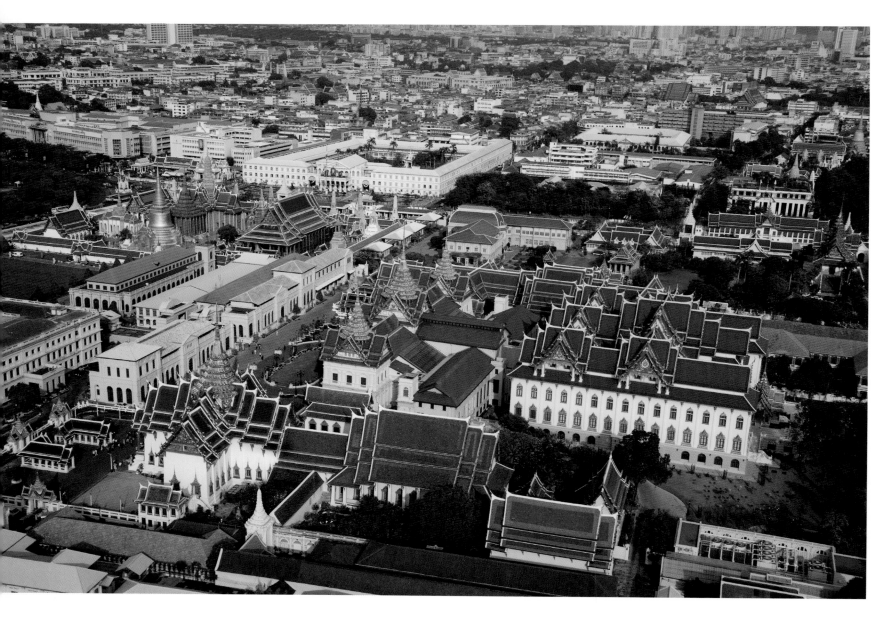

migrated down through the hills to bring an added exotic flavour to northern culture, as well as such social problems as their traditional cultivation of opium poppy and destructive slash-and-burn methods of clearing land.

The northeast, covering almost a third of Thailand's total area, presents a very different physical aspect. In prehistoric times it was the home of a rather mysterious culture that lived in settled villages, cultivated crops and mastered the art of bronze metallurgy before vanishing for unknown reasons around the start of the Christian Era. As we have seen, the northeast was later part of the Khmer empire at the height of its power in the 11th and 12th centuries CE; Prasat Hin Phimai, for instance, near the contemporary city of Khorat (Nakhon Ratchasima), was a fortified Khmer temple from which a road led directly to Angkor.

Once rich in forests and wildlife, the northeast— or Isaan, as it is more popularly known—has become a notoriously harsh region, subjected to both devastating droughts and floods and, in modern times, frequently a centre of political unrest. Many of its younger people have taken advantage of new highways built in the 1960s and 1970s, moving to urban centres elsewhere in search of a better life, migrating in such numbers that they have spread Isaan food and customs throughout the country.

Central Thailand, extending down to the Gulf, is the kingdom's traditional heartland. The Chao Phraya River nourishes this vast plain covered with an intricate grid of rice fields, fruit orchards and vegetable plantations. Here is where, in addition to villages where life moves at a timeless, seasonal rhythm centred around planting and harvesting, the greatest concentrations of wealth and power can be found, mostly in Bangkok and its environs. The capital is the centre of government, of the powerful military, of business and of all forms of transportation: Suvarnabhumi, Bangkok's new state-of-the-art international airport and one of the largest in the region, opened in 2006.

Export-oriented industries along the eastern coast of the Gulf turn out automobiles, computer chips, refrigerators, television sets and other consumer goods that long ago replaced agriculture as the country's major income earners. At the

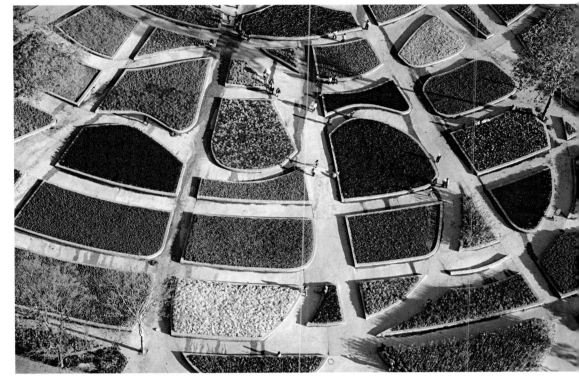

same time they have brought new occupations and aspirations to countless Thais who, only a few generations ago, could have passed their entire lives within the villages of their birth, never having seen a modern shopping centre, an air-conditioned cinema or a soaring skyscraper. (The same, incidentally, could also be said of older residents of the capital itself: almost everything one sees today—the tall buildings, the mass transit systems and the elevated expressways that snake in all directions—have appeared in the last 30-odd years.)

The fourth major region, one quite distinct in many ways, is the south—a long peninsula consisting of some 14 provinces, with a ridge of jungled limestone mountains running down the middle. Major tourist destinations can be found along its scenic coasts, one on the Gulf of Thailand and the other on the Indian Ocean, where peerless white-sand beaches now lure visitors from all over the world and vast plantations of rubber, coconut, oil palm and pineapple provide even greater sources of income. Going back even further into the past are such southern exports as tin—for which Phuket was famous long before the first backpackers discovered its magical strands and crystal-clear waters—and the edible nests deposited by tiny swiftlets in lofty caves, a delicacy that impelled Chinese traders to brave the hazardous seas.

A patchwork of flower beds at the Royal Flora Ratchaphruek flower festival in Chiang Mai.
Yann Arthus-Bertrand, France

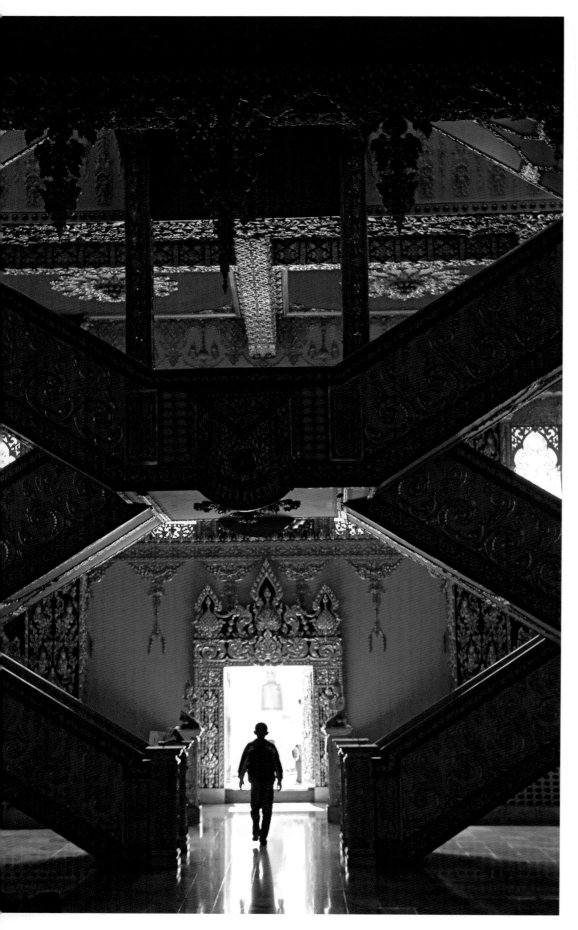

As well as natural wealth, though, the south also has problems of its own. Provinces closest to Malaysia are predominantly Muslim and, for some years now, insurgents have led an active separatist movement, often accompanied by violence affecting ordinary people as well as military forces. Various Thai governments have sought solutions to the conflict, but at the time of the 2007 photo shoot it continued to be a matter of national concern.

Buddhism is the dominant religion of the kingdom. Introduced in the 3rd century BCE from India, the Theravada sect spread throughout the region and was adopted by the kings of both Sukhothai and Lanna, its gentle philosophy seeming to answer the deep-seated needs of people in Thailand and most of its neighbours.

Today an estimated 27,000 *wats*, or monasteries, display their striking, multi-roofed buildings and graceful stupas almost everywhere, and such Buddhist practices as presenting alms to local monks, making merit through donations to temples and ordination ceremonies for young men when they reach maturity, are ingrained parts of daily life, especially in rural areas. Less visibly, yet no less importantly, Buddhist values underlie many basic Thai attitudes, from the fatalistic acceptance of misfortune to an avoidance of confrontation whenever possible. Such influences may not be so apparent in cities such as Bangkok as in villages, but at some level they are still there, waiting to emerge at sometimes unexpected moments.

Thai tolerance accepts other faiths as well, most obviously in the form of different religions but also in more subtle ways. As noted, Islam is a powerful presence in the south and, even in Bangkok, mosques are not uncommon since Muslim groups took up residence in the capital during its earliest years. Catholic missionaries from Portugal and France came during the Ayutthaya period and evangelical Protestants, mostly from America, arrived in the 19th century. They made comparatively few converts but their influence in such fields as education and Western medicine was considerable, and Christian churches can be found in many cities.

Other far more ancient beliefs that pre-date Buddhism are also prevalent, interwoven in a complex pattern that confuses outsiders. Spirits

that watch over individual pieces of land, rice fields, buildings and even certain trees, for example, are honoured with little houses (spirit houses) and regular offerings, and are thought to have not only the ability to provide protection but also to grant general good fortune. Hindu gods are particularly popular in urban areas. Thousands of shrines devoted to these divinities can be seen in Bangkok, some within the precincts of Buddhist temples and many others outside the city's major shopping centres and hotels, while white-robed Brahman priests preside over most rituals associated with royalty.

Few Thais are concerned that such practices are contrary to strict Buddhist teachings. To them, it seems quite logical for a new government minister to present offerings at several different shrines— Buddhist, Hindu and animist—on his first day in office. Similarly, ordinary residents pay homage at Bangkok's City Pillar, where the guardian spirit of the capital is believed to reside, and they carry any number of lucky amulets, which, in turn, have often been blessed by revered monks.

If asked, a majority of the country's people would proudly claim to be Thai; and rightly so in terms of citizenship, loyalty, language and most aspects of a shared culture. But the term also encompasses a number of ethnic groups who live within the national boundaries and, in spite of such modern forces as mass media, a standard education system and greater ease of communication, somehow manage to retain elements of their own identity.

Each of the four major regions, for example, has its own language, or dialect, in some cases quite different from the officially 'approved' Thai that prevails in central Thailand. According to one study, the first language spoken by most residents of the populous northeast is Lao, while for those along the Cambodian border it is Khmer. Other languages are spoken in the north and, to an even greater extent, in the far south.

The Chinese, too, form a prominent ethnic group that has been largely assimilated, but still display many of its traditional customs. Chinese traders have been coming to Thailand since ancient times and they formed significant resident communities in both Sukhothai and Ayutthaya. King Taksin, the leader who finally expelled the Burmese after Ayutthaya's fall, was partly Chinese. When King Rama I decided to establish his new capital in Bangkok, it already had a thriving Chinese business community, which was moved a short distance downriver, outside the city walls, but continued to be an important economic presence.

The greatest influx of people, however, arrived in the 19th century as Bangkok's prosperity grew. Most of them came from the poorest provinces of southern China, bringing only the proverbial 'rice bowl and sleeping mat'. Most, too, were single men, which encouraged intermarriage with local women. Hard-working and thrifty, they did not compete with Thai farmers but tended to settle in cities such as Bangkok, taking such menial jobs as digging canals, building railways and constructing roads. The more successful became moneylenders, rice millers, merchants and businessmen of all kinds. According to one estimate, the Chinese minority grew from around 230,000 in 1825 to nearly 800,000 in 1910, or 9.5 per cent of the total population.

Immigration dropped steeply in the 20th century, particularly after World War II (WWII), but by that time the Chinese presence was an established feature of Thai life. There were occasional conflicts, especially during periods of extreme nationalism, but because of close connections through marriage and business, these were never as serious as in some other societies. In Bangkok today, it would be difficult, if not impossible, to find a prominent family that is not wholly or partly Chinese, though all have

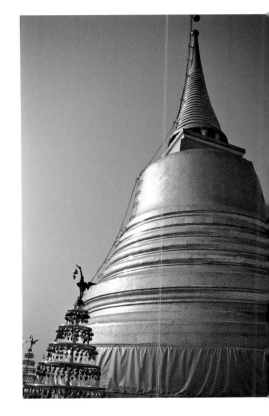

OPPOSITE: The interior of Phra Chedi Maha Chaimongkol. The enormous stupa, though still unfinished, has several storeys, including a loft in the topmost crown of the stupa.
Rio Helmi, Indonesia

ABOVE: The Golden Mount of Wat Saket is located on an artificial hill in Bangkok's historic quarter. Built and bolstered by successive kings during the 19th century and standing out in the low-rise landscape of the area, the Golden Mount is now a popular tourist destination.
Egbert Brehm, Germany

LEFT: As part of his daily errands, a monk sweeps the ground in front of a reclining Buddha statue at Wat Somdej in Kanchanaburi province, near the Myanmar border. Many of the monks there speak Burmese, not Thai.
Waranun Chutchawantipakorn, Thailand

a Thai name (sometimes a royal Thai title) and have shown their patriotism and loyalty countless times.

Smaller, less assimilated but of notable economic importance is the Indian community, almost wholly centred in Bangkok. Originally dealers in textiles, spices and other imports, they have branched out into real estate and now own property in some of the capital's prime areas.

In addition to these larger groups, there are others consisting of Mons, Malays, Burmese and tribal people, all with cultural characteristics which they have kept more or less intact.

Uniting all these disparate elements through the centuries like an enduring thread has been the institution of the Thai monarchy. The ideal model is said to have emerged in the Sukhothai era, when the ruler not only exemplified Buddhist virtues but also enjoyed a paternalistic relationship with his subjects. According to a 1292 stone inscription attributed to King Ramkhamhaeng, the King was both benevolent in his rule and accessible to his people, placing a bell at the palace gate so that anyone with a grievance could ring it and ask for justice. Some modern historians have questioned the authenticity of this inscription, though no one could doubt the heartfelt sentiments and aspirations it expresses, whenever it was created.

Fishermen along Na Klue canal in Samut Prakan province, near the mouth of the Chao Phraya River.
Dominic Sansoni, Sri Lanka

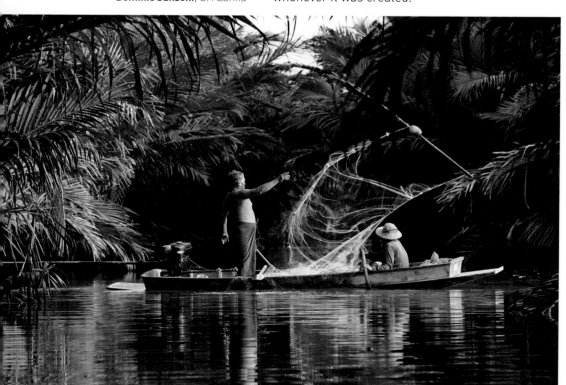

Not all the rulers of Ayutthaya lived up to the ideal, at times returning to the remote, god–king isolation that prevailed under the Khmers. Certain pivotal figures stand out, however: King Naresuan, a dynamic warrior who restored Thai independence after a Burmese invasion in the mid-16th century; and King Narai, whose fascination with the outside world led him to open trade relations with several Western powers and to send the first Thai mission to Europe to the French court of Louis XIV in 1684.

Following the founding of Bangkok, the Chakri Dynasty proved fortunate with a series of effective rulers whose guidance was crucial during a time of extreme peril for independent Asian monarchies. All around, from India to China, such Western powers as Britain, France and Holland were expanding their Far Eastern empires and it seemed merely a matter of time before Siam, as Thailand was then known, joined the list of 'protectorates' or fully fledged colonies.

The sixth Chakri king, the first to receive his higher education abroad, initiated the custom of referring to all Thai monarchs as 'Rama' and numbering them for convenient historical reference—Rama I, Rama II, Rama III etc. Three of these kings, however, are still commonly referred to by their names because of their singular achievements.

King Mongkut (Rama IV), one of these, had spent 27 years as a Buddhist monk before he came to the throne in 1851. During that time, he travelled extensively throughout the kingdom, studying its ancient sites and meeting ordinary people, including foreign missionaries. He had learned Latin, English and French and, perhaps most significantly, had acquired a shrewd awareness of events in the outside world and of the urgent need to deal with them in a constructive way. One of his first acts as king was to open relations with Britain, as a result of which Sir John Bowring, the governor of Hong Kong, came on a diplomatic mission to Bangkok in 1855 with the aim of reaching an agreement on trade that had eluded several previous emissaries. Bowring and King Mongkut established a warm, personal relationship and a historic treaty was duly signed, one that served as a model for other treaties between Thailand and foreign powers, including the United States. It required a number of commercial and judicial concessions

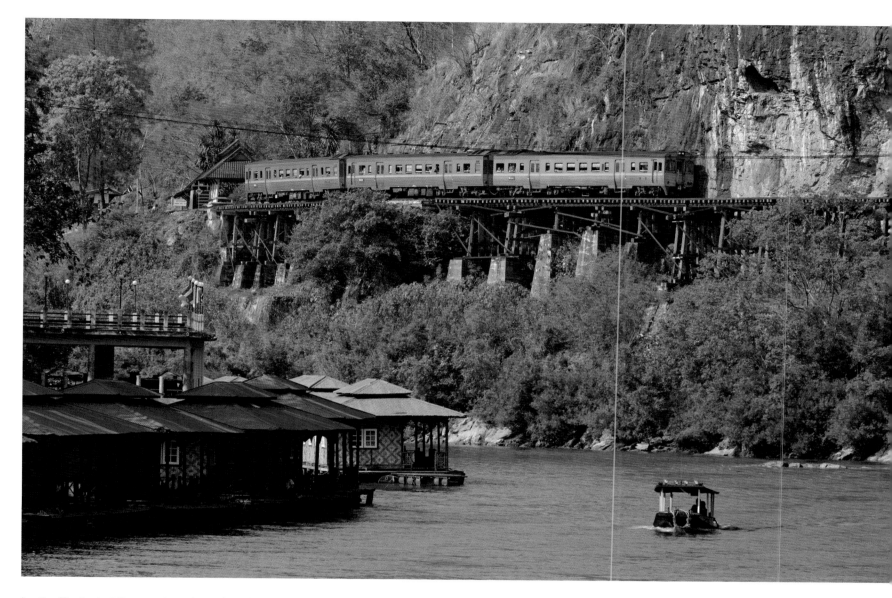

by the Thais, but it served to show that the country was on the road to modernisation and could not be viewed in the same condescending way as neighbouring Burma and Malaya.

The second ruler remembered by name, even still revered, is King Mongkut's son, King Chulalongkorn, who succeeded his father in 1868 and ruled until 1910, a momentous period in Thai history. Only 15 when he became ruler, King Chulalongkorn was represented by a regent during the early years of his reign. He was already set on the road prepared by his father, however, and once he had full power he embarked on a series of dramatic reforms that transformed almost every aspect of Thai life.

These included government administration from top to bottom, education, agriculture and communications. He was the first Thai monarch to travel abroad—first to Dutch and British colonial possessions between 1871 and 1872 and, later, twice to the capitals of Europe. He engaged able foreign advisors for his ministries and sent his own sons, as well as other promising young Thais, abroad for higher education in needed skills. Through diplomacy and compromise, he succeeded in preserving the country's independence, making Thailand the only country in Southeast Asia to enjoy that distinction.

His Majesty King Bhumibol Adulyadej, the present ruler, is the third king known by name to Thais and foreigners alike. His achievements are all the more remarkable in view of the fact that there seemed little chance of his ever reaching such heights at the time of his birth in 1927 in Cambridge, Massachusetts, where his father, Prince Mahidol of Songkhla, was studying medicine at Harvard University. Others

The 'Death Railway' snakes its way around a rock face in Kanchanaburi province. In order to construct a supply line to Burma during WWII, the Japanese used the forced labour of Allied prisoners of war (POWs). Brutal conditions and treatment killed an estimated 16,000 POWs. Today, the River Khwae area is popular with tourists, who visit the waterfalls and WWII memorial sites.

Waranun Chutchawantipakorn,
Thailand

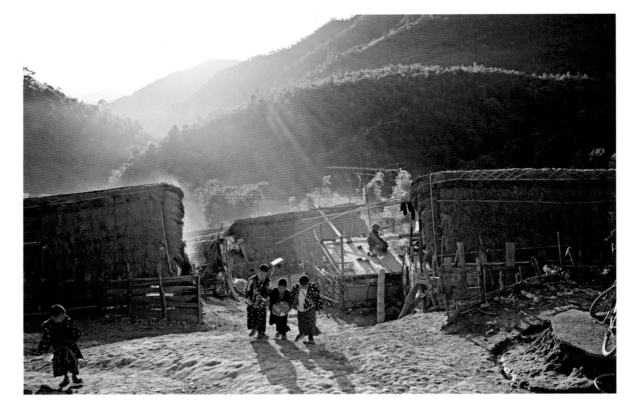

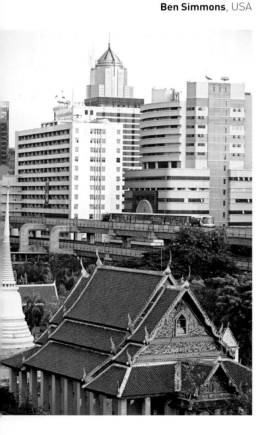

seemed far more likely to take up residence within the long, high walls of the splendid Grand Palace and might have done so had fate not intervened.

First, Prince Mahidol died at an early age in 1929. Three years later, Thailand's ancient absolute monarchy was brought to an end in a coup led by a small group of mostly foreign-educated officials, and was replaced with a constitutional system. King Rama VII, the ruler at the time, accepted the change of government, which he had already been considering. He was disillusioned by some of the results, however, and abdicated while abroad for medical treatment in 1935. Since he had no heirs, Prince Ananda Mahidol, Prince Bhumibol's 10-year-old elder brother, was chosen as his successor, with a regency appointed until he came of age.

The Mahidol family lived in Switzerland then and, except for a brief visit in 1938, remained there until after WWII. When they returned to Thailand in 1946, Prince Ananda was found dead by gunshot in the palace on 9 June. Thus, suddenly and unexpectedly his brother ascended to the throne as His Majesty King Bhumibol Adulyadej. He completed his education abroad and was officially crowned in May 1950, shortly after marrying a young member of the Royal Family, who became Her Majesty Queen Sirikit.

To some observers at the time, his position seemed precarious. For 15 years the kingdom had been without a visible ruler in residence, a non-royal government was securely in charge, and there were questions as to whether the monarchy, for all its traditional prestige, would still prove relevant in the modern world.

The new King, with the able assistance of his Queen, soon laid any such doubts to rest. In the mid-1950s, beginning with the impoverished and largely neglected northeast, they began making frequently arduous trips to rural areas. The response of local people was overwhelming and such provincial tours became a hallmark of the reign, bringing the Royal Family into close contact with every part of the country, however remote and difficult to reach, and every level of society. The King and Queen have also made state visits abroad to over 30 countries, increasing international awareness of Thailand.

His Majesty's first-hand knowledge of his people's needs has resulted in more than 2,000 'royally initiated' projects ranging from water conservation and flood control to village welfare and the introduction of new crops for farmers. In addition, he presides over countless more traditional ceremonies and rituals, nowadays often assisted by

other members of his family, including His Royal Highness Crown Prince Maha Vajiralongkorn and Their Royal Highnesses Princess Maha Chakri Sirindhorn and Princess Chulabhorn.

Another result of His Majesty's obvious dedication has been his emergence as a figure of tremendous moral authority. In a predominantly young population, the great majority of Thais have never known another ruler and tend to look upon him as the ultimate source of wise counsel in times of national unrest. Portraits of him adorn not only public buildings but also private homes and the most humble of neighbourhood shops. Throughout 2006, the 60th anniversary of his accession to the throne, and 2007, the year of his 80th birthday, Mondays were a sea of bright yellow as Thais wore shirts and blouses in the colour associated with the day on which he was born, to demonstrate their affection. Wherever one goes then, he is a constant, deeply revered presence, as potent in photographs and paintings—even in a particular colour—as in person.

Among the images in this book are many of great beauty, and others display typically Thai humour and forms of entertainment. The book's fundamental purpose, however, is not to present an idealised Thailand, nor to entice more tourists to its celebrated sights and pleasures. On the contrary, it seeks to mirror aspects of Thai society as they were, flattering or not, during the first month of 2007.

The country has undergone many physical and social changes over the 20 years since the 1987 photo shoot. These are perhaps most apparent visually in Bangkok. The chronic traffic conditions of the capital have been alleviated, if hardly solved, by a sleek air-conditioned 'sky train' that opened on the King's birthday in December 1999 and that is currently in the process of being extended; a subway was added to the mass transit system a few years later. Elevated expressways have also been built to ease commuting time between the business centre and the ever-expanding suburbs, now stretching for miles in all directions, and a new skyline has been created, with towering office buildings and residential condominiums everywhere. All these developments slowed down during the Asian financial crisis of 1997 but have picked up again in recent years and the city's physical appearance is altering faster than ever.

The changes are somewhat less immediately evident in rural regions, but nonetheless they have had profound social effects. Highway construction, which started in the 1960s, has accelerated so that a network of modern all-weather roads now links every region. Even the most isolated village has electricity and, along with it, television, video and many other features of global culture. A schoolboy in Mae Hong Son, a once sleepy northern town near the Myanmar border, can log on to the Internet with as much facility as his counterpart in Bangkok.

New problems have emerged as well. In addition to the growing unrest in the far south, ethnic groups from Myanmar have crowded into refugee camps to escape the fighting in their country; the gap between the rich and the poor has widened; the environment has steadily deteriorated; and the scourge of HIV/AIDS has spread relentlessly—an estimated 3,000 non-governmental organisations have been formed to draw attention to all these and others.

The multifaceted pictures on the following pages are intended as a tribute to a man of exceptional abilities and also as a record of what was happening in his diverse kingdom during nine days in the midst of a long and eventful reign.

William Warren

The view from inside CentralWorld, Southeast Asia's largest shopping complex. In order to remain competitive with the many new luxury malls in Bangkok, CentralWorld was renovated and relaunched in 2006.

Ben Simmons, USA

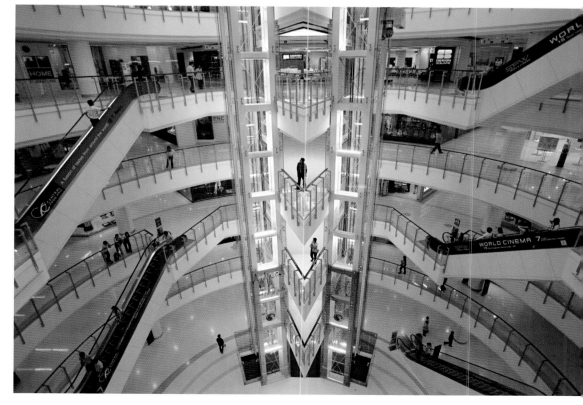

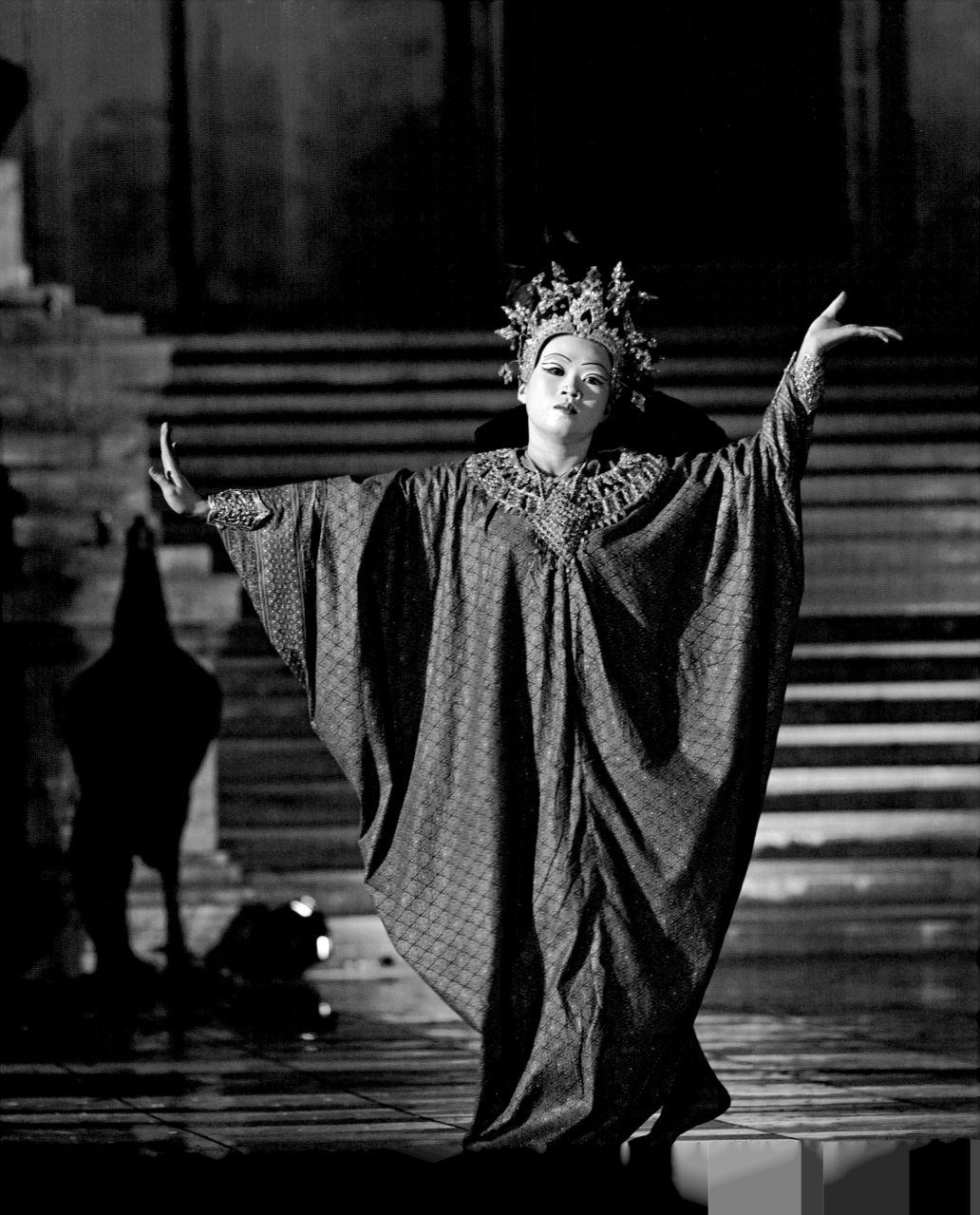

Countdown to 9 Days

On a rooftop 61 storeys high, 75 pairs of eyes scour the Bangkok skyline, looking for Frenchman Yann Arthus-Bertrand. The aerial photographer is set to make a grand appearance by helicopter. Skimming over the tops of downtown skyscrapers, Arthus-Bertrand will approach the Banyan Tree Bangkok. Arriving precisely at 5.15 pm, his military chopper will hover briefly, just long enough to give chief photographer Robert McLeod time to capture a dramatic shot of 55 of the world's great photographers and the Editions Didier Millet (EDM) team, gathered together on the roof in the heart of the Thai capital.

That is the plan at least.

At 5.15 pm, Arthus-Bertrand is nowhere to be seen. And where is Abbas? The man from Magnum Photos has gone AWOL. Like legendary photographer and Magnum Photos founder Henri Cartier-Bresson, Abbas, it turns out, is camera-shy. At 5.30 pm, publisher Didier Millet speaks to Arthus-Bertrand on his mobile phone and learns that the distraught photographer has been grounded at Don Muang airport. Abbas, meanwhile, is in a taxi headed towards dinner. As the sun sets and the jet-lagged crew grow restless, Millet makes the final call: take the picture and call it a day.

Arthus-Bertrand's no-show would normally be nothing to get down about, but then, it was the first official picture for the book and his inaugural flight had been eagerly anticipated and fretted over for months. To help get him airborne, EDM staff had, over coffee and cake at Thailand's military headquarters, presented the project and Arthus-Bertrand's work to a small army of amiable lieutenants, smiling lieutenant-colonels and excited flight captains. They had provided lists of the equipment the photographer would bring on board (assurance that he was not a spy); they had requested special sliding doors as well as two-way radios with which he could communicate with the pilot; and they had even drawn detailed point-to-point maps of his desired flight path. The editorial team had attended so many meetings with Air Force personnel that they had started to salute each other.

But despite these efforts, Arthus-Bertrand's first flight was aborted. Doubts began to surface in the minds of the editorial team. Would his entire mission fail? And if countless hours of preparation could not ensure the success of even the group photograph, what about the rest of the project?

The logistical and organisational challenges of the *9 Days* project were massive: provide 55 photographers with a total of 495 itinerary days squeezed into a single nine-day period; arrange hotels, flights, drivers, translators and assistants to help them; acquire permission to shoot in locations across the kingdom and gain access to them; and to help support and promote it all, secure sponsors in the public and private sectors.

Thus, by necessity, the *9 Days* adventure truly began more than 400 days before that first evening on top of the Banyan Tree. It was in November 2005 that Millet and project director Yvan Van Outrive decided to create a new visual time capsule of Thailand using the same concept as the successful *Thailand: Seven Days in the Kingdom*, which was published in 1987. The timing for such a new book was ideal. Thailand was gearing up to celebrate the 60th anniversary of the accession to the throne of His Majesty King Bhumibol Adulyadej. The following year, 2007, would mark His Majesty's 80th birthday. *Thailand: 9 Days in the Kingdom*, like its predecessor, would be dedicated to His Majesty, otherwise known as Rama IX, on the occasion of that birthday, and would take as its symbolic signifier the number nine.

First, Van Outrive and Millet needed to locate a leading Thai figure to chair the book's all-Thai advisory board. With the help of Dr Suvit Yodmani, Thailand's Minister of Tourism and Sports, they found the perfect man for the job. Surat Osathanugrah, the chairman of Osotspa Co. Ltd, is not only a well-known businessman but also an avid photographer who keeps in his house a virtual museum of cameras. The Minister's proposal to Surat was quickly cut short with two words: 'I accept.' Surat's role would not

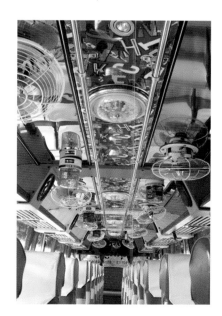

be limited to chairman—the unassuming president of The Royal Photographic Society of Thailand would also go on assignment for the project.

Without sponsorship, such an undertaking is impossible. The cost of flying in photographers from around the world, providing them with accommodation and paying for their movements around the country would be beyond the reach of any publishing house. Once Thai Airways and Dusit International agreed to offer their support in the form of flights and rooms, two more of the project's key pieces were in place.

Meanwhile, Thailand was experiencing a year of historic importance. Beginning in January 2006, His Majesty's Diamond Jubilee was celebrated across the kingdom with displays of reverence unique in the modern world. In the lead-up to the June anniversary, every Monday, Thais donned shirts in His Majesty's birthday colour, yellow. An exhibition on the King's life was attended by millions; and Apple even released 9,999 iPods in commemorative boxes. On the weekend of 9 June, monarchs and their representatives from 26 countries arrived to celebrate with His Majesty—an event that garnered headlines around the world.

At the same time, political turmoil formed an unsettling undercurrent to the year. In 2006, Thailand's loved and loathed Prime Minister Thaksin Shinawatra had stepped down and called for new elections, which were boycotted by the main opposition party. With the country moving from crisis to crisis, in September the military intervened, exiling Thaksin and installing a new government.

The spirited, edgy climate of Thailand in 2006 only enhanced the anticipation felt by the photographers, who began receiving invitations from the publisher. EDM's reputation ensured that many of the most celebrated photographers in the world would come to the kingdom. In order to make the project a truly international effort, the big names from Europe and America were complemented by talents from around the Asia-Pacific region, including 11 from Thailand. In the end, 55 photographers accepted the invitation, five more than the expected 50.

Reviewing the photographers' portfolios, the project's assignment editors started dividing Thailand into areas and themes. It would not be good enough to simply turn loose a group of photographers in different directions. Months of planning were undertaken to ensure that the country was covered comprehensively. The assignment editors wanted the photographers to take pictures not only of rice farmers but of the folk musicians whose songs they know by heart.

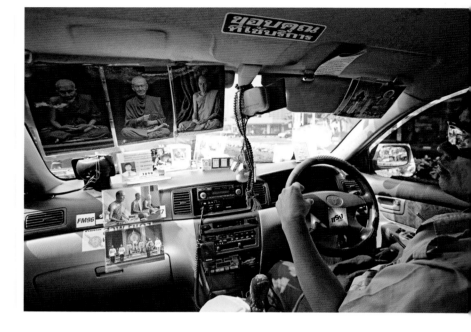

Itineraries were arranged along the meandering Mekong and through the violence-ridden deep south; invitations were secured to gala movie premieres and provincial cockfights; and a squid-boat captain and emergency response team were asked to make room for one more. Taken together, these myriad perspectives and subjects, they hoped, would present, like a great composite photograph, a single slice of time in the life of a modern kingdom.

As the editorial team soon learned, expectations among the photographers were also high, further expanding the scope of the project. After being assigned to take pictures of the Royal Thai military, Guido Alberto Rossi put in a special request: the former pilot wanted to fly in a jet plane and take pictures of other planes in formation. Éric Valli decided to return to the site of one of his great career successes: the caves of southern Thailand where birds' nests flourish. The caves that are the basis of this multi-million-dollar industry, however, also happen to be guarded by rifle-wielding patrols and are extremely difficult to photograph. Valli needed special permission from the industry's boss, a boat, climbing equipment and a team of climbers to follow him into the upper reaches of the massive caves where the nests are located.

Even in the modern metropolis of Bangkok, challenges abounded. Only three months removed from a coup and less than a month after minor bombs were set off around the city, the capital was on high alert and security was tight. Ben Simmons could not just saunter around Bangkok's new airport pretending he was a tourist. He needed permission from airport officials, a badge and an escort.

Fixing thousands of such details, the editorial staff did not stop dialling, faxing, emailing and sending text messages for weeks and, even more amazing, barely stopped smiling either.

With heat, traffic, language barriers and cultural nuances guaranteed to pose challenges on the ground, a team of assistants and translators was recruited to provide essential aid to the photographers. The core of this team was made up of 25 members of Thailand's Nikonian club, a group of local amateur and professional Nikon-lovers based in Bangkok. Joining them were a handful of other photography enthusiasts from both inside and outside Thailand. They included a *Lonely Planet* writer, freelance photojournalists and an official from the Tourism Authority of Thailand. By the time the shoot began, the roster of volunteers was larger than the team of photographers—65 in all. As keen lovers of photography themselves, they took pictures too, often of the photographers at work, some of which are published in the back section of this book.

As volunteers joined, sponsors continued to sign on: the *Bangkok Post* would cover the event and Spa Advertising would handle public relations, while other sponsors would contribute financial support.

As the shoot approached, EDM's Singapore team, two documentary production crews and the Bangkok editorial team joined forces on the top floor of the Dusit Thani, Bangkok, setting up an 'Operations Centre' that would double as a clubhouse for the photographers. Fingers danced faster on keyboards as the staff ground out the final details of the parties and itineraries to the never-ending buzz of two coffee machines. Then, in a sudden flurry, on 14 January 2007, the photographers—previously only names on spreadsheets, flight itineraries, appointment diaries and booking systems—appeared in person.

They came from Cairo, Dhaka, New York, Paris and capitals around the world. That more than 50 busy professionals had gathered together in one place, at one moment in time, seemed a feat in itself. In an opening weekend full of anticipation and camaraderie, old friends were reunited and assistants met their idols, and between cocktails and interviews with the press, the photographers received the final details of their assignments.

On the eve of the first day of the shoot, Arthus-Bertrand was in good spirits, laughing as he recounted his aborted mission. The next day his chopper was cleared to fly and the project, too, was smoothly launched as the 54 other photographers fanned out across the kingdom. For the staff, there was a moment to take a breath. The torch had been passed. *Thailand: 9 Days in the Kingdom* had truly begun...

Nicholas Grossman

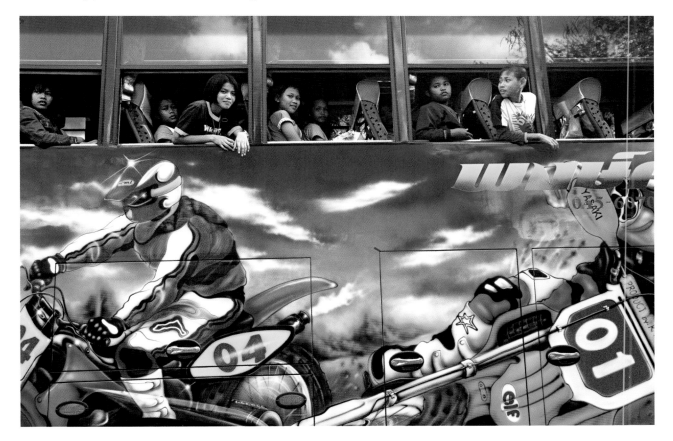

LEFT: In Buriram province, a bus full of local youth tours the area's ancient temples. Thai buses sometimes feature rather eccentric and elaborate airbrushed designs on their sides.
Kaku Suzuki, Japan

FOLLOWING PAGES: At the annual football match between Thammasat University and Chulalongkorn University, Thammasat fans don yellow shirts—their school's colour and also the birthday colour of His Majesty the King. Thammasat and Chulalongkorn, two of the country's oldest universities, enjoy an intense but spirited rivalry.
Dow Wasiksiri, Thailand

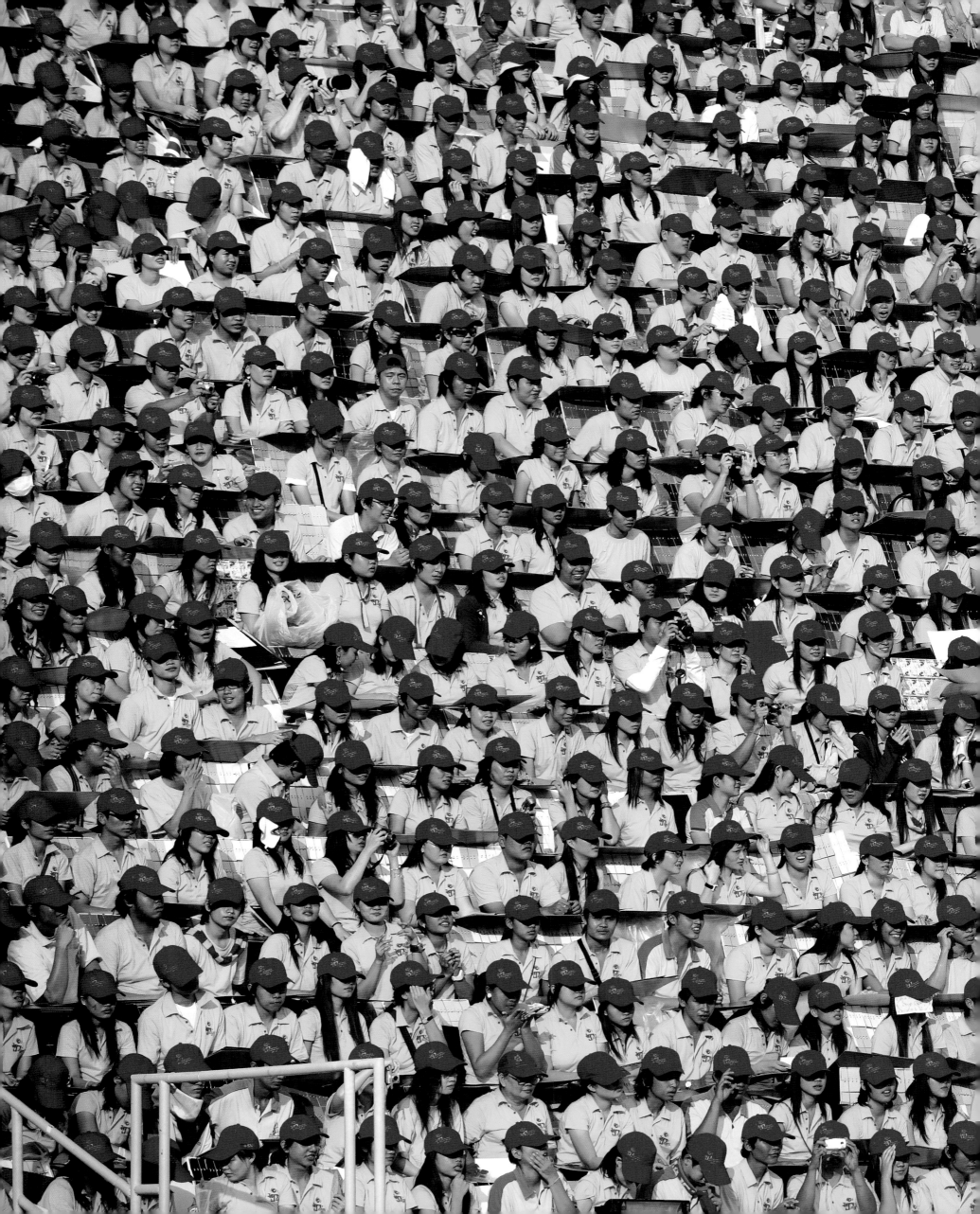

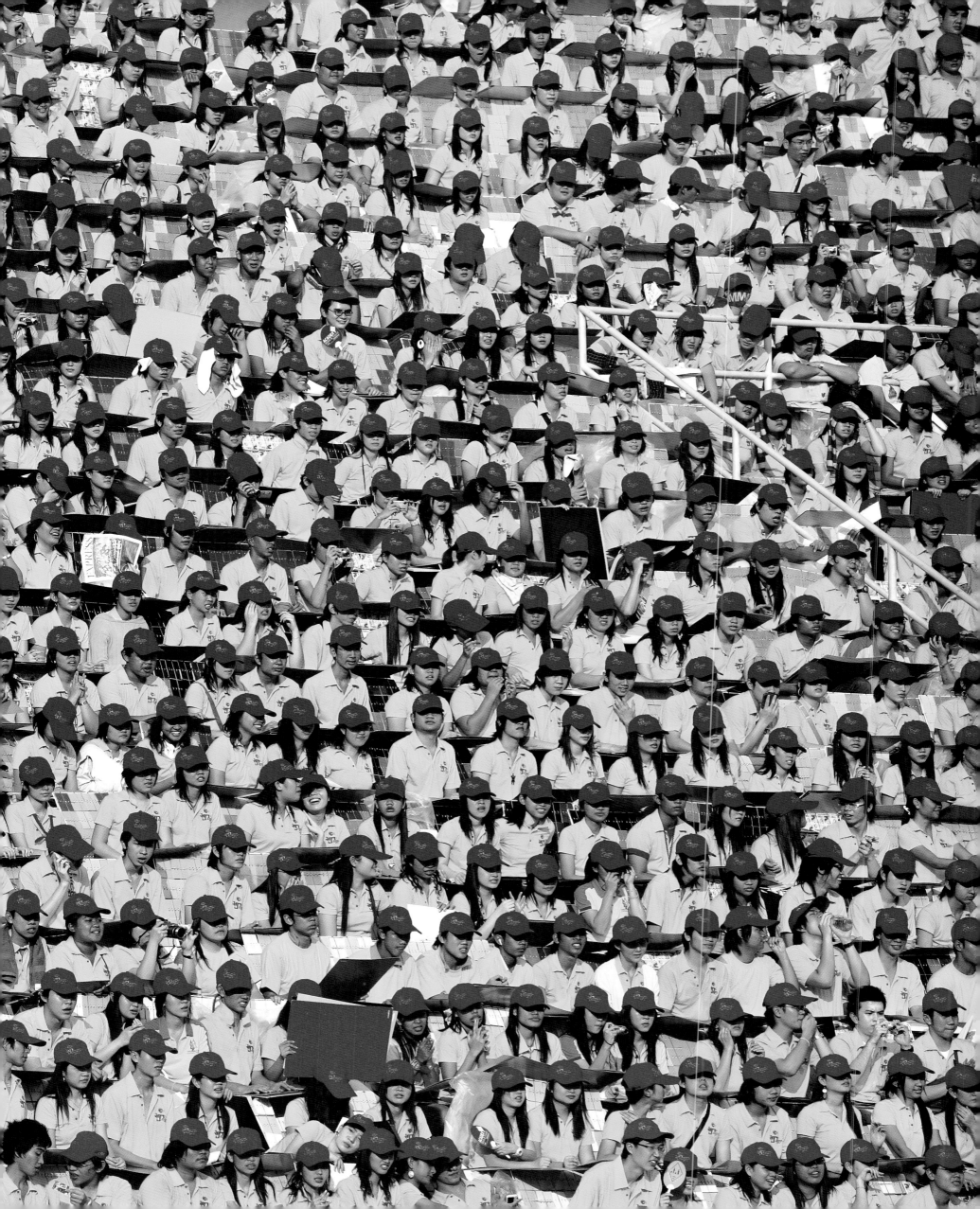

King of Hearts

His Majesty King Bhumibol Adulyadej, who has reigned since 1946, longer than any other monarch in the world, commands great power and respect in Thailand. He is also universally loved by his people.

Look through these pictures carefully and you will see that many photographs—often unintentionally—capture how that love manifests itself throughout Thai life. There are the very public displays of respect—his image is erected on office buildings, along roads and inside shops and restaurants throughout the country—and there are the personal indicators—Thais choose to wear yellow wristbands or yellow shirts in his honour.

Photographer Martin Reeves, who took pictures of the northern hill tribes, recounts: 'No matter how remote I got, everywhere I went, their love of the King was so apparent. When we got right up to the border with Myanmar, they had a massive poster of the King, and when we told people that we were taking pictures in his honour, their faces would just light up.'

Why do the Thais, who, according to a popular saying, consider themselves 'the dust beneath the dust beneath His Majesty's feet' genuinely love His Majesty? In short, he has been there for them for a long time. For 61 years, he has been a stabilising influence on the country, acting as a benevolent father, morally guiding the nation, showing compassion for all of his subjects, and serving as an example to the people.

What's more, he has dedicated his energies to directly helping his subjects. His royal projects, for instance, have developed economic opportunities for the country's most needy. In addition, Thais are inspired by His Majesty's intelligence, spirituality and creativity. He is an excellent painter, has composed many jazz songs, and even holds patents for his engineering innovations. His Majesty is also, it is worth noting, an avid photographer. In public, he is rarely seen without a camera around his neck.

In return for his dedication to his people, His Majesty is deeply revered and sincerely adored by all those who call him 'my King'. It was not a royal decree that inspired Thais, beginning in January 2006, to wear yellow shirts every Monday in his honour. (His Majesty was born on a Monday and thus yellow, according to Thai tradition, is his birthday colour.) The idea, originally suggested by the government, was voluntarily picked up by millions around the nation. Walk through the streets of Thailand on a Monday and you will find them awash in yellow, as Thais literally wear their hearts on their sleeves.

For this book, His Majesty did not sit for a portrait but, in a very real sense, most of the pictures are connected to him. His influence, after all, impacts so many aspects of life in the kingdom, and extends into the hearts of all Thais.

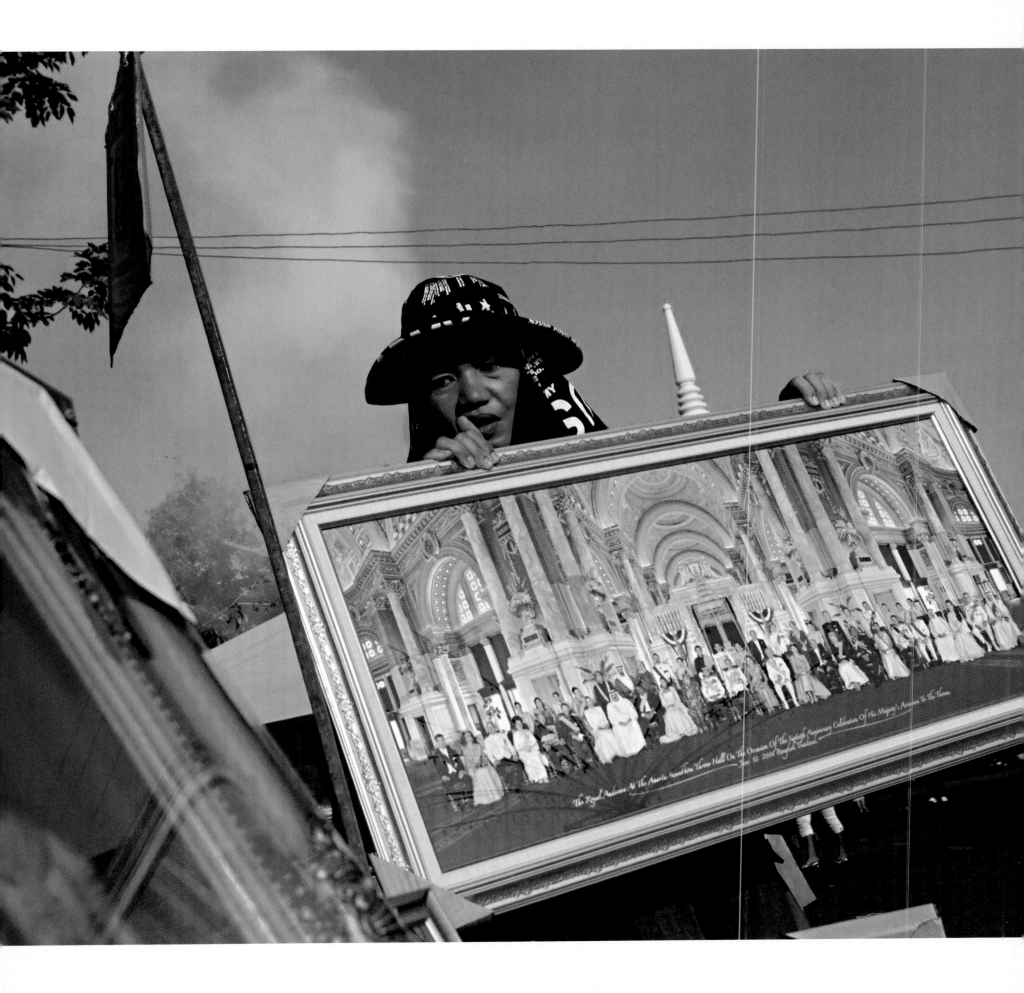

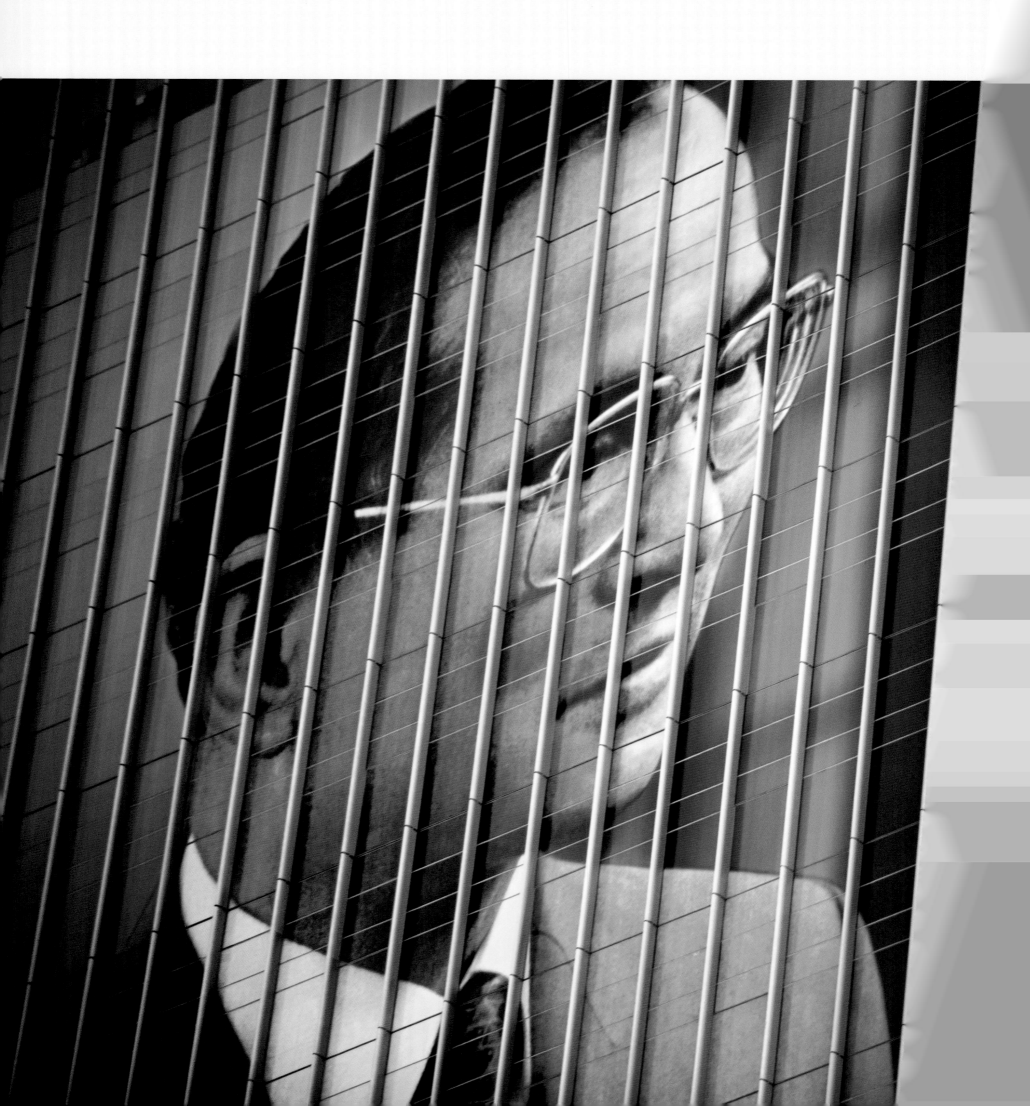

PRECEDING PAGES (FROM LEFT):
At the annual Thammasat University and Chulalongkorn University football match, fans create a portrait of His Majesty by raising coloured placards.
Dow Wasiksiri, Thailand

A vendor in Suphan Buri province carries a picture of the gathering of the world's monarchs and their representatives, taken at Bangkok's Ananta Samakhom Throne Hall on 12 June 2006 during the 60th-anniversary celebrations of His Majesty's accession to the throne.
Laura El-Tantawy, Egypt/UK

LEFT: A portrait of His Majesty is displayed over multiple storeys on the side of an office building in downtown Bangkok.
Jeff Hutchens, USA

RIGHT (TOP): On the wall outside Phrathomthaweetapisek School near Bangkok's Wat Arun, the schoolchildren have painted tributes to His Majesty.
Richard Kalvar, USA

RIGHT (CENTRE): Fun (left), her cousin Nan, Uncle Tong Uwap and pet dog Poi in front of portraits of His Majesty at Wat Phu Khao Tong in Ayutthaya province.
Romeo Gacad, Philippines

RIGHT (BELOW): A life-size cutout of a police officer—which typically reminds motorists to drive safely—near a plaque honouring His Majesty.
Tara Sosrowardoyo, Indonesia

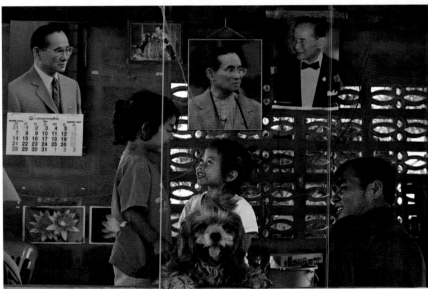

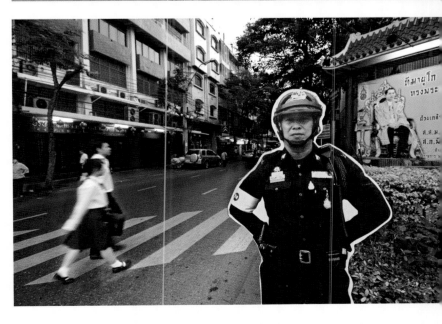

THROUGHOUT THE KINGDOM, portraits of His Majesty, as well as other royals, are placed in honorary positions on the walls of homes, shops, offices and restaurants. The practice is not only a sign of respect but represents the Thai people's sense of hierarchy and is believed to bring businesses good fortune.

RIGHT: Sotee Saelow makes brassware such as teapots at Leng Nei Yee market.

OPPOSITE (TOP LEFT): Pornthap Lorvichit, the owner of a small restaurant in Leng Nei Yee market in Bangkok.

OPPOSITE (TOP RIGHT): Lee Saetae in his coffee shop at Klong Suan market in Samut Prakan.

OPPOSITE (BELOW LEFT): Somkoun Veerabuth, the owner of a small shop at Samchook market in Suphan Buri province, sells antique beads.

OPPOSITE (BELOW RIGHT): Inside a small antique shop at Chatuchak weekend market in Bangkok.

**Photos by
Anuchai Secharunputong**,
Thailand

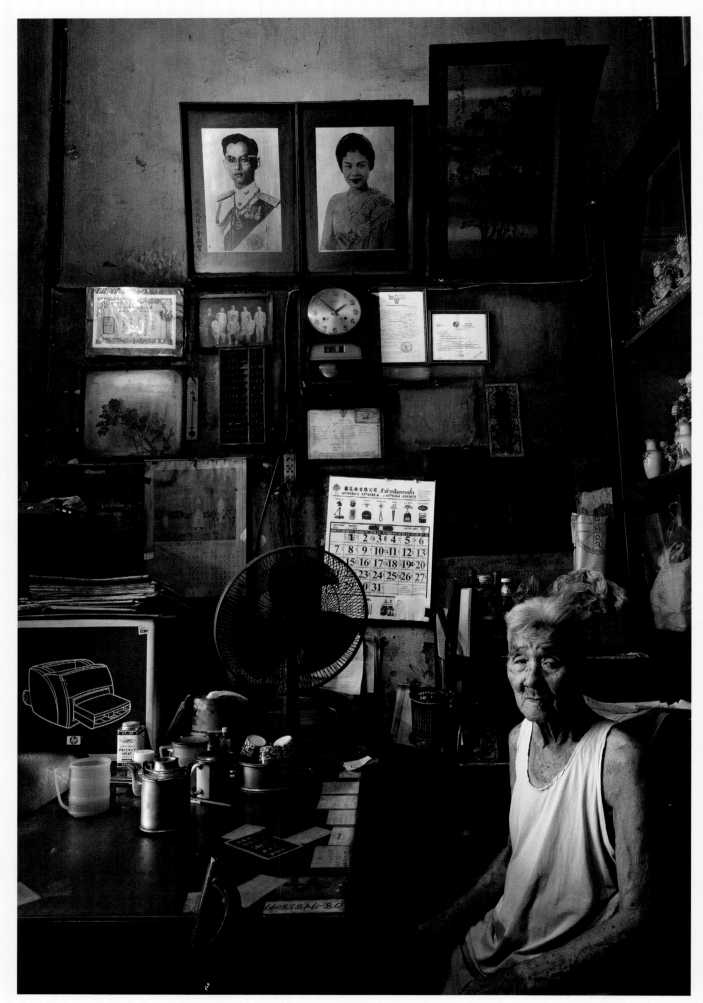

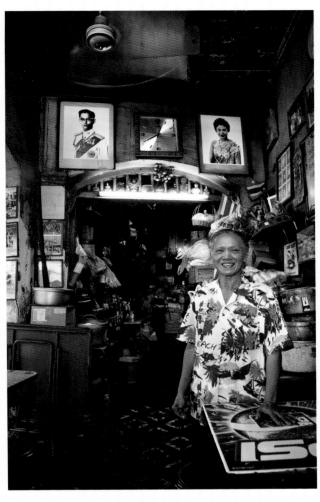
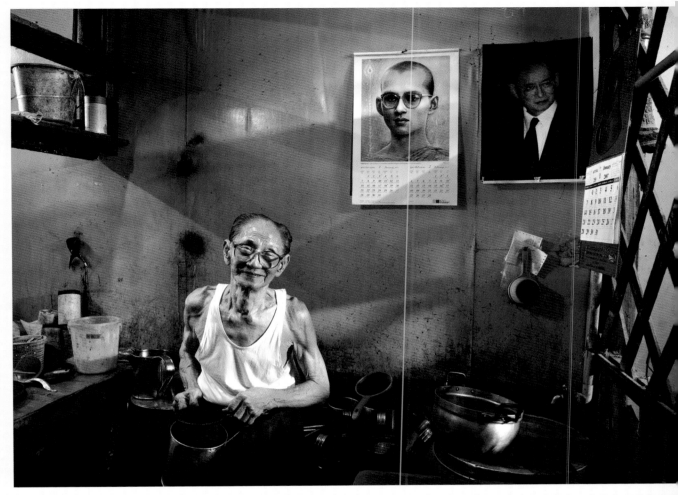
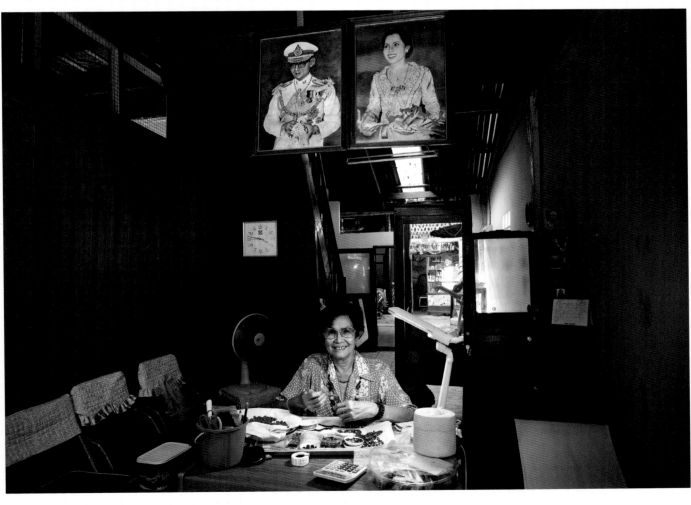
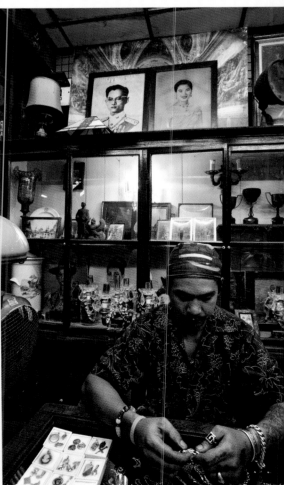

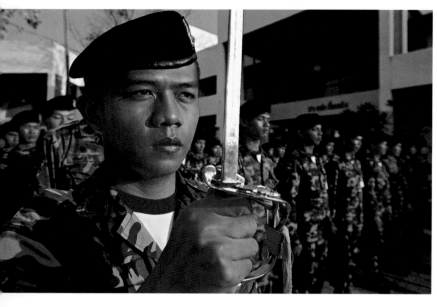

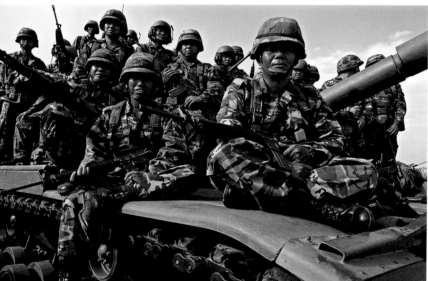

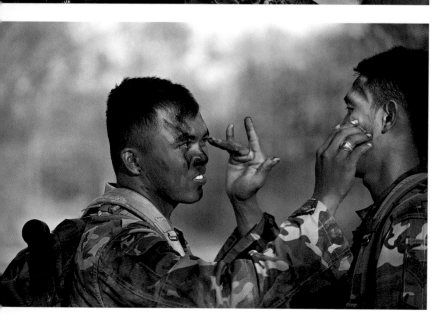

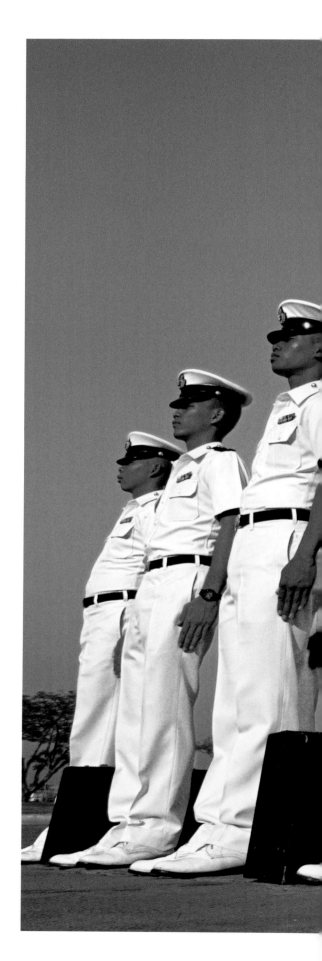

LEFT (TOP): A commander of the Royal Guards of the 11th Infantry leads a march on National Armed Forces Day in Bang Khen in Bangkok. National Armed Forces Day also marks a famous battle between the Thai and Burmese on 25 January 1592 in Suphan Buri. According to legend, during the fight King Naresuan, riding an elephant, killed his arch-enemy the Burmese crown prince with a lance, thereby preserving Thai independence.

LEFT (CENTRE): A company from the 22nd Squadron of the army's Royal Thai Cavalry poses on an M60 tank at the Cavalry Centre in Saraburi.

LEFT (BELOW): Two Royal Thai Army Rangers help each other apply camouflage make-up at the Infantry Centre in Phrachuap Khiri Khan.

RIGHT: At 8 am, Royal Thai Navy cadets stand in formation before beginning their classes at the Royal Thai Naval Academy in Samut Prakan. Their briefcases contain books and other study materials.

Photos by Guido Alberto Rossi, Italy

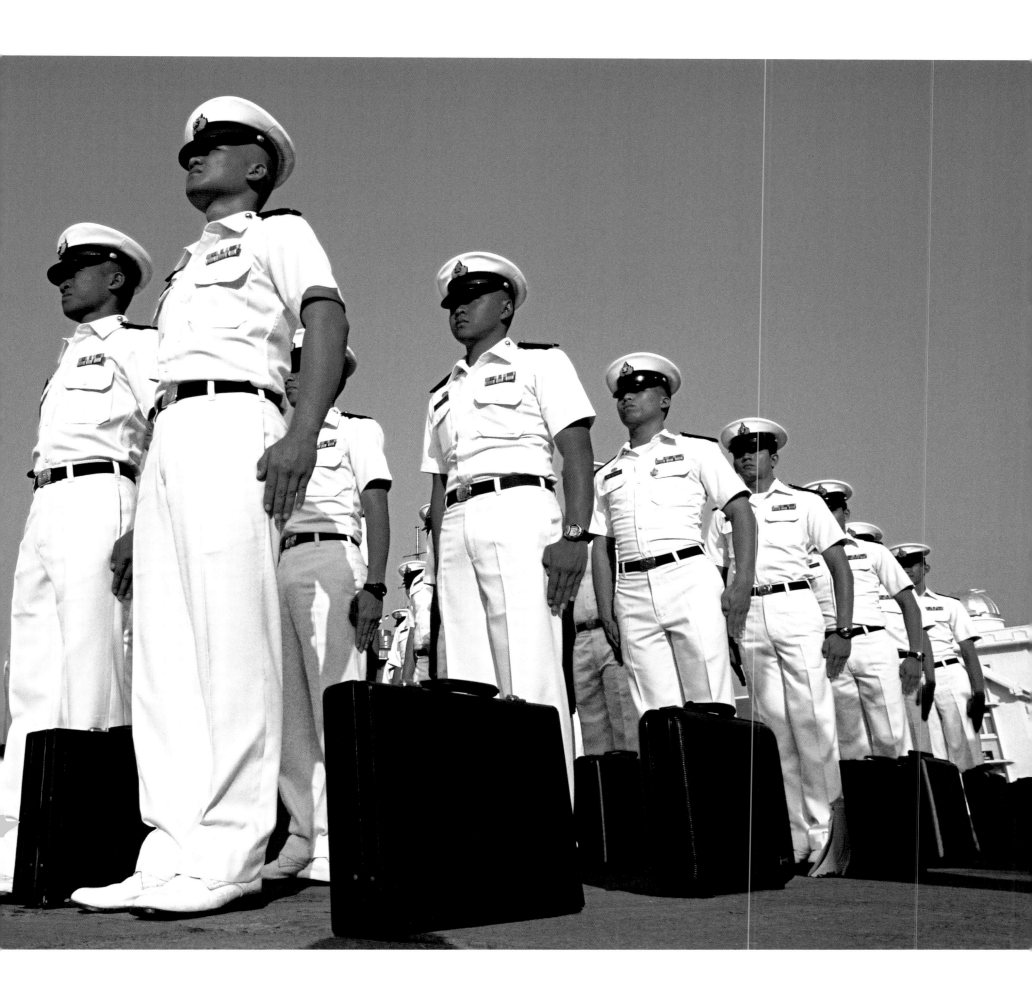

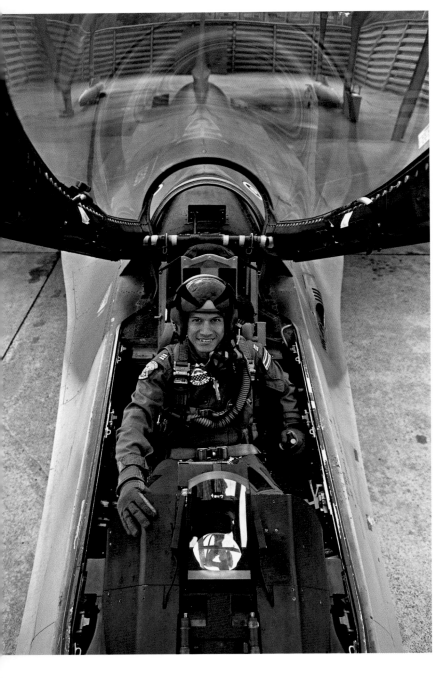

LEFT: Khorat Royal Thai Air Base Wing 1 squadron leader Phusit Timkerd posing inside the cockpit of his F-16.
Guido Alberto Rossi, Italy

RIGHT: Two Royal Thai Air Force F-16s from the 403 Squadron, Wing 4, fly over Chiang Mai. The picture was taken by the photographer from inside the cockpit of an L-39 jet moving at 450 kilometres an hour.
Guido Alberto Rossi, Italy

FOLLOWING PAGES: Traffic is backed up as usual on Bangkok's Saphan Taksin Bridge, which spans the Chao Phraya River. Lit up along the riverfront are some of Bangkok's most famous luxury hotels.
Dominic Sansoni, Sri Lanka

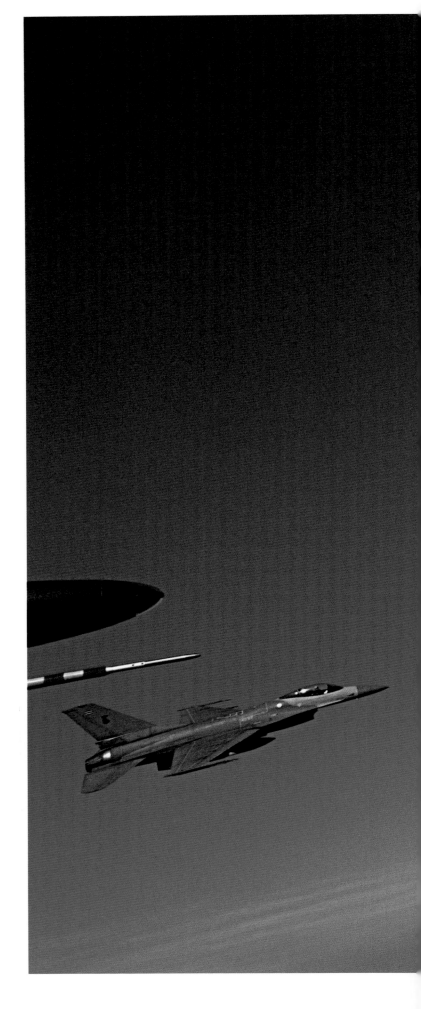

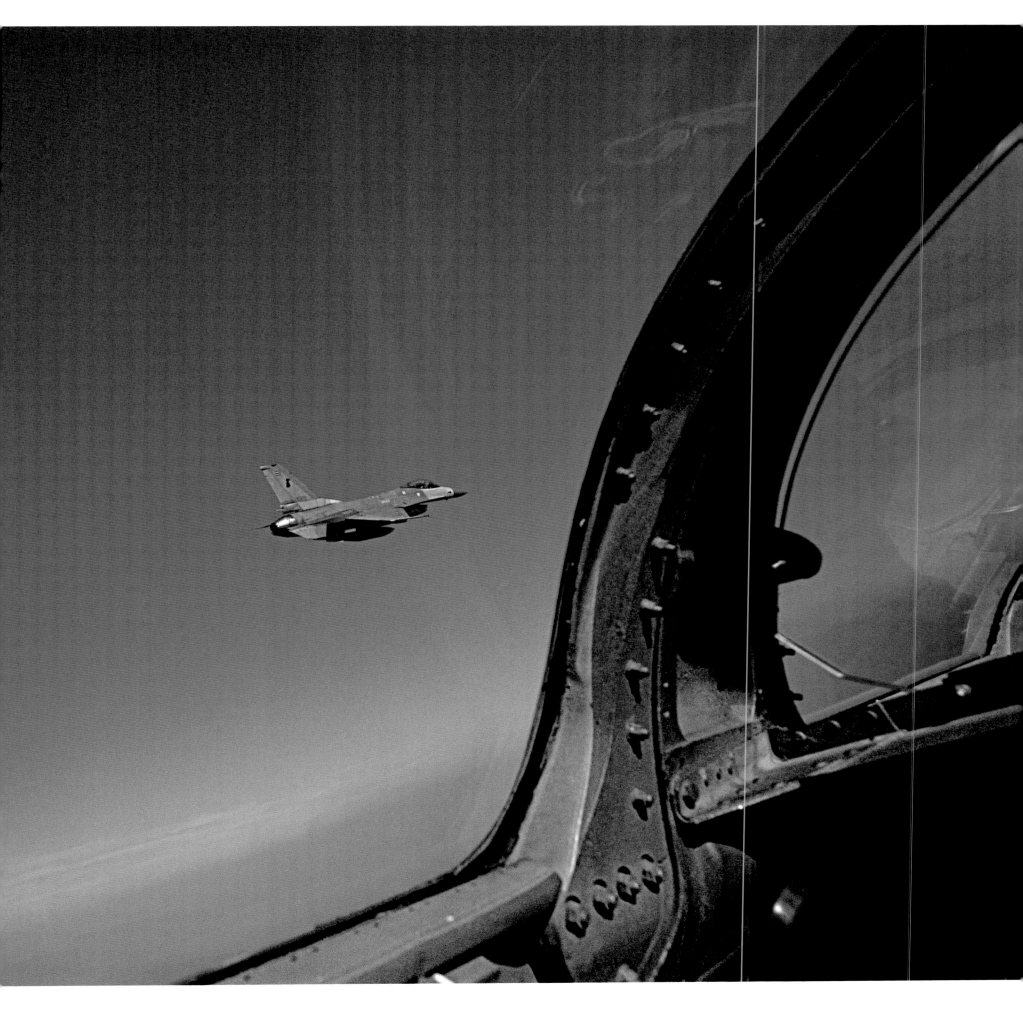

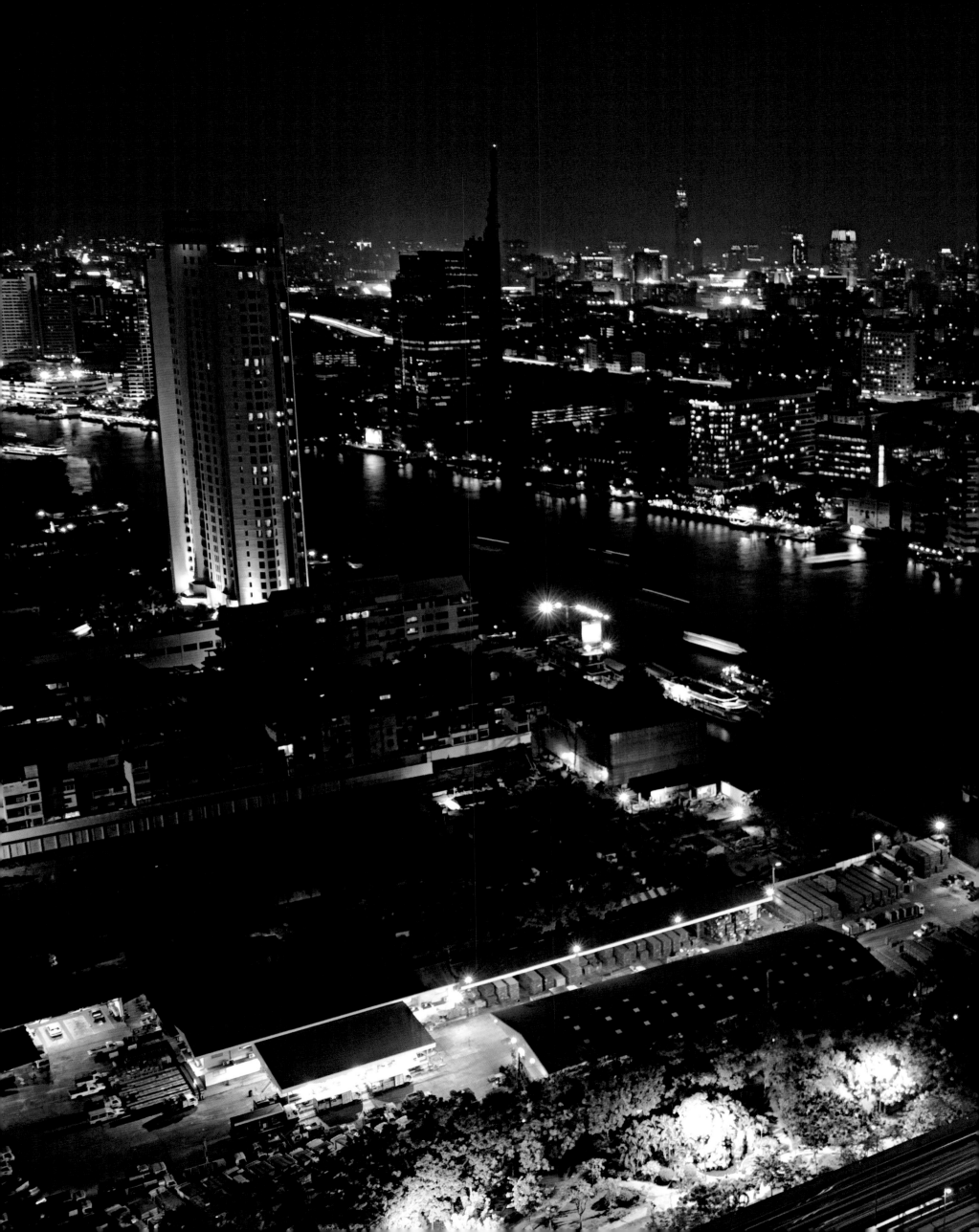

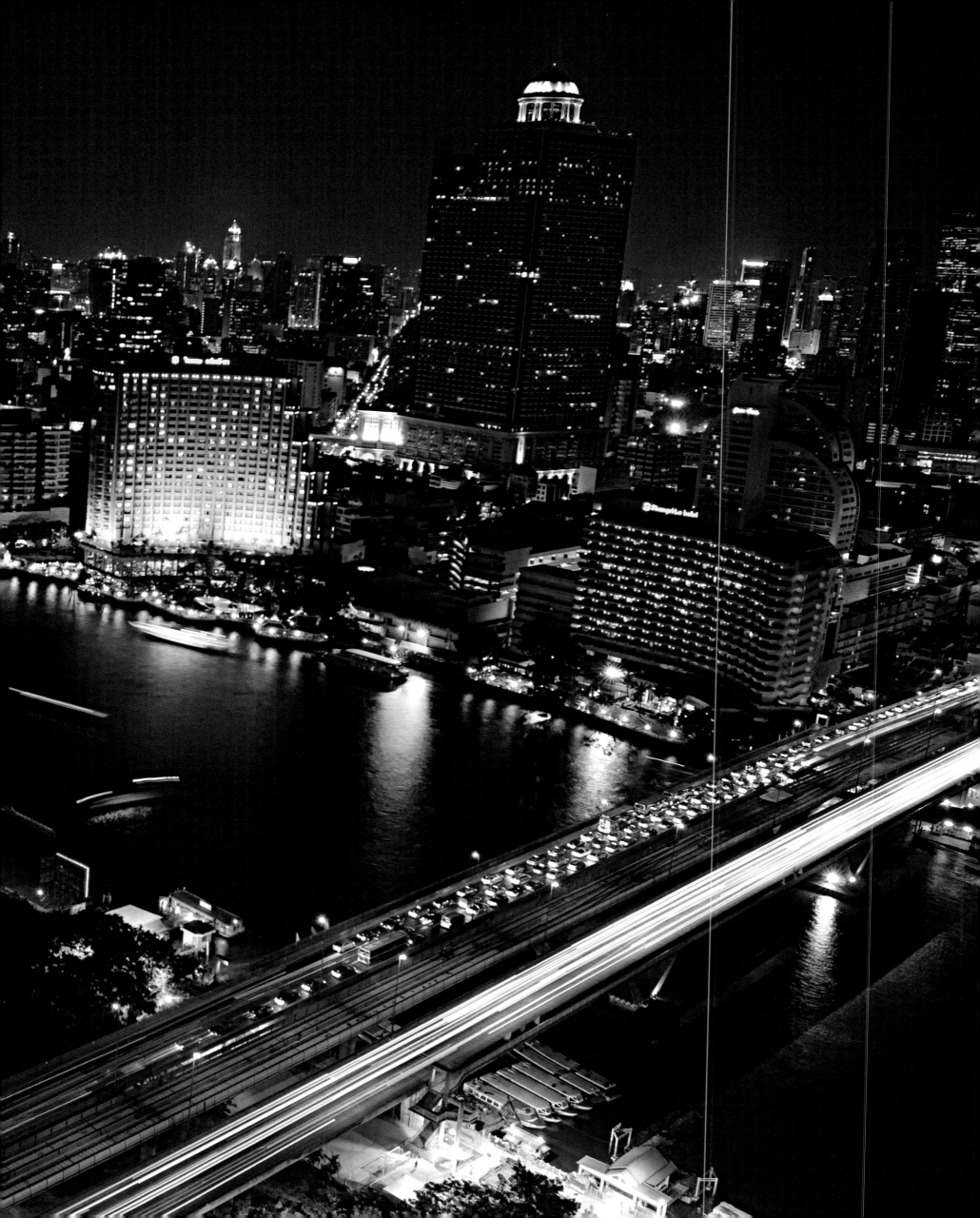

ABOVE: A boat plies the Saen Saeb canal in Bangkok. The city was once called the 'Venice of the East' due to its network of canals. Today, most of the canals have been filled in to create streets, but the inexpensive passenger boats on the Saen Saeb are still a popular form of transport, especially among commuters travelling to work.

Michael Freeman, UK

RIGHT: Traffic in Bangkok is not limited to roads. During rush hour, passenger boats take locals and tourists up, down and across the river. The Chao Phraya, also known as the 'River of Kings', is used by small cruise boats and tugboats as well, which pull barges full of supplies from the north.

Ben Simmons, USA

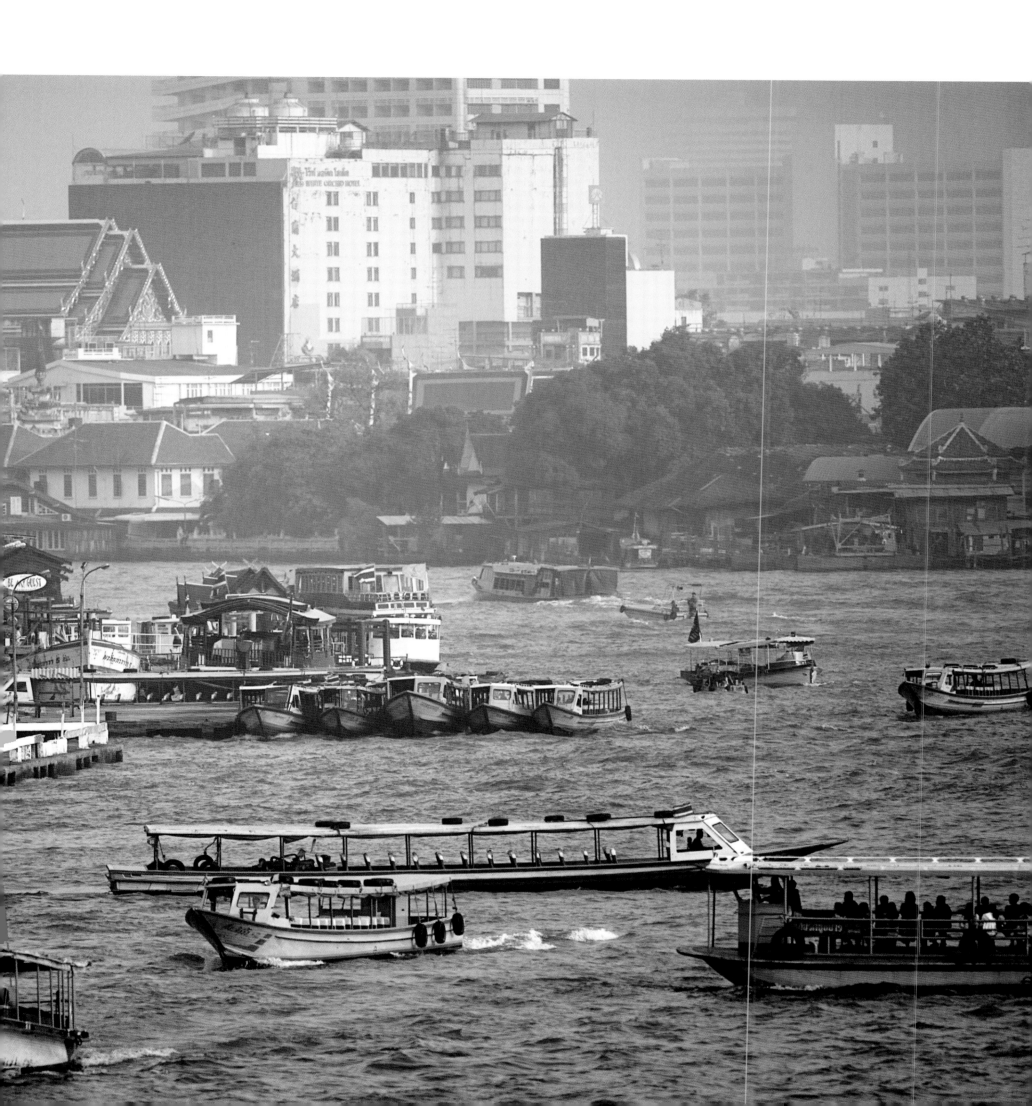

ABOVE: A large, sparkling glass cube under the relentless tropical sun, this building stands out in the sea of concrete structures that characterise the Bangkok skyline. Behind the hardness of its face flows the elixir of life. It is the Blood Bank of Bangkok.

Photos by
S. C. Shekar, Malaysia

RIGHT: The venerable Sulakasathan, the former Customs House, was completed in 1890 during the reign of Rama V. Today, Sulakasathan is home to the families of the Marine Police and the Bang Rak fire station, but that will change. Plans are underway to convert the building, which is situated on prime riverfront property, into a six-star boutique hotel.

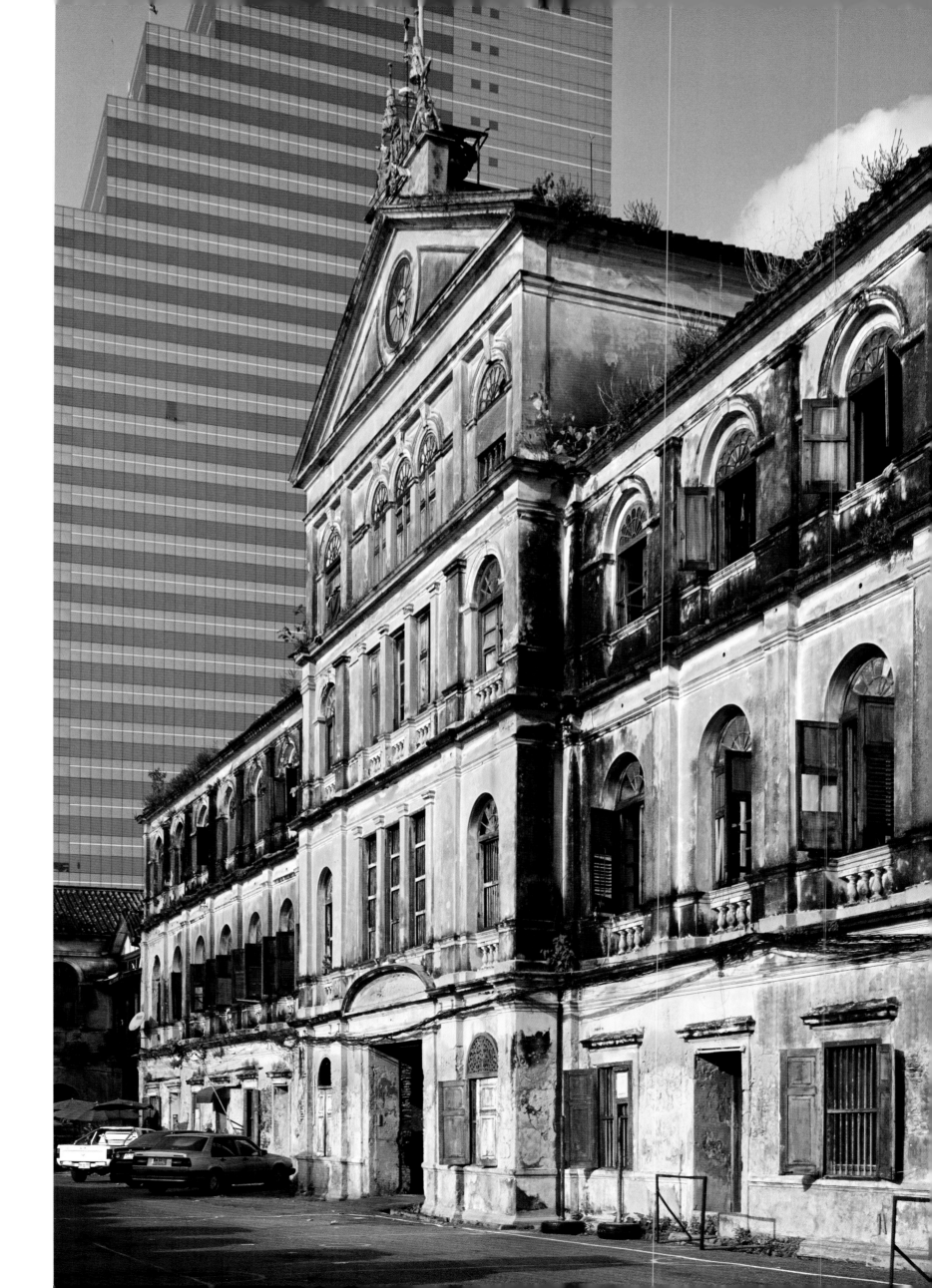

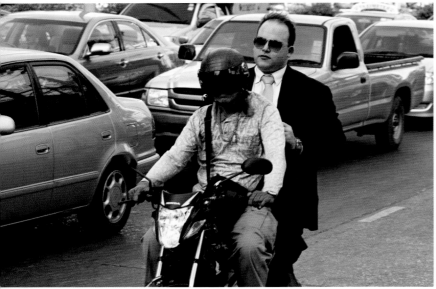

LEFT (TOP): A streetside vendor in Bangkok, who sells sweet sticky rice with toppings, shelters himself from the sun as he takes a nap.
Raghu Rai, India

LEFT (BELOW): An expatriate gets a ride on the back of a motorcycle, the quickest way to beat the traffic in Bangkok.
Tara Sosrowardoyo, Indonesia

RIGHT: An almost life-size elephant statue stands placidly in the middle of late-afternoon rush hour traffic on Silom Road in Bangkok. Silom Road is one of the city's busiest areas, featuring a mix of office buildings, hotels, condominiums, pubs, restaurants and shops, as well as the red light districts of Soi Patpong and Soi Thaniya.
Ben Simmons, USA

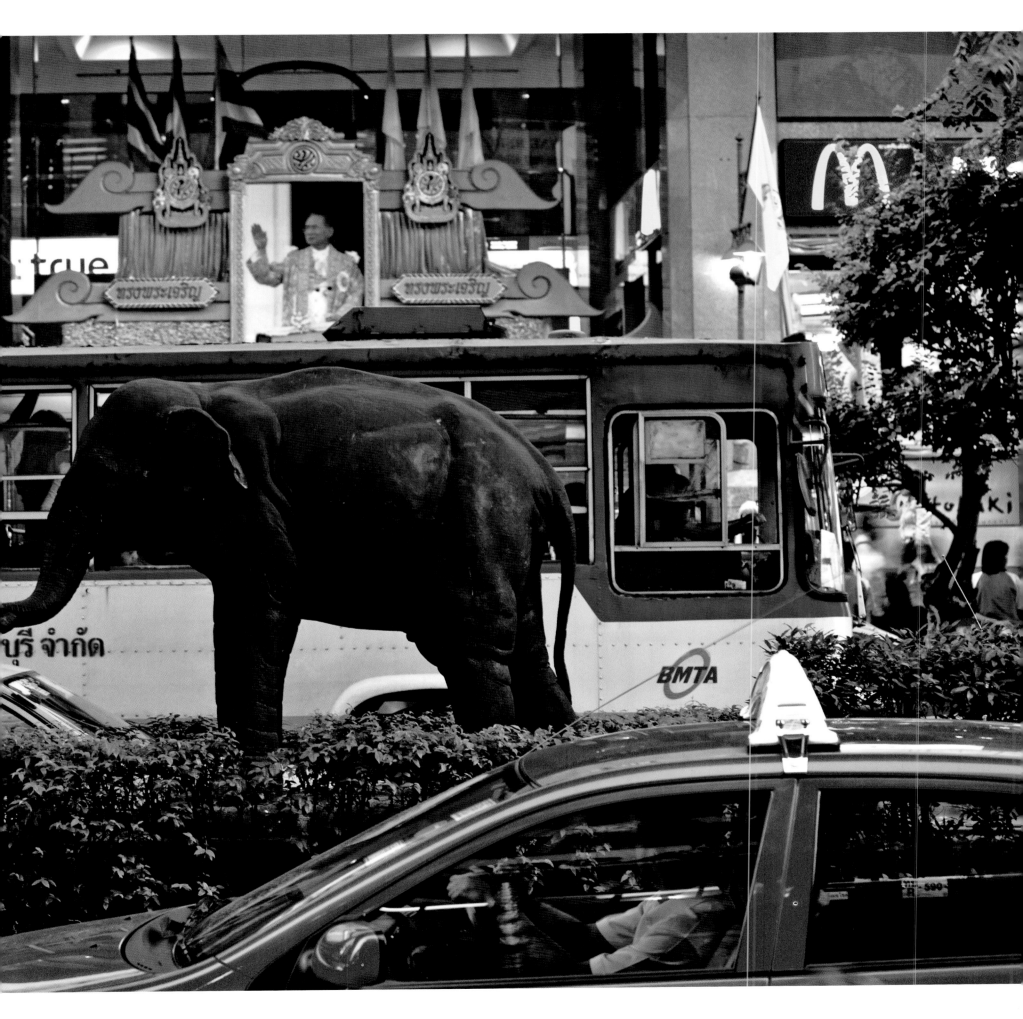

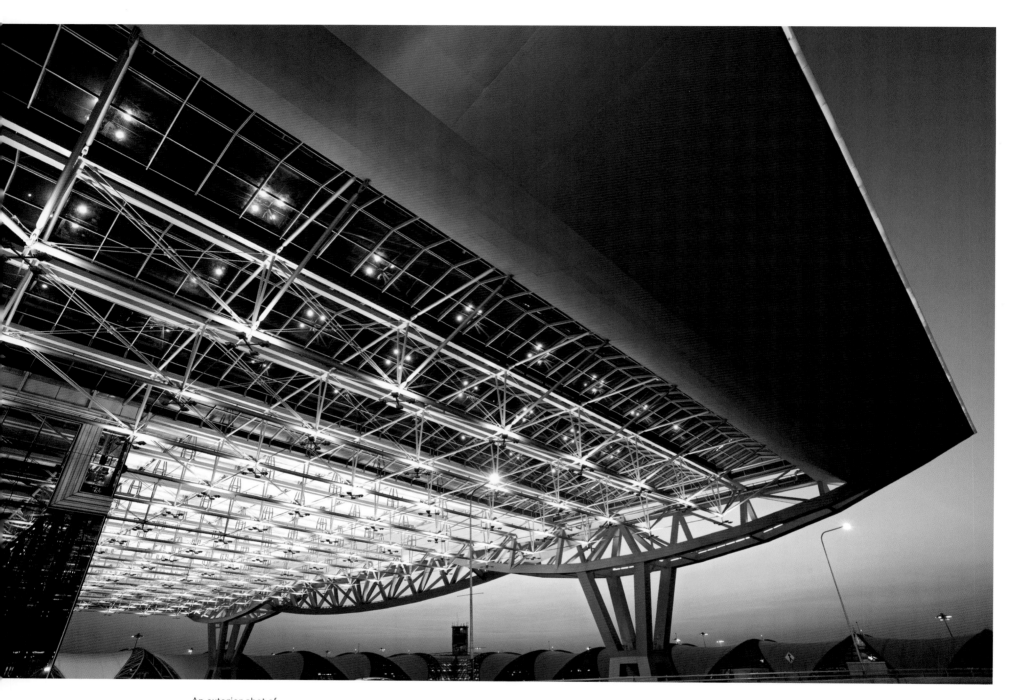

An exterior shot of
Suvarnabhumi airport, which
opened in September 2006.
The name 'Suvarnabhumi',
meaning 'Golden Land', was
chosen by His Majesty the
King and refers to an ancient
kingdom believed to have
existed in Southeast Asia more
than 2,000 years ago. Intended
as the travel hub of Southeast
Asia, the airport is designed for
passenger movements of
45 million people per year.

Ben Simmons, USA

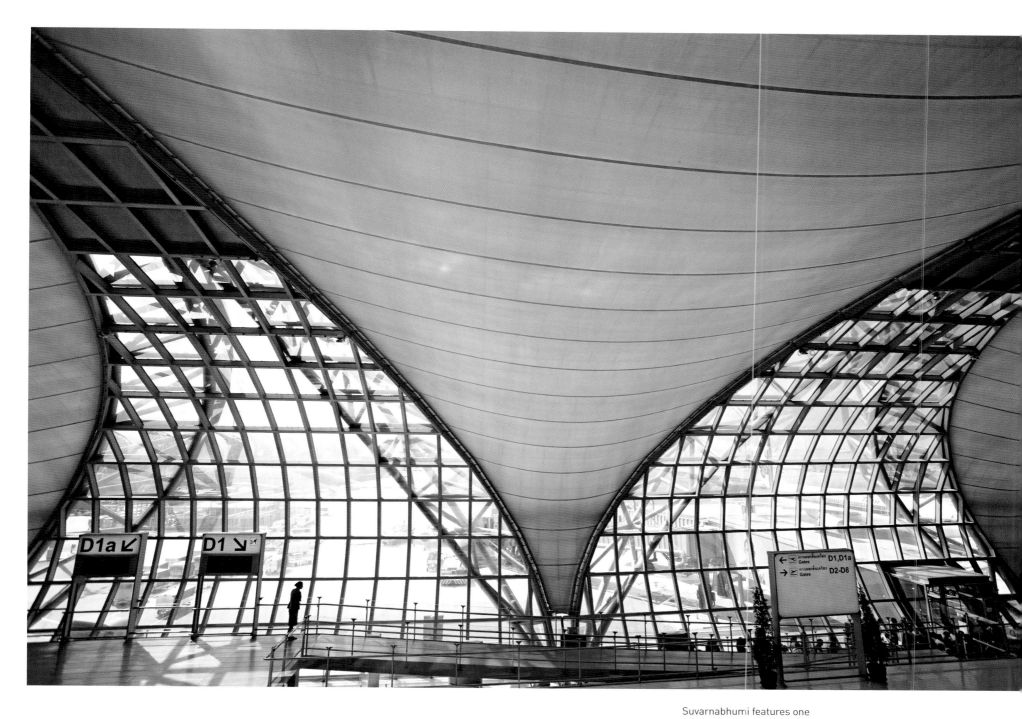

Suvarnabhumi features one of the largest passenger terminals in the world. The construction of the airport, which was initiated many decades after the idea was first conceived, was not without controversy. Numerous delays, corruption scandals and questions about its readiness plagued the project all the way through till its opening.

Ben Simmons, USA

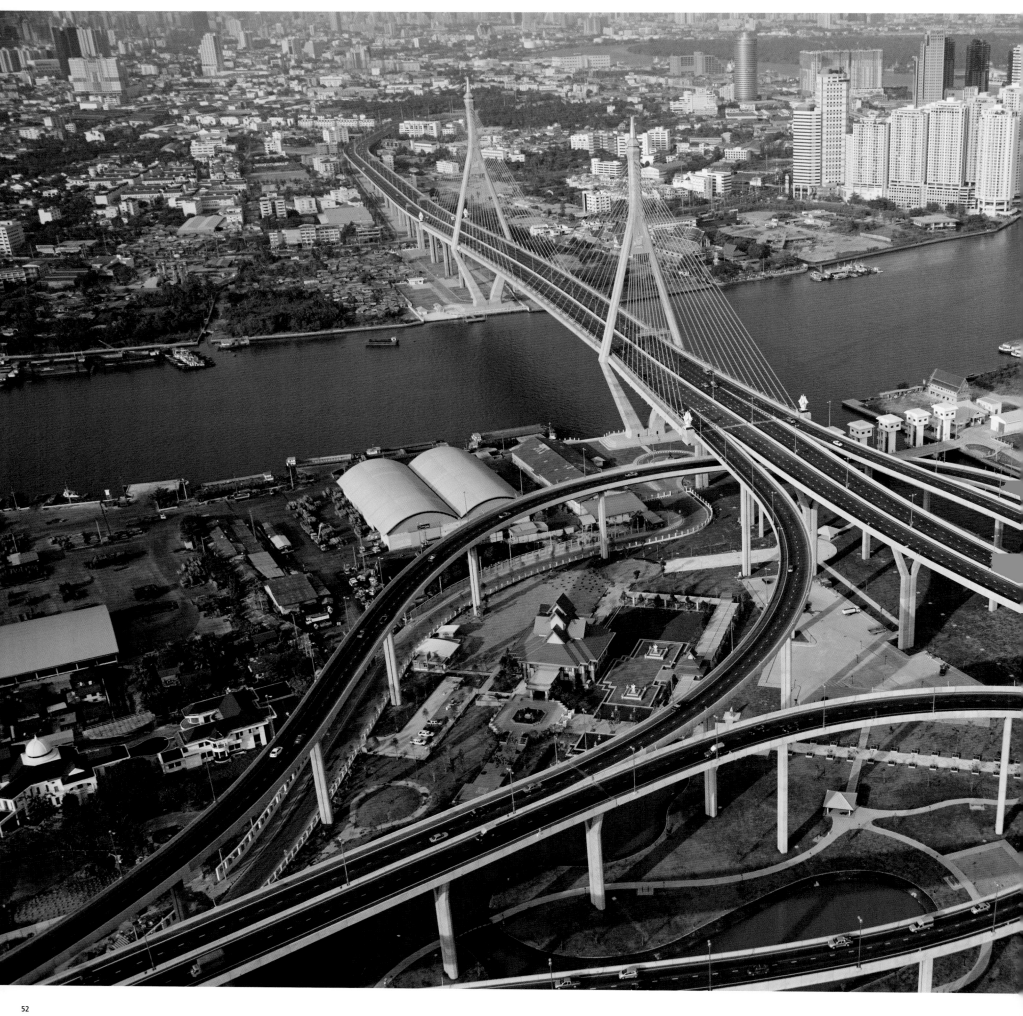

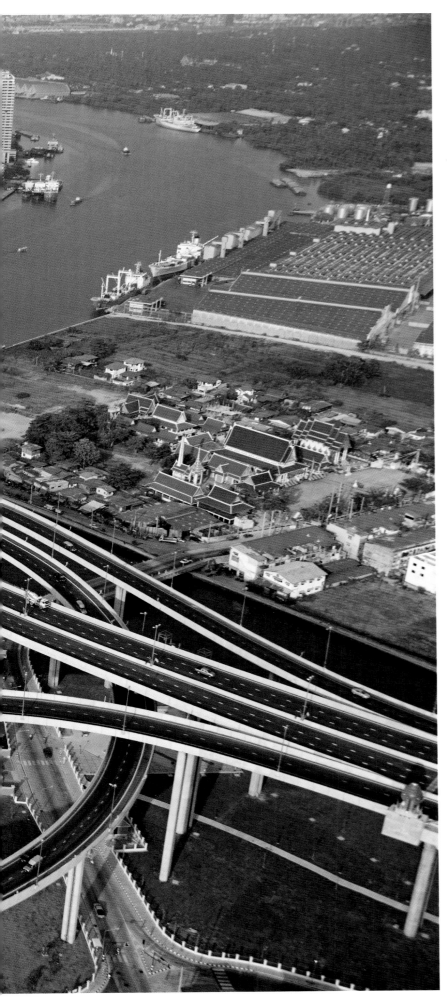

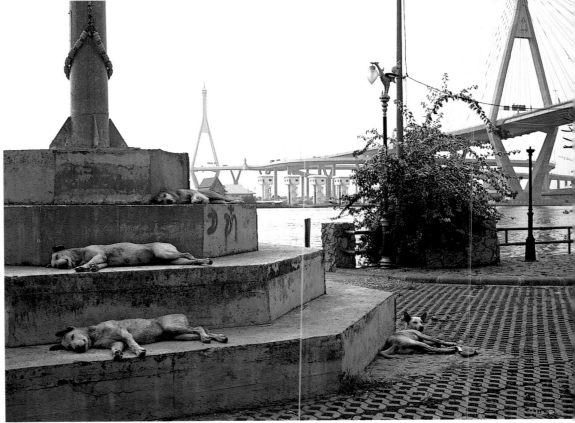

LEFT: An aerial shot of the Mega Bridge spanning the Chao Phraya River, which links Bangkok to neighbouring province Samut Prakan. The bridge opened in September 2006. Its official name is Dipangkorn Rasmijoti Bridge, in honour of His Majesty's young grandson and future heir to the throne.

Yann Arthus-Bertrand, France

ABOVE: In a park adjacent to the Mega Bridge, a pack of stray dogs takes an afternoon nap. A group of well-meaning foreigners has set up a foundation known as Soi Dog Rescue, aimed at humanely addressing the city's large population of strays.

Chien-Chi Chang, USA

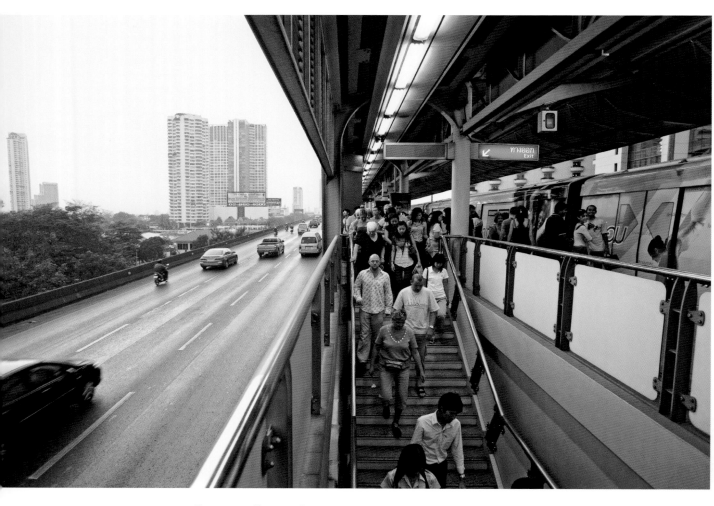

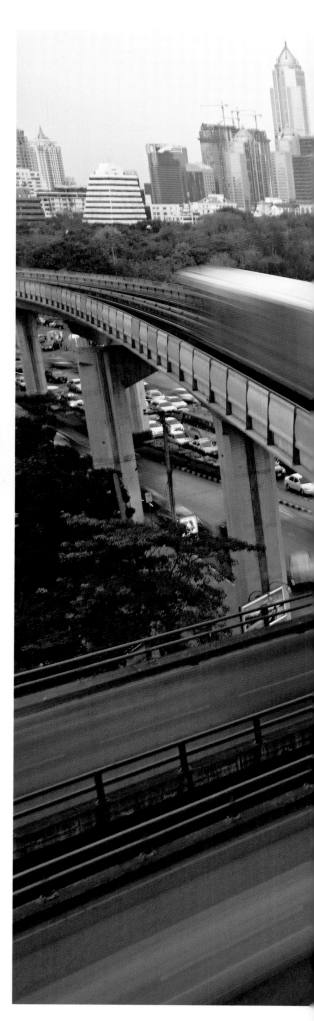

ABOVE: Passengers filter out of the Saphan Taksin Skytrain station by the Chao Phraya River. The Skytrain, opened in 1999 on His Majesty the King's 72nd birthday, will expand across the river in the coming years, increasing the reach of the popular transit system.

Catherine Karnow, USA

RIGHT: The Skytrain zips over one of the city's busiest intersections, past Lumpini Park. It connects 23 stations in the downtown area and has revolutionised public transportation in the city.

Ben Simmons, USA

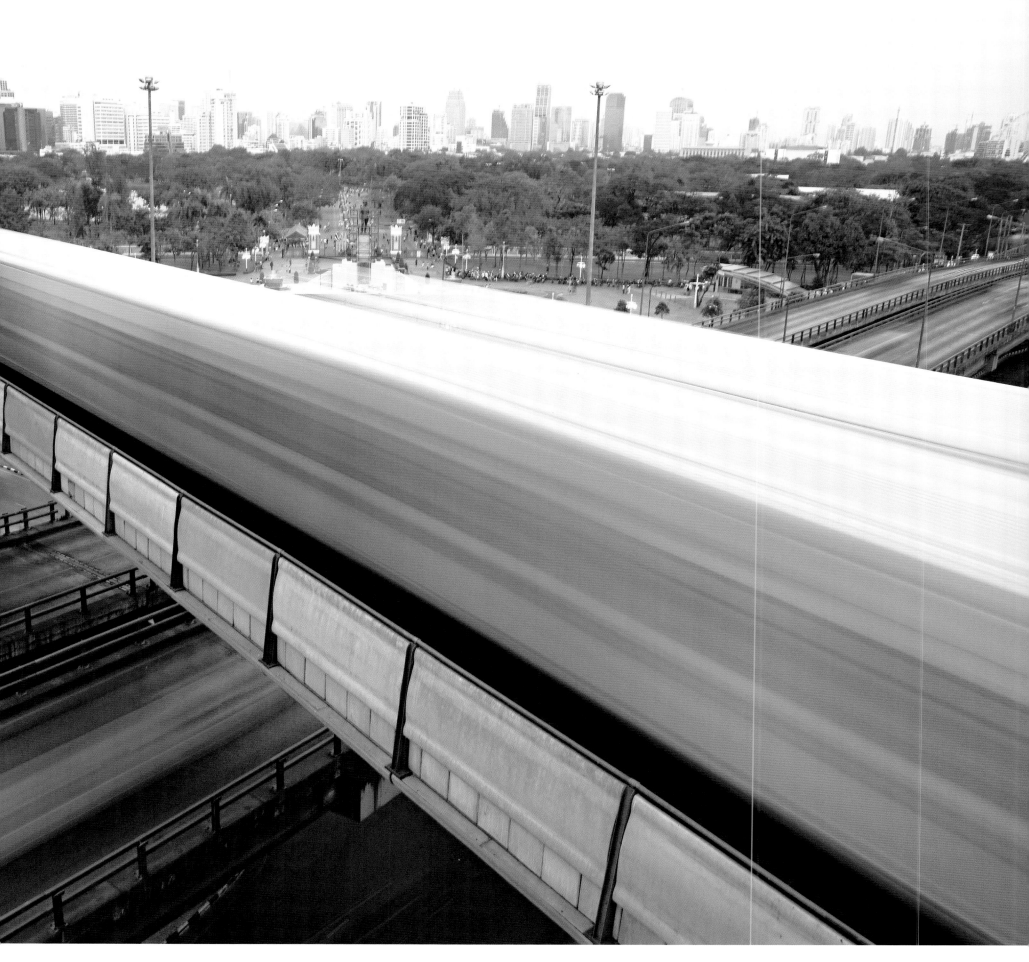

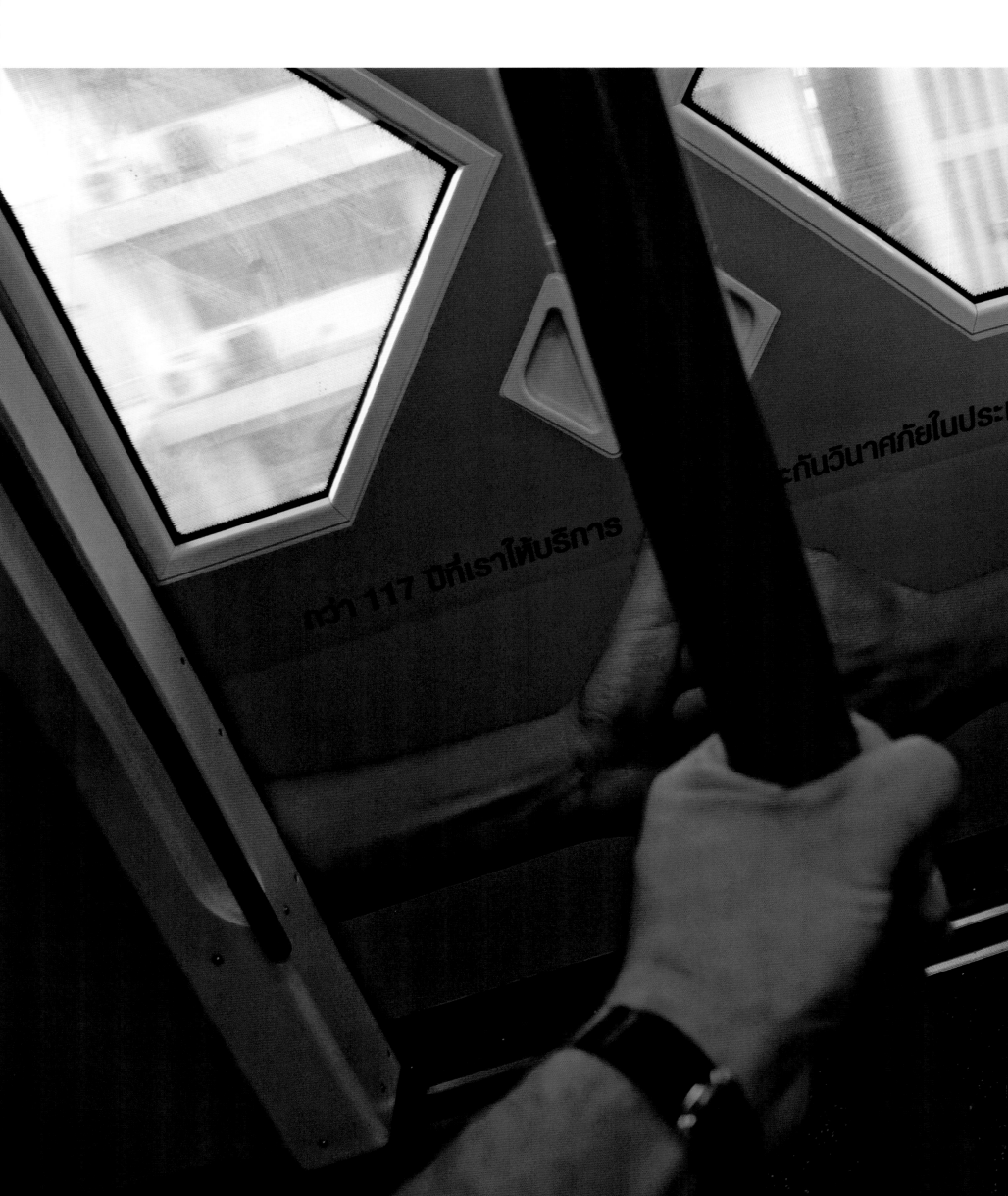

Inside the Skytrain. The elevated railway handles up to 435,000 passengers per day.
Gueorgui Pinkhassov, France

FOLLOWING PAGES: An office worker walks home along Rama IV Road, past the popular night market known as Suan Lum Night Bazaar. The market's Ferris wheel has since been dismantled and the bazaar is set to close in favour of a new real estate project.
S. C. Shekar, Malaysia

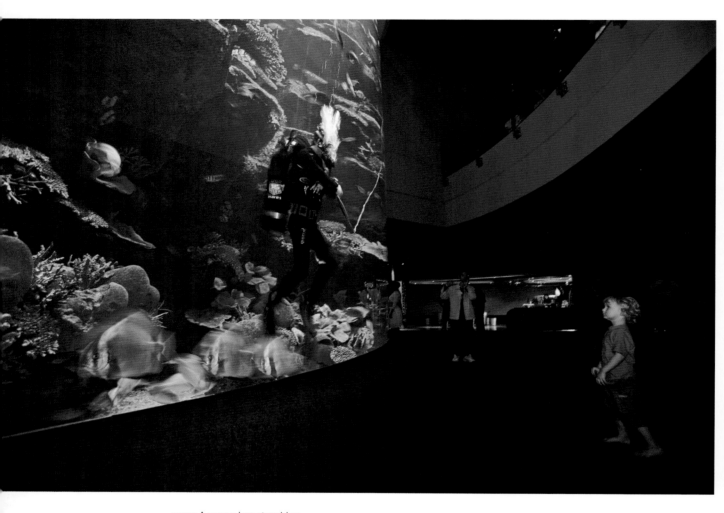

ABOVE: A young boy stumbles upon an unexpected mammal at Siam Ocean World in Siam Paragon. The aquarium, Southeast Asia's largest, allows visitors to take dives into some of its tanks.

RIGHT: A young woman reads a magazine in front of an advertisement at CentralWorld in Bangkok. The glitzy shopping centre is one of Asia's biggest malls.

Photos by Ben Simmons, USA

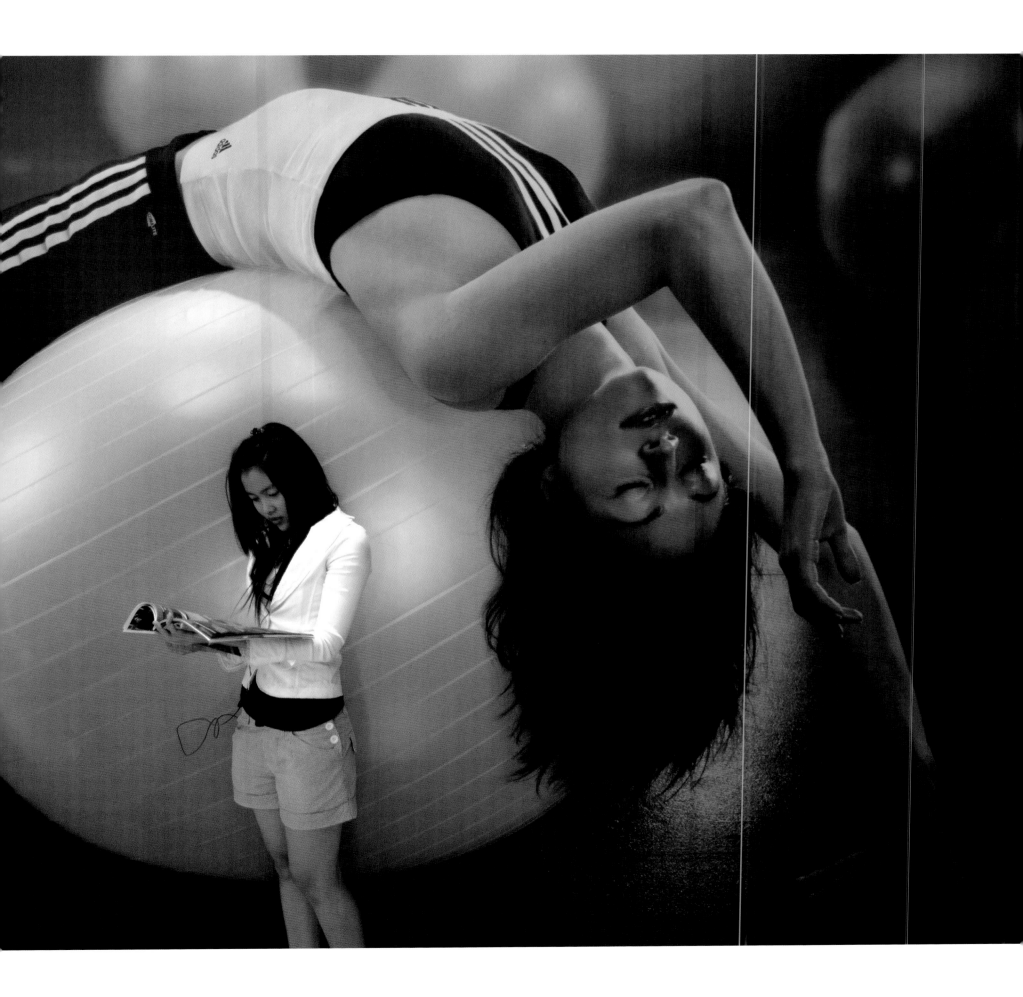

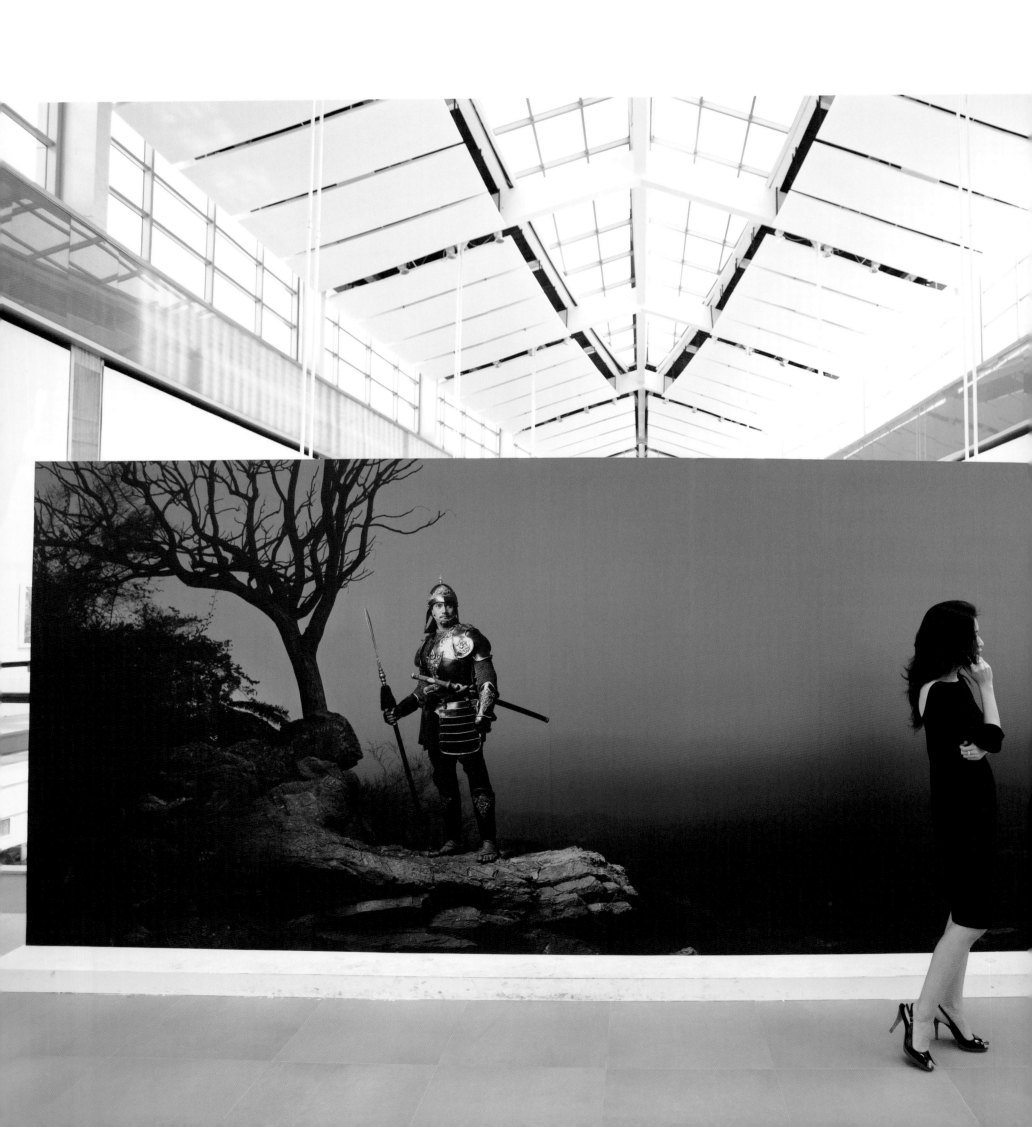

LEFT: A stylish, young woman talks on her mobile phone at an exhibition promoting the film trilogy *The Legend of King Naresuan* in the spacious, sunny atrium inside CentralWorld in Bangkok. Behind her is a poster featuring the trilogy's title character. King Naresuan, who reigned from 1590 to 1605, is an iconic figure in Thai history, credited with reclaiming Thai sovereignty from the Burmese.

RIGHT (TOP): Two university students get some advice on make-up at a promotional pavilion set up by Estée Lauder inside the upscale Siam Paragon shopping centre in Bangkok.

RIGHT (BELOW): Office workers head up the subway escalator at Silom Station during the Monday rush hour. Thailand's first subway, known as the MRT, officially began operating in July 2004. It is part of a larger scheme to improve public transportation in the capital.

**Photos by
Ben Simmons**, USA

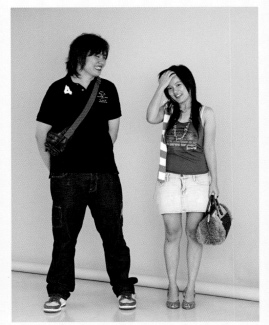

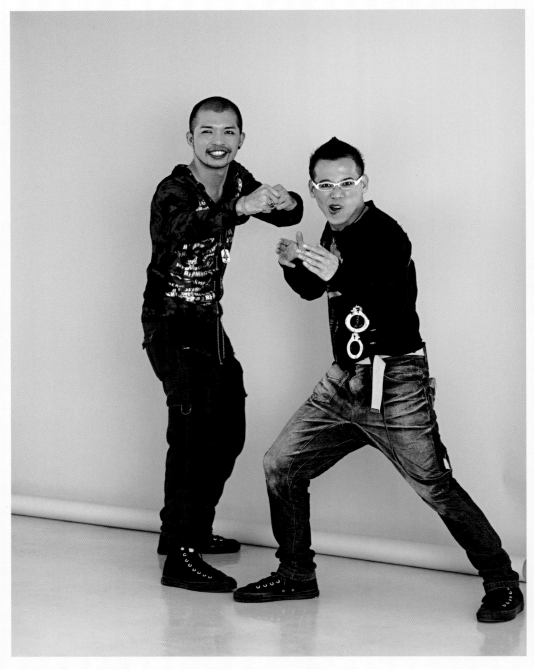

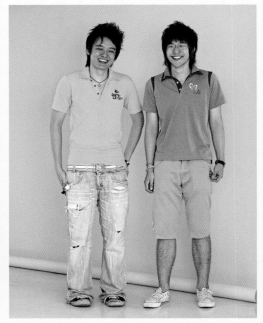

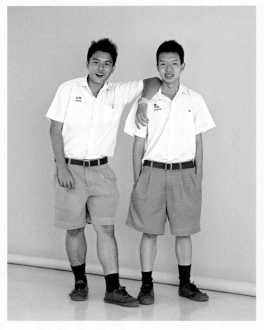

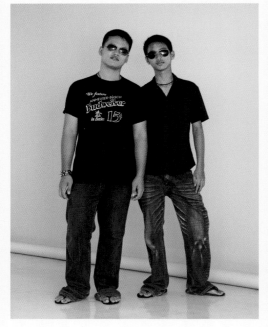

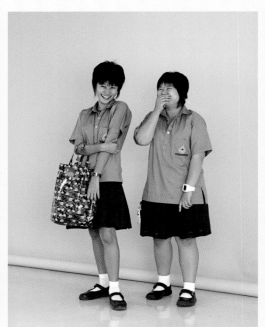

BANGKOK'S SIAM SQUARE is Thailand's modern heart and the centre of its youth culture. The area hosts multiple cineplexes, malls, designer clothing boutiques, fast food restaurants and the upscale shops of international brand names. Teenagers gather there to check out the latest trends and set them, too. For nine days, passers-by in Siam Square were asked if they would like to have their portrait taken in a temporary studio set up in the Siam Centre car park by British photographer Robert McLeod. Altogether, 186 pairs in total—couples, friends, colleagues and more—agreed. The portraits capture a cross-section of the area's characters and prevailing looks, events, attitudes and hairstyles.

Photos by Robert McLeod, UK

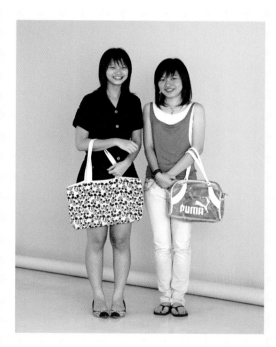

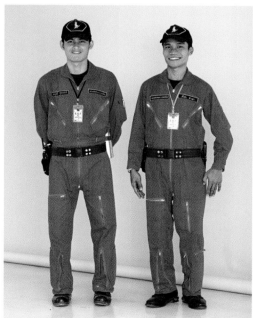

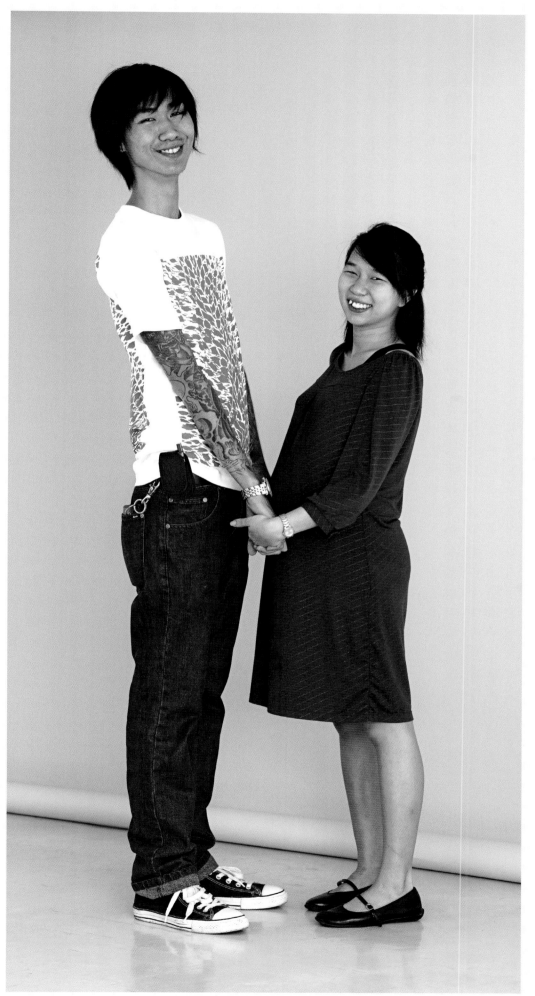

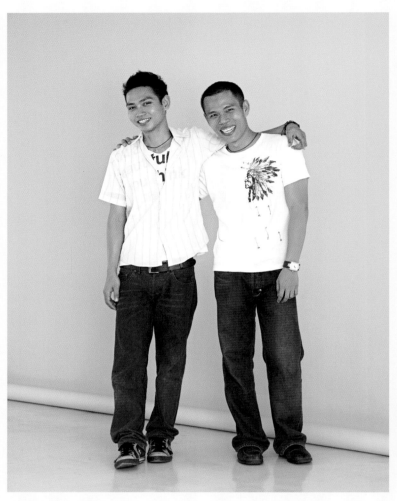

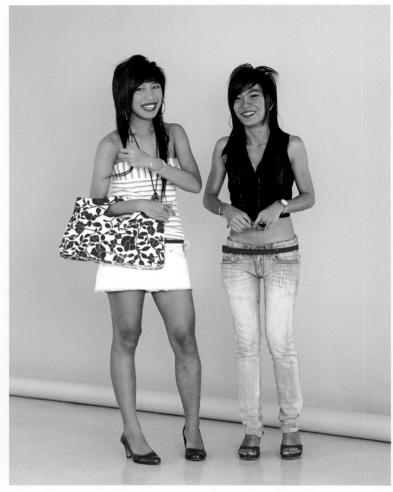

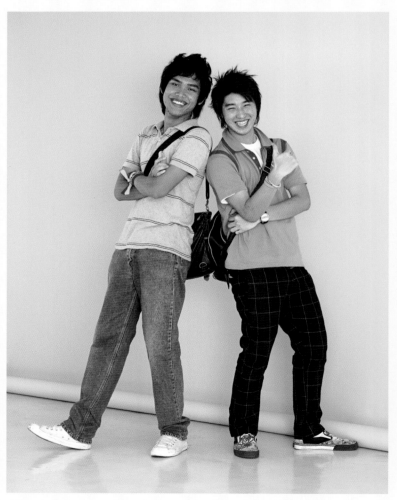

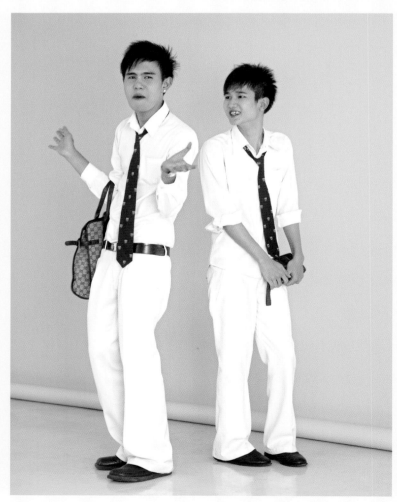

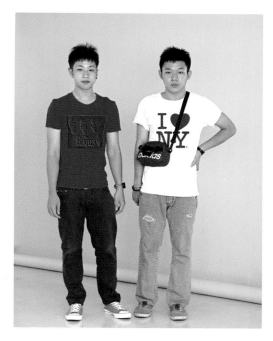

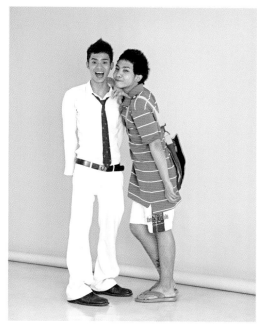

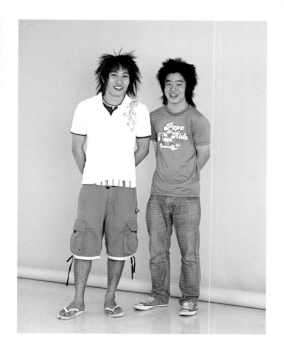

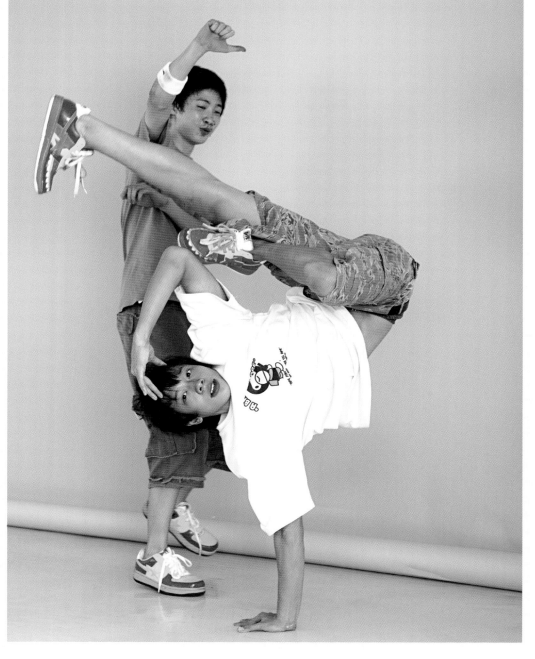

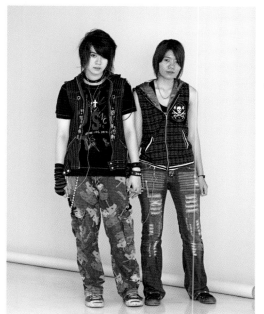

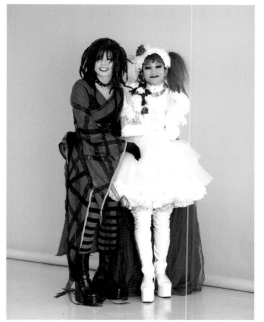

Two young women walk through Siam Square, a popular shopping district in downtown Bangkok. One of the girls holds a chihuahua. Small, 'fashionable' dogs have become especially popular in Bangkok over the last 10 years and there are even special spas catering to the city's canine pet population.

Dow Wasiksiri, Thailand

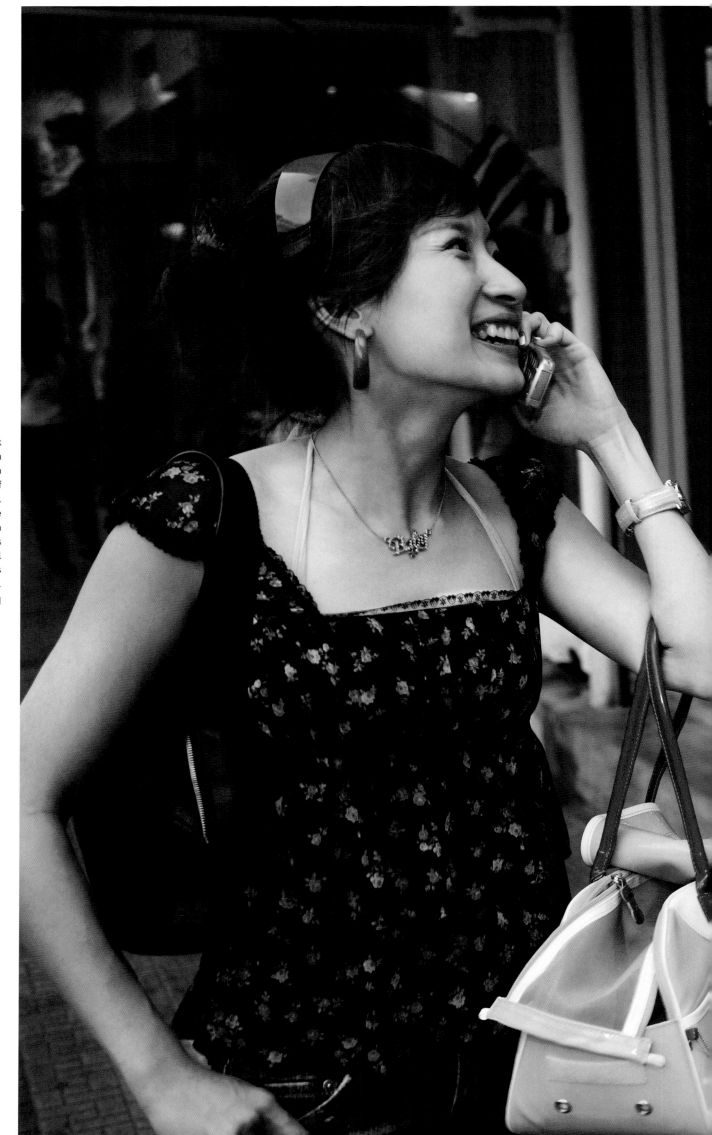

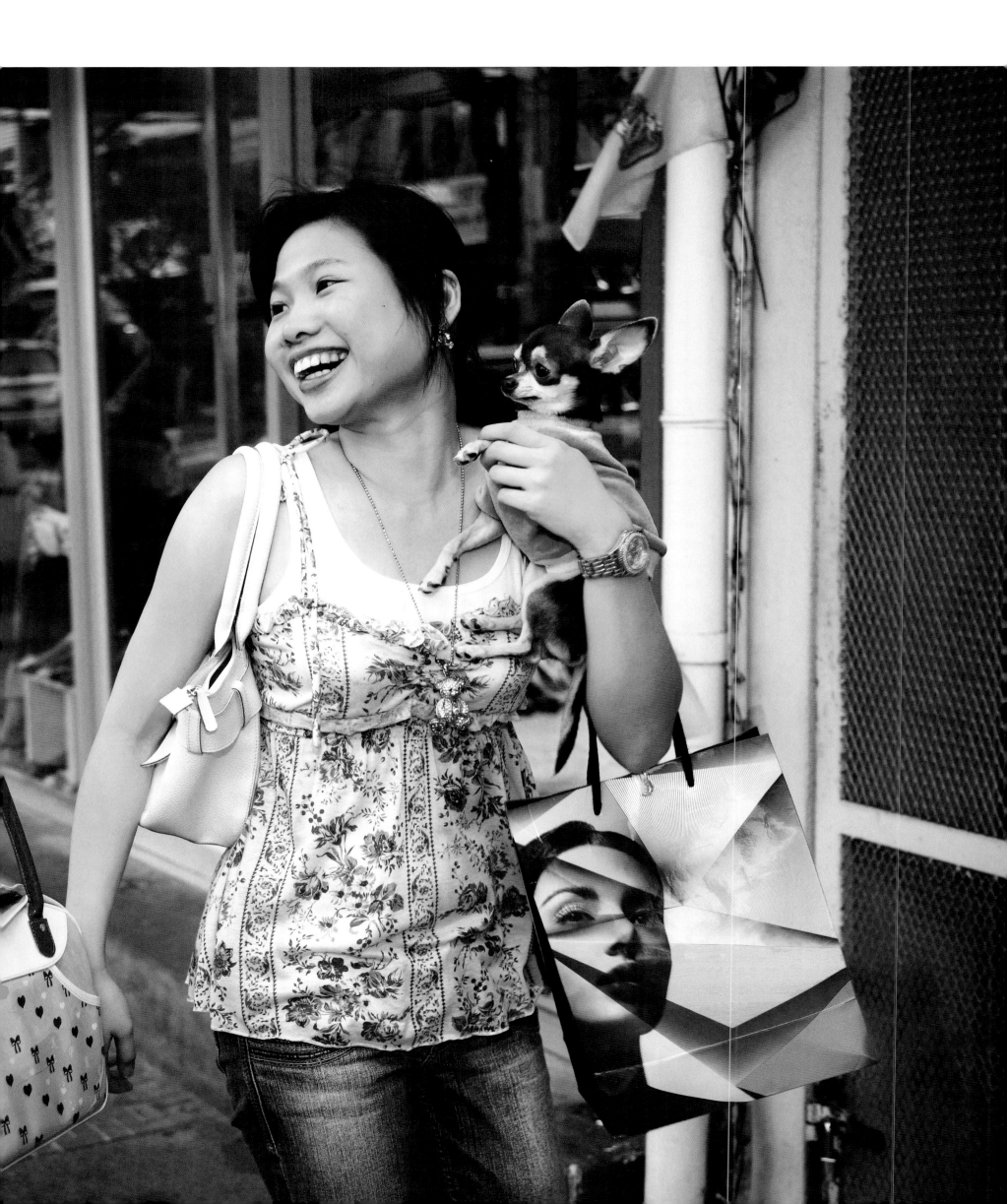

PRECEDING PAGES: Late afternoon at the Chatuchak weekend market in Bangkok. This sprawling market, one of the biggest in the world, attracts hundreds of thousands of shoppers every Saturday and Sunday. Its more than 10,000 stalls sell everything from turtles to used sneakers to the latest creations of young Thai designers.
Gueorgui Pinkhassov, France

A man reads the newspaper in a corner café at the Suphan Buri Historical Market.
Laura El-Tantawy, Egypt/UK

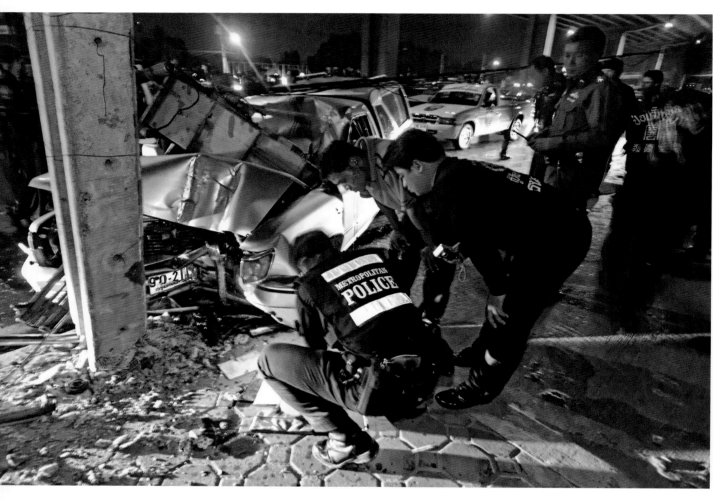

ABOVE: Police gather at the scene of a fatal car accident involving an off-duty officer. The man drove his vehicle into a cement pylon in Bangkok's Pin Klao district. The impact dislodged a large transformer on top of the pylon, which then fell through his windshield. The photographer arrived on the scene first with the Por Tek Tung volunteer emergency response team, which delivers victims to area hospitals.

Michael Freeman, UK

RIGHT: This street, Bamrung Mueang, which runs next to Wat Suthat in Bangkok's historic district, is famous for the dozens of shops that sell Buddha paraphernalia. Often, the stores will display large Buddhas to attract customers. Here, employees wheel a large metal Buddha back to storage after displaying it on the sidewalk.

Steve McCurry, USA

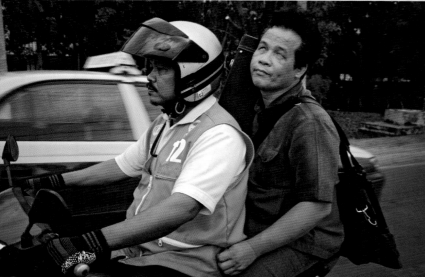

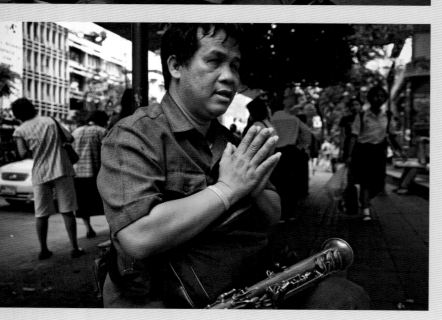

THE BLIND MUSICIANS who sing and play music for donations in Bangkok, help keep the city's beat. Rewat (nicknamed Tee) is a saxophonist who is a fixture on the commercial thoroughfare of Silom Road. Photographer Gerhard Jörén followed Tee on a typical day in his life.

LEFT (TOP): Tee sits with his family in their two-storey house. Tee's wife Aree, holding her son Pakawat, is also blind. Tee played some songs on a bamboo flute before heading off to work.

LEFT (CENTRE): Tee travels three kilometres on a motorcycle to the bus stop every day. When the motorcycle stops, he is led across a busy road to the bus stop by a young woman. While waiting for bus no. 504, another woman becomes his guardian. 'It all seemed so natural and effortless, almost like these women were positioned to be there for him,' recounted Jörén. The bus ride takes almost one hour and Tee spends the time chatting with fellow passengers and making phone calls to friends. 'There didn't seem to be any social borders between him and other people,' said Jörén, 'nor did people treat him as a victim, but more with respect.'

LEFT (BELOW): On arrival at Silom Road, Tee puts out his folding chair. Before he begins to play he says a prayer for his teacher and His Majesty the King. He starts to play one melody composed by His Majesty and soon attracts the attention of pedestrians.

RIGHT: In the afternoon, Tee is met by his daughter. Occasionally he is asked to play at parties and in restaurants. On this day, she takes him up the river to meet and jam with Koh Mr Saxman, one of Thailand's most famous jazz musicians. Far away from the noisy street the two musicians jam together for almost an hour and both men share smiles and laughter.

Photos by Gerhard Jörén,
Sweden

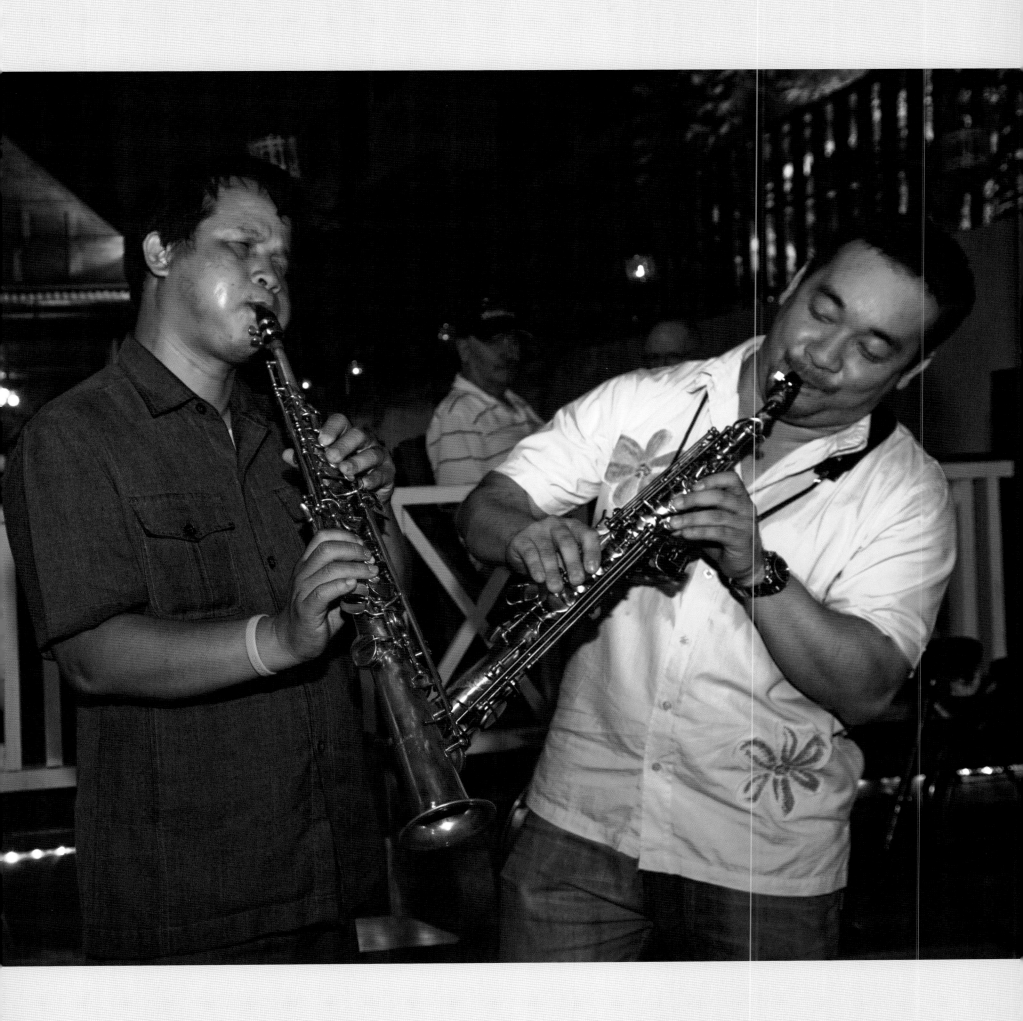

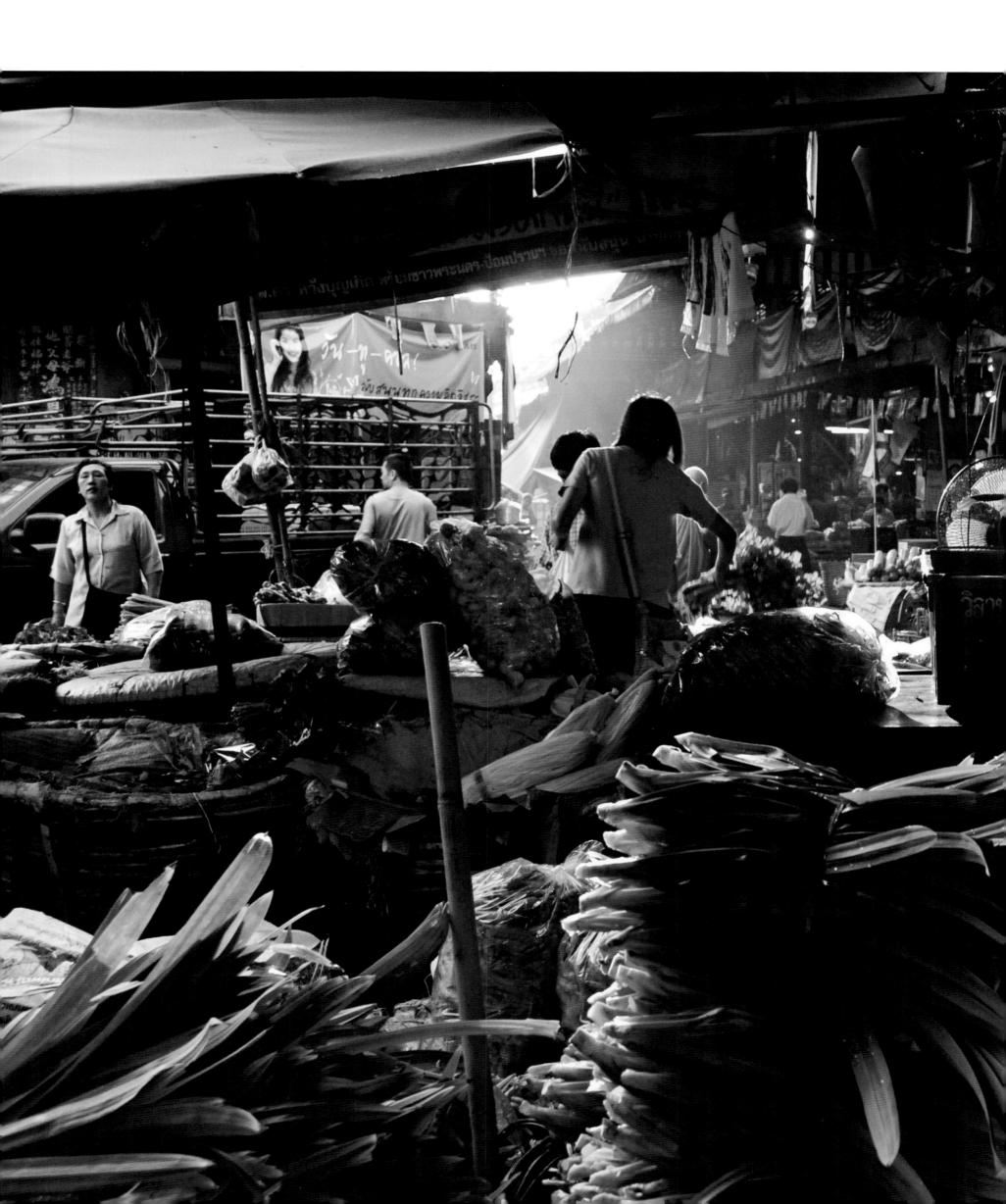

The first light of day at the wholesale vegetable section of Pak Klong Talad, a 24-hour market in Bangkok, which is also the country's biggest wholesale supplier of flowers.

Gueorgui Pinkhassov, France

FOLLOWING PAGES: Each year for 10 days, hundreds of monks from Nong Khai and surrounding provinces in northern Thailand gather at Mahachulalongkorn Buddhist University's Nong Khai campus for a winter camp in order to further their religious studies. Here, at the break of day, they are chanting and praying before eating their morning meal.

Michael Yamashita, USA

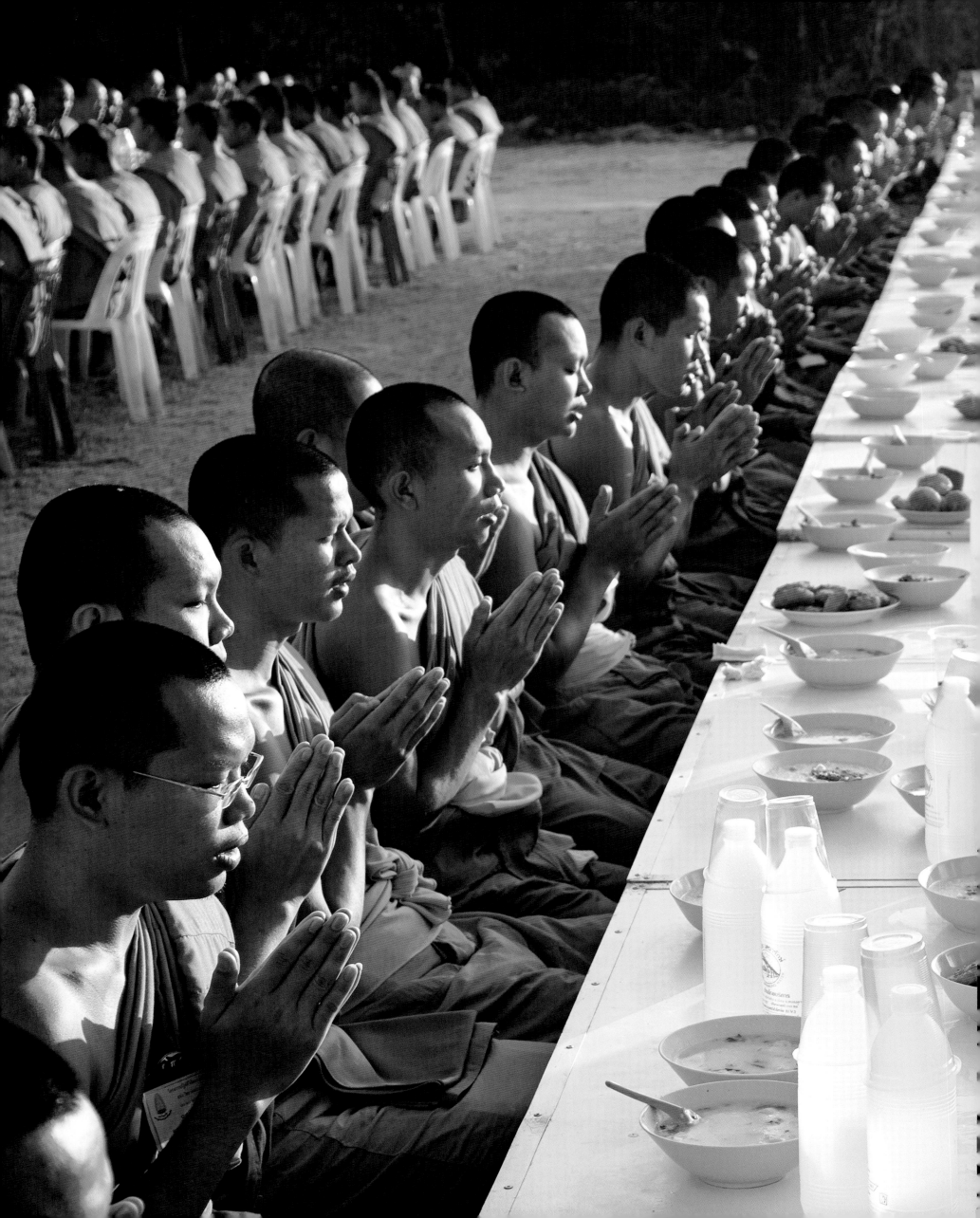

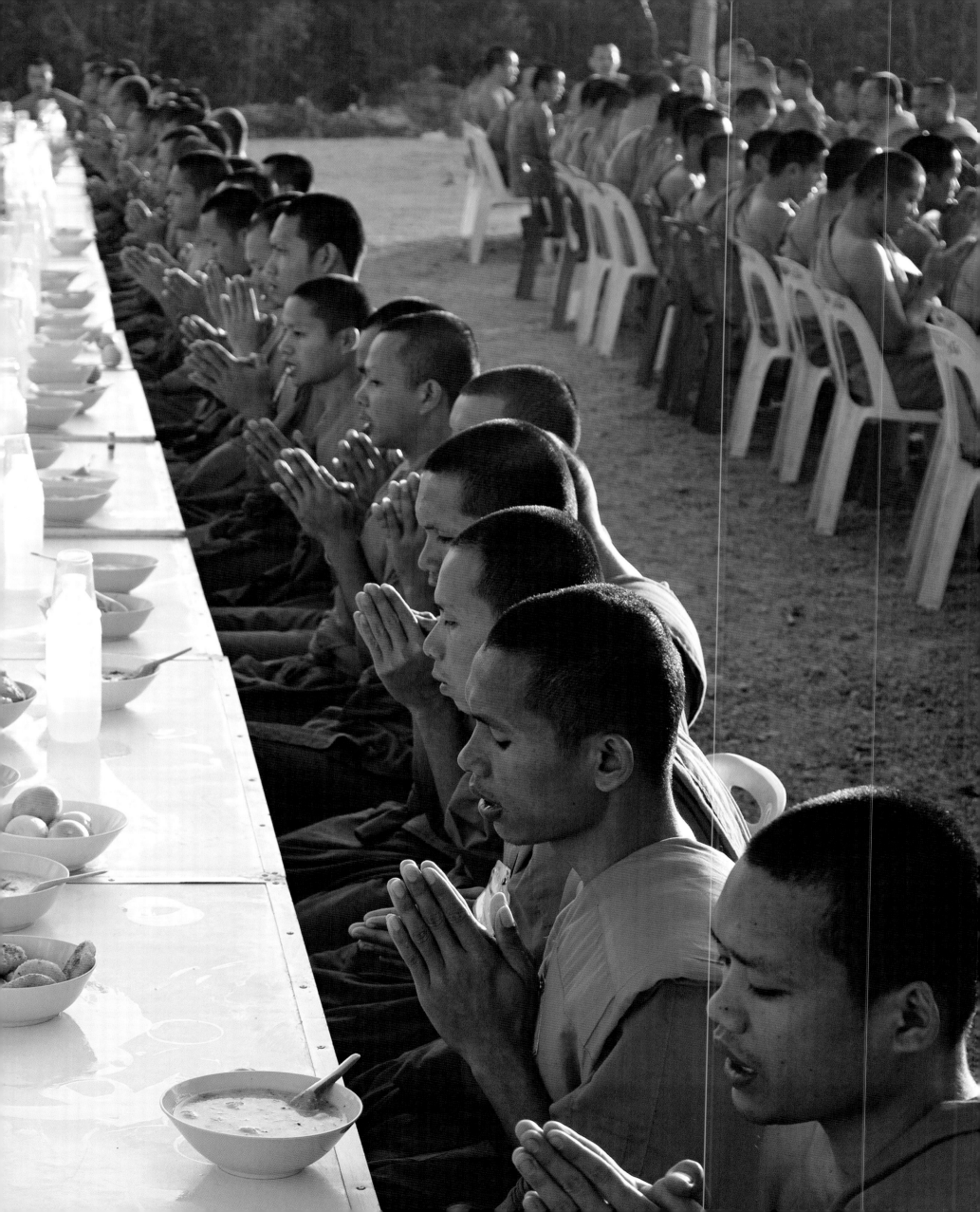

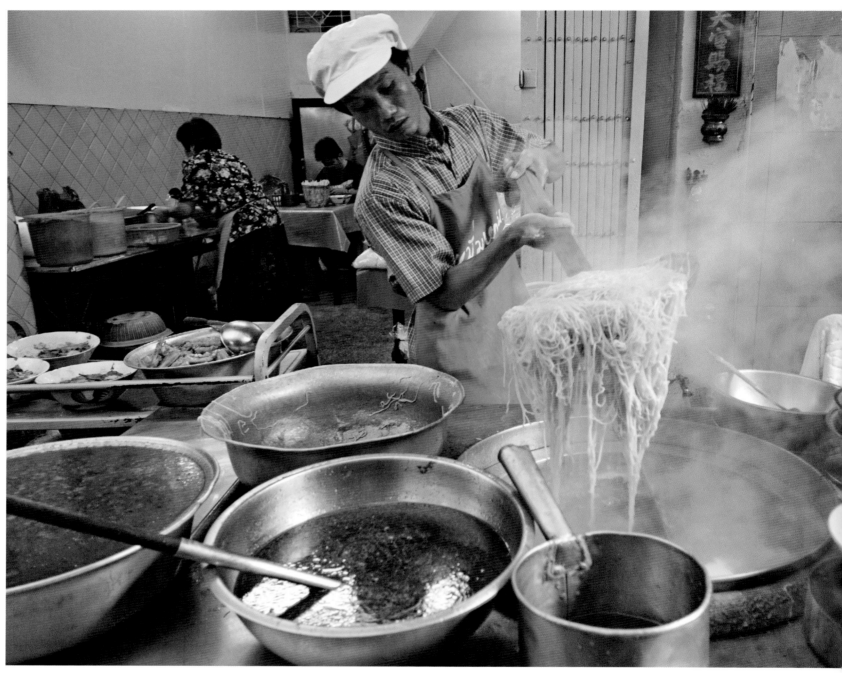

ABOVE: A vendor sells fresh yellow noodles at his popular restaurant in Chinatown.

Dominic Sansoni, Sri Lanka

BELOW (LEFT): An old Coca-Cola advertising board topped with empty bottles at a rest area near Sirindhorn Dam.

Bohnchang Koo, South Korea

BELOW (RIGHT): The spicy dip known as *naam phrik*, with salty boiled eggs.

Hans Hoefer, Germany

FAR RIGHT: A boy eats a snack on the street outside his home on Soi Rambutri in Bangkok.

Dow Wasiksiri, Thailand

OTHER PICTURES: At the Khong Jiam morning market in Ubon Ratchathani province, small sardine-like fish and shrimp are displayed, along with vegetables and tiny white ants placed on banana leaves. On the far right (top) is more produce at the Ban Chee Tuan market.

Bohnchang Koo, South Korea

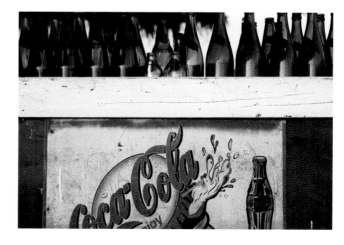

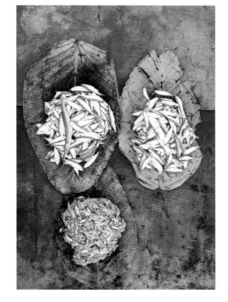
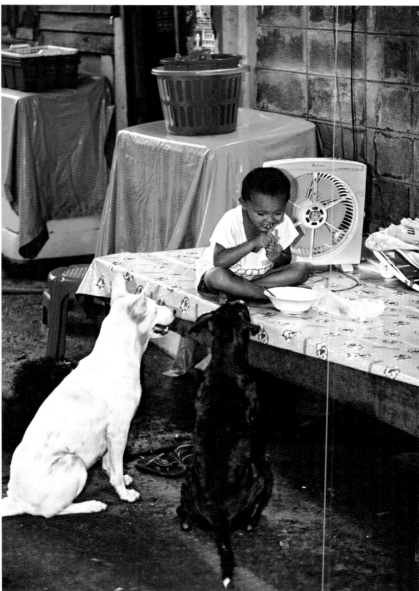
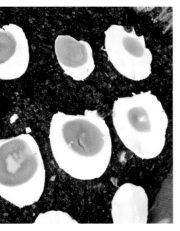
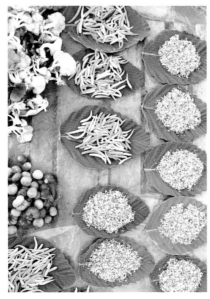

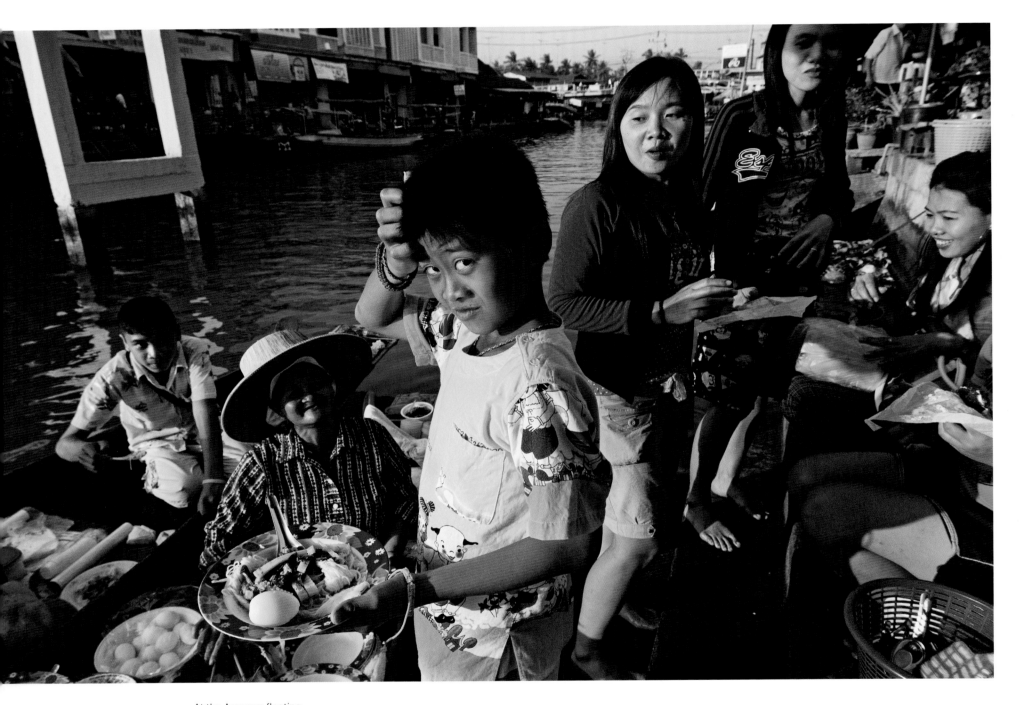

At the Ampawa floating market, siblings help their grandmother sell (and eat) her traditional Thai food. The young boy holds a plate of rice noodles with green curry and a boiled egg. The vendor's granddaughters are seen in the background.

Dominic Sansoni, Sri Lanka

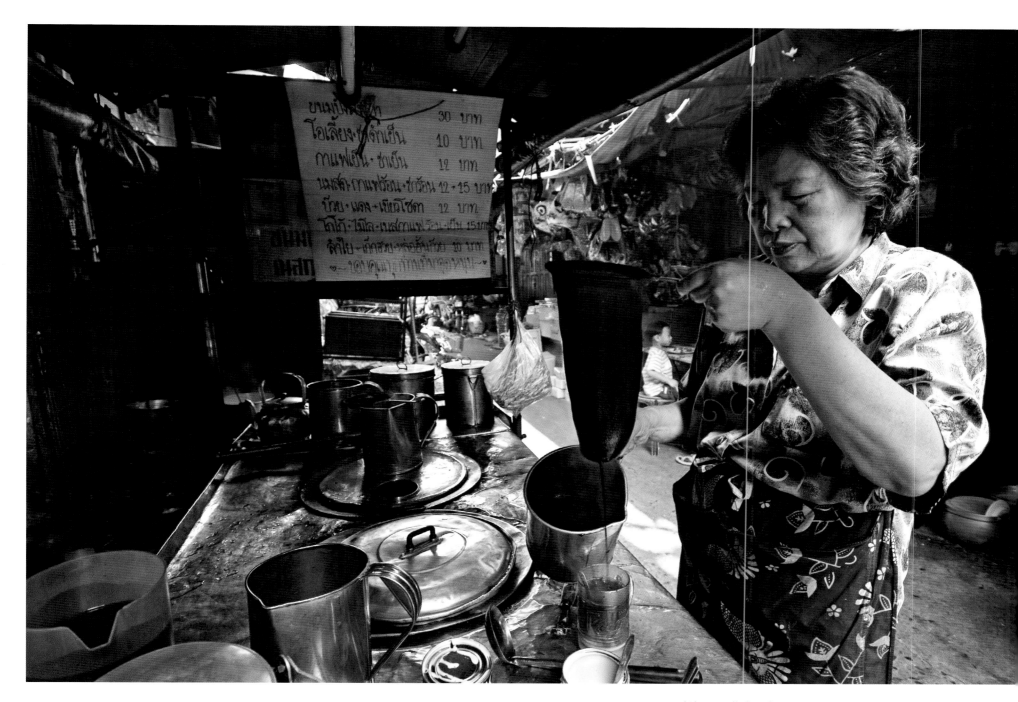

At her small shop down a Chinatown alley, a coffee vendor strains a cup of local coffee. One cup costs between 10 baht and 12 baht (around US$0.30). While there are now thousands of modern coffee franchises all over Thailand, local-style brews are still popular.

Dominic Sansoni, Sri Lanka

Locals walk through the stalls at the annual Suphan Buri fair. Fairs and festivals are an important part of the cultural fabric of Thailand and there is unlikely to be a town in the country that does not host one.

Laura El-Tantawy, Egypt/UK

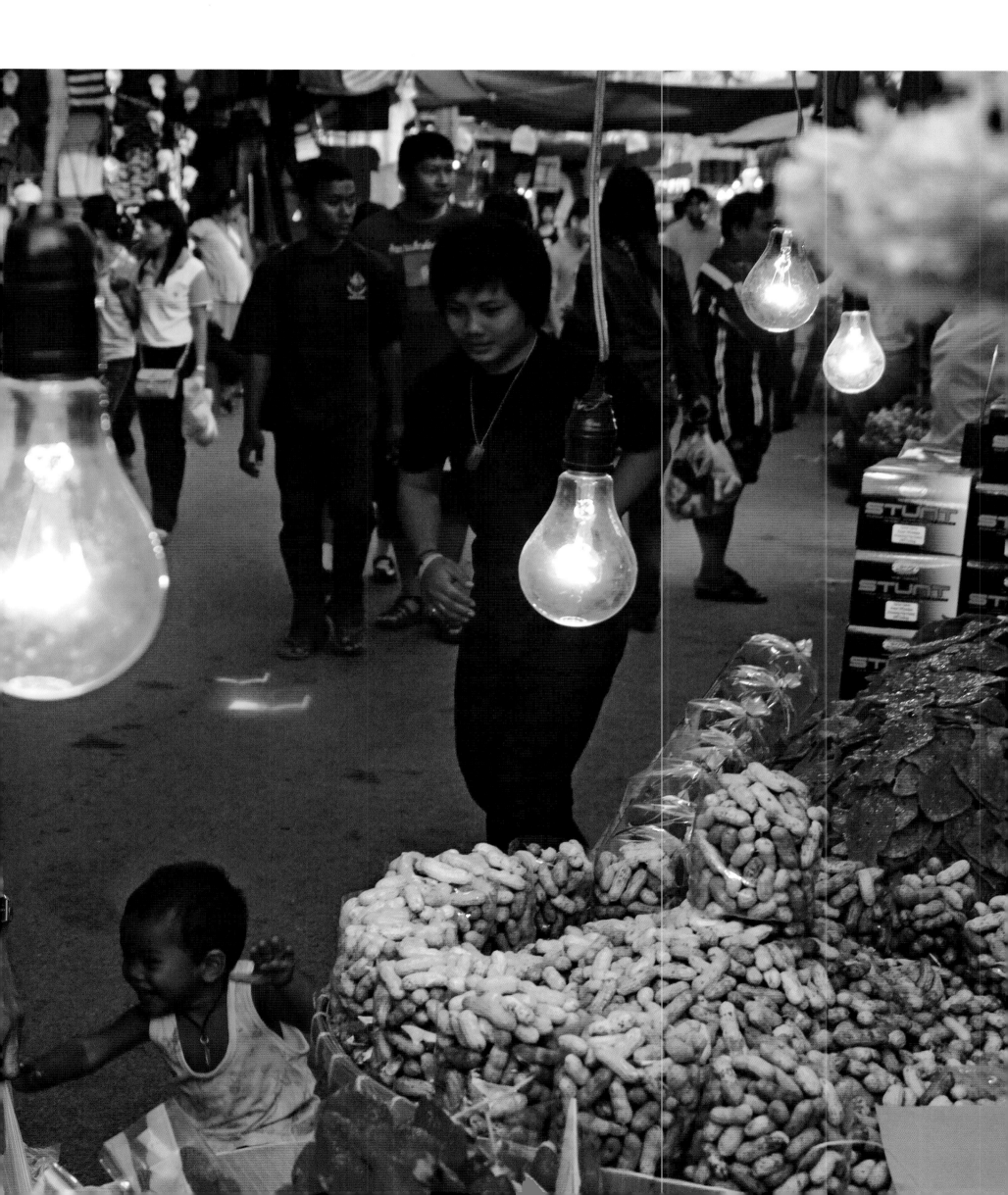

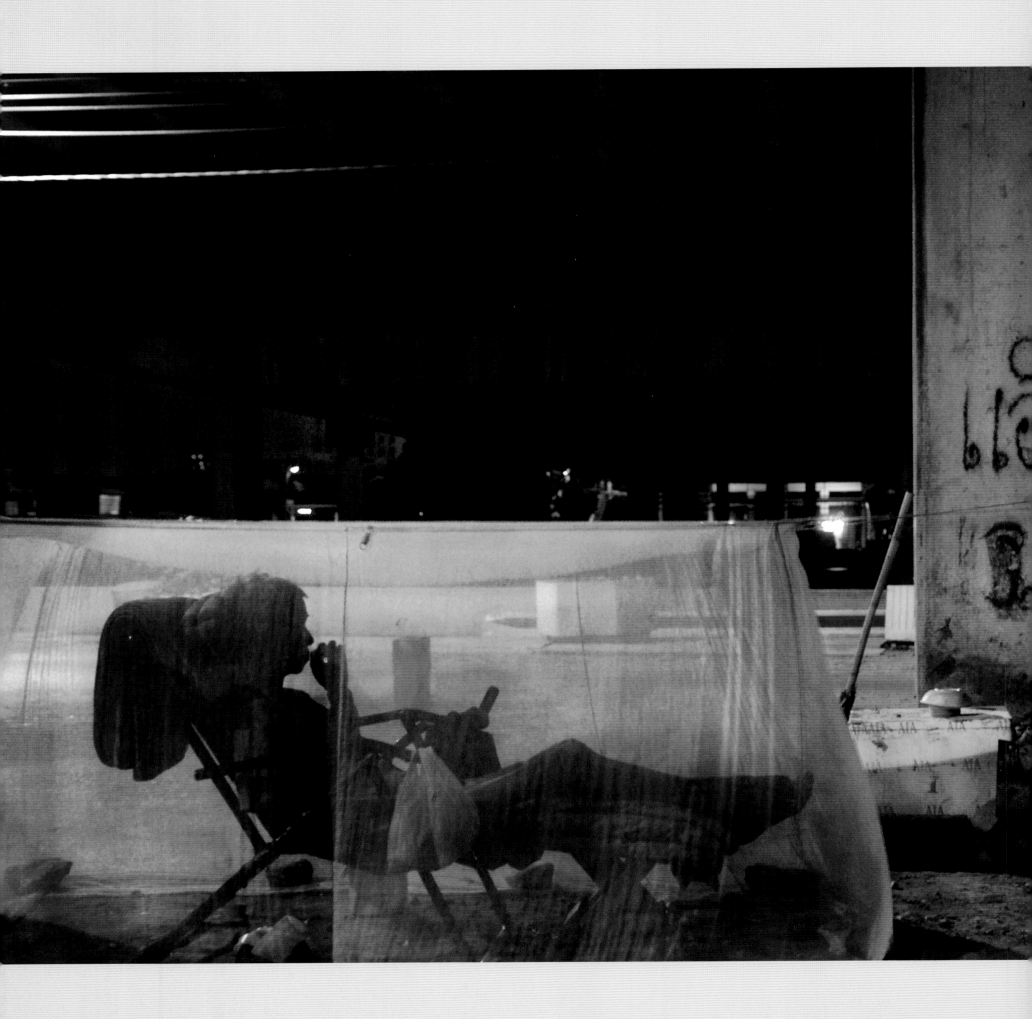

IN BANGKOK NOI, UNDER AN EXPRESSWAY, lives a community of homeless people. Some of them are mentally ill, while others are penniless or fleeing their families. They have set up camp under the bridge, which protects them from heavy rains. Brought together by loneliness and the need for shelter, they have also recreated a sense of family and solidarity. A few have regular jobs, while many make a living by begging at the nearby temple.

Every day after sunset, the sleepiness prevailing under the bridge makes way for excitement—it's rehearsal time. A few of those who live under the bridge and youngsters from the neighbourhood have created a Singto performance troupe. When the weather cools, they rehearse the Chinese-style parade dance to the beat of drums. Jumping from one pole to another, wearing masks, they practice forming, in unison, the body of a lion. This derelict place is suddenly lit up by music and dance.

LEFT: Nam Ruanphee, a homeless man, has set up a mosquito net around his mat and smokes a last cigarette before trying to get some sleep. He earns money by begging at a nearby temple.

RIGHT (TOP): Members of the Singto troupe play a board game using bottle caps. The tattoo on one of the players depicts a character from the Indian epic, the *Ramayana*.

RIGHT (CENTRE): A view of the space under the expressway, where the homeless live and the troupe rehearses.

RIGHT (BELOW): Two members of the Singto troupe in the middle of a rehearsal. The troupe is now quite well known and booked year-round to perform at various events inside and outside of Bangkok. The performing youth have gained skills and a source of income that keeps them away from the dangers of life on the street.

Photos by Gilles Sabrié, France

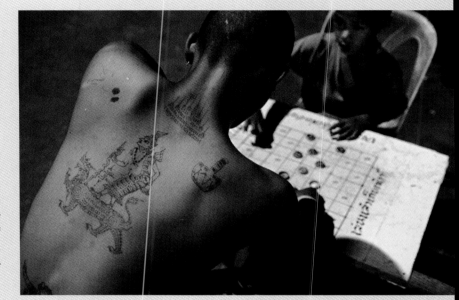

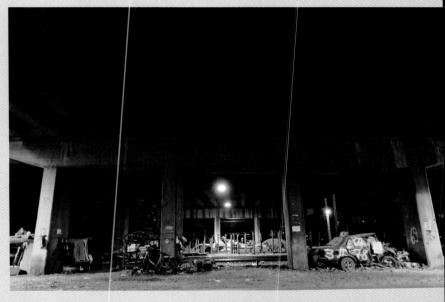

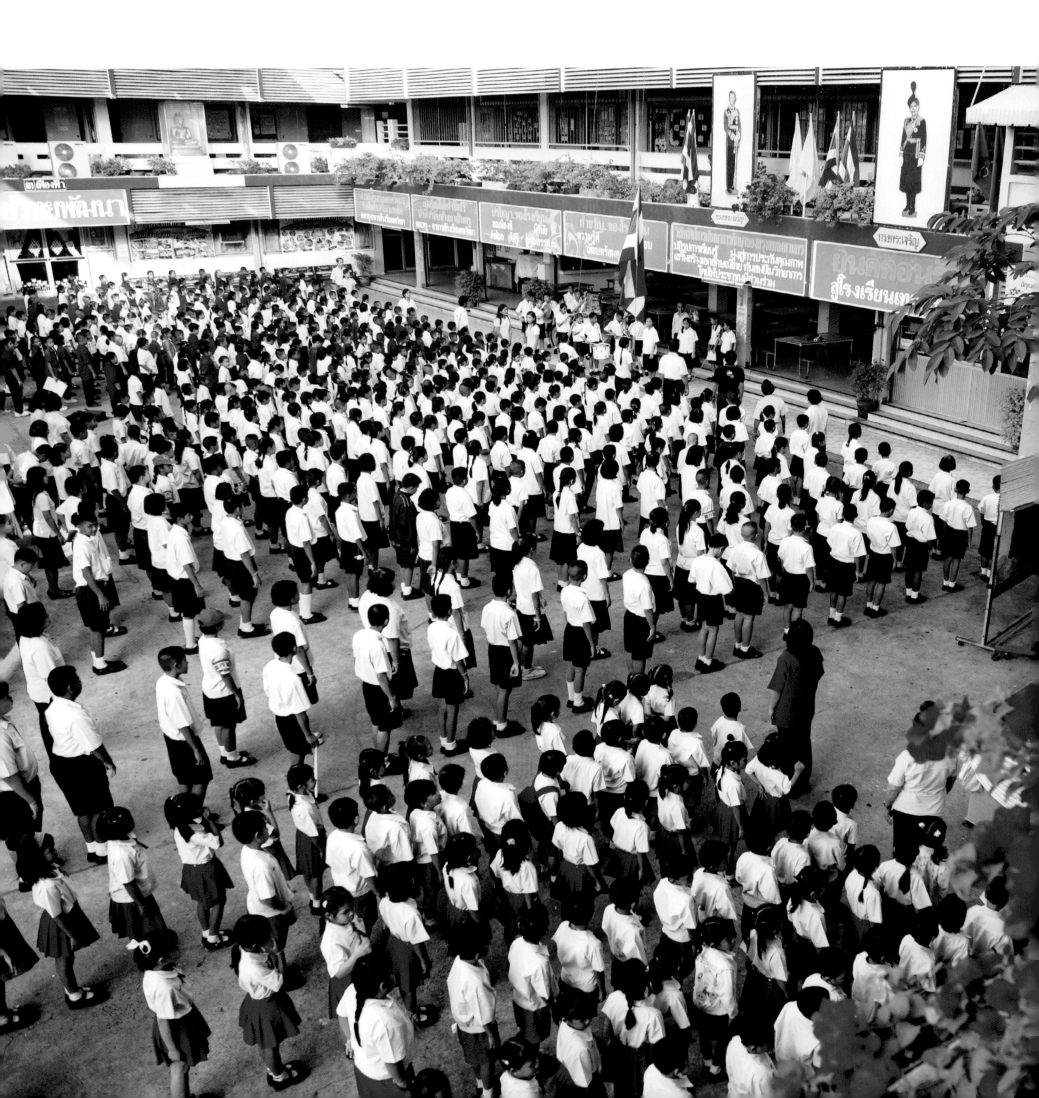

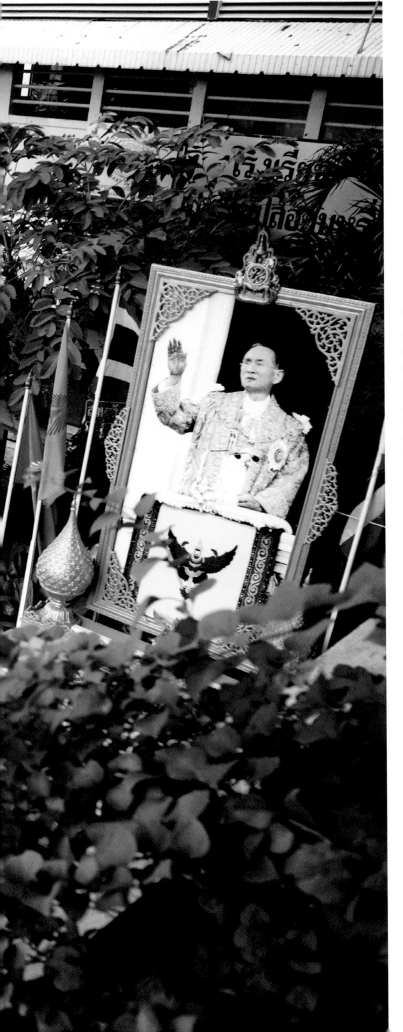

LEFT: Junior high school children stand in formation to pay respects to the Thai flag and His Majesty the King during the national anthem at Thepwittaya School in Bangkok. Every day at 8 am, in schools across the country, the flag is raised and the national anthem is played before classes begin.

Dow Wasiksiri, Thailand

RIGHT: A young girl from Pong Ku Wae School in Yala province in the deep south offers a salute during a visit by a special military task force in charge of promoting peace and winning the hearts and minds of local Muslim youth in the troubled south.

Charoon Thongnual, Thailand

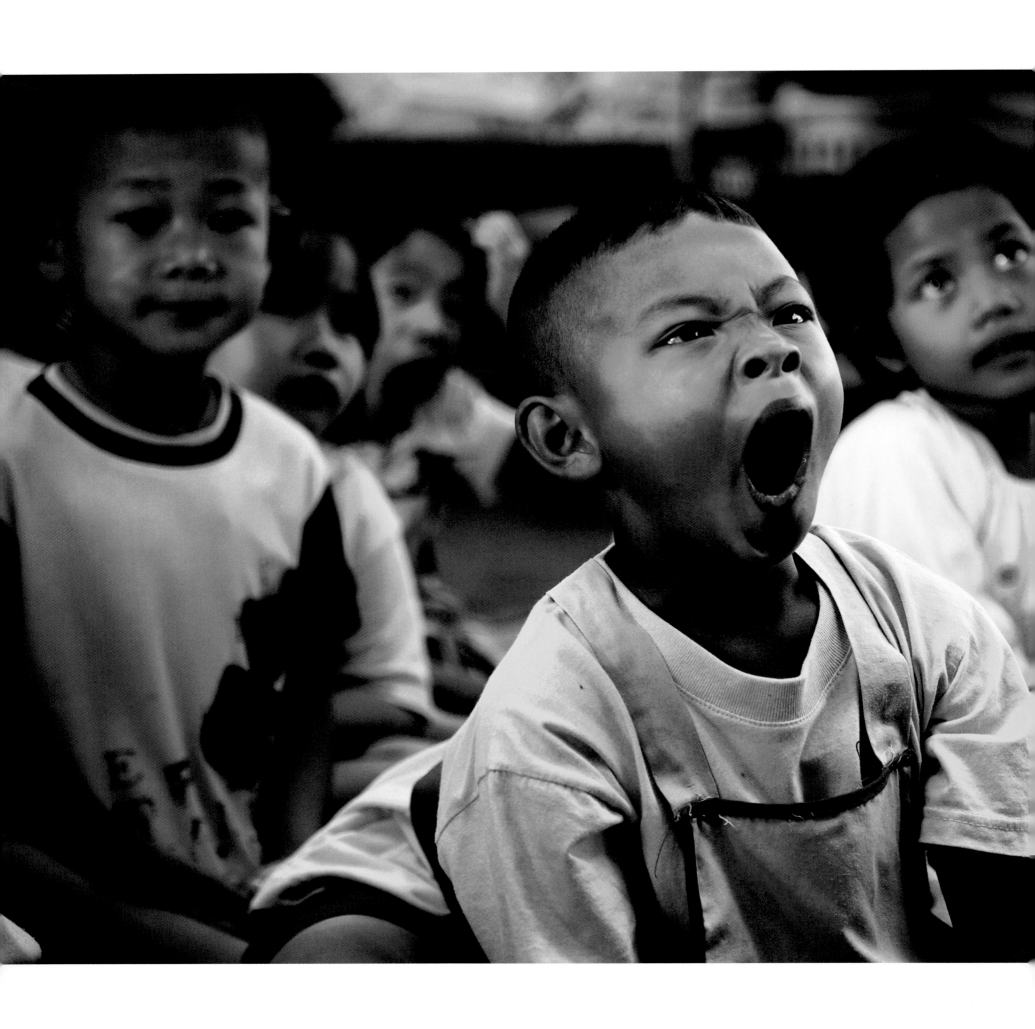

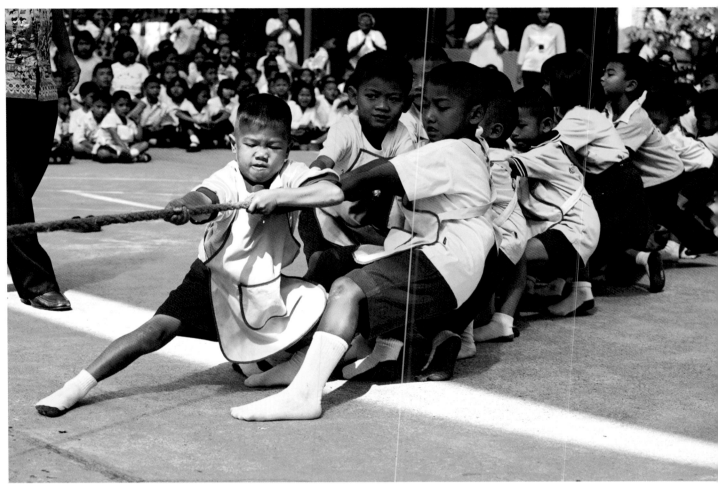

LEFT: Kindergarteners struggle to stay focused on their teacher's lesson during an art class at Klong Sarm School in Minburi district.

ABOVE: Students at Klong Sarm School play tug-of-war during the annual Sports Day activities. On this day, the students wear yellow shirts, in honour of His Majesty the King, instead of their regular uniforms.

Photos by
Dow Wasiksiri, Thailand

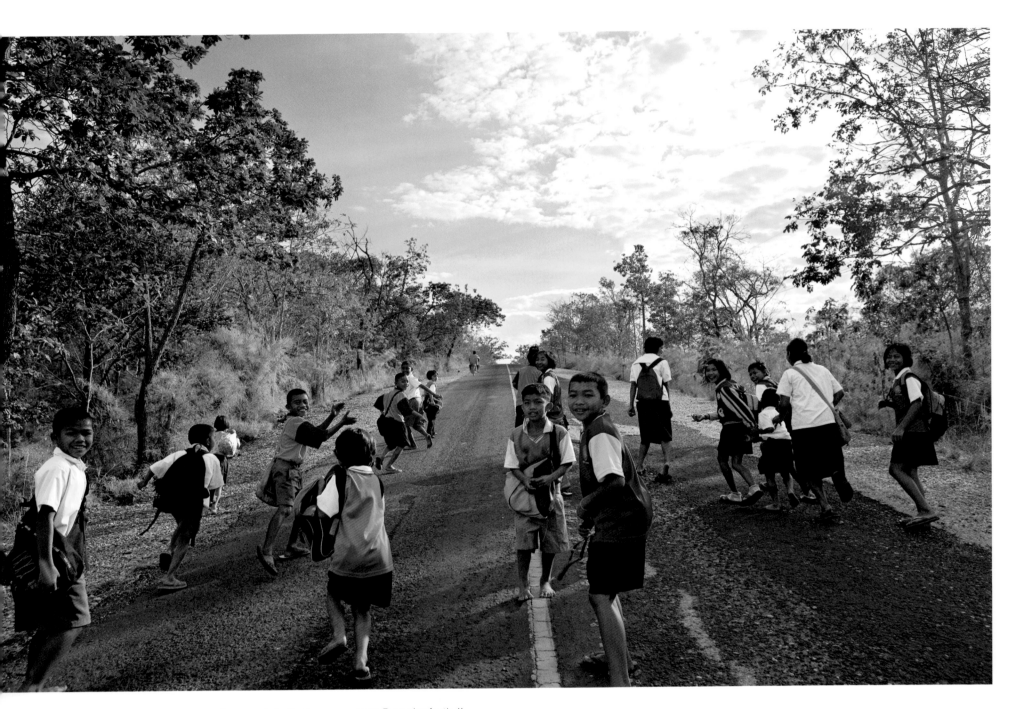

ABOVE: A group of students walking to Baan Hoongluang School along a country road in Ubon Ratchathani suddenly run away in laughter as the photographer takes a picture.

Bohnchang Koo, South Korea

RIGHT: Boys play football outside Pangkae School in Pak Chong in northeastern Thailand before standing for the national anthem. Football is a favourite sport among Thai schoolchildren, and many Thais, young and old, passionately follow the English Premier League.

Dow Wasiksiri, Thailand

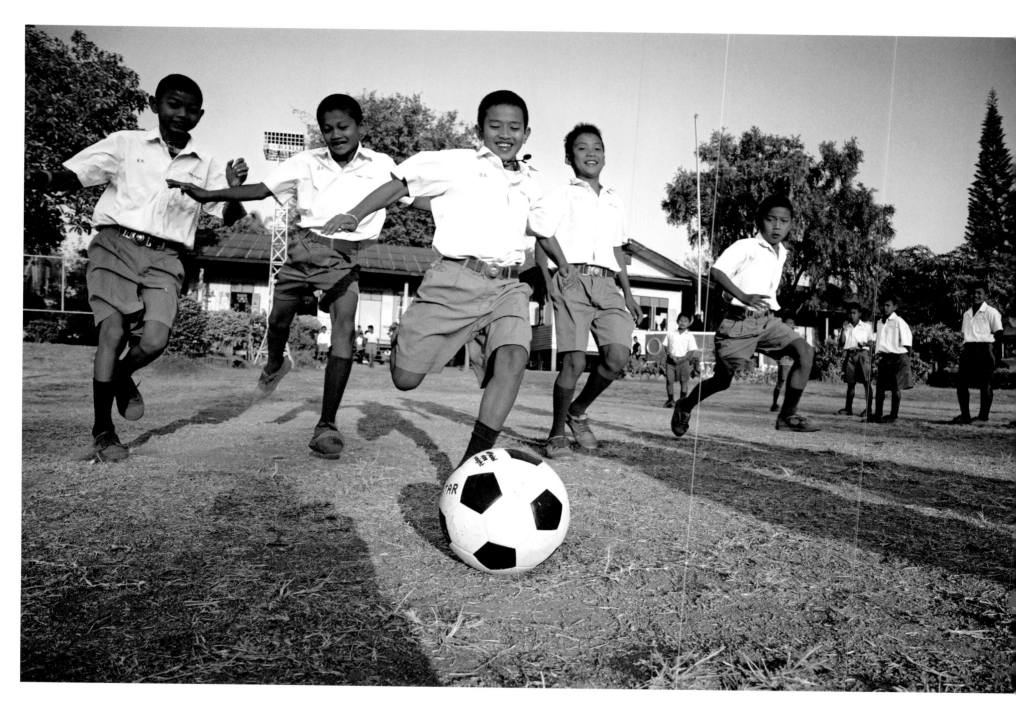

FOLLOWING PAGES (CLOCKWISE FROM LEFT): A group of friends at Katong School in Yala province are on their way to pay respects during the national anthem. Katong was the first school to allow girls to wear a veil.

In a village in Yala province, 68-year-old midwife Johsong Lateh takes care of Pataheyah Adae, 36, who has just given birth to her fourth child. Johsong has been a midwife for 25 years and has delivered more than 1,000 babies in the village. Thai-Muslims in the three southernmost provinces of Thailand usually prefer midwives to hospital care.

Charoon Thongnual, Thailand

Girls from an all-girls Muslim boarding school in the village of Hua Kao Daeng cook, sleep and do their homework in these basic homes.

Jeremy Horner, UK

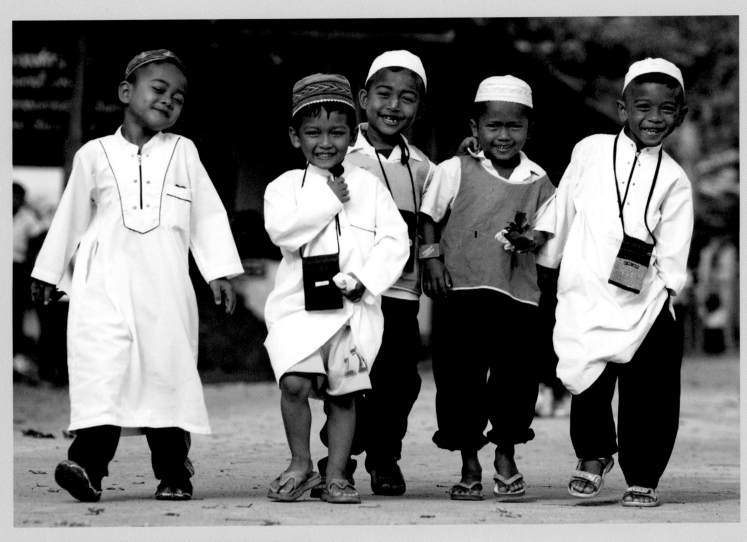

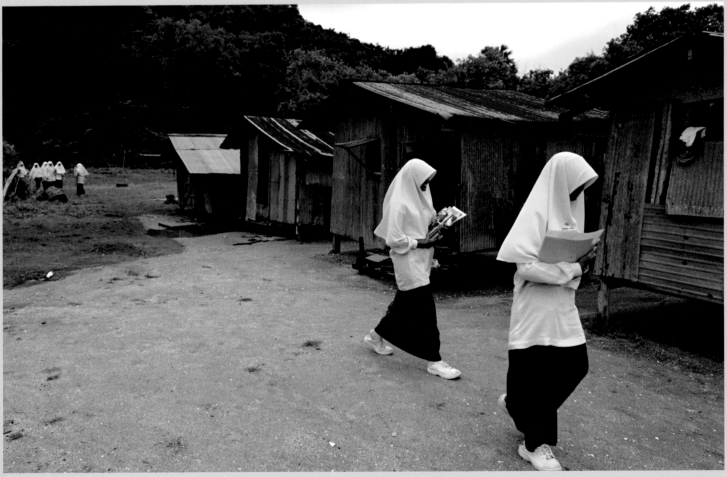

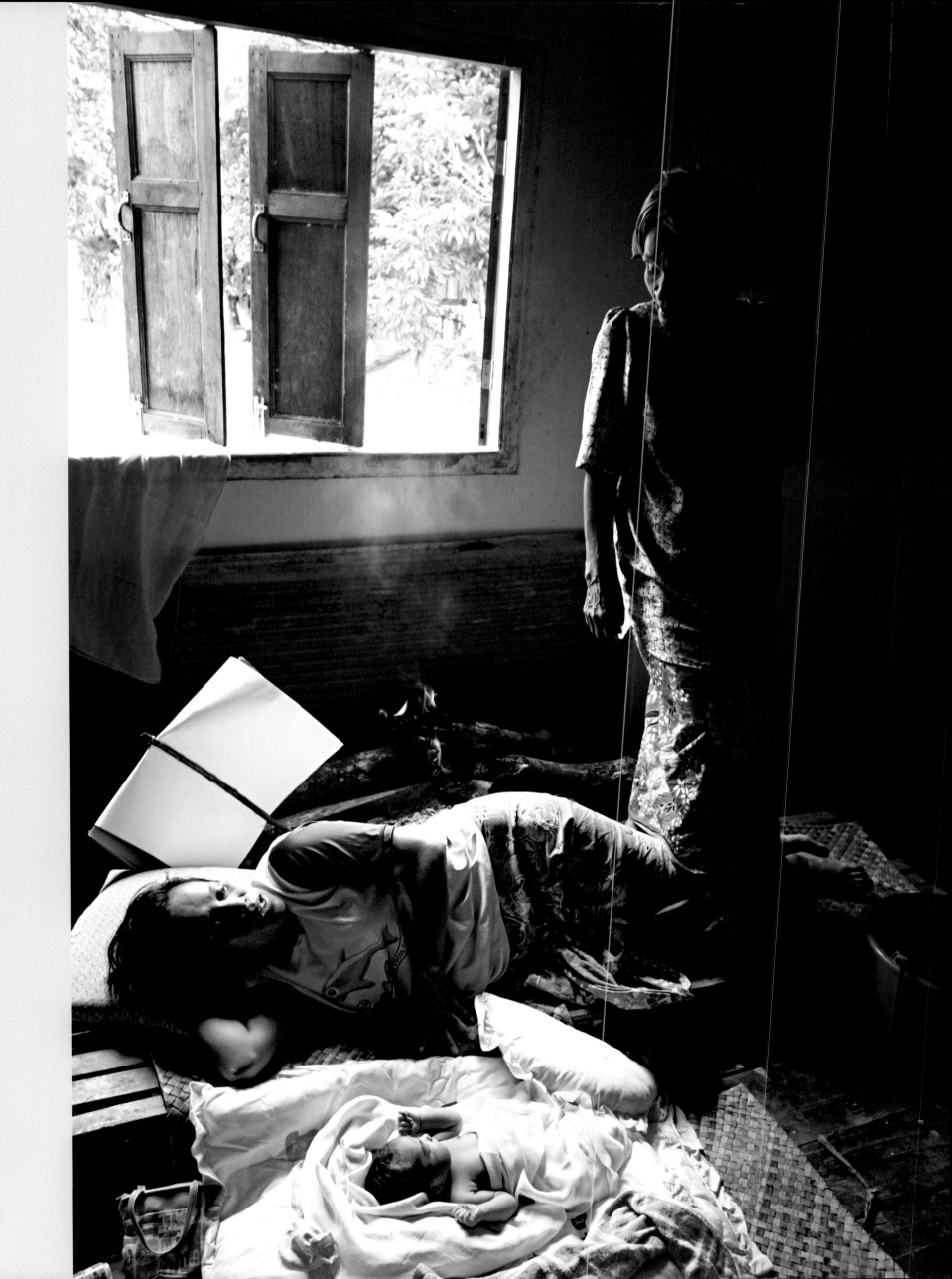

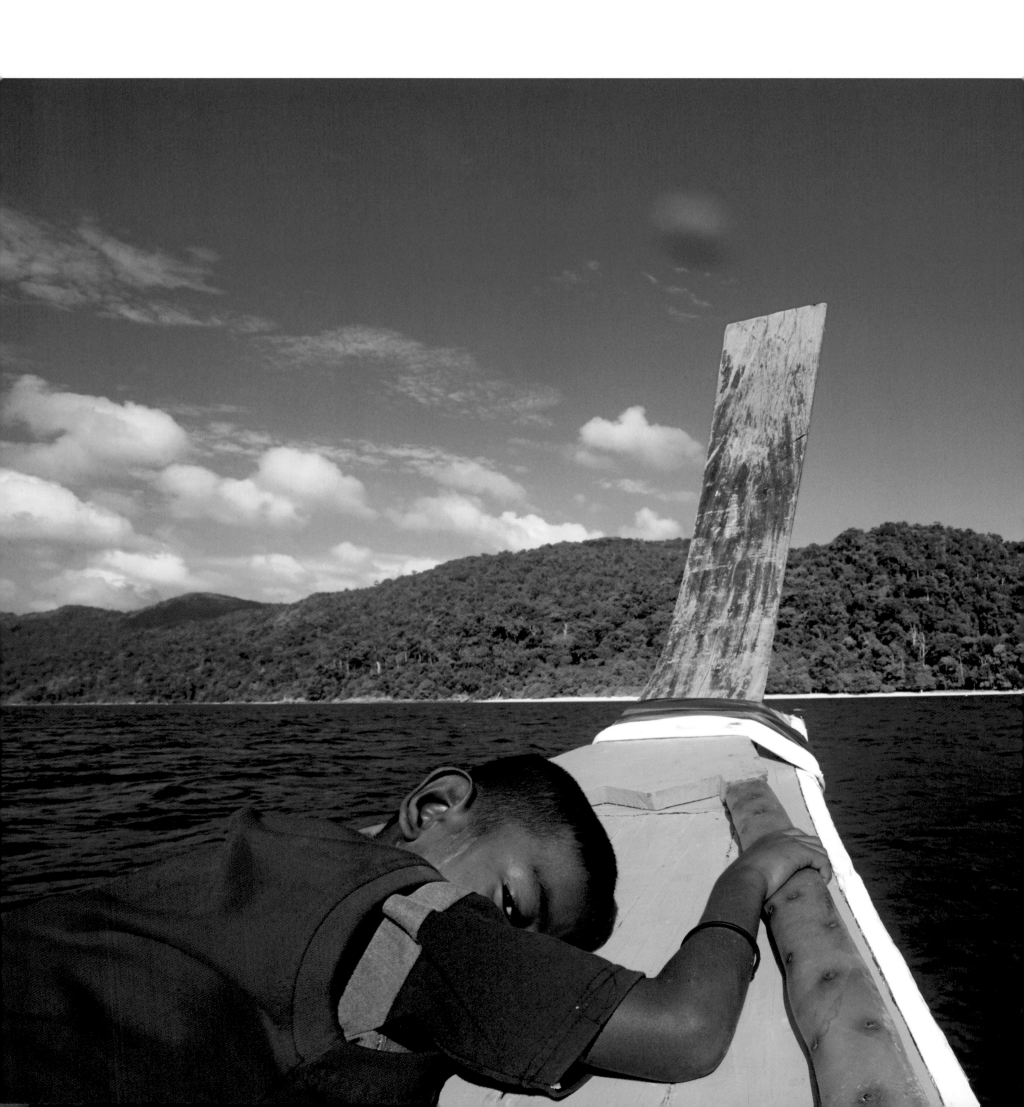

LEFT: Undeterred by the sun and splashing surf, the son of a longtail boat captain goes for a nap on the bow. The boat is headed to Ko Lipe, which is the most inhabited island of the Adang-Rawi archipelago of southern Thailand. Its 800 natives are sea gypsies who occupied the island long before the government designated it a national park area.

Ernest Goh, Singapore

RIGHT: A four-year-old boy named Gla Tapreuk, from the Mlabri tribe, squats in the village of Huay Yuak in Nan province. The Mlabri are known in Thai as *phi tong luang*, which means 'spirits of the yellow leaves'. Some estimates suggest there are only hundreds of Mlabri left in Thailand, living mainly in the northern provinces of Nan and Phrae.

Olivier Föllmi, France

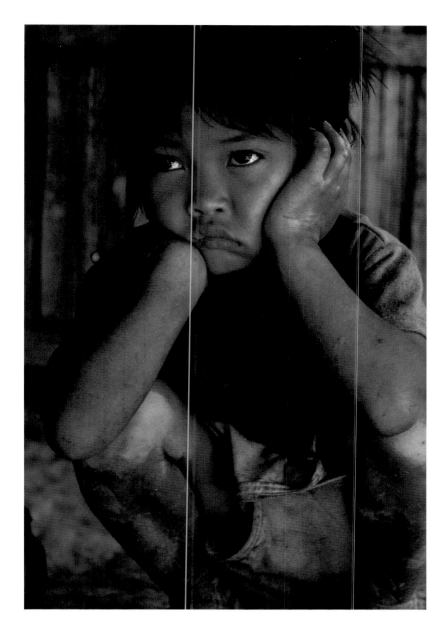

The 92-metre-high Buddha statue at Wat Muang in Ang Thong province is surrounded by rice fields. Workers were applying gold paint to the statue when this picture was taken and the photographer ascended in their crane to capture this shot.

Romeo Gacad, Philippines

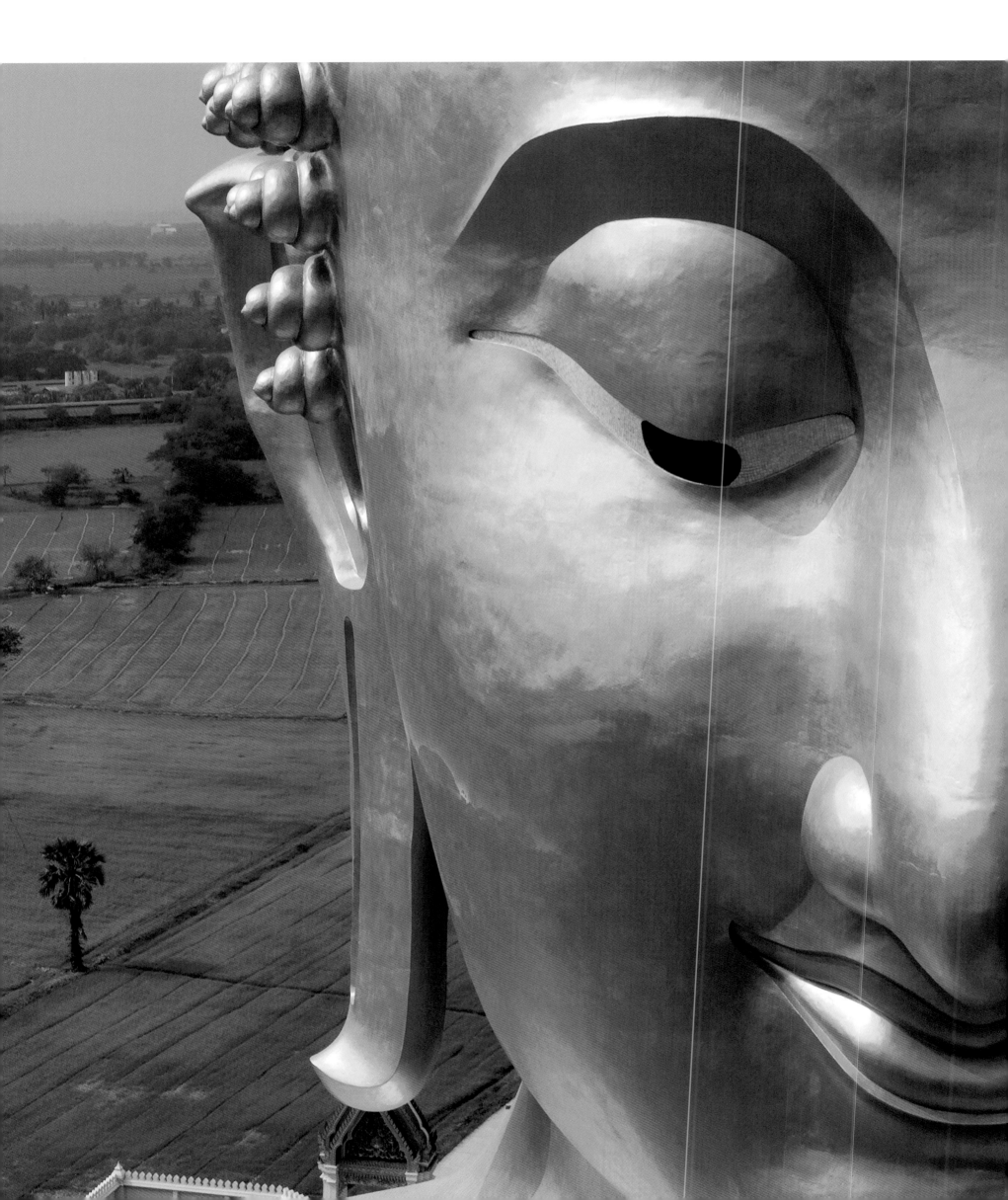

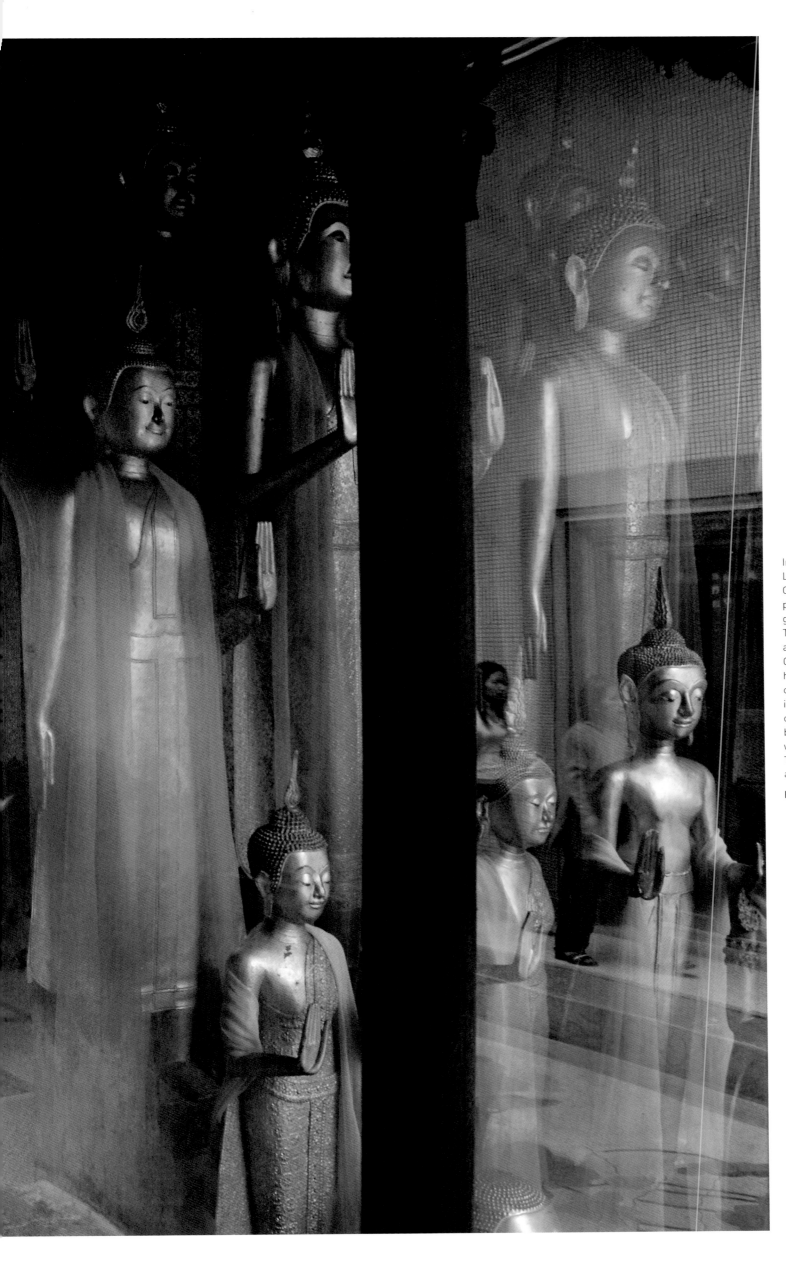

Inside the Chinese temple Leng Nui Yee in Bangkok's Chinatown, a young woman prepares to pay respects to the gods. A large percentage of Thais have Chinese ancestry and pay regular visits to Chinese temples. The Chinese have migrated to Thailand for centuries, with the greatest influx occurring in the 19th century. Intermarriage between Thais and Chinese was common and today the Thai-Chinese form a wealthy and influential community.

Raghu Rai, India

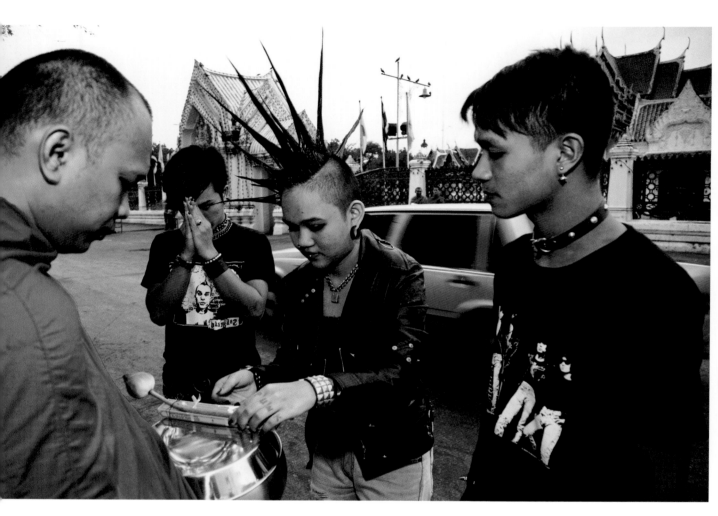

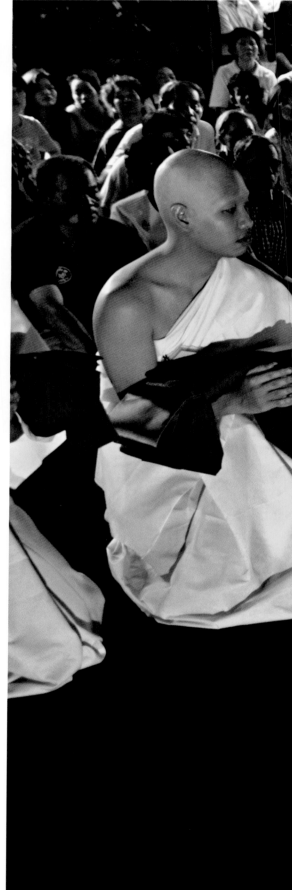

ABOVE: Early in the morning, punks make an alms offering to a monk outside Wat Benchamabophit after attending an all-night alternative music concert in Bangkok.

Dow Wasiksiri, Thailand

RIGHT: At a ceremony at Wat Bowonniwet Vihara in Bangkok, young men are being ordained by a senior monk, who will dress them in their robes for the first time. In the background, family members look on during this significant day. Wat Bowonniwet Vihara is the same temple His Majesty and many other royals from the Chakri Dynasty were ordained at as young men.

Raghu Rai, India

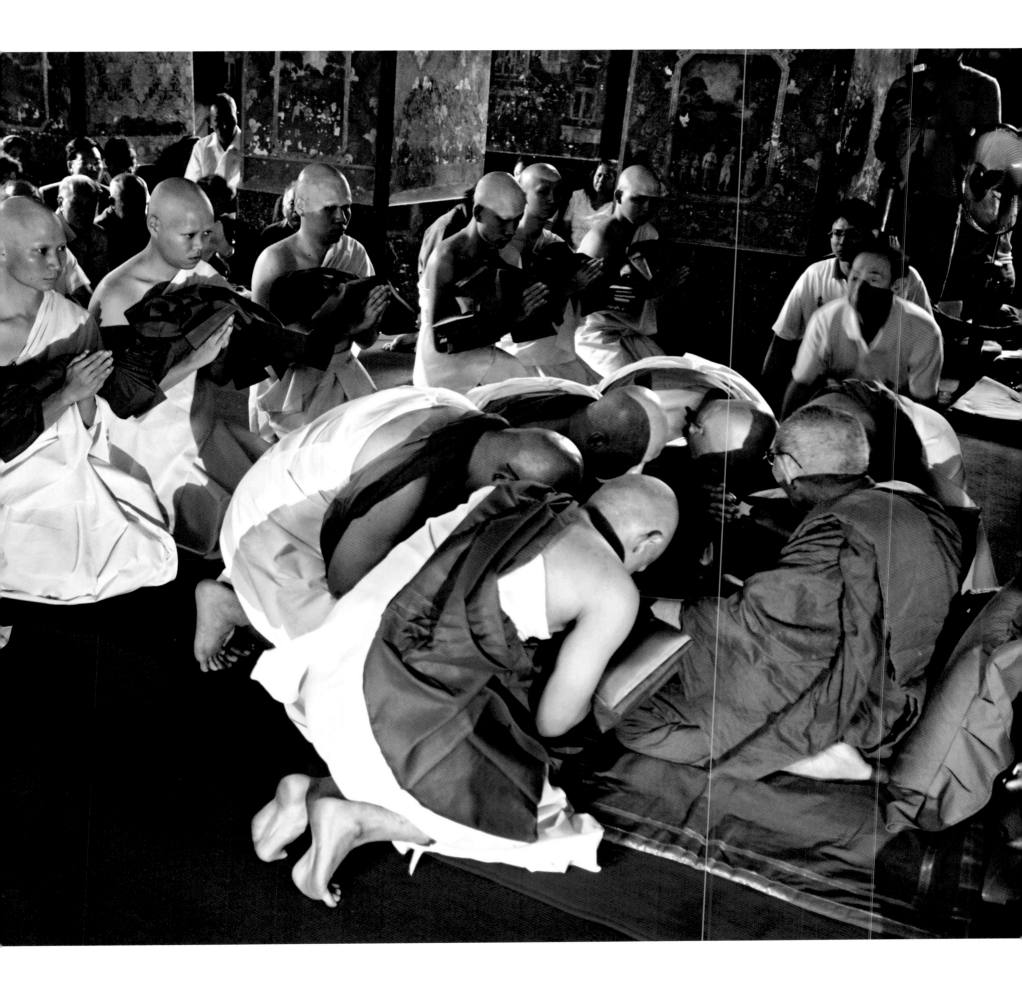

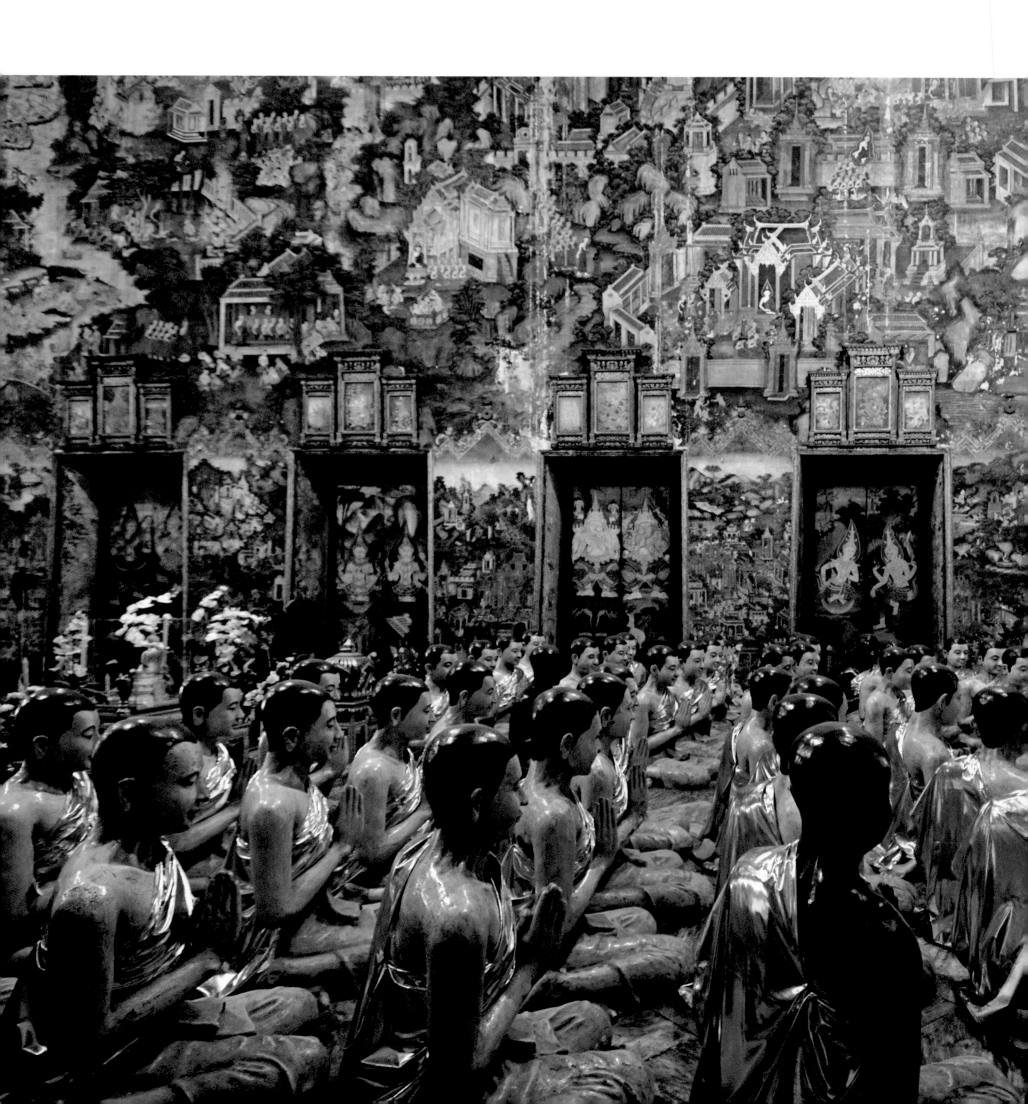

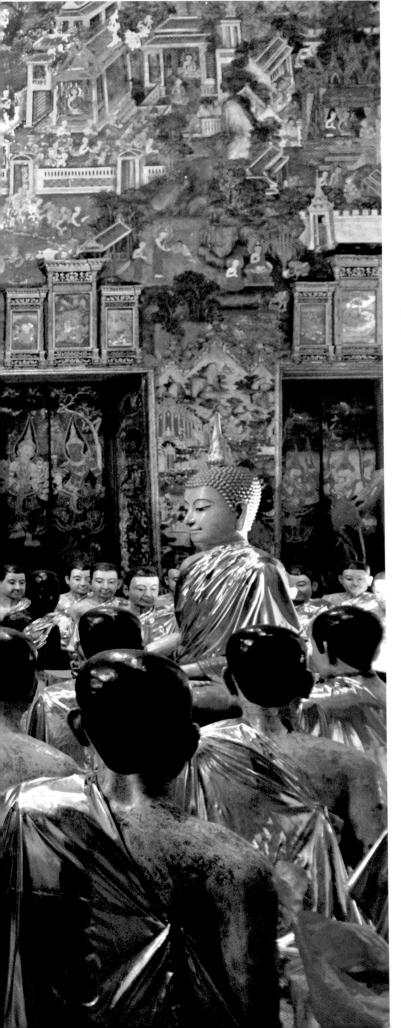

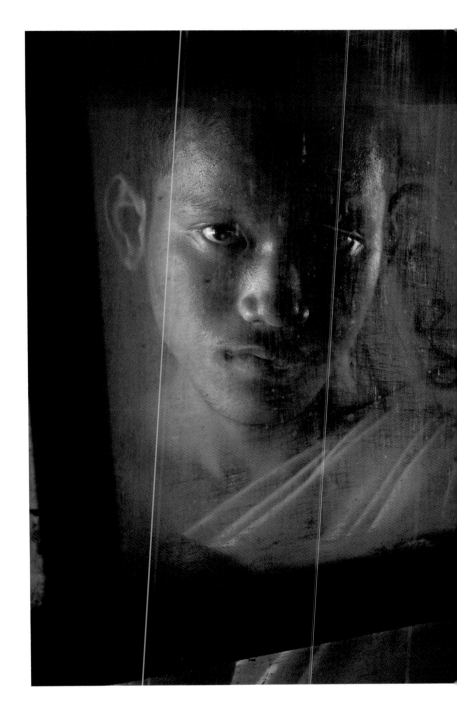

LEFT: A collection of Buddha statues inside Wat Suthat. The arrangement forms a re-enactment of the Buddha's first sermon more than 2,500 years ago. In this sermon, the Buddha is believed to have established the key precepts of Buddhism. Today, the sermon is commemorated as Asanha Bucha Day, one of Buddhism's holiest days and a national holiday in Thailand.

Raghu Rai, India

RIGHT: A young monk looks through a monastery window in Ayutthaya. Most Buddhist men will enter into the monkhood for at least a short period at some point in their lives.

Steve McCurry, USA

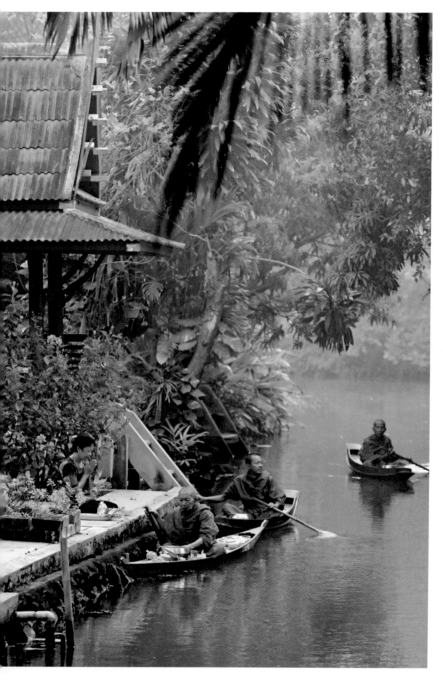

LEFT: In the early morning by Ban Song Thai Plai Pong Pang homestay in Ampawa district, three monks receive food from a woman giving alms. Ampawa, which is only 90 kilometres from Bangkok, is known for its charming network of canals, which have floating markets and other activities typical of traditional village life.

Dominic Sansoni, Sri Lanka

RIGHT: As dawn breaks, five monks receive their morning meal during an alms round near their forest monastery, Wat Nanthawararam, in Kanchanaburi province.

Steve McCurry, USA

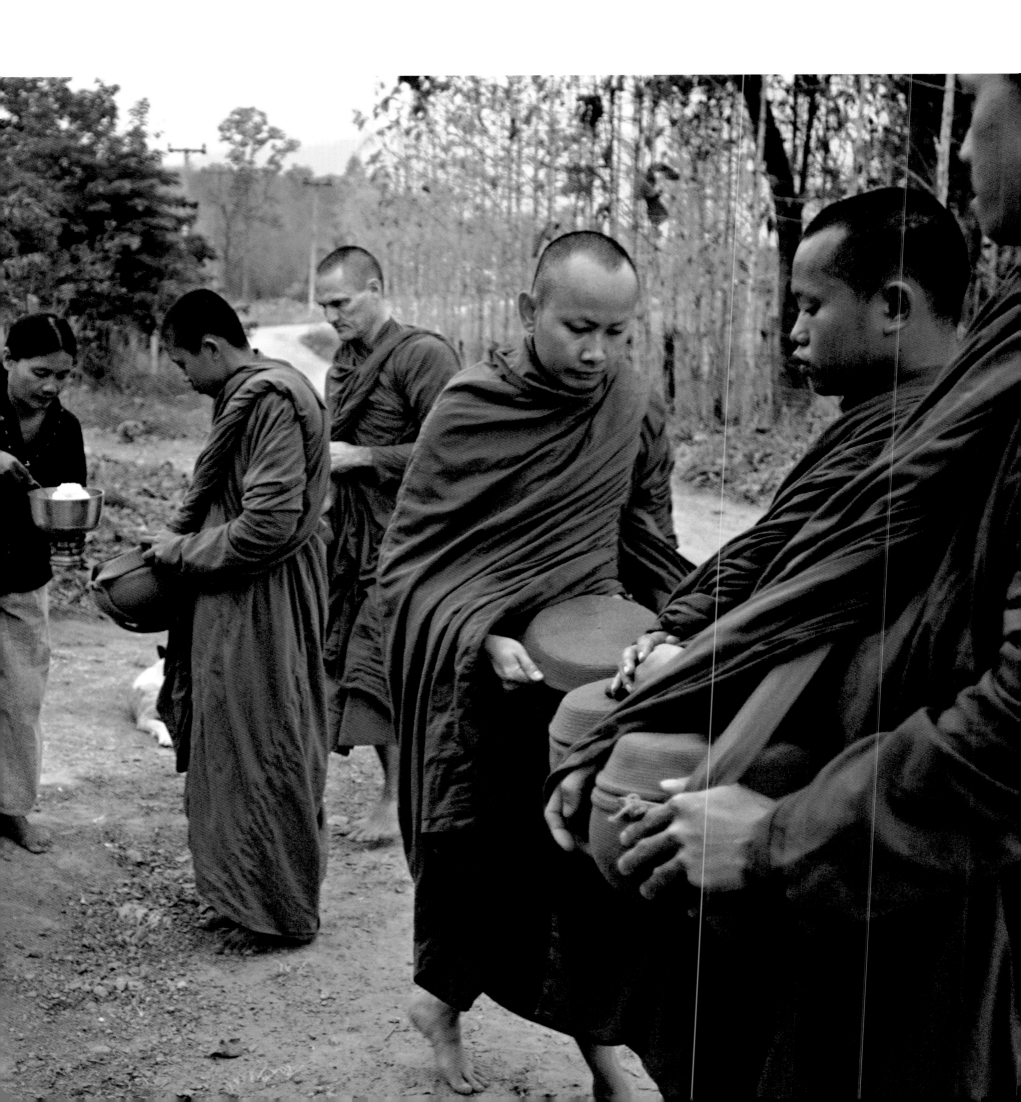

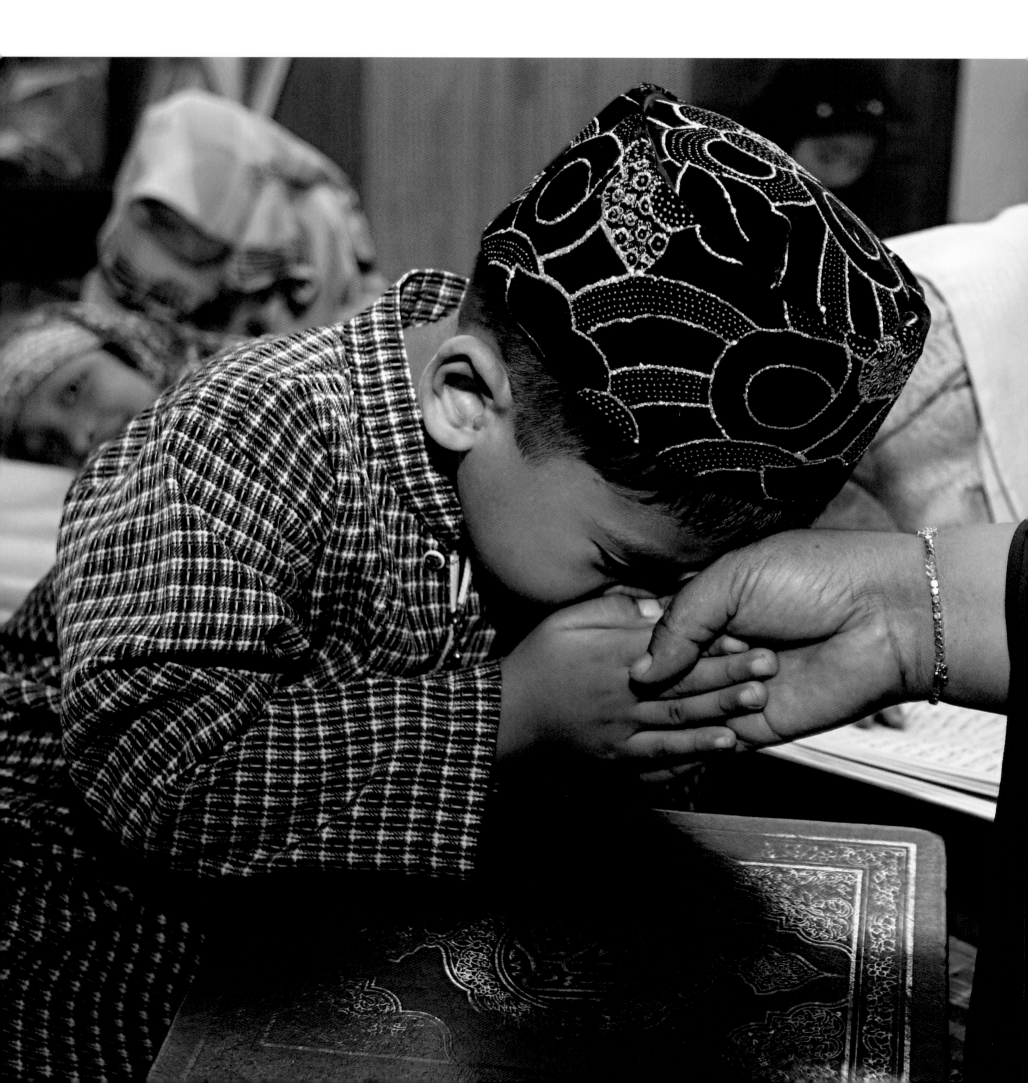

LEFT: A boy in Yala province pays respects to his teacher after he finishes his daily study of the Quran. It is a routine for all Thai-Muslim children in the three southernmost provinces to study the Quran after school.

Charoon Thongnual, Thailand

RIGHT: Seventy-year-old Muslim Sa Neam takes his afternoon tea in the local café of Kao Saen fishing village in Songkhla province in the south of Thailand.

Jeremy Horner, UK

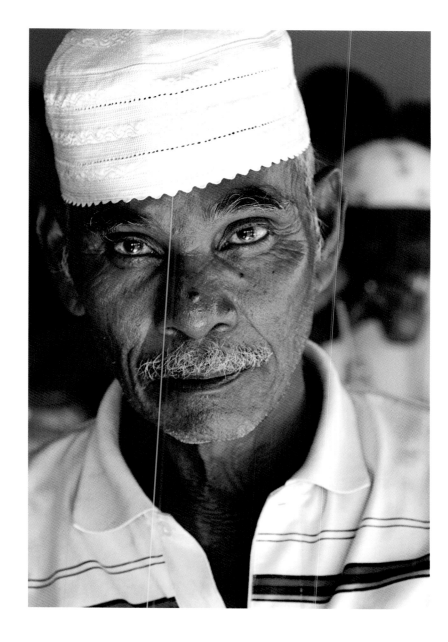

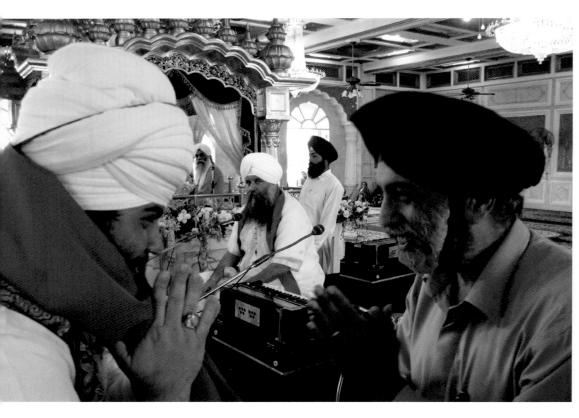

ABOVE: Inside Bangkok's Gurdwara Siri Guru Singh Sabha, located in Bangkok's 'Little India', Paruhat.

RIGHT: Sikh women attend a wedding at Gurdwara Siri Guru Singh Sabha. There are approximately 35,000 Sikhs living in Bangkok and more than 100,000 Indians, most of whom are Thai citizens.
Photos by Raghu Rai, India

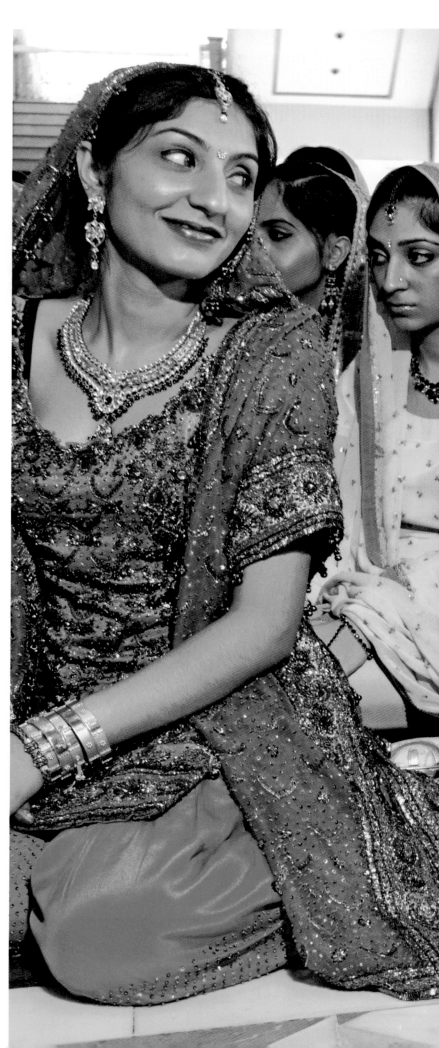

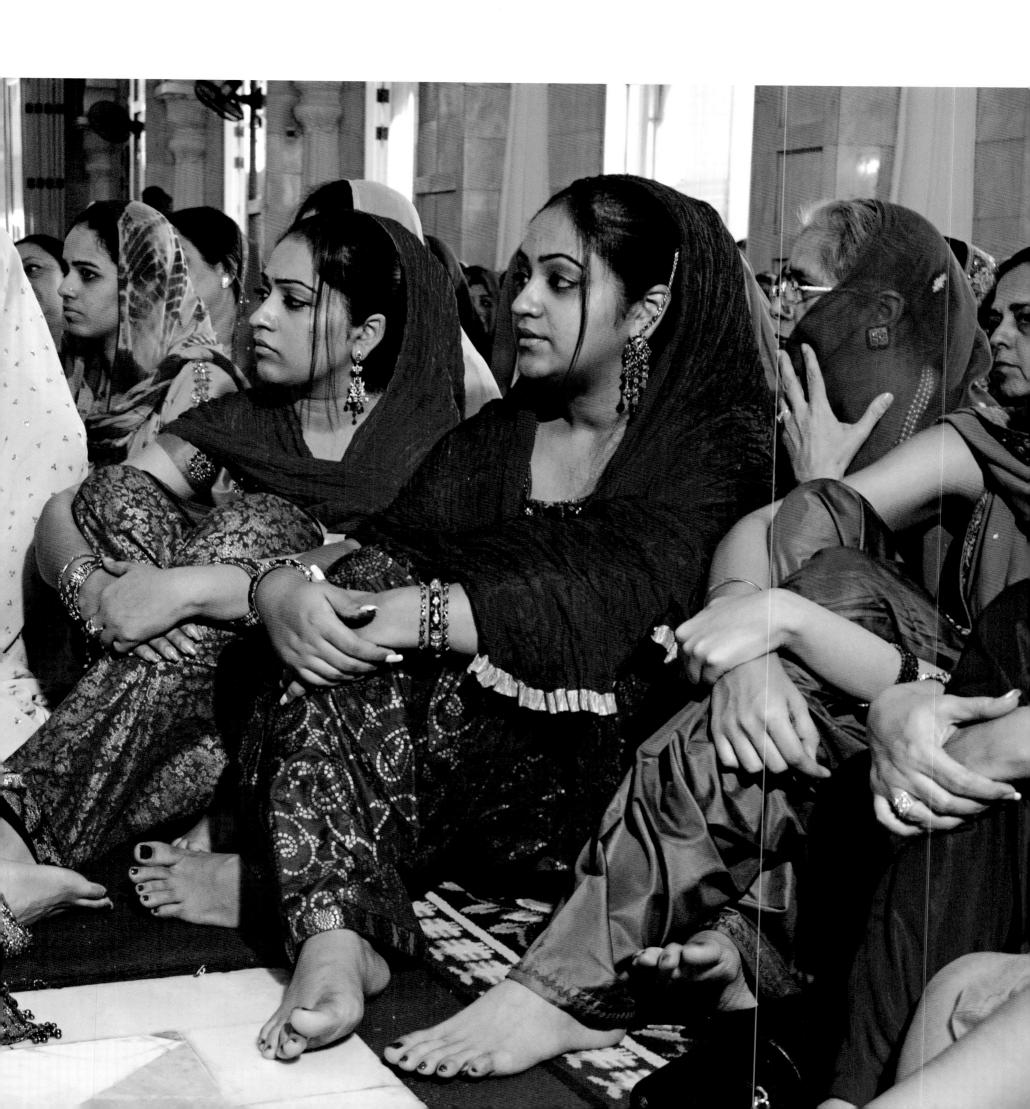

A fortune-teller peeks out of
his shop in Chinatown. One of
the more obscure methods of
fortune-telling is face reading,
where the fortune-teller bases
his predictions on a person's
facial features. In Thailand,
fortune-telling is not just
for fun. The vast majority
consult fortune-tellers to
answer serious questions
about when to hold important
events such as a wedding or
a business launch, or when to
have a child.

Dominic Sansoni, Sri Lanka

In Sukhothai Historical Park, visitors pay their respects to King Ramkhamhaeng the Great, who ruled the Sukhothai kingdom from 1275 to 1317, commonly considered a golden age in Thai history. King Ramkharnhaeng is credited with the creation of the Thai alphabet, expanding the kingdom and the spread of Theravada Buddhism.

Laura El-Tantawy, Egypt/UK

LEFT: Pinyo Pongcharern, an astrologer and president of the Association of Astrology, is held in high esteem among Thais. High-ranking politicians, generals, businessmen and everyday people alike regularly consult fortune-tellers and often pay high fees for their advice and predictions.

Catherine Karnow, USA

RIGHT (TOP): A student of one of Thailand's most famous tattoo artists, known as Ajarn Noo, bares his amulets and tattoos. Amulets are hugely popular in Thailand. Thought to provide luck and protection, passed down through the generations and traded on the street, they are also a big business.

S. C. Shekar, Malaysia

RIGHT (CENTRE): Mannequins are decorated with garlands, forming a makeshift roadside shrine in Lop Buri province. The most unusual-looking shrines often mark the site of a supernatural or significant incident.

Kaku Suzuki, Japan

RIGHT (BELOW): Three pilgrims at the sacred stone which gives the fishing village of Kao Saen its name. Treasure said to be worth 900,000 baht (around US$26,000) is believed to lie beneath the boulder.

Jeremy Horner, UK

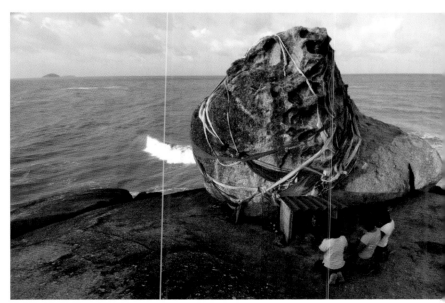

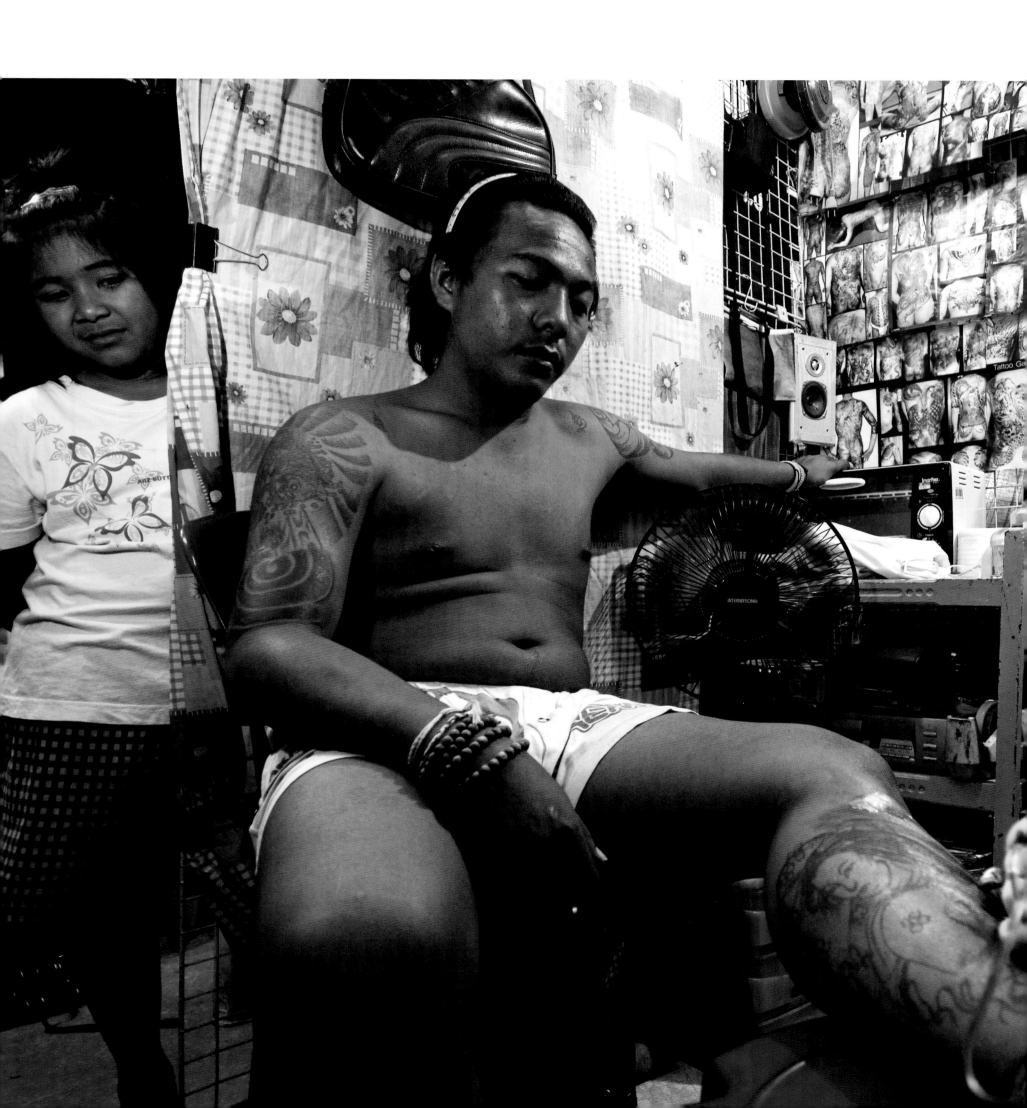

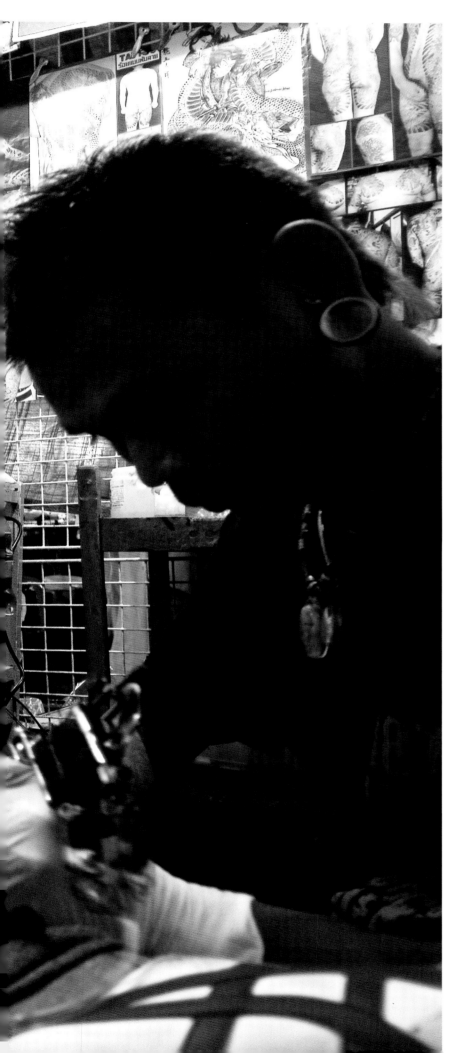

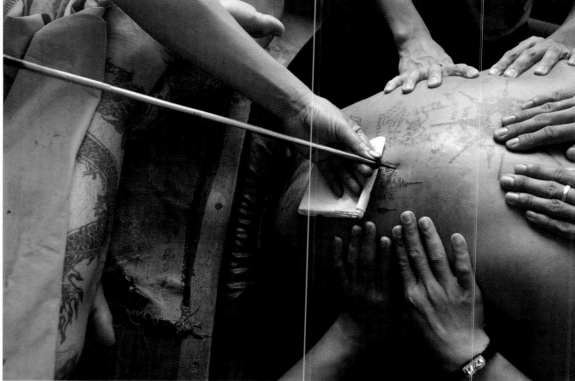

LEFT: A tattoo artist at Khon Kaen's night market adds to an ongoing creation for a client who periodically comes up from Bangkok for an addition to his body art.

Rio Helmi, Indonesia

ABOVE: A man receives a tattoo at Wat Bang Phra in Nakhon Pathom province. The temple is home to monks renowned for their tattooing skills and hosts a popular annual tattoo festival. These talismanic tattoos from monks typically involve geometric *yantra* designs and Khmer script. They are believed to protect their owners and empower them with new traits.

Steve McCurry, USA

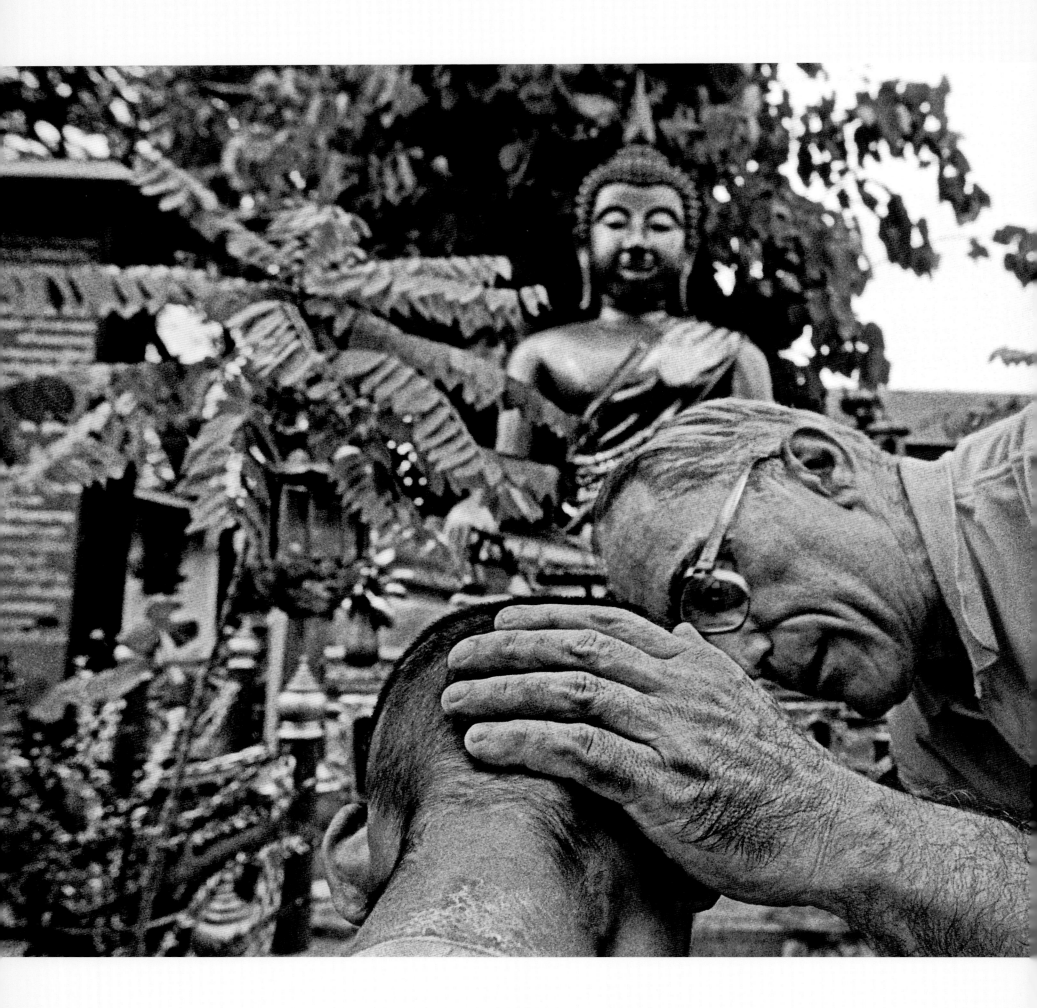

A Human Touch

At 10.30 am on a Sunday, the Assumption Cathedral in Bangkok is standing-room only. Inside its grand interior, Father Michael Bassano is giving the Eucharist to a large congregation. Following the service, the friendly American patiently chats with those who approach him before setting off with some colleagues to a Sunday matinee. 'We're going to see *Casablanca*,' he says, visibly excited.

The weekend is Father Mike's chance to escape, and a few hours of entertainment inside a dimly lit theatre is, no doubt, an appealing prospect to a man who spends the rest of his week confronting a grim reality.

From Monday through Friday, the 58-year-old priest volunteers at an unlikely location—a Buddhist temple in Lop Buri, Wat Phrabaat Namphu, which has been turned into an AIDS hospice. Over the last four years, he has become a fixture there, humbly caring for men and women who are fighting painful and heartbreaking battles against AIDS.

Each day, for six hours, Khun Paw ('Mister Father'), as he is affectionately called, applies Vaseline to dried lips, changes diapers, gives massages and provides comfort and companionship to those who have none. In the context of such raw human contact, differences in dogma are, for all concerned, beside the point. 'I believe that compassion transcends religion, nationality and boundaries between people,' he says. 'It makes us one.'

Wat Phrabaat Namphu's own story offers much proof of Father Mike's claim. Since the temple's abbot, Phra Alongkat Dikkapanyo, provided sanctuary to a single HIV-infected man in 1992, thousands of the sick, many of them abandoned by their families, and volunteers, such as Father Mike, have arrived at the temple's gates. Today, people from all faiths and from great distances are drawn to the Lop Buri temple's promise of compassion, which has led Father Mike to refer to it as the 'Temple of Life'.

In many ways, Wat Phrabaat Namphu has mirrored Thailand's larger success in combating the AIDS crisis. Originally shunned by misinformed locals, for example, the temple now receives a steady stream of private donations. In addition, survival rates have increased dramatically since 1992, thanks in part to improved healthcare, facilities and affordable medication.

That does not mean that Wat Phrabaat Namphu is not also a place of great anguish and physical suffering. Since 1992, some 10,000 men and women have died there, and the number grows.

Still, the examples of Wat Phrabaat Namphu and Father Mike have created hope where there was little before. Twenty-two other temples in Thailand have followed suit, dedicating themselves in some fashion to helping HIV/AIDS patients. Only one temple though is fortunate enough to have a Father Mike making the rounds, a man whose mantra is: 'Compassion is a way of being in the world. Compassion is the way to be.'

Photos by James Nachtwey, USA

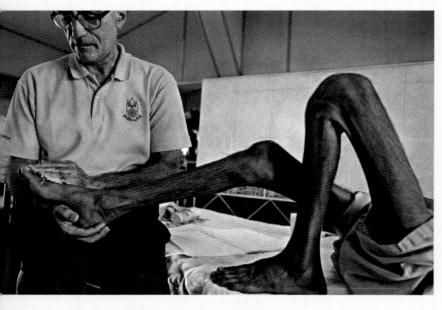

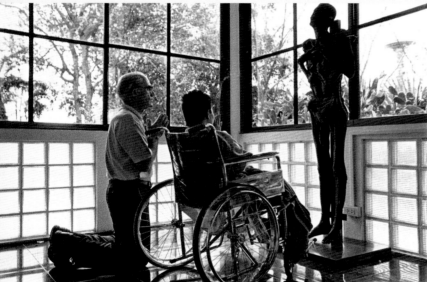

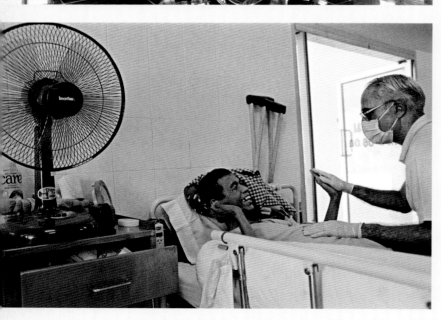

PRECEDING PAGES (FROM LEFT):
Father Mike takes Amphan, who is a Muslim, to the statue of the Buddha each day, where she likes to pray. He comforts her in her distress and joins her in prayer.

Father Mike rides a bicycle seven kilometres to and from the temple every day, an experience he finds relaxing and uplifting.

LEFT (TOP): He is very humble about his work, but what he does is very important to the patients. He bathes them, gives massages, changes diapers, washes feet, offers words of encouragement and provides human contact to people who would otherwise be largely isolated.

LEFT (CENTRE): Before he died, one of the former patients donated his body to the hospice to be embalmed and put on public display in order to educate visitors to the temple. The patient's former girlfriend, Amphan, also an AIDS patient at the hospice, likes to pray for him each day.

LEFT (BELOW): Father Mike, who speaks Thai fluently, brings an easy-going sense of humour to his job, lifting the patients' morale.

RIGHT: He helps a very ill and fragile patient out of bed and into a wheelchair so she can be transported to her bath.

Photos by James Natchtwey,
USA

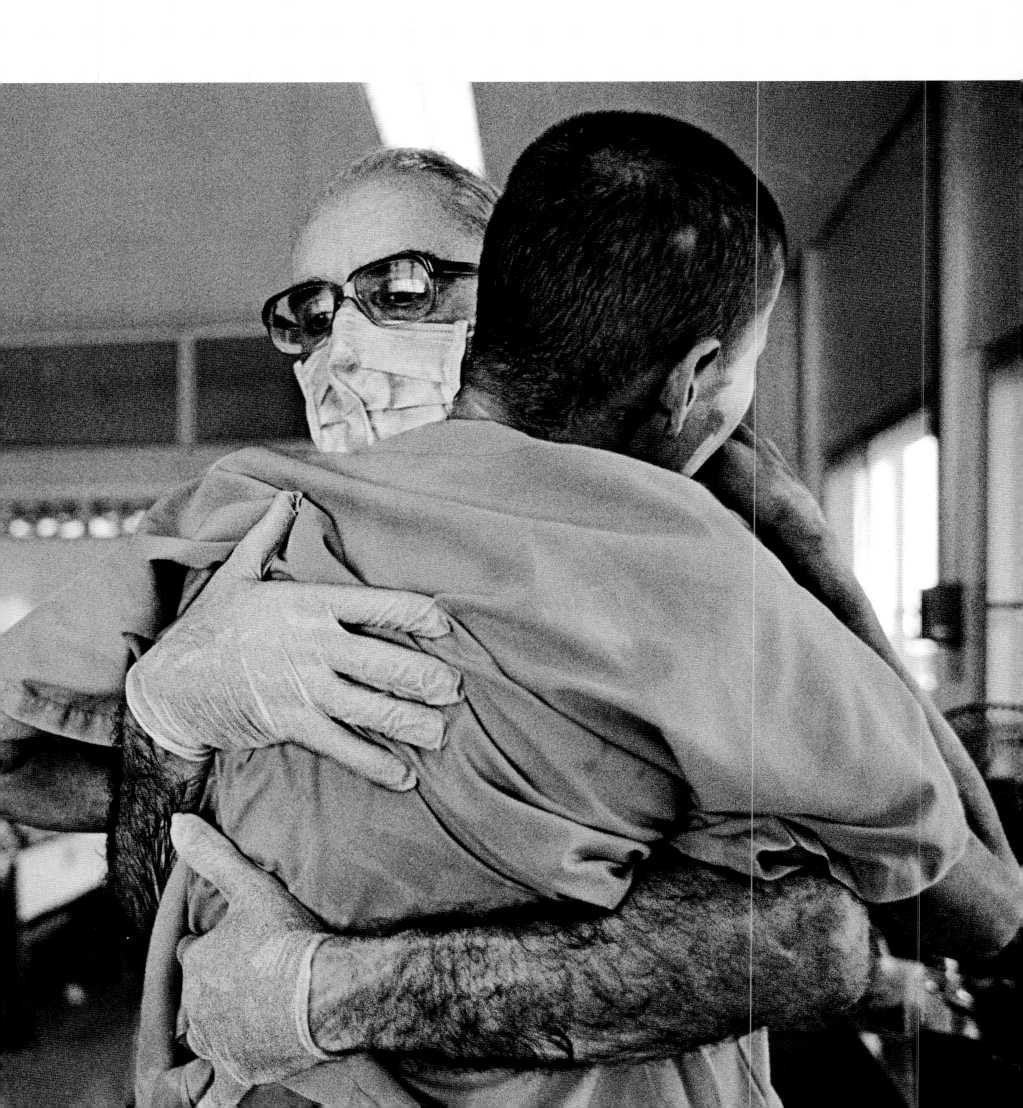

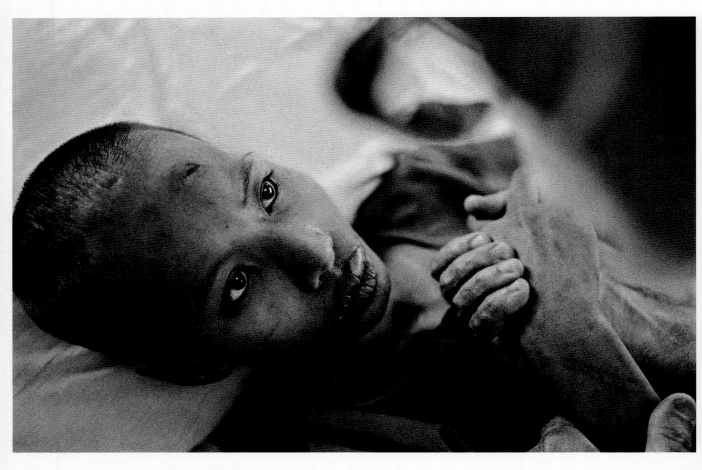

ABOVE: Lek, who had advanced AIDS at the time of this photo, receives encouragement and spiritual comfort. She died a few months later.

RIGHT: At the Assumption Cathedral in Bangkok, Father Mike, who is a member of the Maryknoll Catholic Foreign Mission Society based in New York, presides over Sunday Mass.

Photos by James Natchtwey, USA

Elementary schoolchildren at Pangkae School in Pak Chong, Khorat province, have fun with an enormous pair of model teeth, which are used to teach them the right way to brush.

Dow Wasiksiri, Thailand

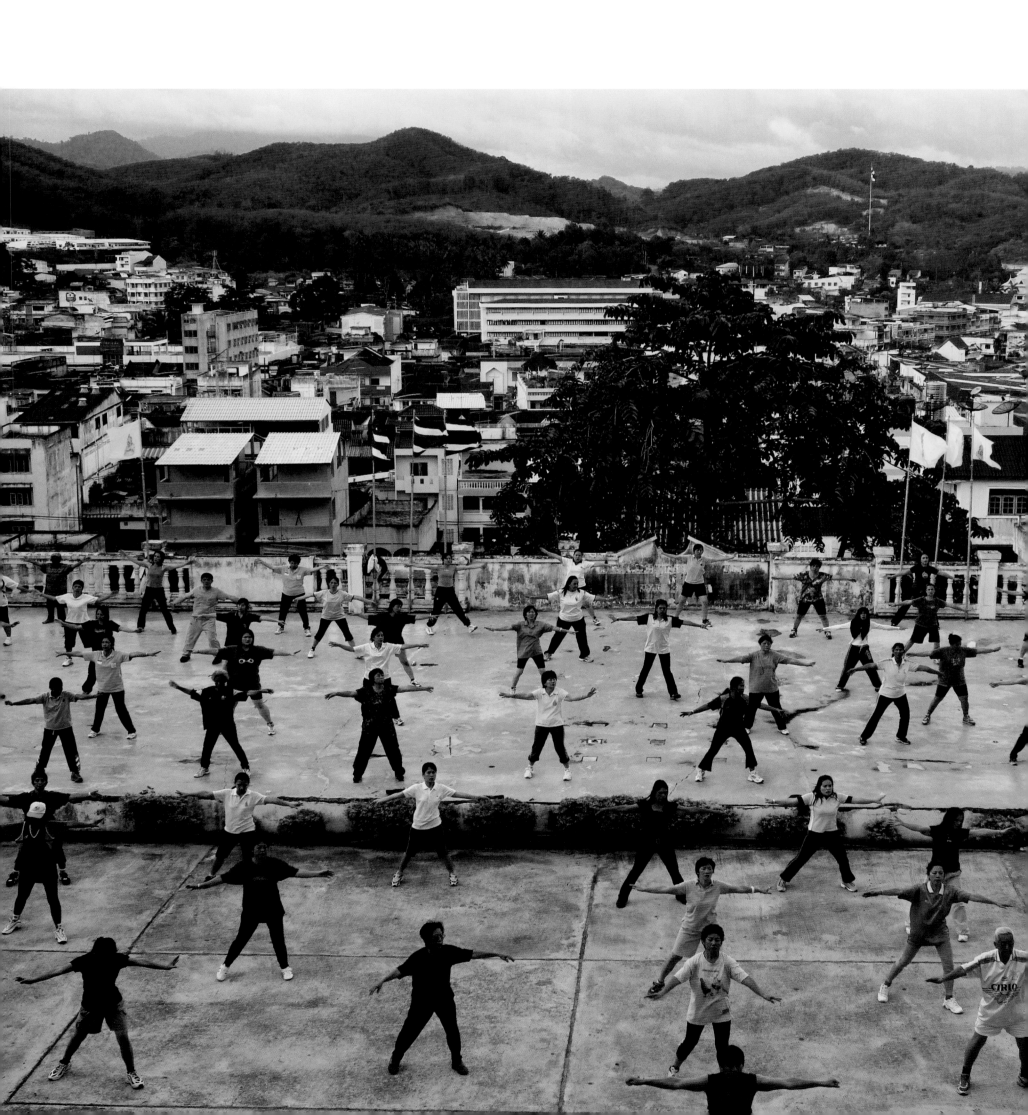

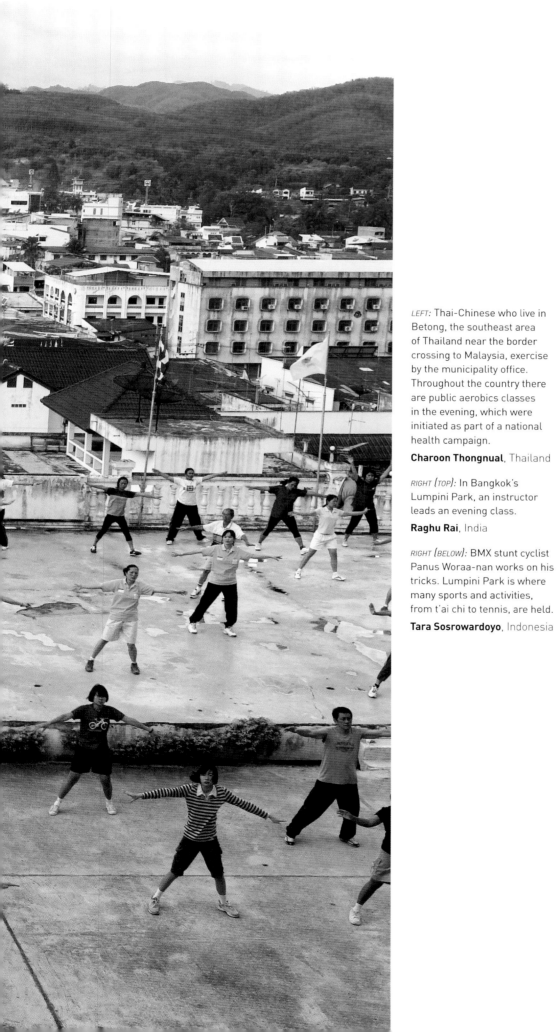

LEFT: Thai-Chinese who live in Betong, the southeast area of Thailand near the border crossing to Malaysia, exercise by the municipality office. Throughout the country there are public aerobics classes in the evening, which were initiated as part of a national health campaign.

Charoon Thongnual, Thailand

RIGHT (TOP): In Bangkok's Lumpini Park, an instructor leads an evening class.

Raghu Rai, India

RIGHT (BELOW): BMX stunt cyclist Panus Woraa-nan works on his tricks. Lumpini Park is where many sports and activities, from t'ai chi to tennis, are held.

Tara Sosrowardoyo, Indonesia

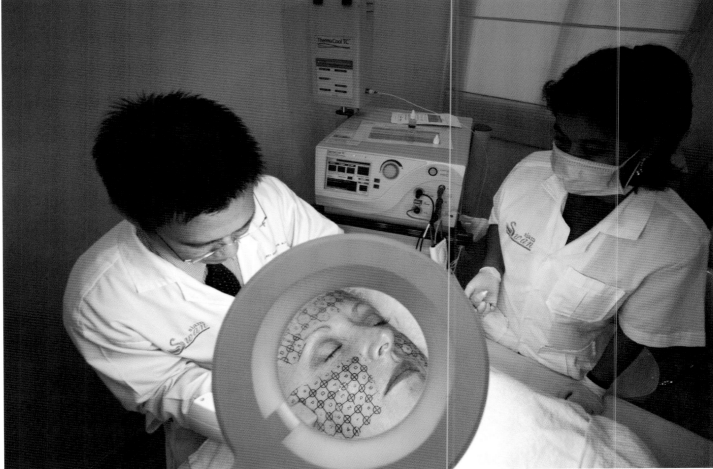

LEFT: Two patrons receive a foot massage in Bangkok. Massage parlours and spas offering traditional Thai massage, foot massage and more have sprouted up on almost every block in commercial areas throughout the capital and in tourist areas throughout the country. The one- to two-hour treatments typically cost between 250 baht and 600 baht (US$8–US$15).

Bruno Barbey, France

ABOVE: Doctor Niwet Sermsintham prepares patient Stephanie Jenkins for Thermage treatment, a non-surgical alternative to the facelift. Like 30 per cent of the doctor's patients, Jenkins came from overseas for her cosmetic enhancements. Attracted by private hospitals offering reputable treatments at a relatively low cost and by the potential for an exotic holiday, foreigners are spurring a huge growth in the medical tourism industry.

Catherine Karnow, USA

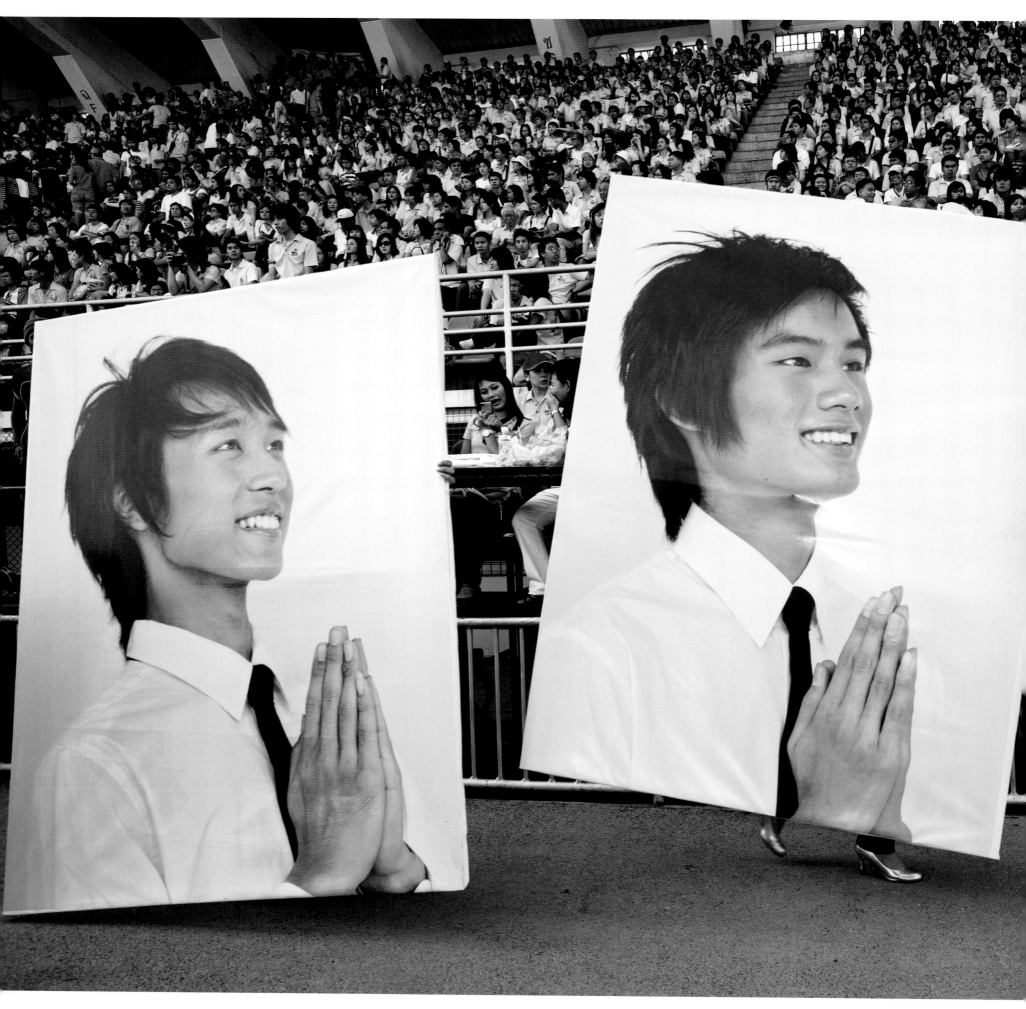

LEFT: The annual football game between Chulalongkorn and Thammasat universities is more than just a heated match between two rivals. The country's two most prestigious intellectual centres also put on spirited parades and political and cultural satires during the game. These posters were part of those festivities.

Catherine Karnow, USA

RIGHT: On the road from Mae Sot to Umphang along the Thai–Myanmar border, members of the Karen community play *takraw*, a sport that is popular all over Southeast Asia. Players use their head and feet to volley a rattan ball over a net. In international competitions, Thailand and Malaysia dominate the sport.

Palani Mohan, Australia

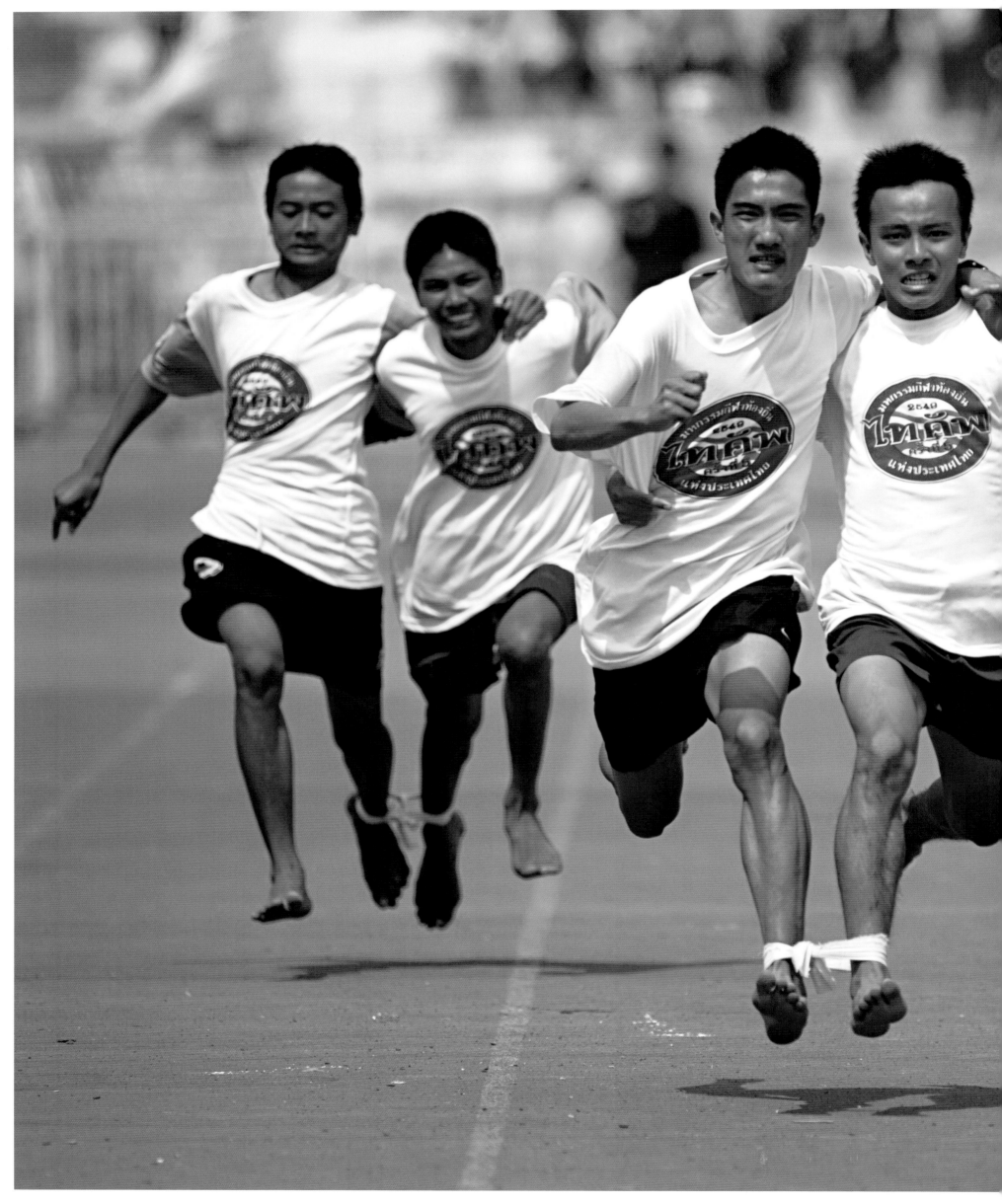

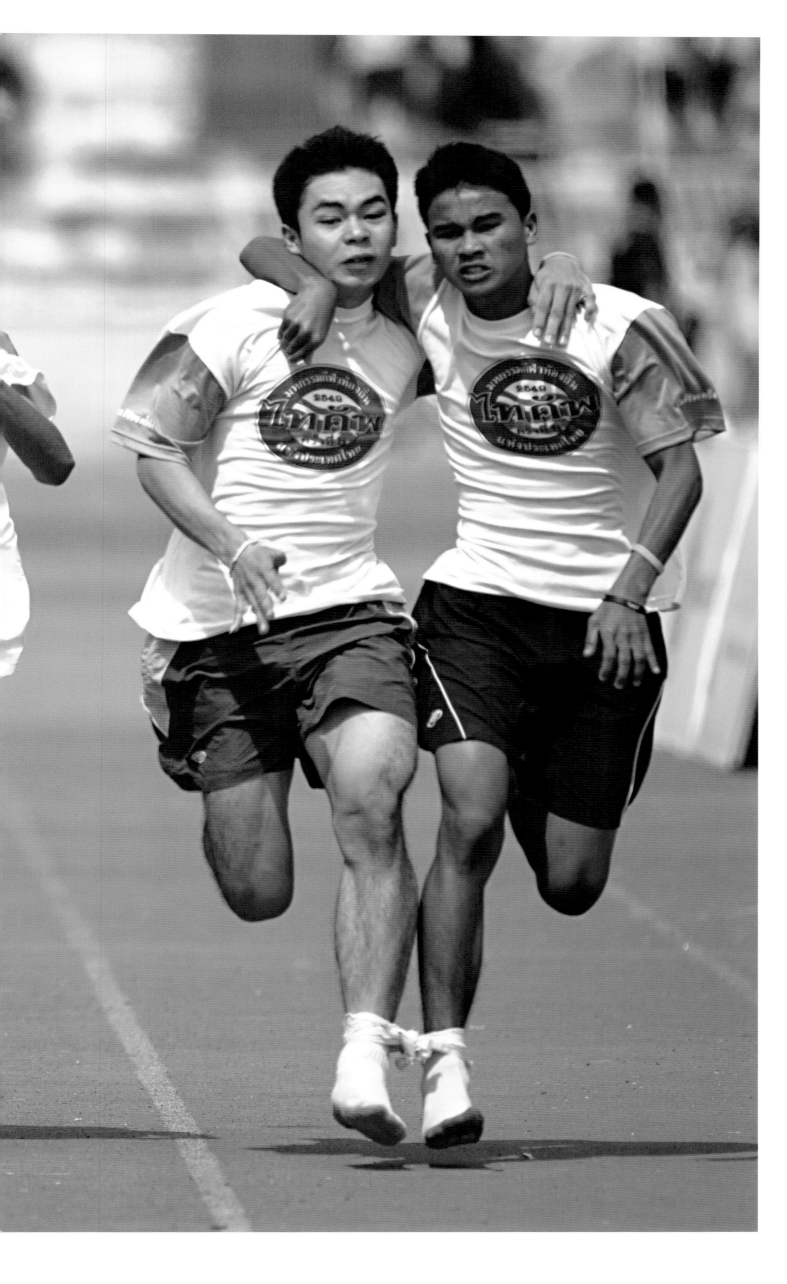

Athletes compete in the men's three-legged race at the Thai Cup annual national sports festival in Nakhon Sawan province, which is sponsored by Boonrawd Brewery. The event pits schools against each other in a mix of track and field events and some less traditional competitions.

Ben Simmons, USA

Glove Story

Muay Thai is much more than just an entertaining and brutal sport. Steeped in history and legend, and mixing ritual and superstition, it is part of Thailand's national heritage, a form of combat that has moved from the battlefield and courts to the boxing ring.

Believed to have been developed as a vital defence against invaders, Muay Thai gradually evolved into an expression of the vitality of the Thai people. Legend explains that even kings were expert practitioners in this martial art. King Prachao Sua, or the 'Tiger King', for example, is said to have snuck into villages in disguise in order to take on local champions, who would otherwise never dare to lay a finger on him.

During the current Chakri Dynasty, Muay Thai evolved into a form of popular exercise and a modern sport, but it has not been uprooted from its historical underpinnings. Matches are still preceded by highly ritualised routines based on the bouts of earlier times, the boxers wear sacred armbands blessed by monks, and fights are always accompanied by traditional Thai music. As the boxers become completely focused on the combat and the intensity of the crowd increases, the spectacle assumes an almost trance-like quality, punctuated by moments of ecstatic action.

Modern concerns have, however, led to a decline in its prestige. Upper-class Thais are more likely to look down on Muay Thai as barbaric, lowbrow entertainment. Indeed, the sport has become synonymous with gambling, plagued by charges of match fixing and questioned for its treatment of children.

While today's urban professionals head to fitness centres, in the countryside, Muay Thai rings remain a focal point of temple fairs and many rural youngsters pin their hopes on moving to Bangkok to earn money for their families as Muay Thai champions. Boys, mostly from the poorer northeast part of the country, may begin conditioning their bodies and hardening their bones for the demanding fights as young as age six. By their teens, many are already wily veterans, with over 50 matches under their belts.

What the sport has lost in stature at home, it has gained internationally. A surge of interest from around the globe in the martial art, including among women, has led amateurs to Thailand to train, and recent world champions have hailed from Germany, Japan and Sweden. Hopes that it will become an Olympic event one day now seem more plausible.

Still, the heart of Muay Thai remains inside the boxing rings of Thailand, wherever they are set up—under an expressway, on the grounds of a temple fair or inside one of Bangkok's two championship stadiums. There, the fighters maintain this ancient Thai pastime, delivering blasts derived from a distant past.

Photos by Greg Gorman, USA

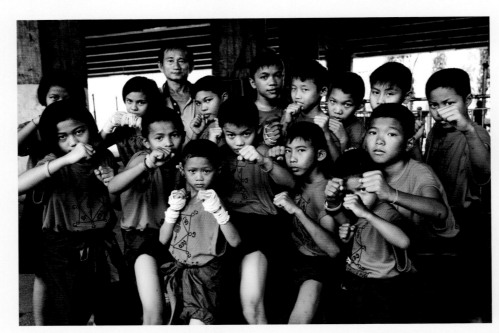

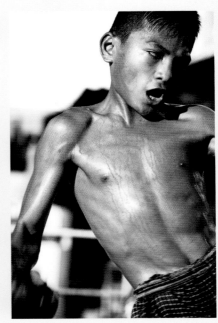

PRECEDING PAGES (FROM LEFT):
Two exhausted fighters come together in a clinch at Ratchadamnoen Stadium. In Muay Thai, boxers are not separated when this happens and they will typically take advantage of these moments to deliver blows with their knees.

A young fighter, only a teenager, lies on a stretcher inside the ring at Ratchadamnoen Stadium.

CLOCKWISE FROM TOP LEFT:
Under an expressway in Bangkok's Klong Toey neighbourhood, young boys and girls pose beside the ring they train in. Many youngsters come to this 'slum' camp to be handled by some of Bangkok's well-known trainers.

A young champ in the middle of a workout.

He poses in the ring under the expressway.

A world champion who trains at Fairtex Muay Thai camp in Pattaya.

Fighters work on their conditioning at another Bangkok 'slum' camp, 96 Penang Boxing Camp.

The owner and manager of the Fairtex Muay Thai camps, Bunjong Busarakamwongse, better known as Philip Wong, one of the sport's biggest personalities and promoters.

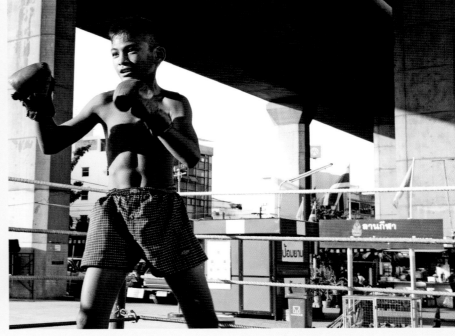

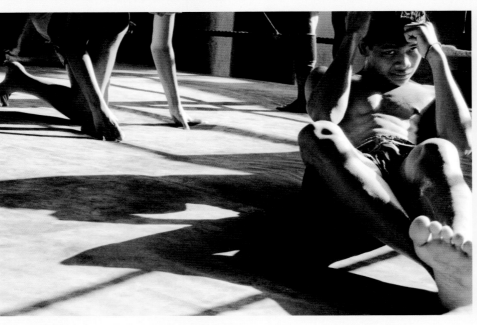

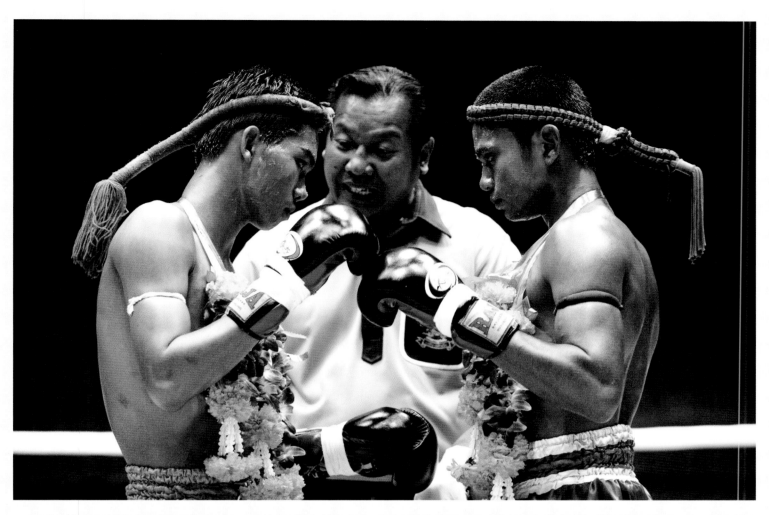

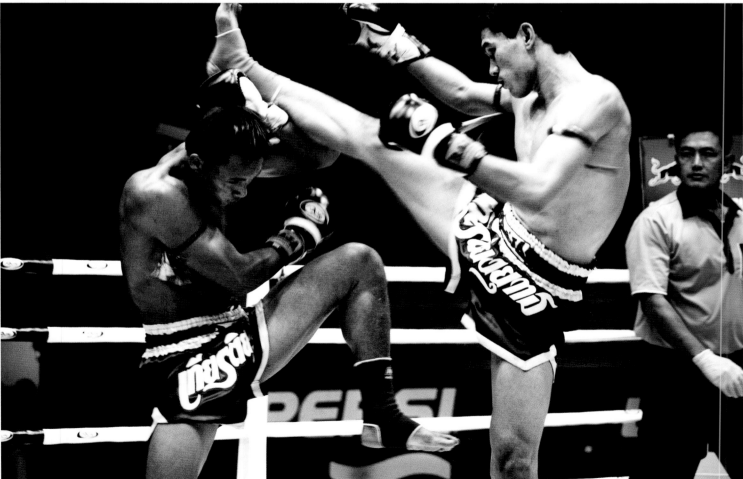

TOP: Boxers touch gloves before the fight begins and listen to instructions from the referee. Before the match, they perform a ritual known as *wai khru ram muay* to the accompaniment of traditional Thai music. This is not merely a ceremonial act. Each fighter develops his own style for this pre-match 'dance', in which he circles the ring, bowing and prostrating himself. Typically the *wai khru ram muay* is performed in order to express humility and respect for his trainer and mentors.

BELOW: A fighter blocks a kick at Ratchadamnoen Stadium. Muay Thai is sometimes referred to as the 'Art of the Eight Limbs', a reference to the fact that boxers can defend themselves and deliver blows with not only their hands, but also their knees, feet and, most violently, their elbows.

FOLLOWING PAGES (FROM LEFT): Between rounds, a boxer is attended to by his trainer. Muay Thai fights consist of five three-minute rounds.

Two fighters embrace in a match at Ratchadamnoen Stadium. Going hand in hand with the violence of Muay Thai is an unmistakable poetry.

Photos by Greg Gorman, USA

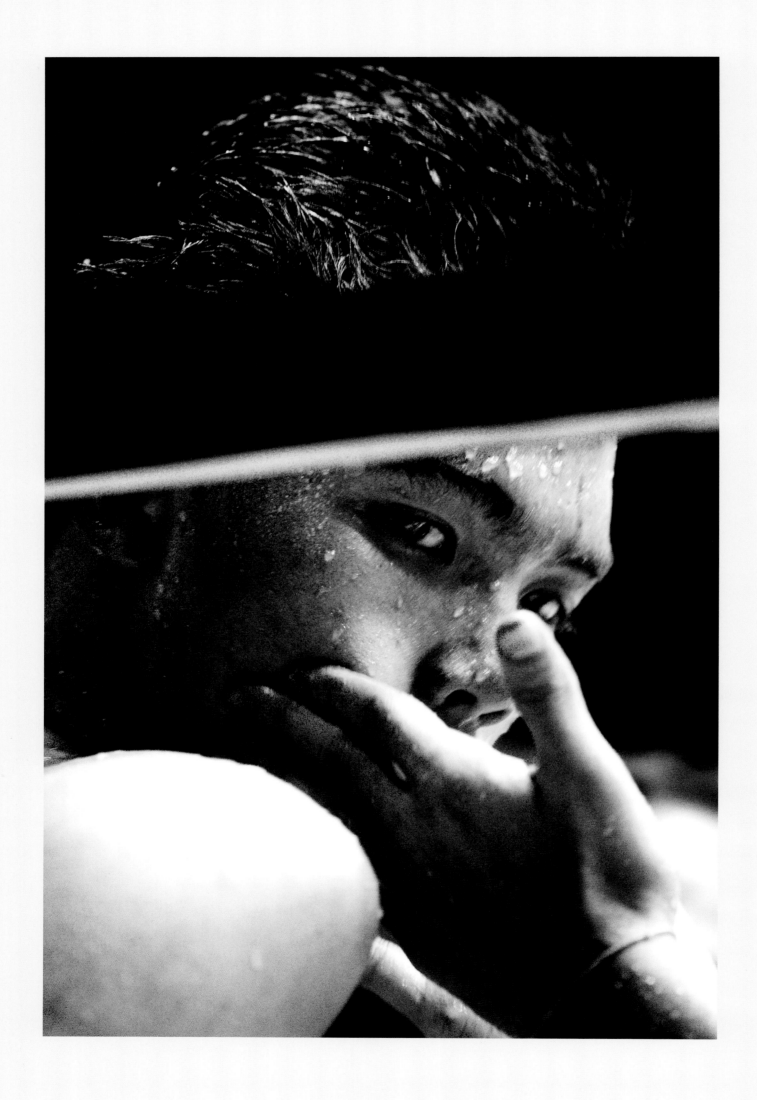

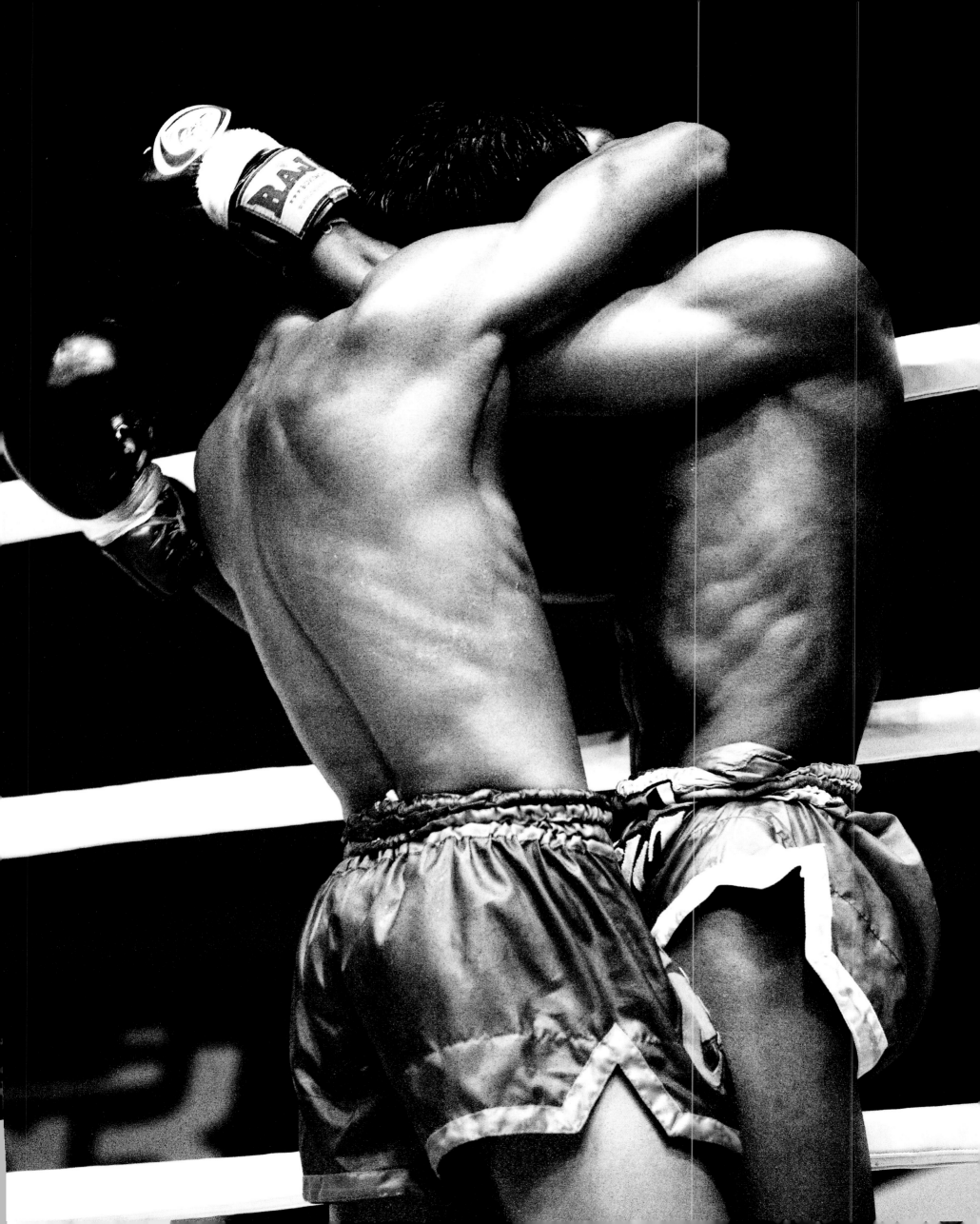

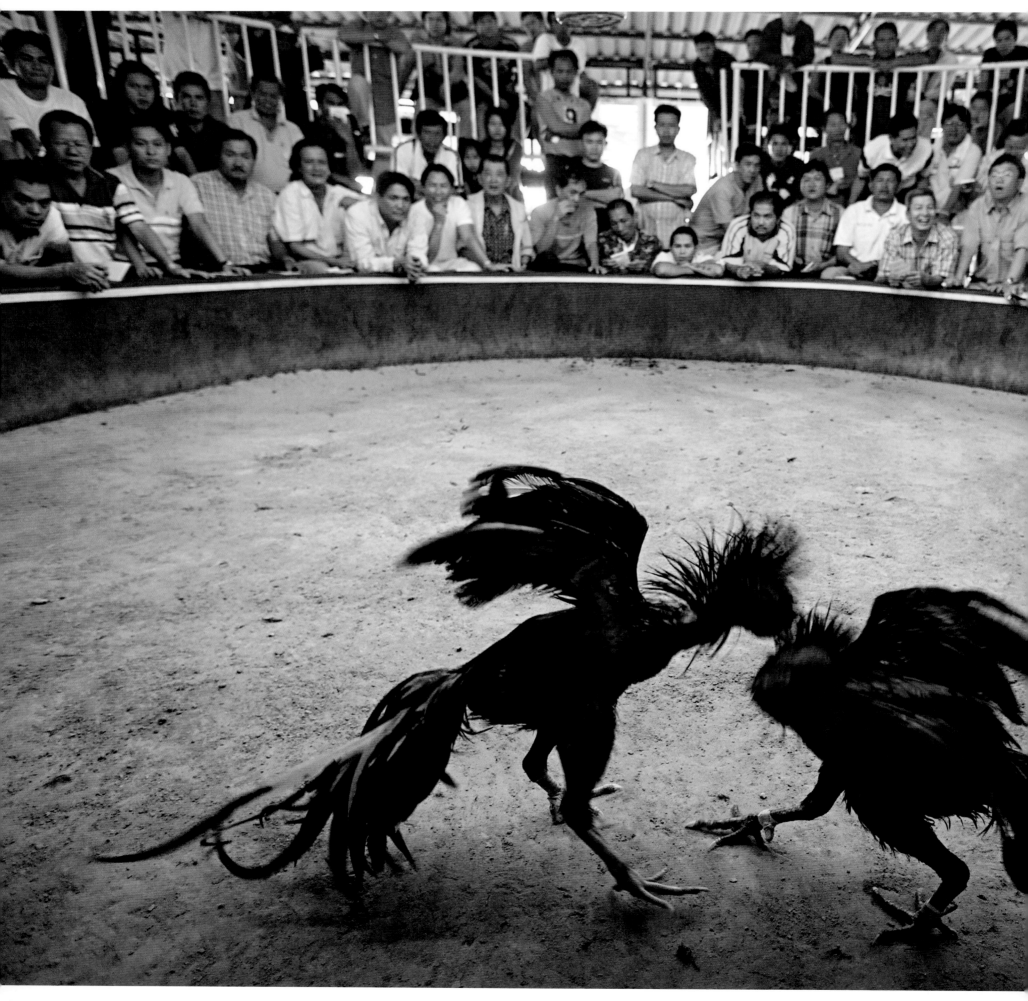

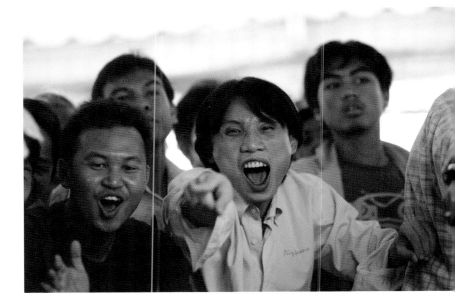

LEFT: A cock goes for the kill at a weekend fight in Udon Thani province. Cockfighting has been a popular form of sport, entertainment and gambling in Thailand for centuries. Moves to ban or regulate the sport, due to concerns that it is cruel or fears that the cocks will spread avian influenza, have been met with fierce opposition from fans and breeders. In general, owners take great care of not only the physical condition of the birds but also their health and looks.

Michael Yamashita, USA

RIGHT (TOP): A fan reacts to an exciting exchange of blows during a cockfight in Sukhothai province. This arena had a special area for its celebrity guests, which included top businessmen, politicians and legendary musician Ad Carabao, a passionate supporter of cockfighting.

Shahidul Alam, Bangladesh

RIGHT (BELOW): As one cock begins to triumph over another, an owner ponders the fate of his prized animal. While sometimes there is a clear winner, other times an owner will throw in the towel to protect his bird for a later fight. There is prize money as well as pride at stake.

Shahidul Alam, Bangladesh

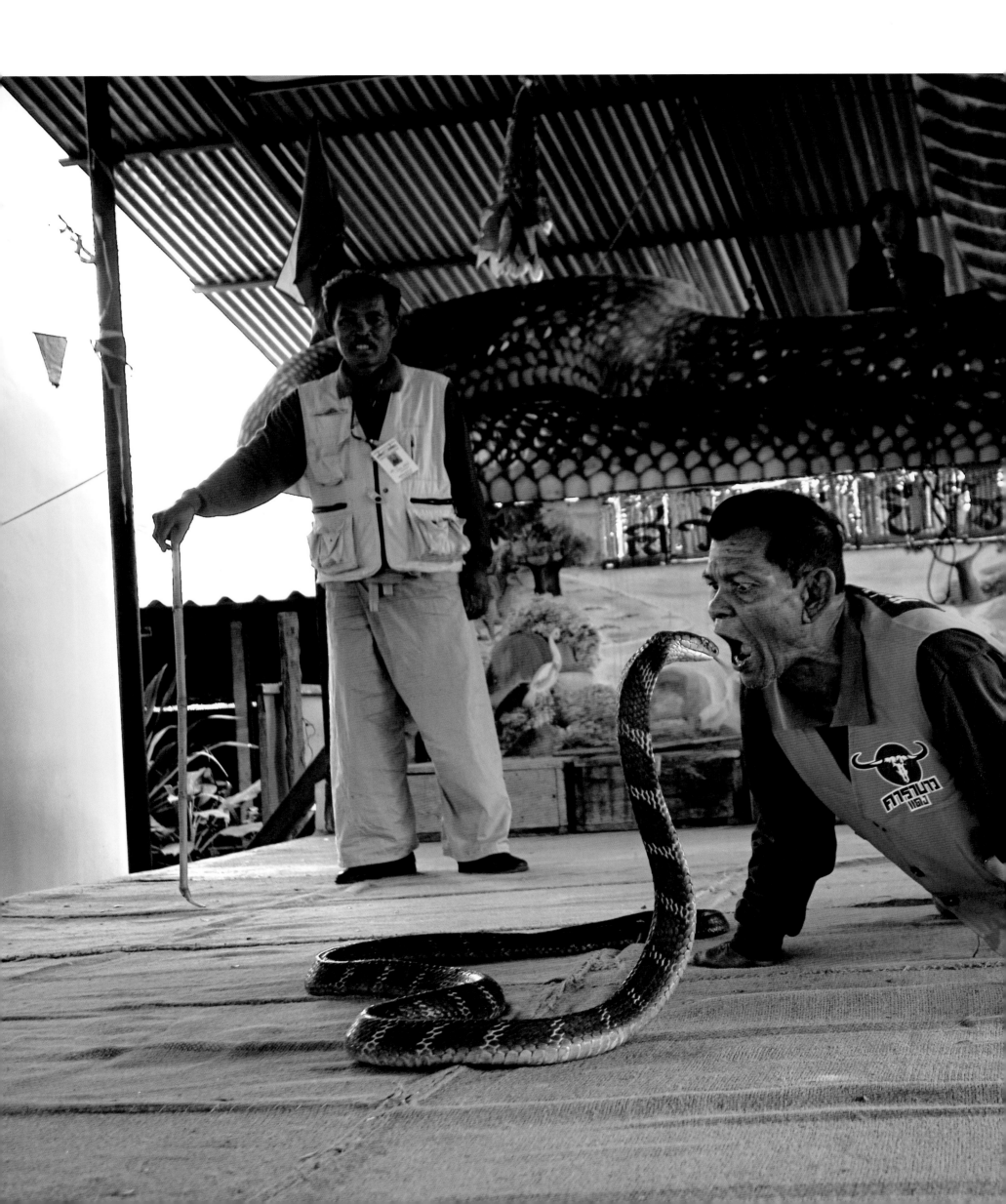

A snake charmer prepares to place the head of a king cobra inside his mouth at the King Cobra Village in Khon Kaen province, northeast Thailand. The villagers have been putting on snake shows for decades.

Rio Helmi, Indonesia

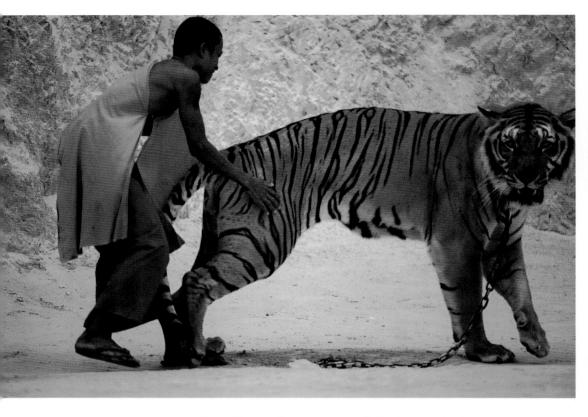

ABOVE: A monk keeps a tiger in line at Wat Pa Luangta Bua Yannasampanno Forest Monastery, also known as the 'Tiger Temple'. Home to boars, goats, gibbons, buffaloes and deer, the temple seconds as a wildlife sanctuary. Its most famous residents are its Indo-Chinese tigers, which are brought out once a day for tourists to pet and photograph.

Waranun Chutchawantipakorn, Thailand

RIGHT: On the Myanmar border, near the town of Umphang, a mahout brings his elephant for a morning bath. He does this every day at 6 am. Mahouts typically take care of a single elephant for its entire life and form a deep bond with their charge. This elephant and its mahout earn their living by catering to tourists.

Palani Mohan, Australia

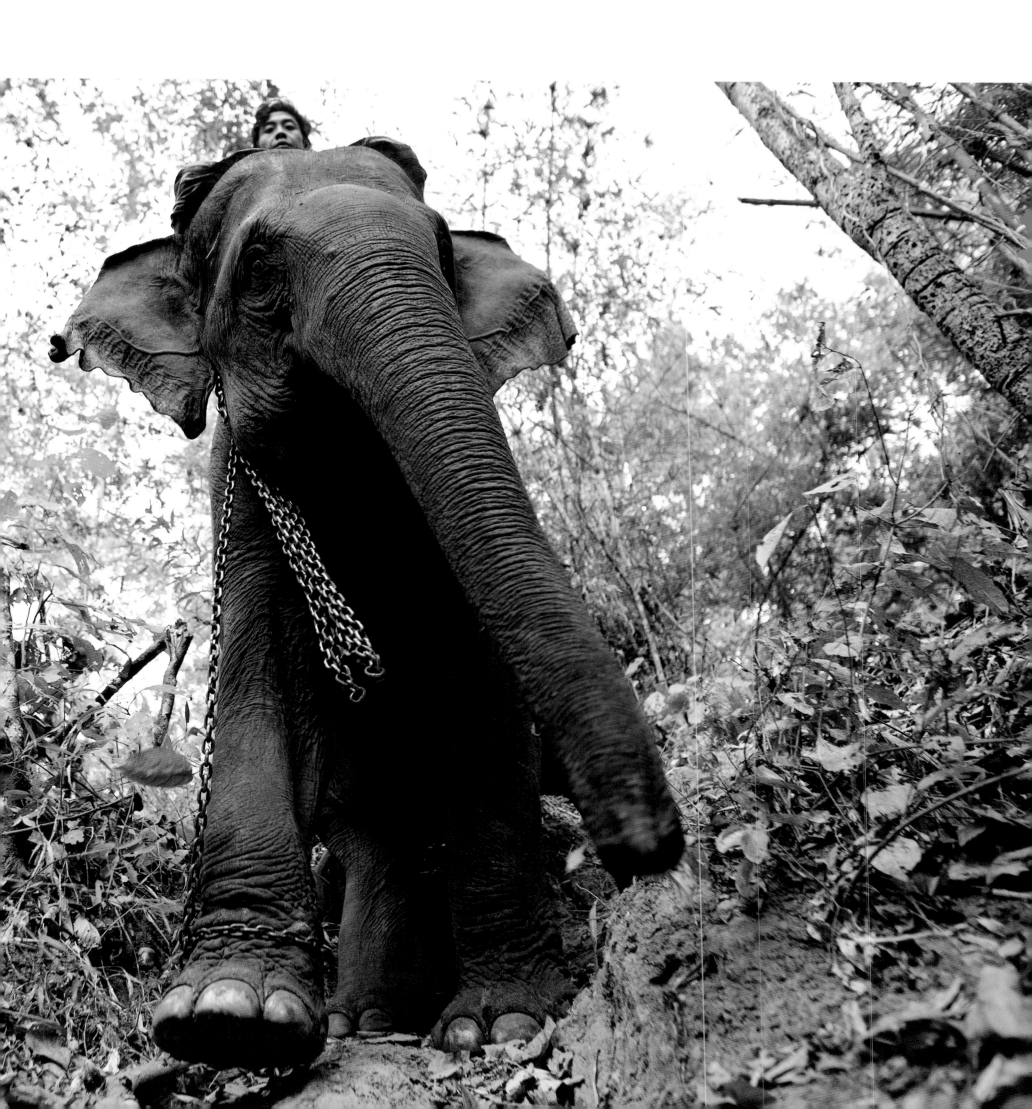

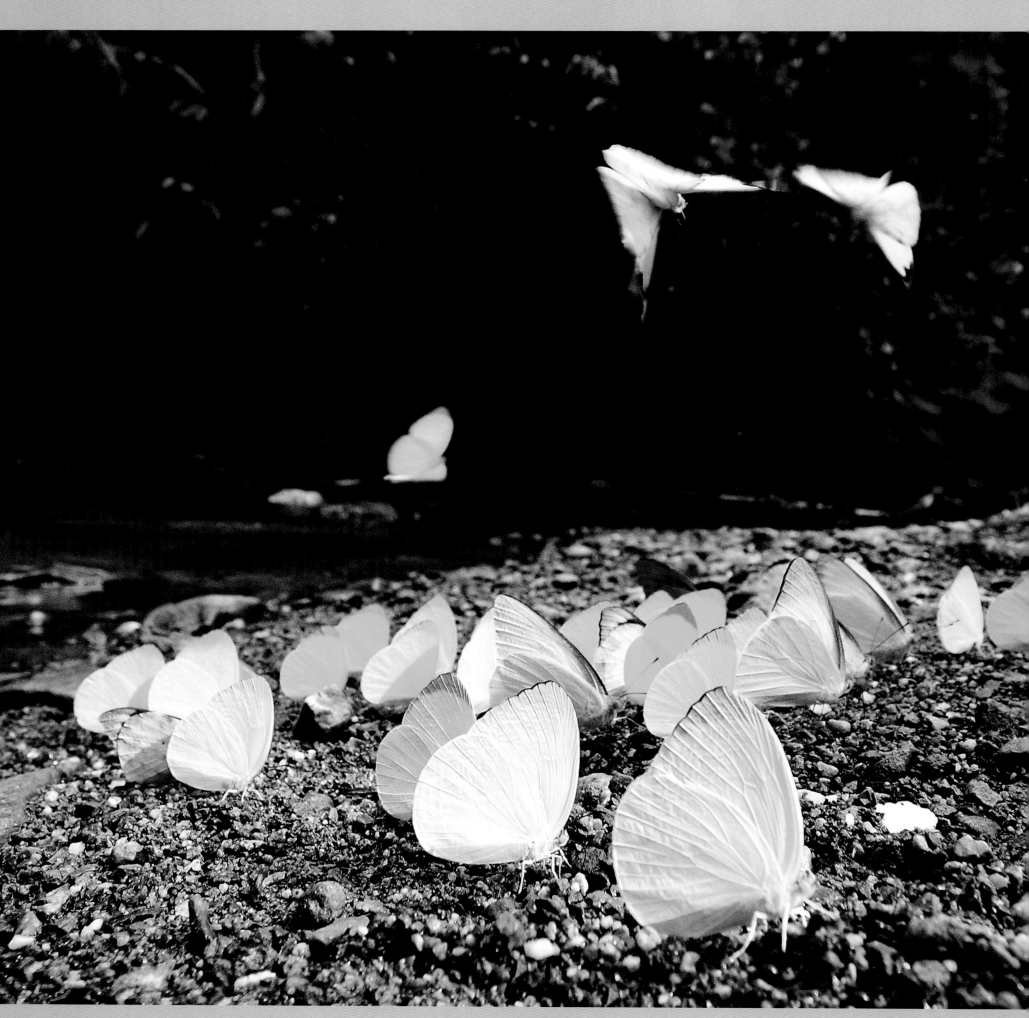

FROM THE BUSH TO THE SEA, Thailand features an astounding diversity of wildlife. Unfortunately, massive economic growth in the last few decades has often come at its expense. Development and encroachment has resulted in deforestation, pollution and erosion, leading to a decline in many wildlife populations. Poaching and smuggling exacerbate these problems.

Still, there is hope that the homes of the thousands of non-human species which also live in Thailand will be protected. The country has 112 national parks now. In addition, new local regulations as well as increased support of international agreements are helping to protect the country's flora and fauna.

LEFT: Butterflies swarm on a stream bed, sucking up minerals and moisture, in Kaeng Krachan National Park. An abundance of butterflies is a sign of rich biodiversity.
Jan Matthysen, Belgium

RIGHT (TOP): One of the most spectacular and charismatic birds of Asia, the majestic hornbill has a loud voice and wingbeat that can be heard from a far distance.
Jan Matthysen, Belgium

RIGHT (CENTRE): A pig-tailed macaque in Khao Yai National Park climbs the thorny branches of a bombax tree in order to steal the nectar from its flowers. The highly intelligent primates are a common sight and have learned how to beg for food from the park's tourists.
Jan Matthysen, Belgium

RIGHT (BELOW): A juvenile king cobra swims along a river bank at Huay Kha Khang Wildlife Sanctuary. The sanctuary preserves a variety of threatened wildlife. The king cobra is the largest venomous snake in the world, reaching a length of up to 5.5 metres.
Suthep Kritsanavarin, Thailand

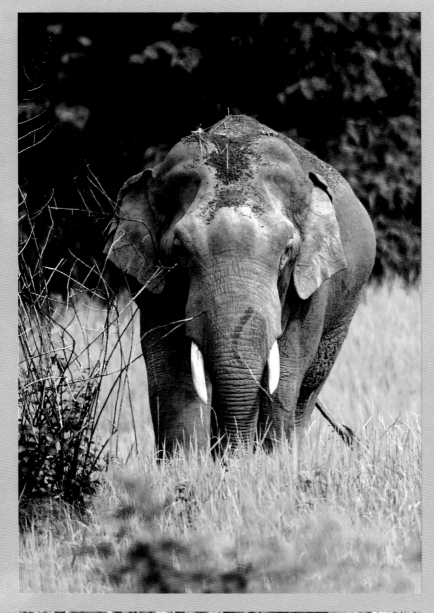

LEFT (TOP): Preferring shade during the day, wild Asian elephants are rarely spotted in broad daylight. This mature bull appeared after a dust bath in the red soil.

Jan Matthysen, Belgium

LEFT (BELOW): After an unexpected encounter with humans, one male and one female elephant, protecting a youngster between them, march hastily back into the camouflage of the bush.

Jan Matthysen, Belgium

RIGHT: A flock of egrets gather on a rice paddy in Ang Thong.

Romeo Gacad, Philippines

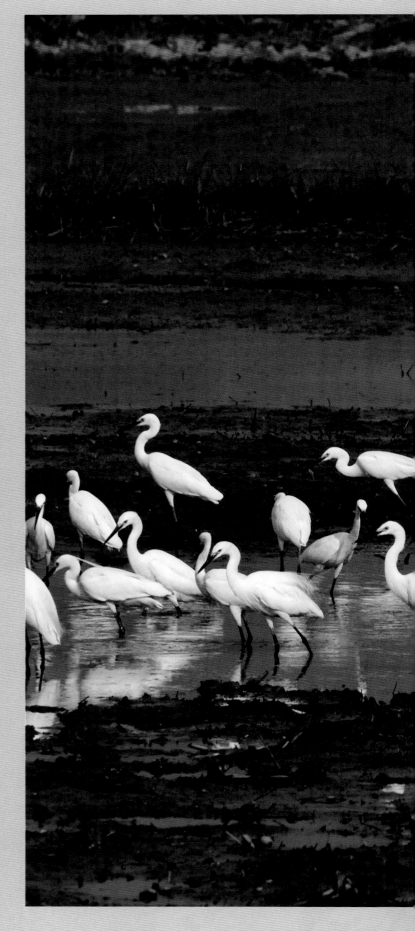

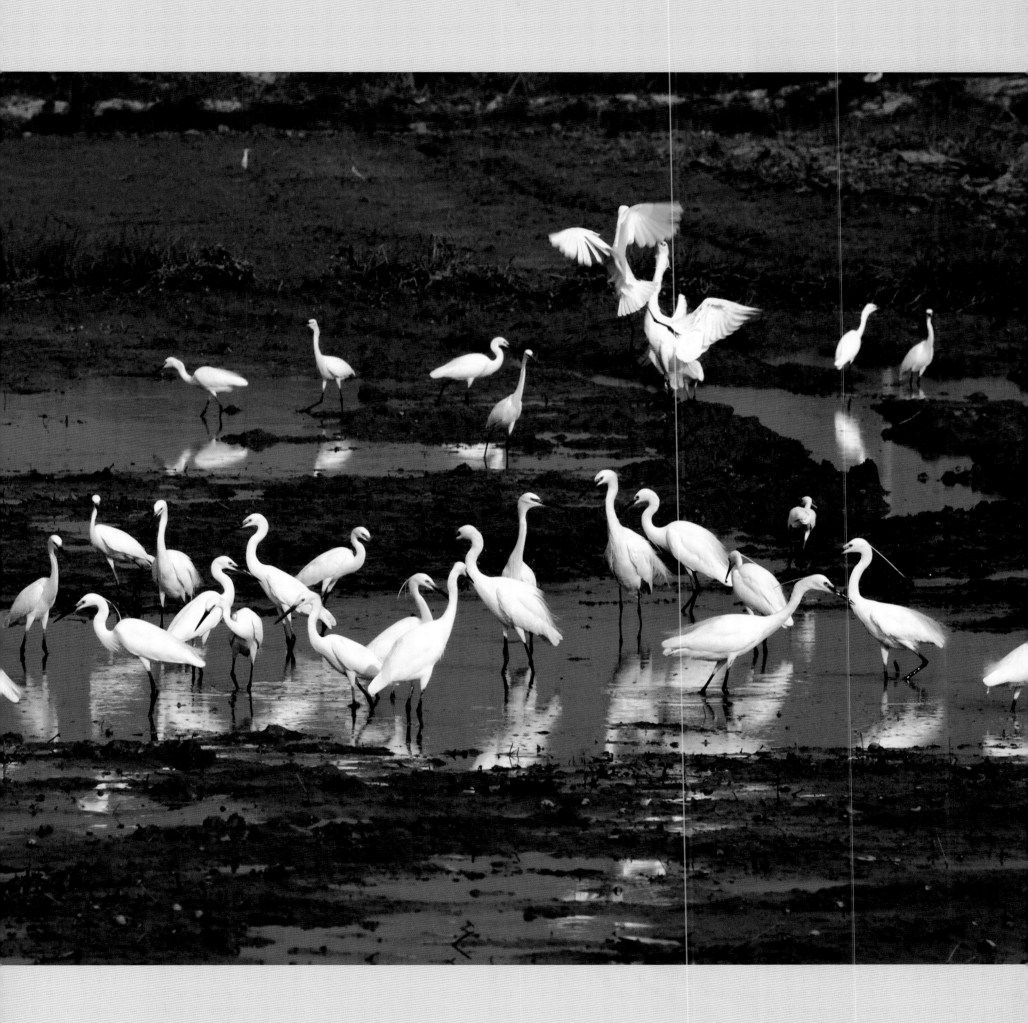

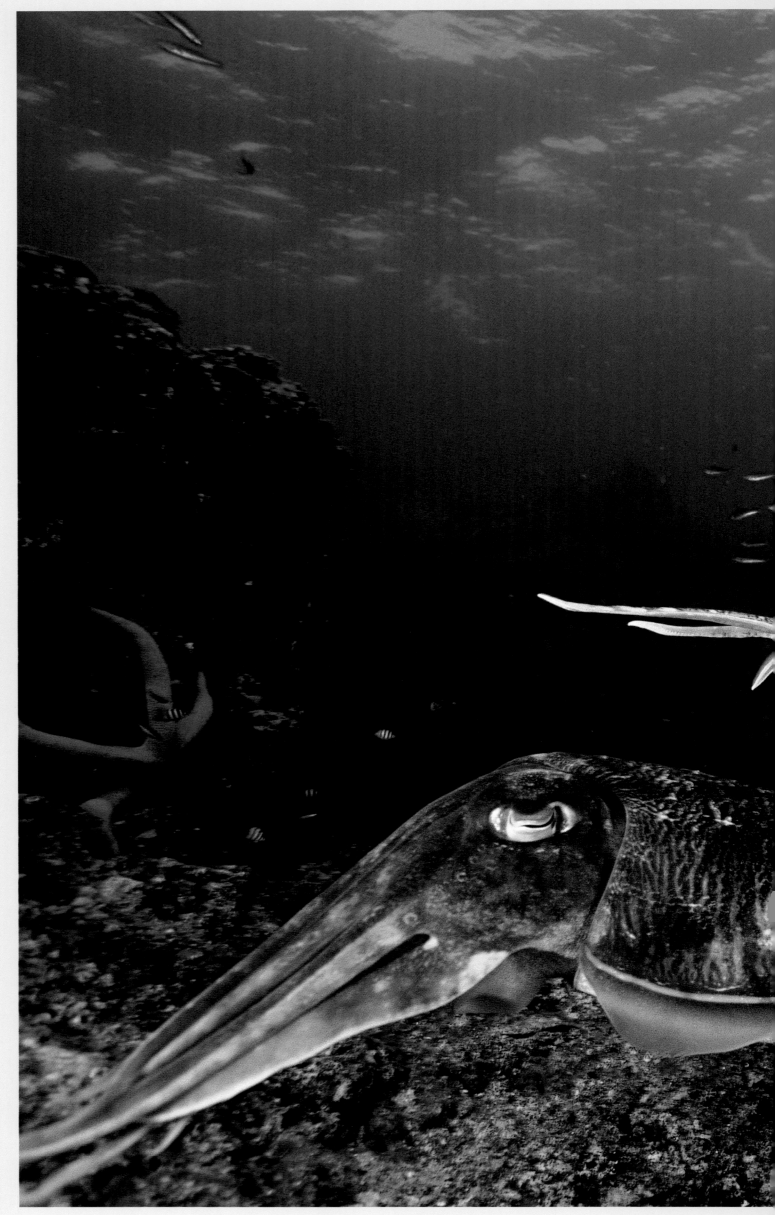

A male Pharaoh cuttlefish (centre) guards his mate from another male at Richelieu Rock in Mu Ko Surin National Marine Park. Richelieu Rock, named after the Danish navy commander who helped thwart a French attack on Thailand during the time of Rama V, is a famous place to spot whale sharks and to watch the mating behavior of cuttlefish. These particular molluscs are about 80 centimetres long.

Nat Sumanatemeya, Thailand

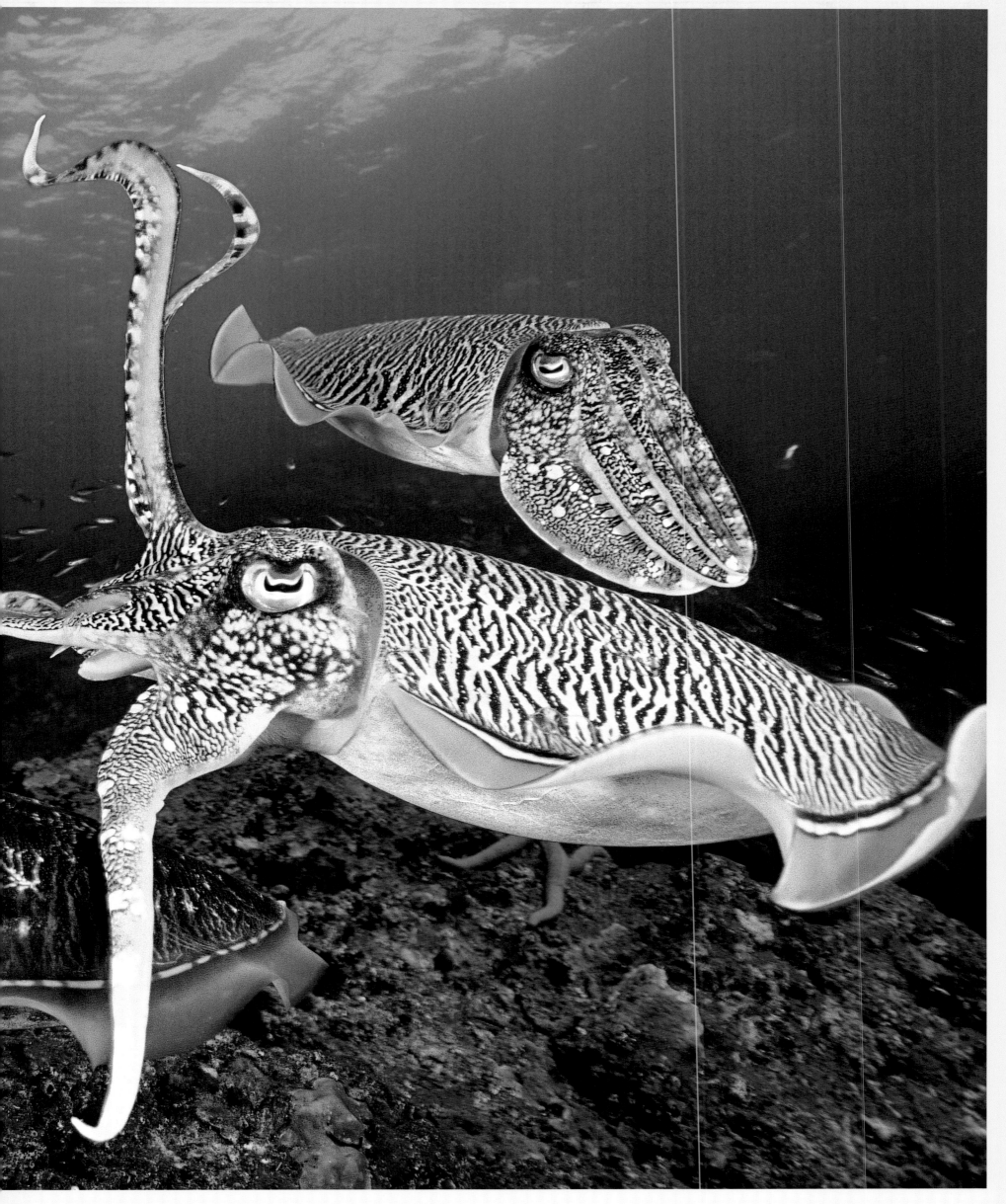

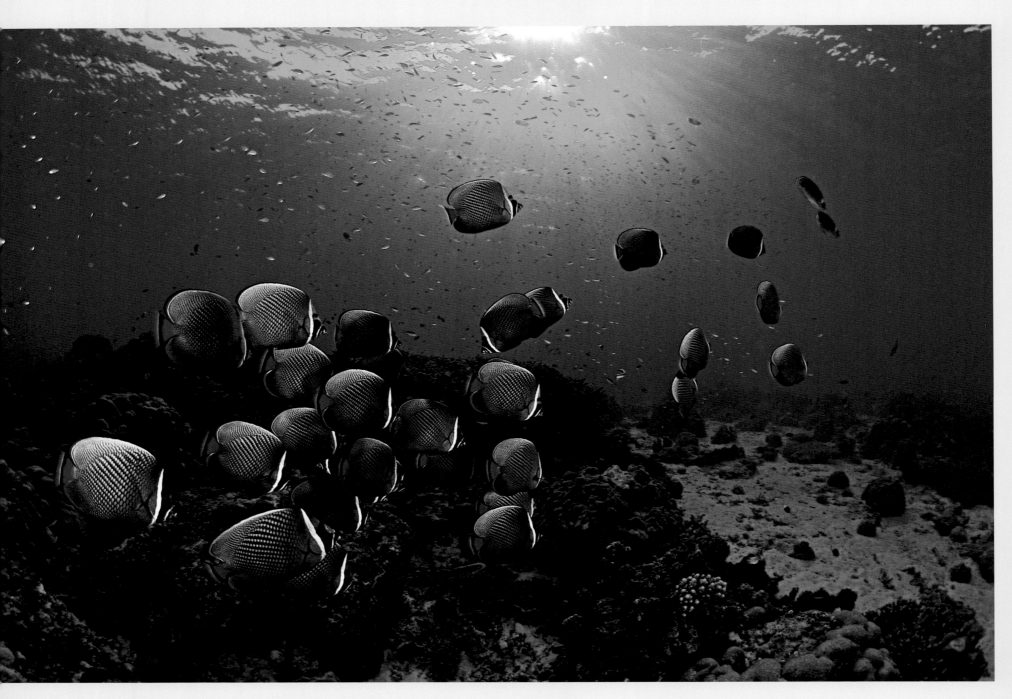

ABOVE: White-collar butterflyfish form a school close to a reef near the Similan Islands, one of the world's top dive sites. The butterflyfish are waiting at a 'cleaning station' frequented by cleaner fish. The cleaner fish swim into their mouths and clean out parasites in exchange for food in a symbiotic relationship.

RIGHT: A manta ray tries to attract cleaner fish near Ko Bon, which is near the Similan Islands. Manta rays have a wingspan of three metres and live in the open seas. Every manta ray has different markings, like fingerprints. This picture was taken 20 metres below the surface.

Photos by
Nat Sumanatemeya, Thailand

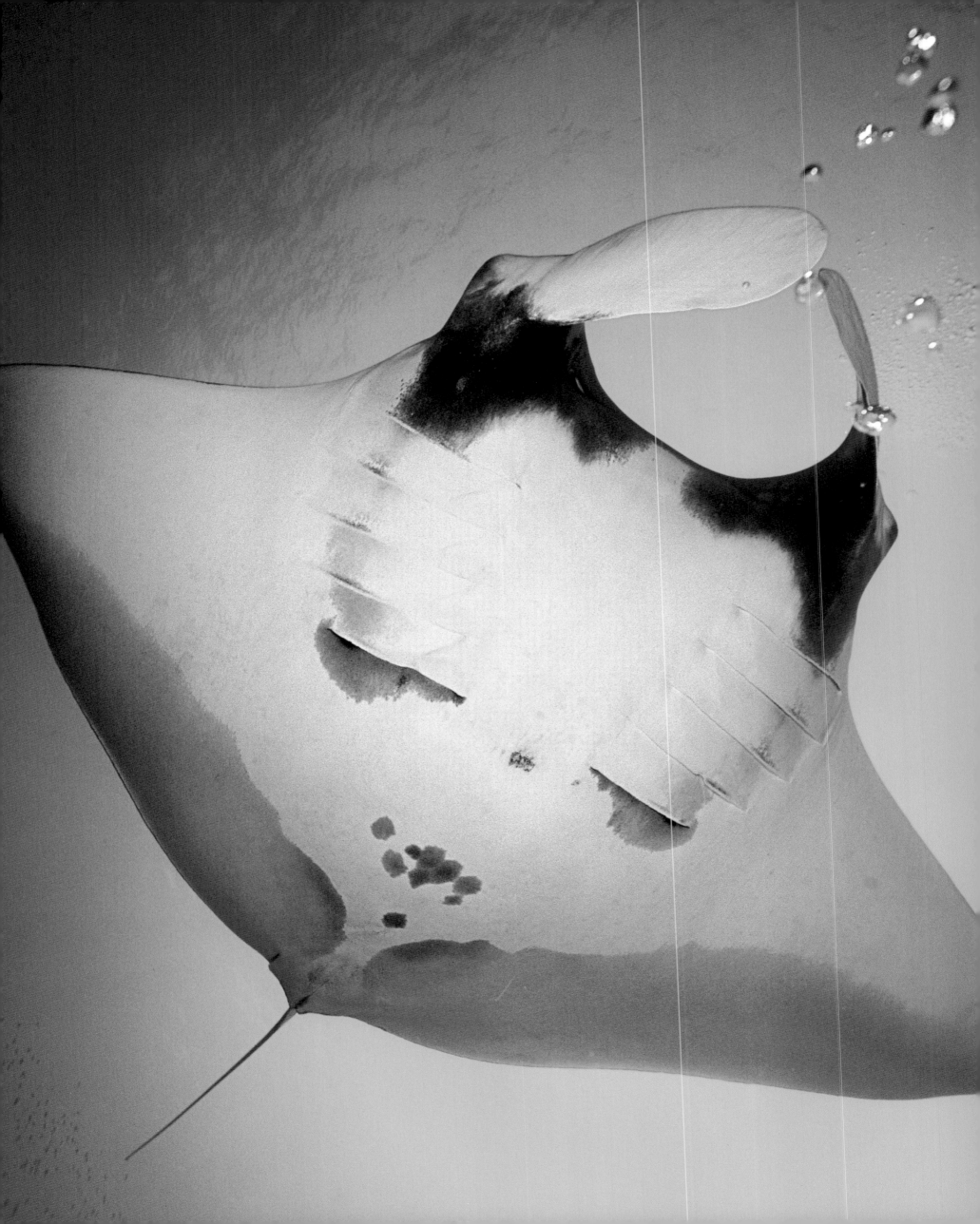

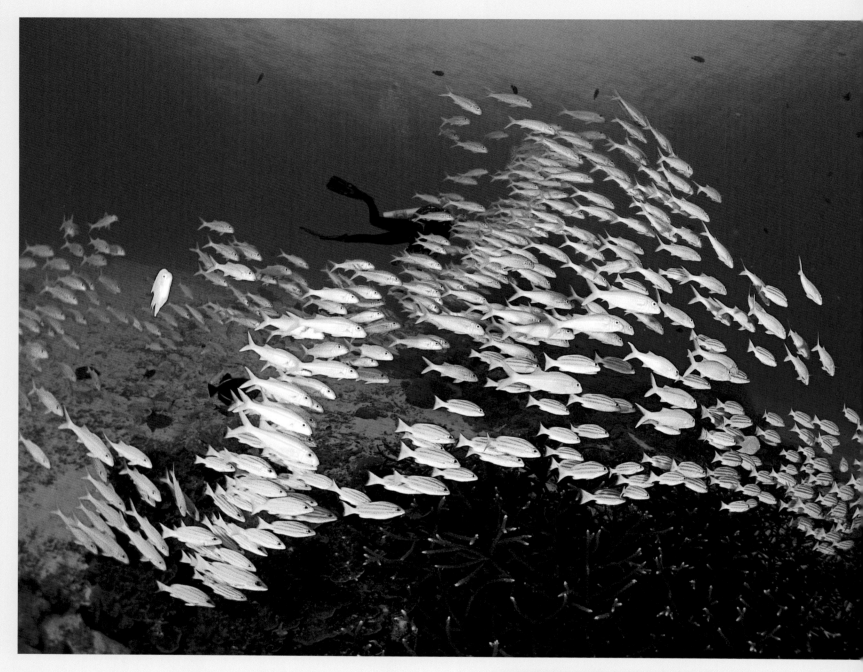

CLOCKWISE FROM ABOVE:
Blue-striped snapper and goat fish form a school together near Similan Island No. 5.

An Indian anemone fish relaxes in purple anemone and sea anemone.

The yellow-margin moray eel compensates for bad eyesight with an acute sense of smell.

A Midas blenny takes cover in a rock. These fish hide when they feel threatened.

The juvenile emperor angelfish uses markings to confuse predators about which end is its head. It changes pattern as it ages, becoming more colourful to attract mates.

A detail of a white-collar butterflyfish sleeping on a gorgonian sea fan at night.

The tigertail sea horse is the most common in the Andaman Sea.
**Photos by
Nat Sumanatemeya**, Thailand

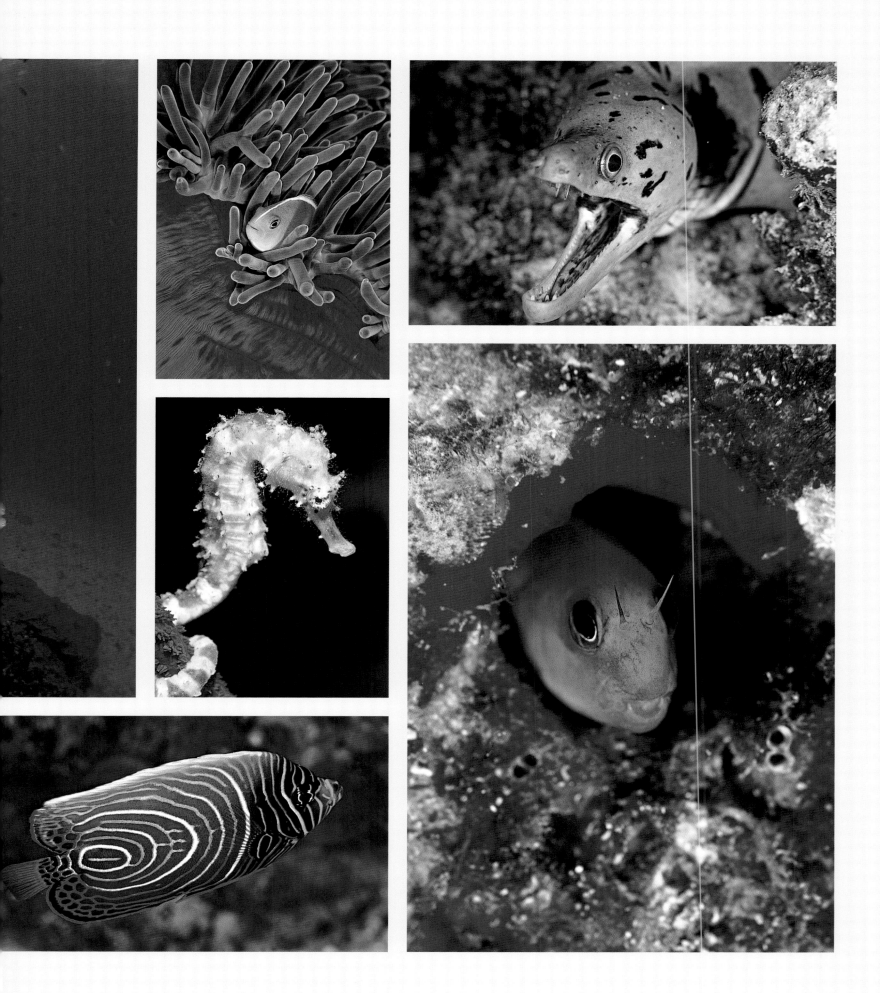

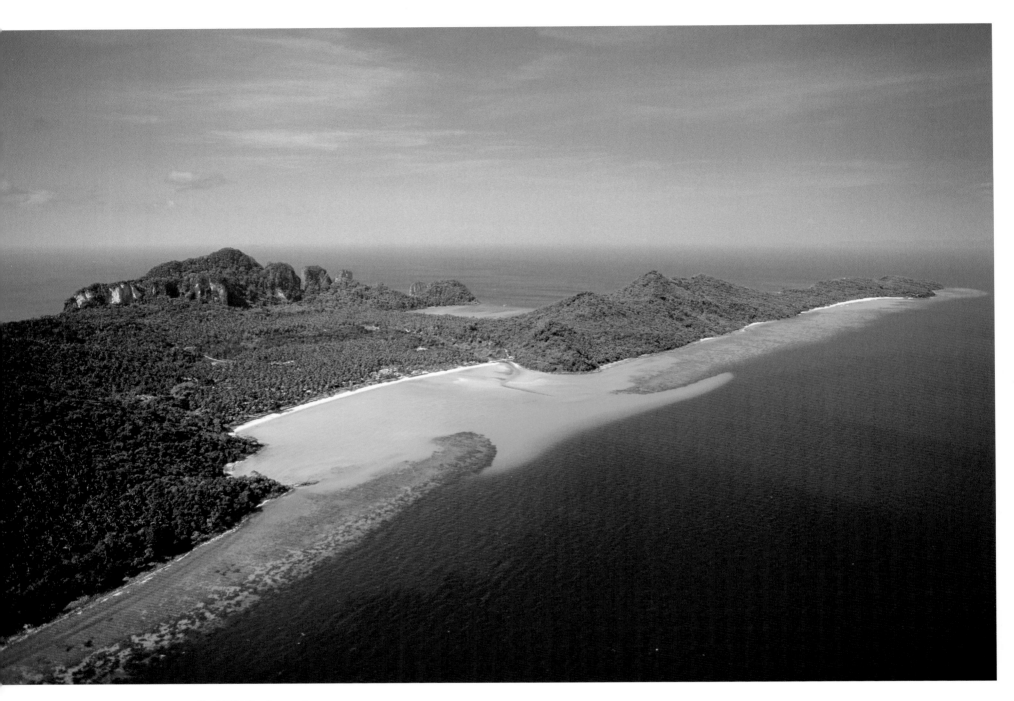

Ko Phi Phi Don is one of
Thailand's most famous
tropical islands. Located in the
Andaman Sea, it was extremely
popular with backpackers until
the tsunami of 26 December
2004 wiped out almost all of
its bungalows, restaurants and
infrastructure. The locals have
since rebuilt the facilities.

Yann Arthus-Bertrand, France

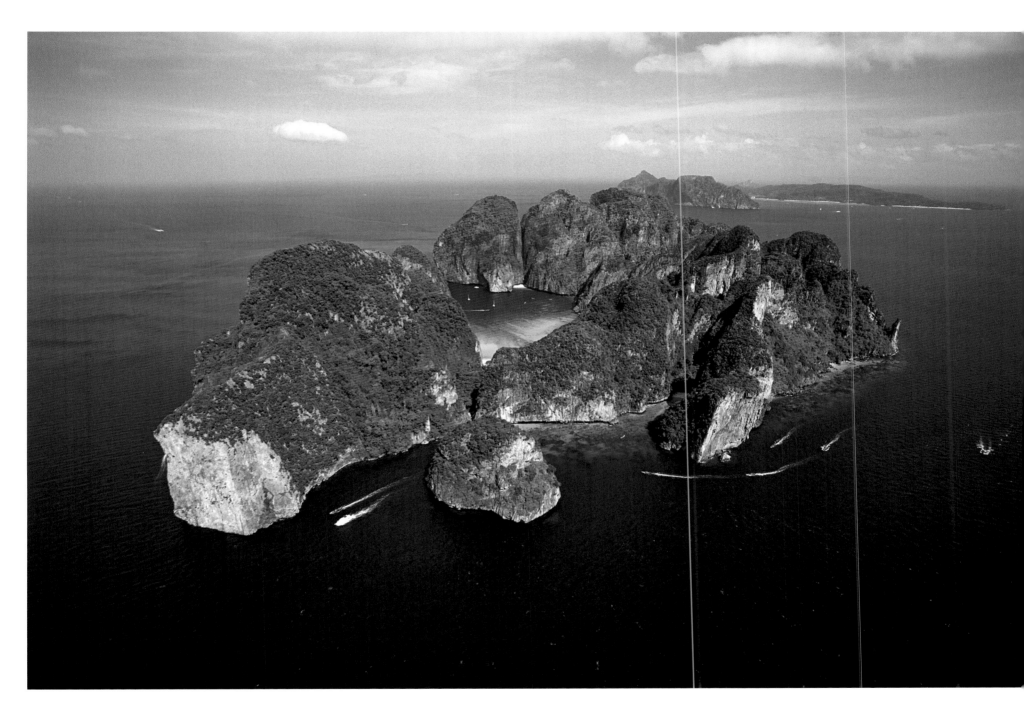

Ko Phi Phi Leh is adjacent to
Ko Phi Phi Don. It was made
famous by scenes shot there
for the Hollywood movie *The
Beach*, starring Leonardo
DiCaprio. In the film, DiCaprio
fights off a shark in the
island's Maya Bay, which is
almost completely enclosed by
limestone cliffs.

Yann Arthus-Bertrand, France

Tourists splash about in Pattaya Water Park in Pattaya. The seaside town less than two hours from Bangkok has become a massive international draw in the last two decades. Over-the-top nightlife, affordable accommodation, golf, sun and surf draw tourists, long-term residents and retirees alike.

Jeff Hutchens, USA

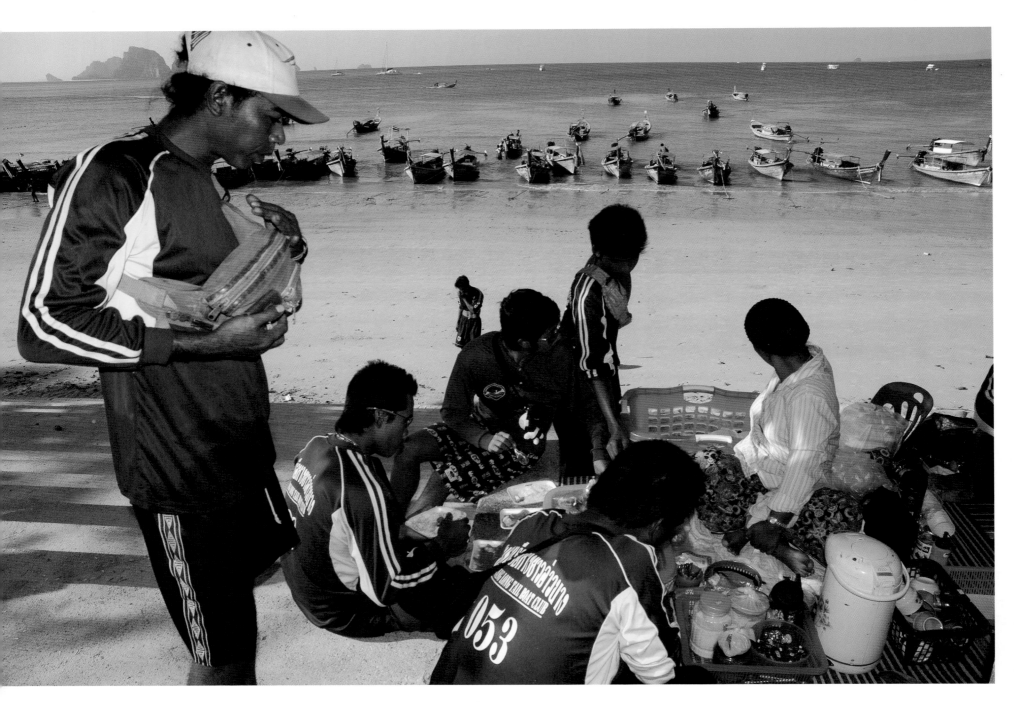

ABOVE: In Krabi province, longtail boat drivers wait for tourists, who take the boats between the surrounding islands and beaches.

John Everingham, Australia

RIGHT: A Moken village in Mu Ko Surin National Marine Park in southern Thailand. The Moken are sea gypsies who traditionally lived nomadic, self-sufficient lives on the ocean. Today there are only a few thousand Moken left and their traditional ways of life are severely threatened.

Bruno Barbey, France

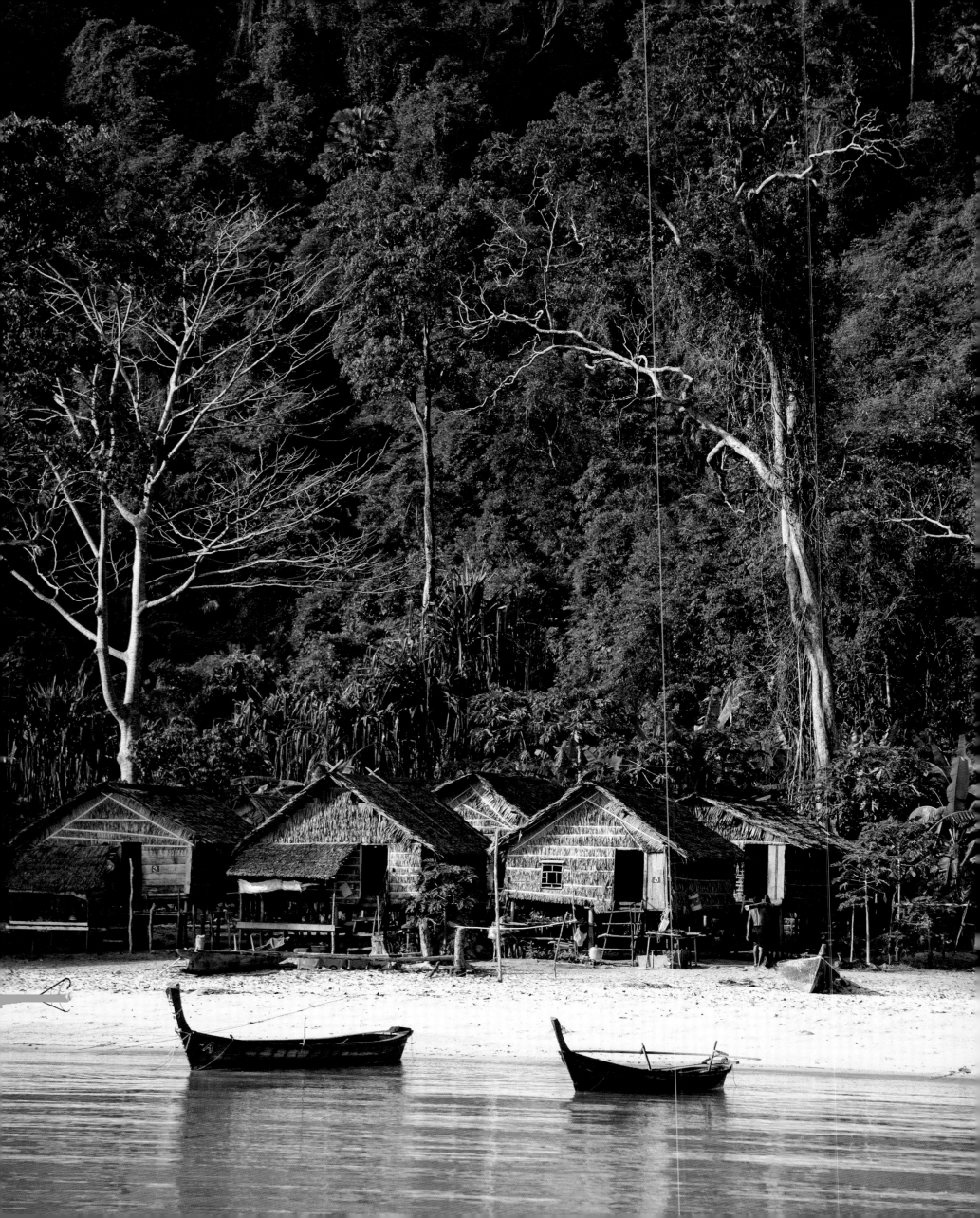

ABOVE: On Bang Niang beach in Khao Lak, Phang-Nga province, German tourists lean against the remains of a structure uprooted by the December 2004 tsunami. The tourism industry of Khao Lak is gradually recovering since thousands of tourists and Thai and Burmese workers perished in the tsunami.

Bruno Barbey, France

RIGHT: A beachside vendor on Ko Lipe, in southern Thailand, sells plastic flowers made from recycled plastic bottles.

Ernest Goh, Singapore

FOLLOWING PAGES: Fishermen paddle on the massive Khao Laem Reservoir in Sangkhla Buri, near the Myanmar border.

Waranun Chutchawantipakorn, Thailand

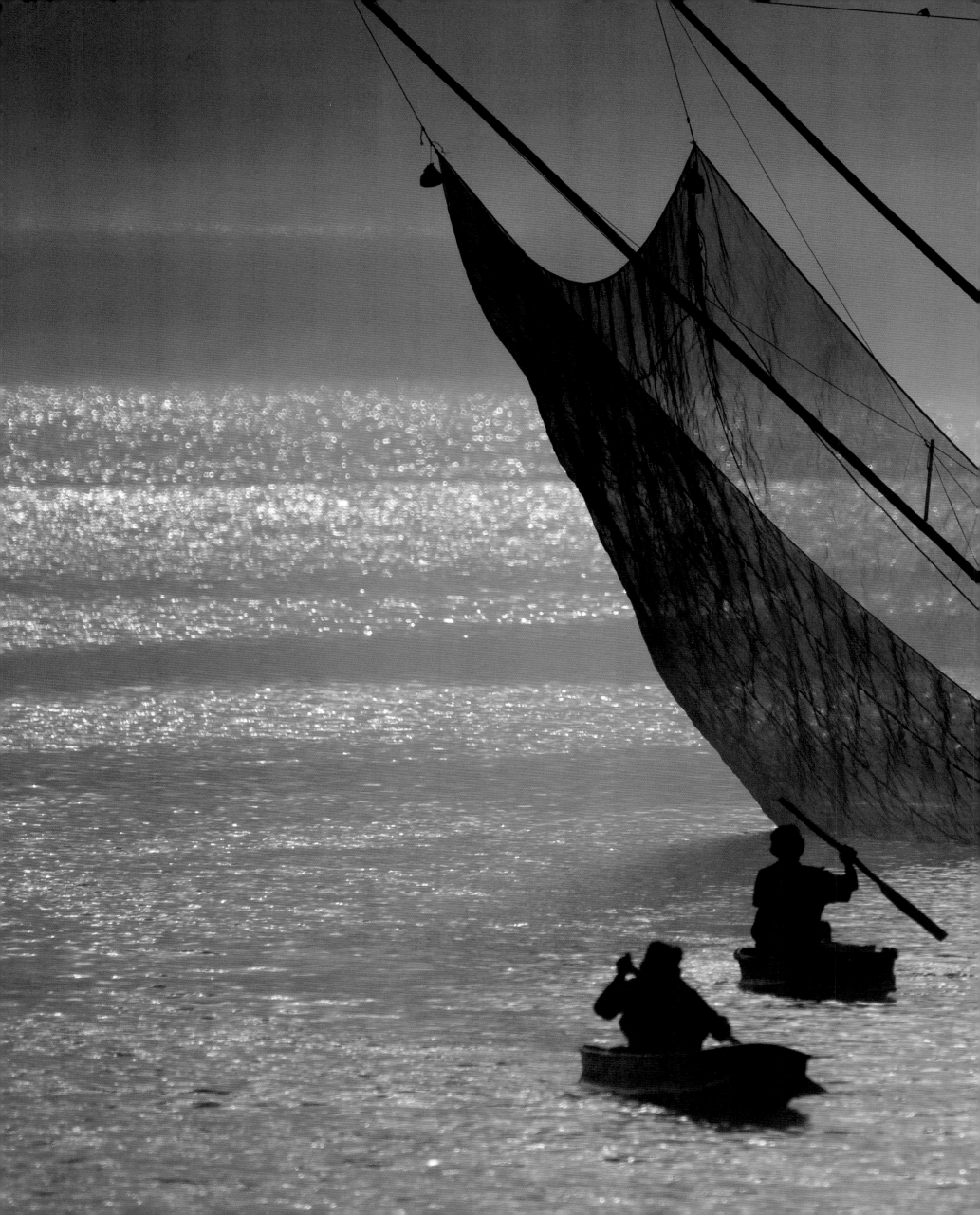

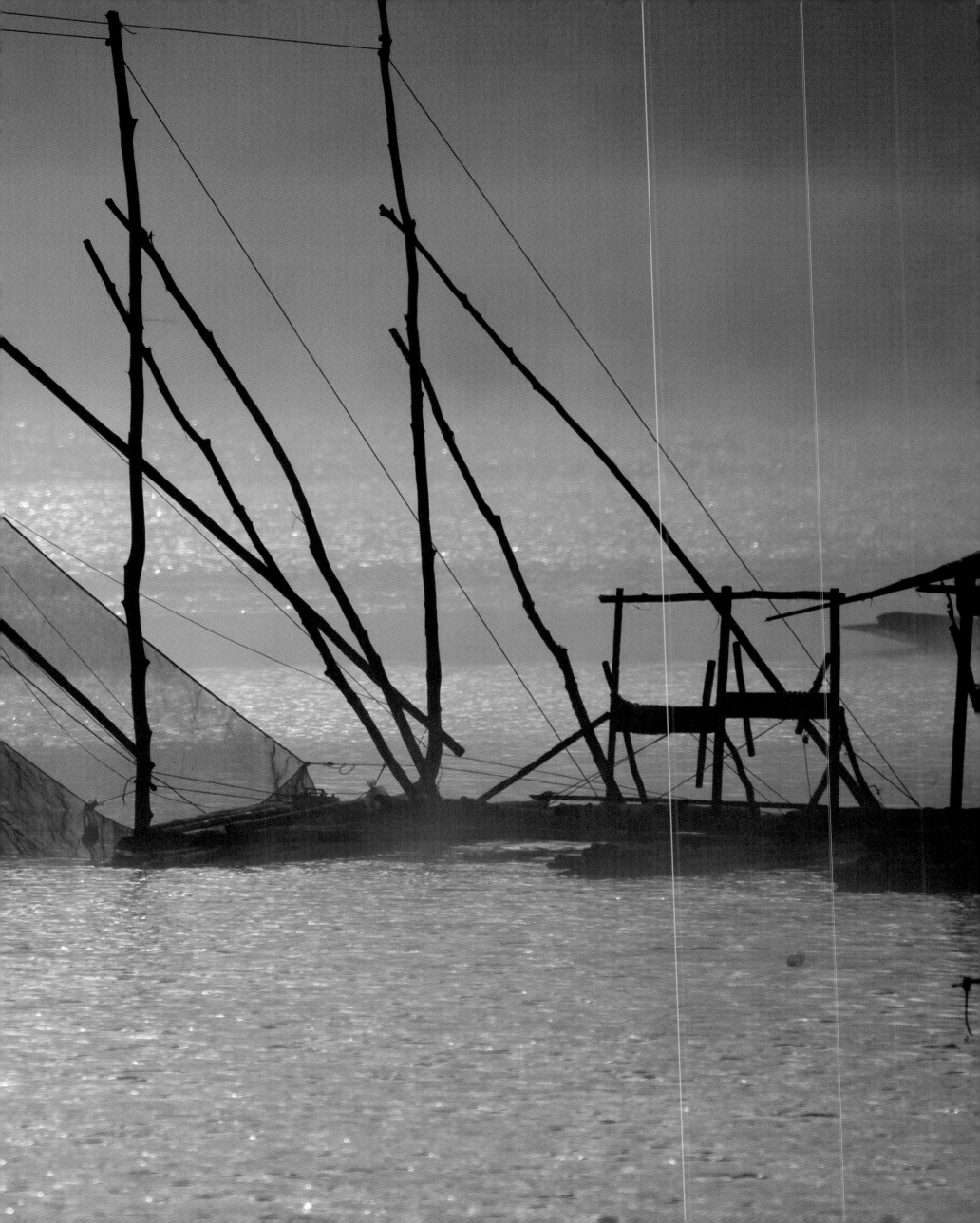

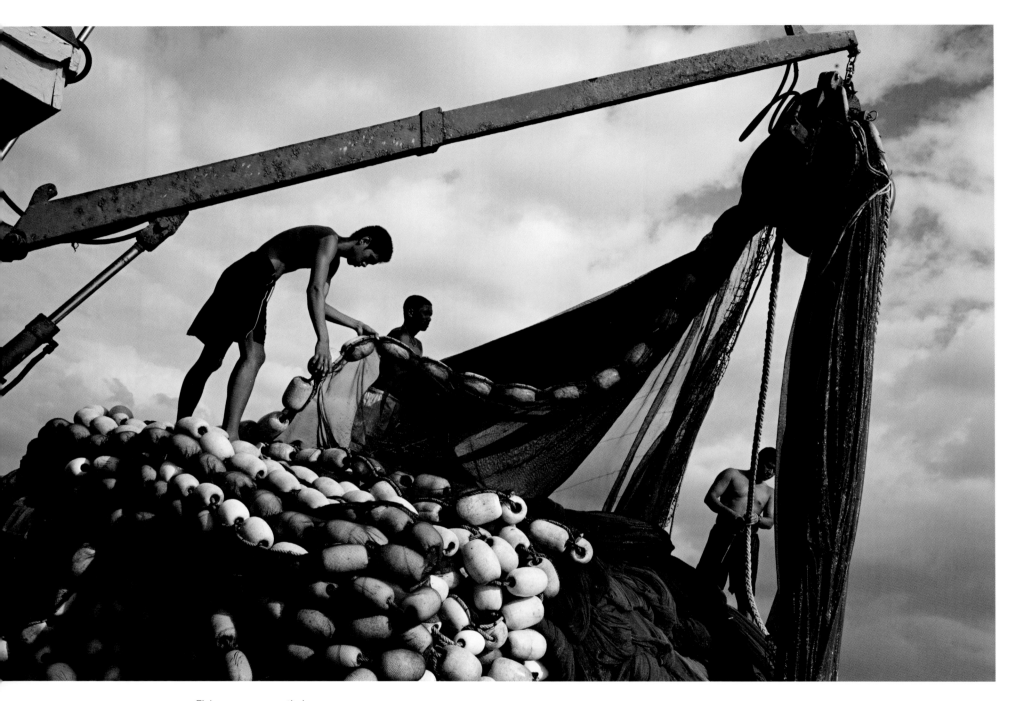

Fishermen prepare their deep-sea trawler for an expedition in the Andaman. Typically the crew fish the deep sea for up to a week in order to make the most of their fuel and secure a big haul.

Bruno Barbey, France

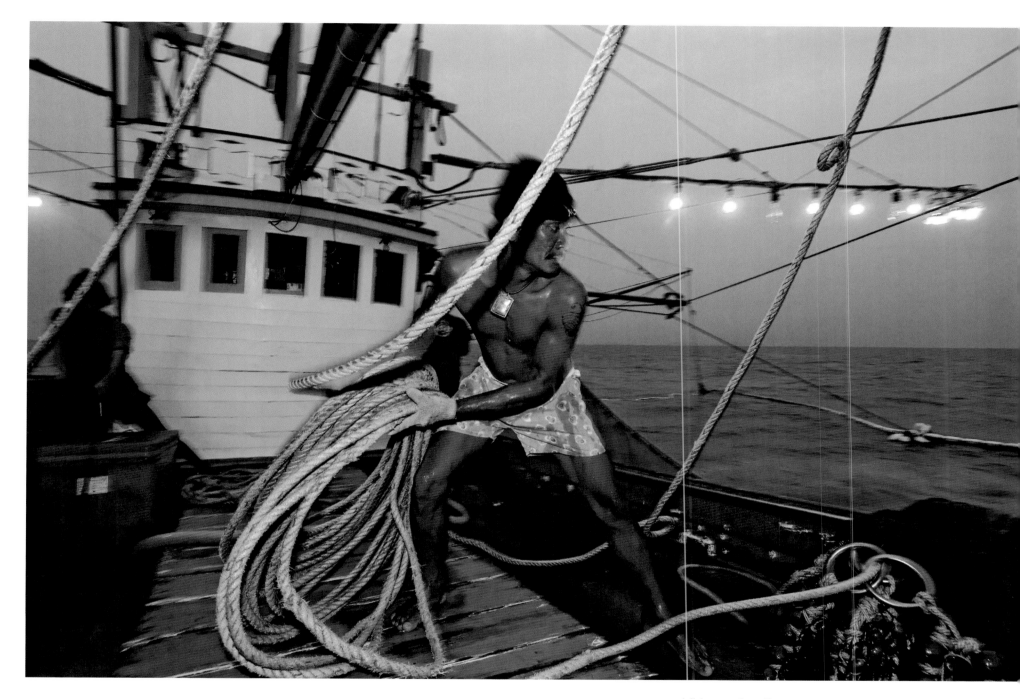

A fisherman from Rayong casts
a rope from a multi-purpose
trawler on the Gulf of Thailand.
The boat is rigged with a
special lighting system that
tricks squid, who are attracted
by moonlight, into surfacing.
The squid industry is massive
in Thailand and, all along
its coasts, boats like this one
can be seen lighting up the
horizon at night.
Michael Freeman, UK

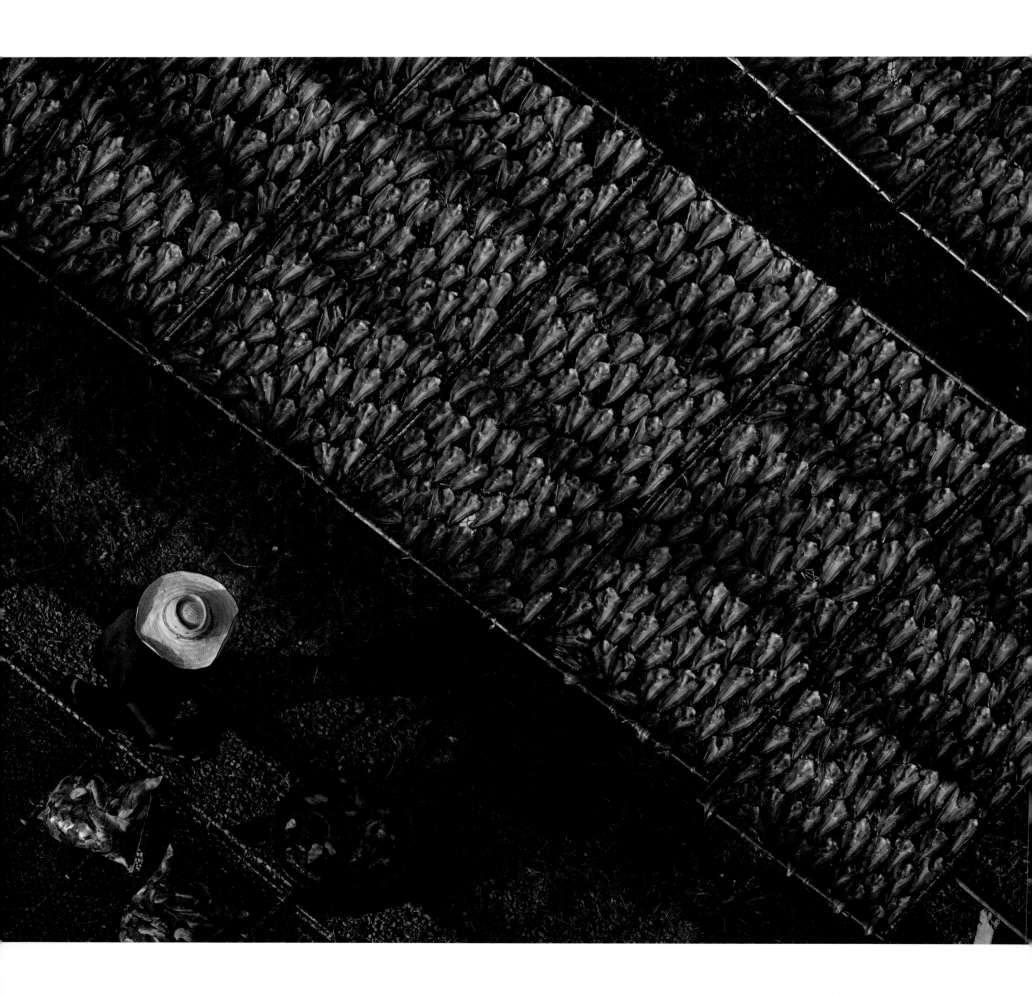

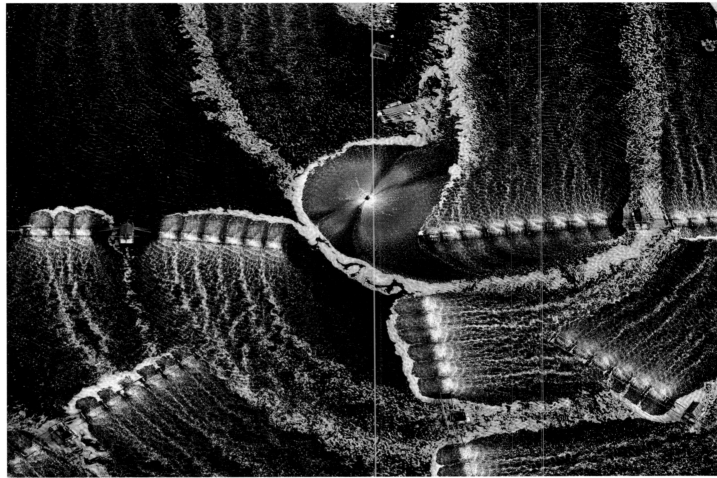

LEFT: In the countryside just outside of Bangkok, a farmer sets out racks of fish to dry under the sun.

ABOVE: A man-made shrimp farm by Phang-Nga Bay uses machines to keep the water clean and aerated. The kingdom is the largest exporter of shrimp in the world. As demand has massively increased, farmers have moved from low-key production in small ponds to high-tech, large-scale farming.

Photos by
Yann Arthus-Bertrand, France

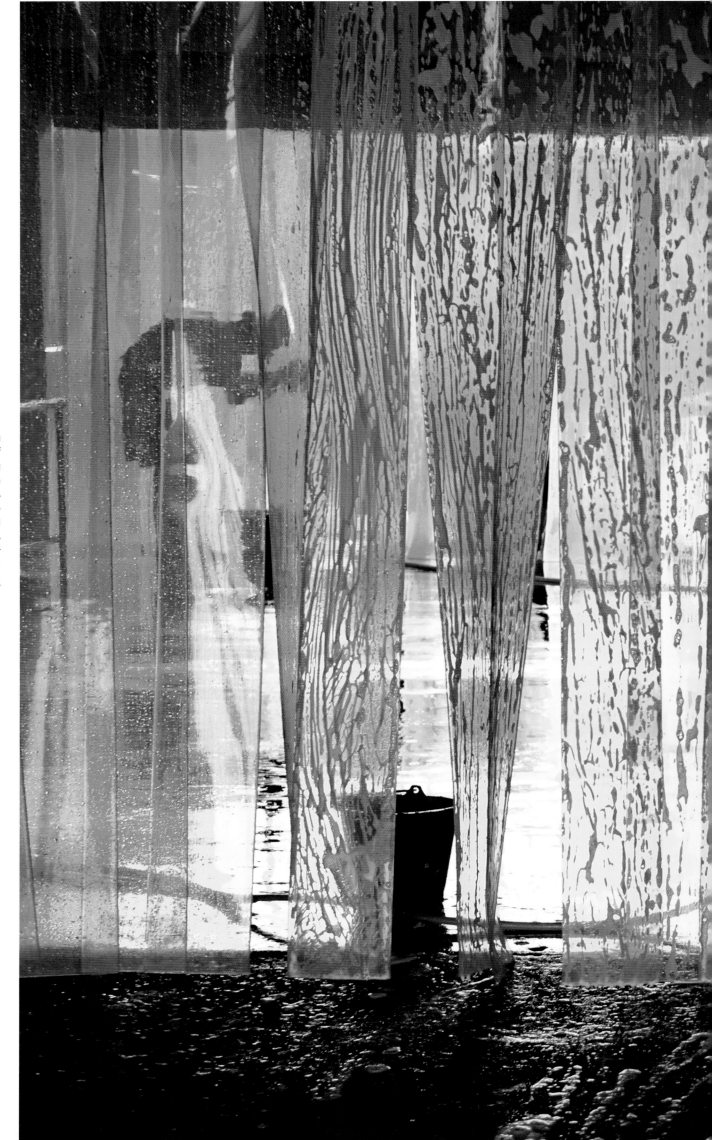

Songkhla's fish market, along the harbour, is at its height of activity early in the morning when the trawlers return from their night-time expeditions laden with fish. After the seafood is loaded onto road transportation, the market is hosed down in preparation for the next day.

Jeremy Horner, UK

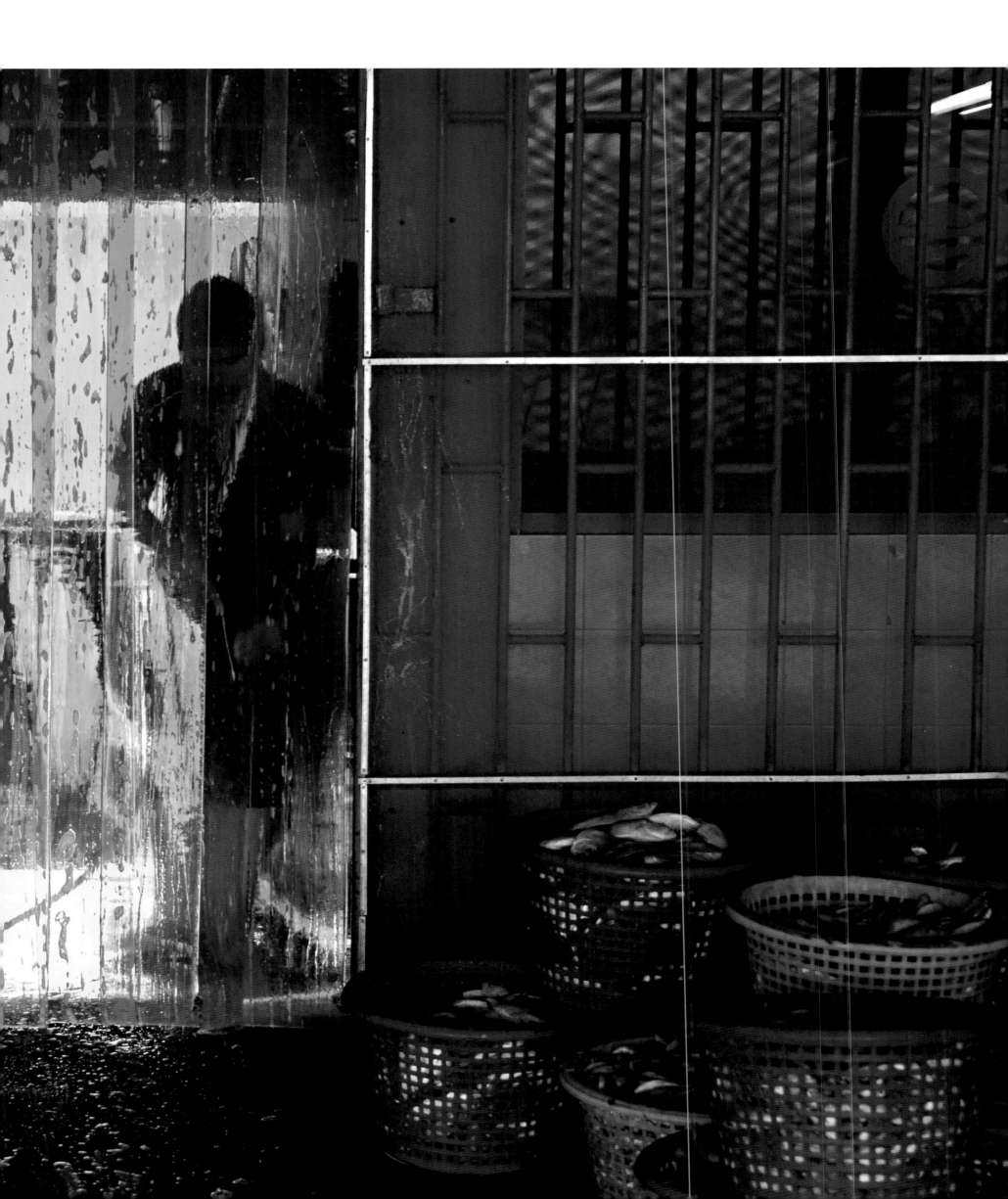

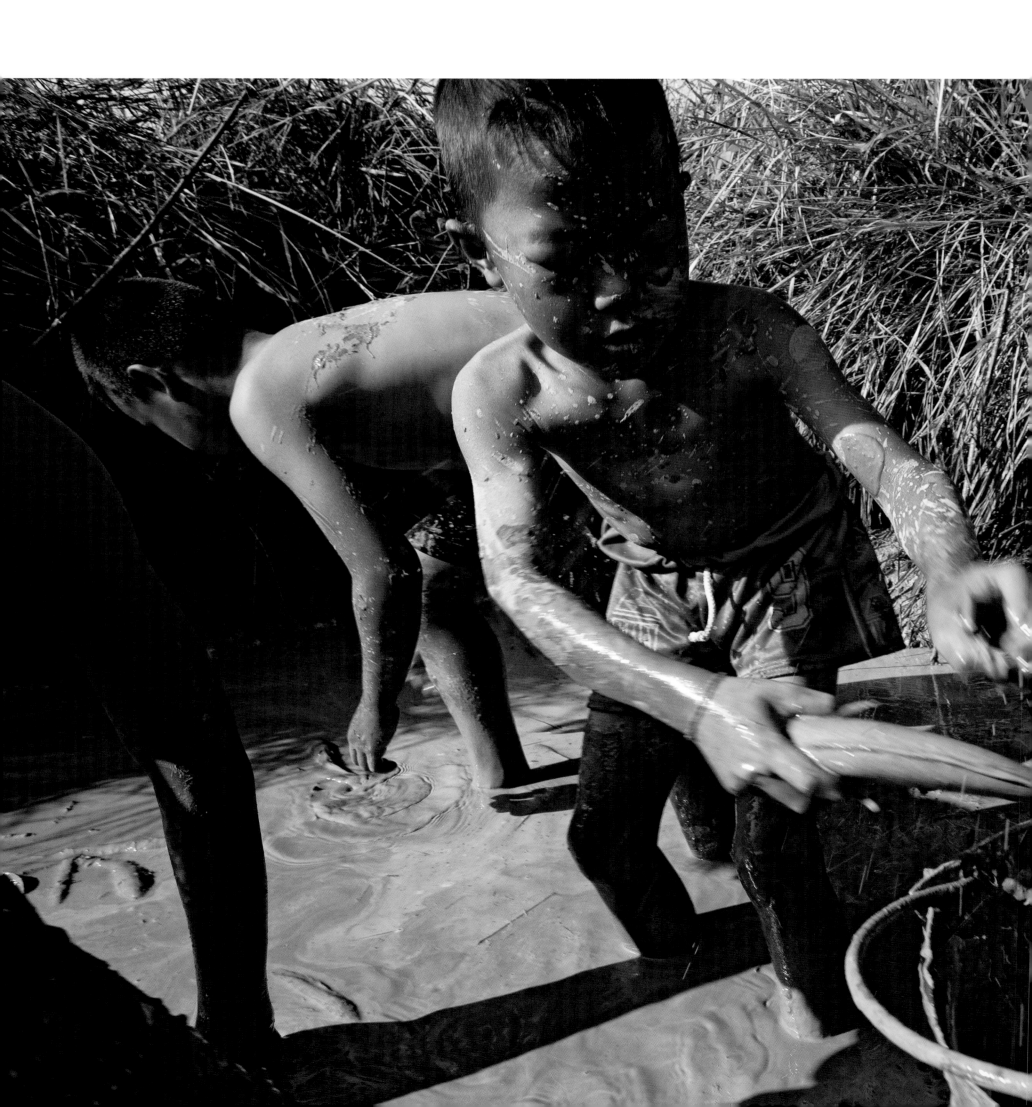

LEFT: In Bueng Khong Long district, Nong Khai, children gather catfish from a muddy, man-made pond on the edge of a rice field. In the countryside, catfish are a staple of the diet. Rural children and adults frequently have fun catching their free dinner in the fields.

Michael Yamashita, USA

RIGHT: For good luck, a *Thailand: 9 Days in the Kingdom* photographer releases a fish into the Chao Phraya River. Before setting out on their assignments, all of the photographers participated in traditional merit-making ceremonies. Releasing birds and fish is a common method of making merit.

Gueorgui Pinkhassov, France

FOLLOWING PAGES: The Muslim fishing village of Panyi Island, located in Phang-Nga Bay in southern Thailand, is built on stilts. The island is believed to have been settled by Muslim fishermen from Java more than 200 years ago and the residents today still make a living from the sea, and from day-tripping tourists.

Yann Arthus-Bertrand, France

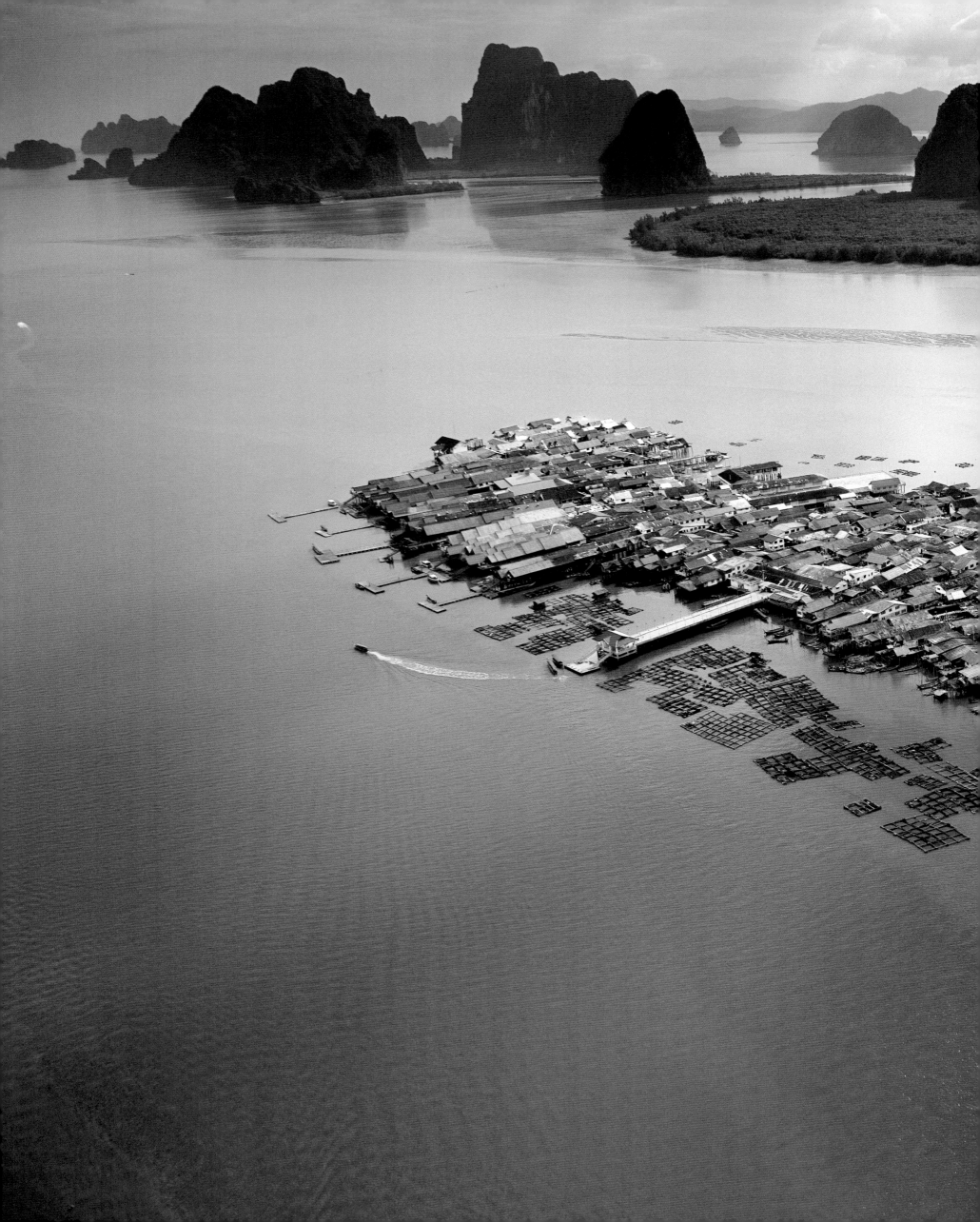

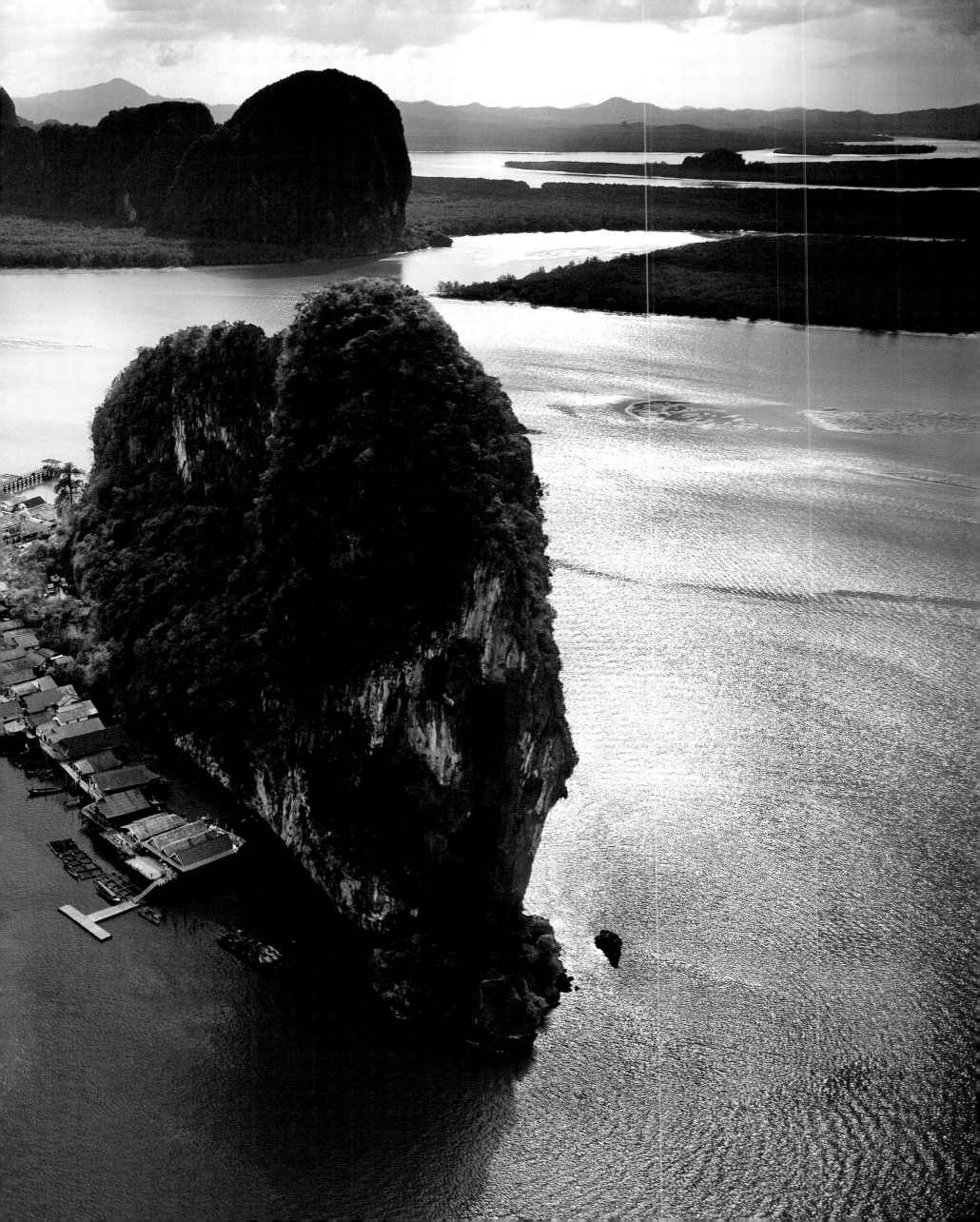

White Gold

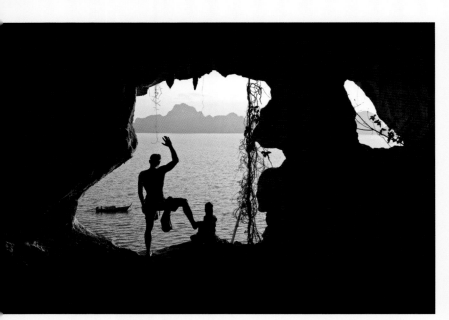

Muscles burning, his heart pounding like a runaway tabla, sweat pouring off his face, burning his eyes, dripping down his chest and arms, even off his hands, photographer Éric Valli clings to the side of Tam Yai ('The Big Cave'). The cave, too, is sweating, a slick green slime on which Valli's bare feet slip. Occasionally, in search of a better angle, he triggers an avalanche of bird excrement, which cakes his wet skin.

Tam Yai, where the Frenchman took pictures of bird's nest collectors for nine days, deserves its name. Full of infinite shades of green, highlighted by the climbers' torches, the cave is truly immense. Its silence is disrupted only by the fluttering of the swiftlets and their rapid clicks, which allow them to navigate in the dark. Occasionally the network of bamboo poles, used by climbers like a giant spider web to reach the furthest vault of the cave, creak.

As they have for centuries, the nest collectors work in darkness, in search of 'white gold': tiny birds' nests that are the essential ingredient of bird's nest soup, a famous and expensive Chinese delicacy which is believed to have special health benefits. The valuable nests are formed from the gummy saliva of the swiftlet (*Aerodramus fuciphagus*) and are found high in the caves of the limestone islands of the Andaman Sea, in southern Thailand, perhaps the most physically dramatic part of the kingdom.

Valli had been there before on an assignment for *National Geographic* to create a memorable feature story, and ultimately a book and film on the industry.

Seventeen years later, the caves and work of the nest collectors were no less awe-inspiring. 'I would wonder if I was still on planet Earth,' Valli recounts, 'then realise that I was inside it. I was inside the belly of a gigantic beast, which, if I made the slightest mistake, was just waiting to digest me and leave me in one of its darkest corners, a pile of white bones.'

There have been changes to this multi-million-dollar industry since his last visit. Everybody uses mobile phones now and, since safety equipment was introduced, there have been no more deaths in this extreme workplace. As for the 'white gold', it is more valuable than ever—an astounding 100,000 baht per kilogram (approximately US$3,000).

What has not changed, besides the presence of guns to protect the caves from thieves, is the athleticism of the collectors. 'They are such incredible men, artists in their own way, always in perfect control of their body and their mind in such an alien world,' says Valli. 'Back in the village, they will not brag about their craft or the risks they take. It's simply their life on the razor's edge.'

Photos by Éric Valli, France

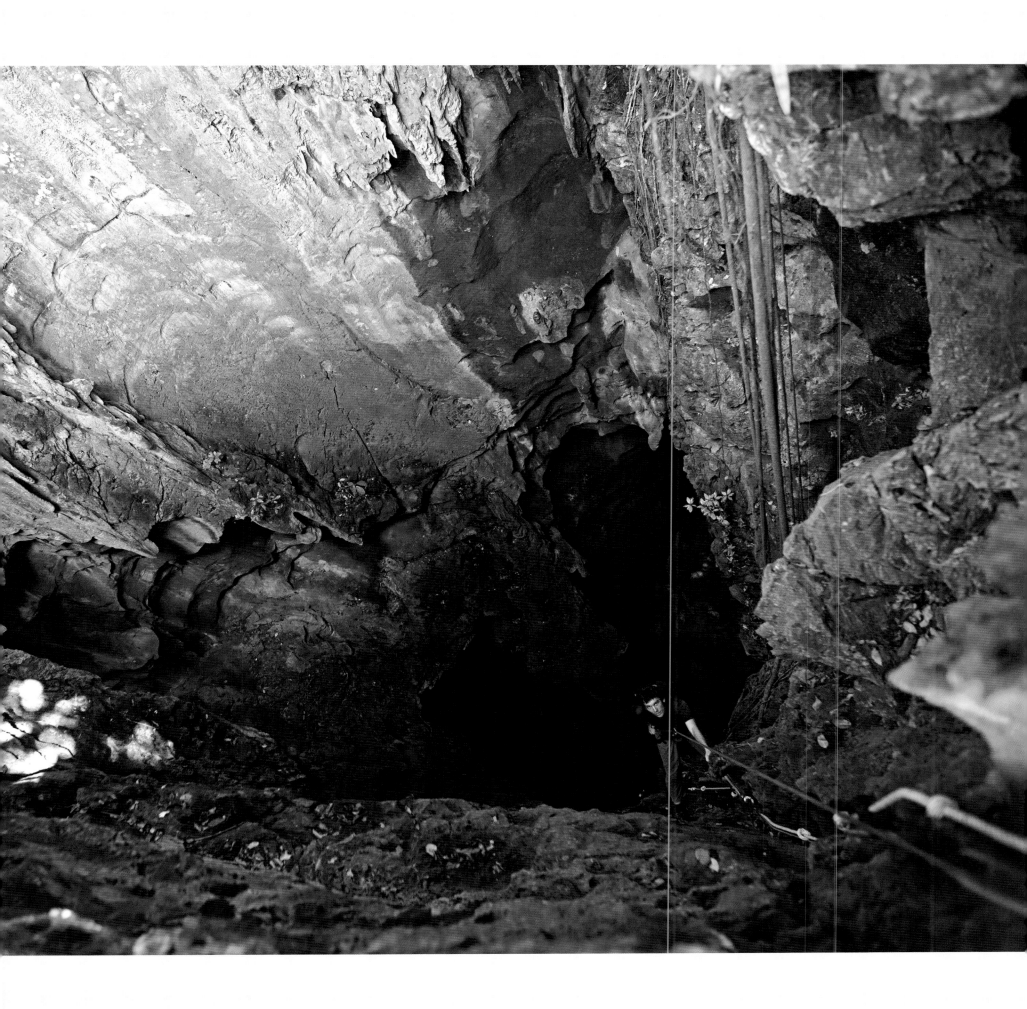

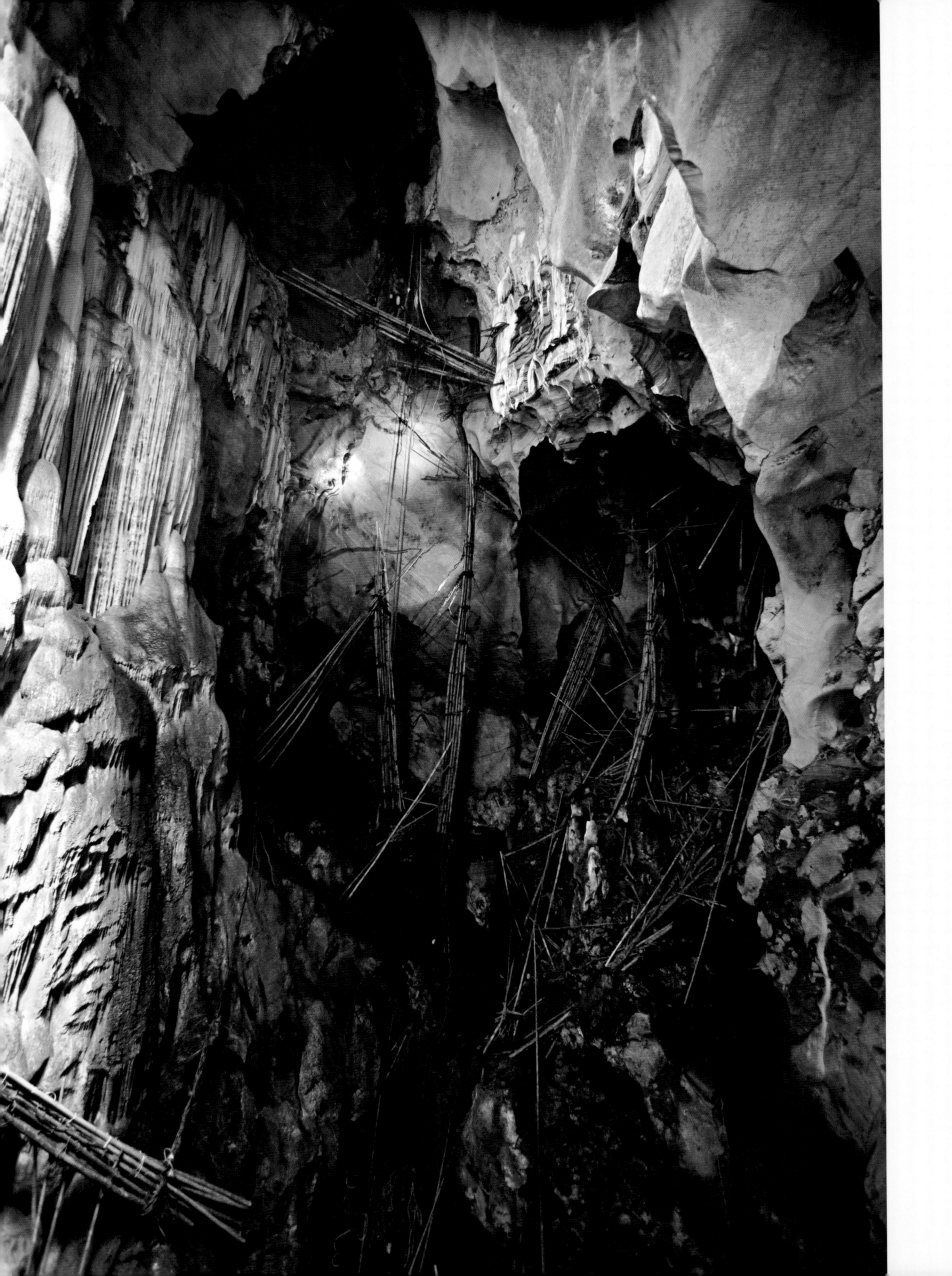

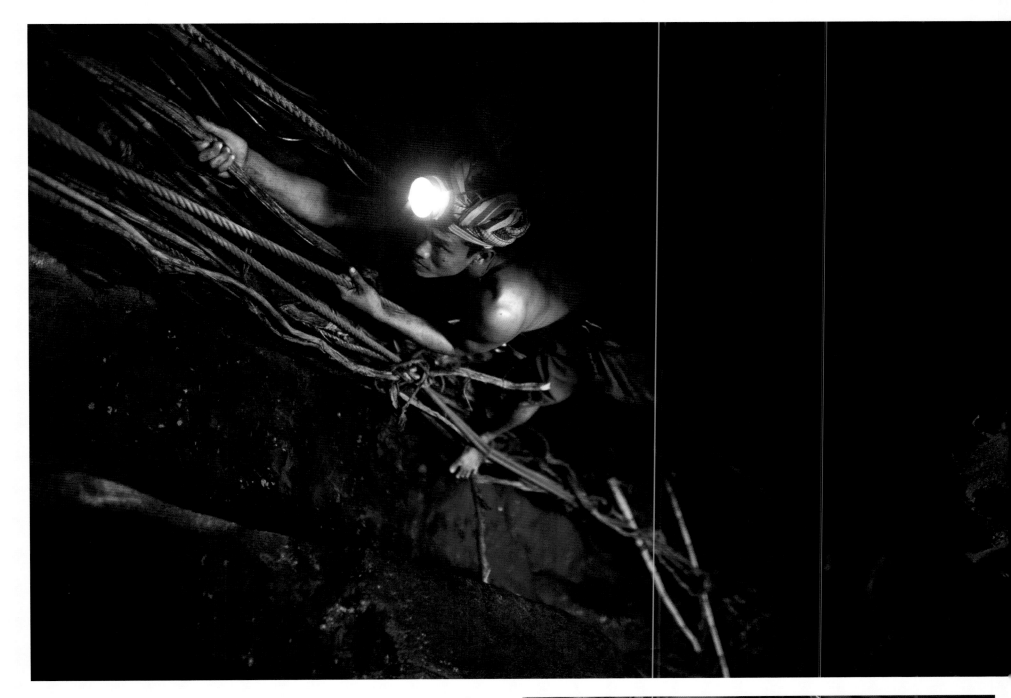

PRECEDING PAGES (FROM LEFT): After harvesting a cave high on a cliff, nest collector Sun hails a boat to fetch him.

Valli's assistant, Austin Bush, descends into Tam Yai. To access this location, Valli and Bush hiked for 40 minutes to the mouth. They then lowered their equipment and themselves into the cave where, from precarious positions, they took photographs of the climbers.

LEFT: Inside Tam Yai, Sun stands on a bamboo bridge, inspecting the walls. The scaffolding that allows the climbers to reach the top is replaced every year.

ABOVE: Sun scales the wall in search of birds' nests, using the vines and bamboo the climbers have brought inside the cave. Until recently, the agile men did not use harnesses or safety equipment, instead trusting their lives to their own strength, agility and years of experience.

RIGHT: The nests are typically served in a simple chicken broth. They contain high levels of magnesium, calcium, iron and potassium; are believed to boost the immune system; increase libido; help with growth; and maintain skin tone, among other benefits.

Photos by Éric Valli, France

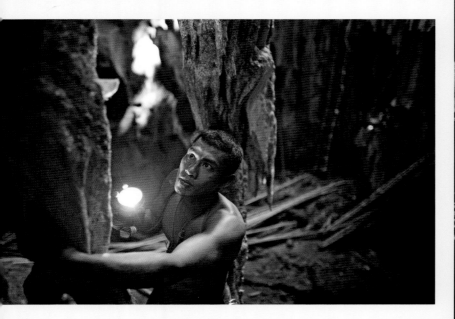

ABOVE: Thirty-year-old Sun spots a nest. Typically, the collectors will leave some nests for the birds so that they can continue to reproduce. The practice of collecting the nests is not without controversy, with some animal rights groups claiming it is inhumane and has led to a serious decline in the population of the birds.

RIGHT: Sun, followed by a fellow climber, searches for nests after completing a dangerous ascent. A huge stalactite hangs from the roof of the cave.
Photos by Éric Valli, France

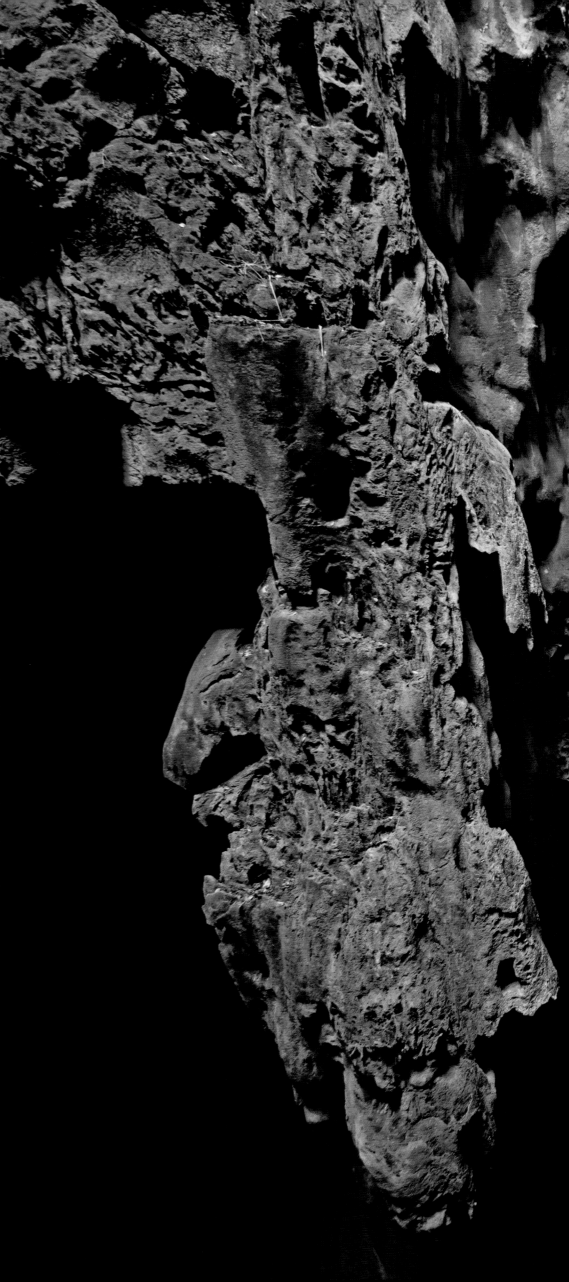

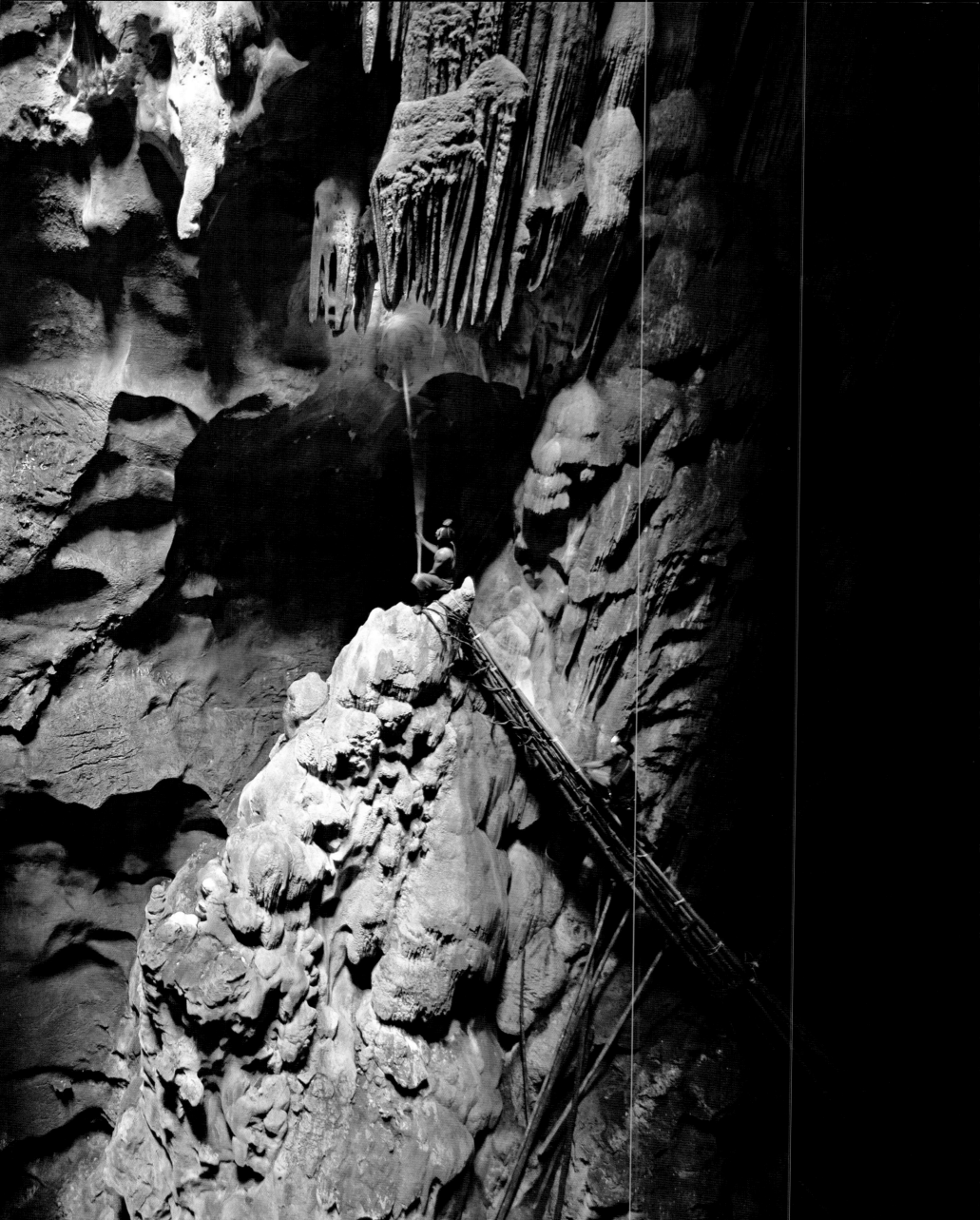

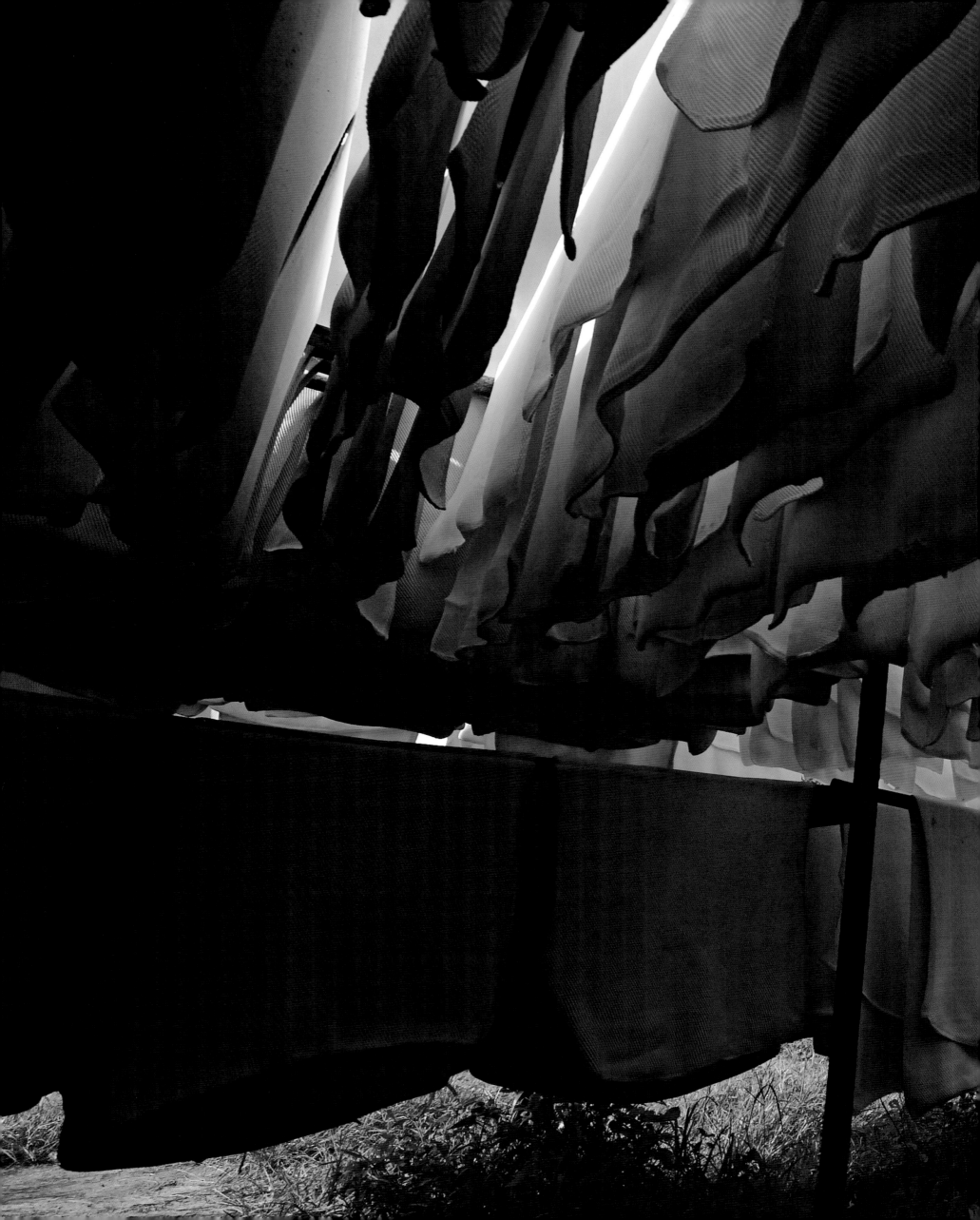

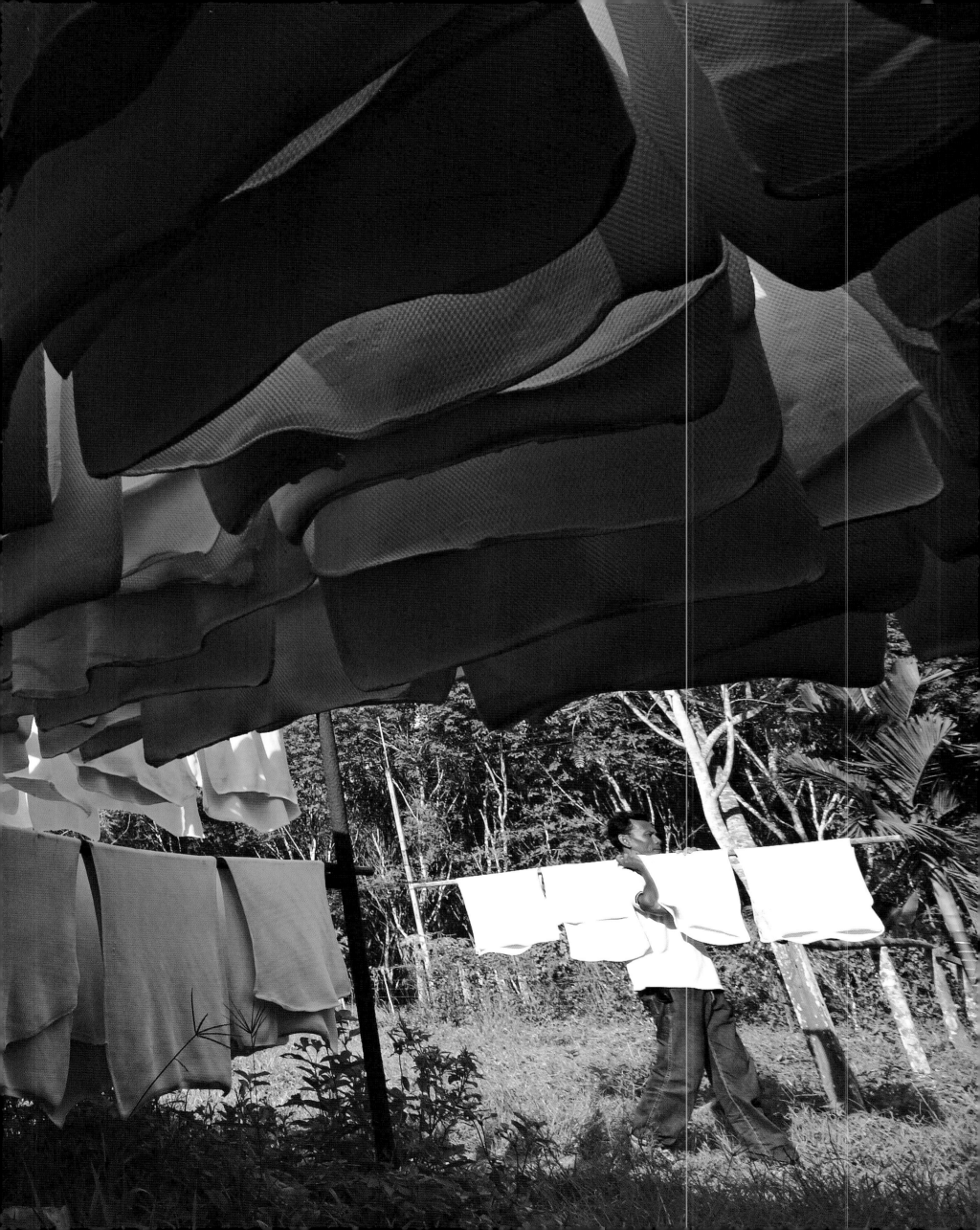

PRECEDING PAGES: Workers in a rubber estate in Tanoh Maeroh, Pattani province, gather rubber sheets dried under the sun. The sheets will be smoked in the factory before they are sold. The area is cool all year, making it suitable for planting rubber trees, which produce one of Thailand's main exports.

Charoon Thongnual, Thailand

ABOVE: Fifty-six-year-old rice farmer Suthep Ad-noi poses by one of his rice fields in Pathum Thani province. Suthep has been farming since he was 15 years old.

Romeo Gacad, Philippines

RIGHT: Fifty-three-year-old rice farmer Mangkorn Yudee prepares the rice paddy for planting in Pathum Thani, located in the central plains. Thais produce what is often considered the best rice in the world. In addition to its economic worth as the country's most important crop, rice has also heavily influenced the kingdom's culture: whisky is made from it and rituals and festivals are arranged around its seasons.

Romeo Gacad, Philippines

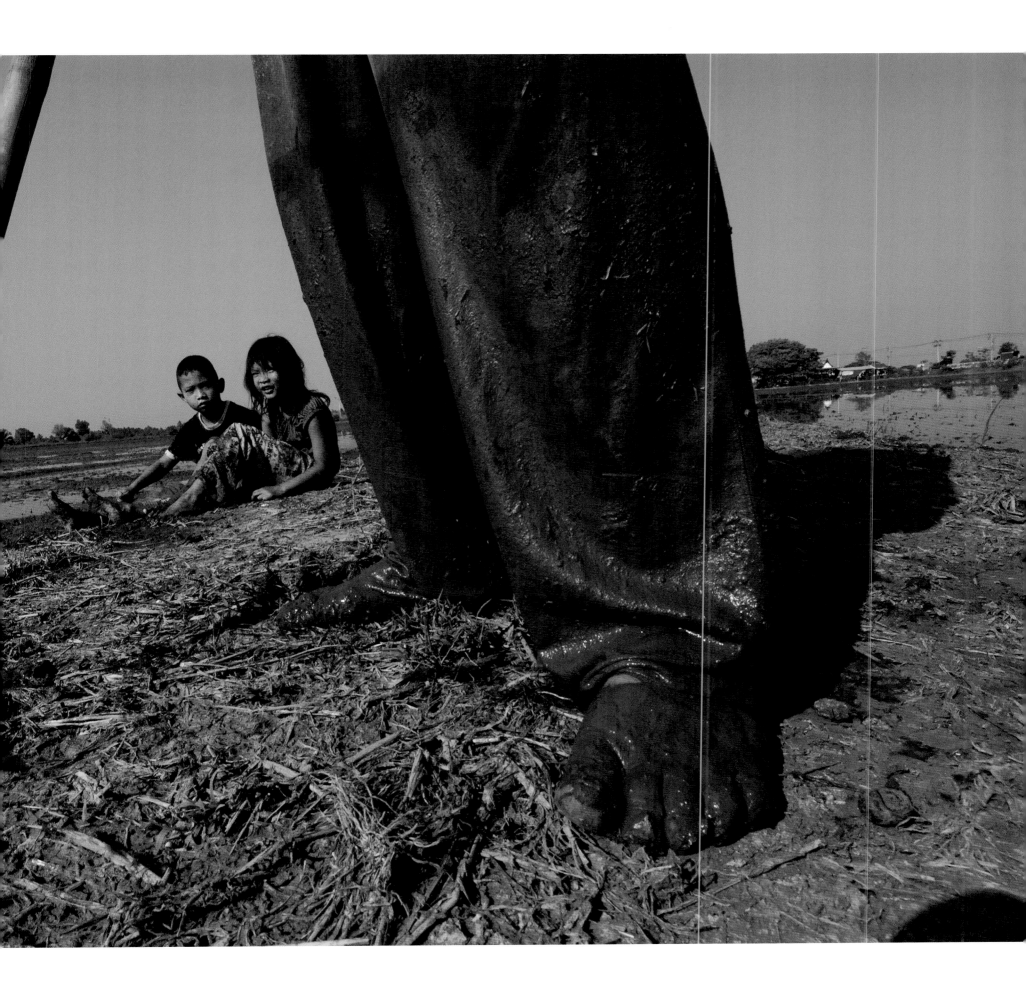

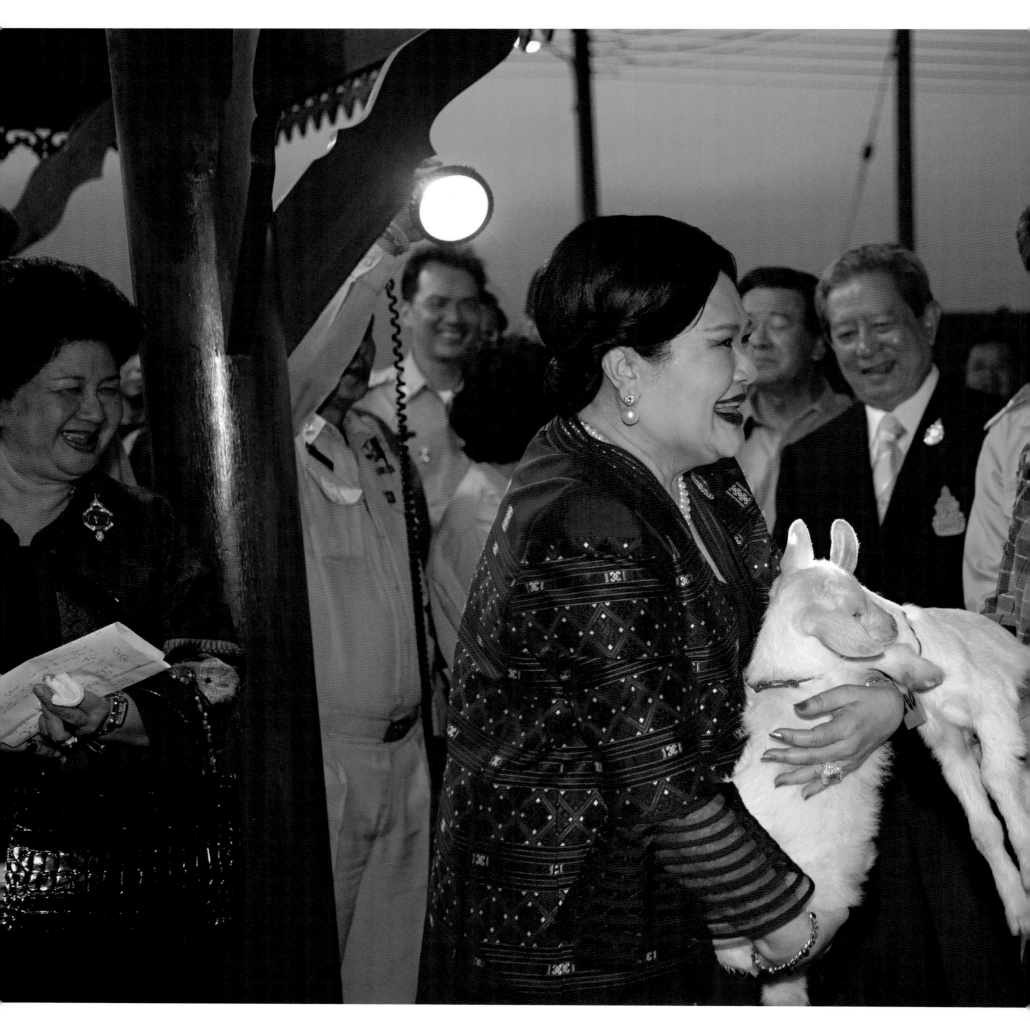

LEFT: Her Majesty Queen Sirikit cuddles a goat during her trip to Sawaeng Ha district in Ang Thong province, where she presented land to flood victims as part of an agriculture project. The countryside has suffered heavy flooding in recent years. Prime Minister General Surayud Chulanont (in a suit) smiles in the background.
Kraipit Phanvut, Thailand

RIGHT: A chicken farmer prepares to vaccinate a hen against disease. The farm produces 40,000 eggs per day, worth about US$2,000 wholesale. Outbreaks of avian influenza ravaged many small farms in the country, but large-scale farms such as this one have not been affected.
Romeo Gacad, Philippines

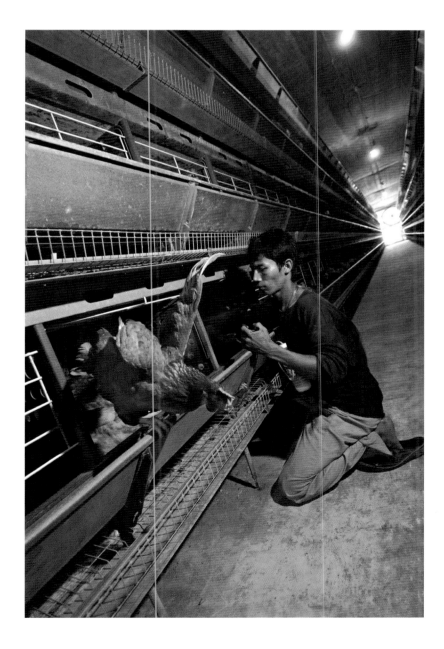

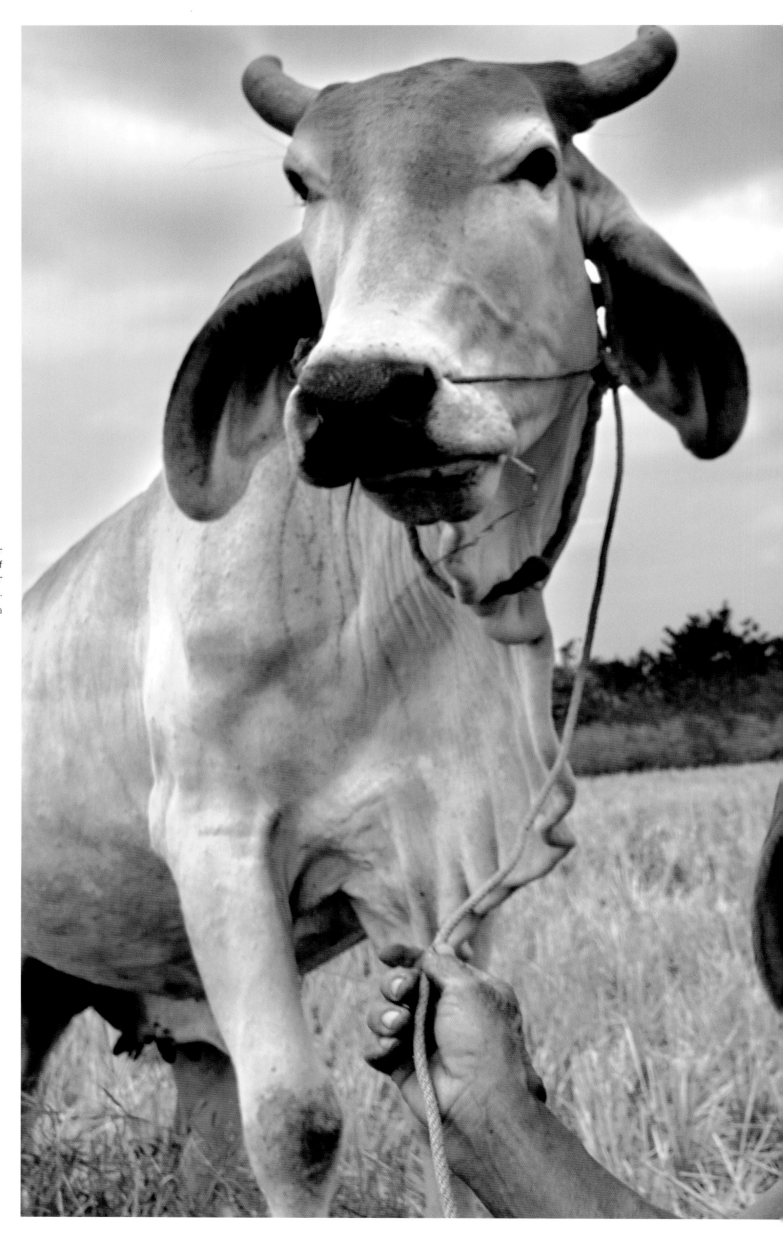

In northeast Thailand, a farmer tends to his wealth: a pair of Brahmin bulls in the sugar cane fields in Khon Kaen.

Rio Helmi, Indonesia

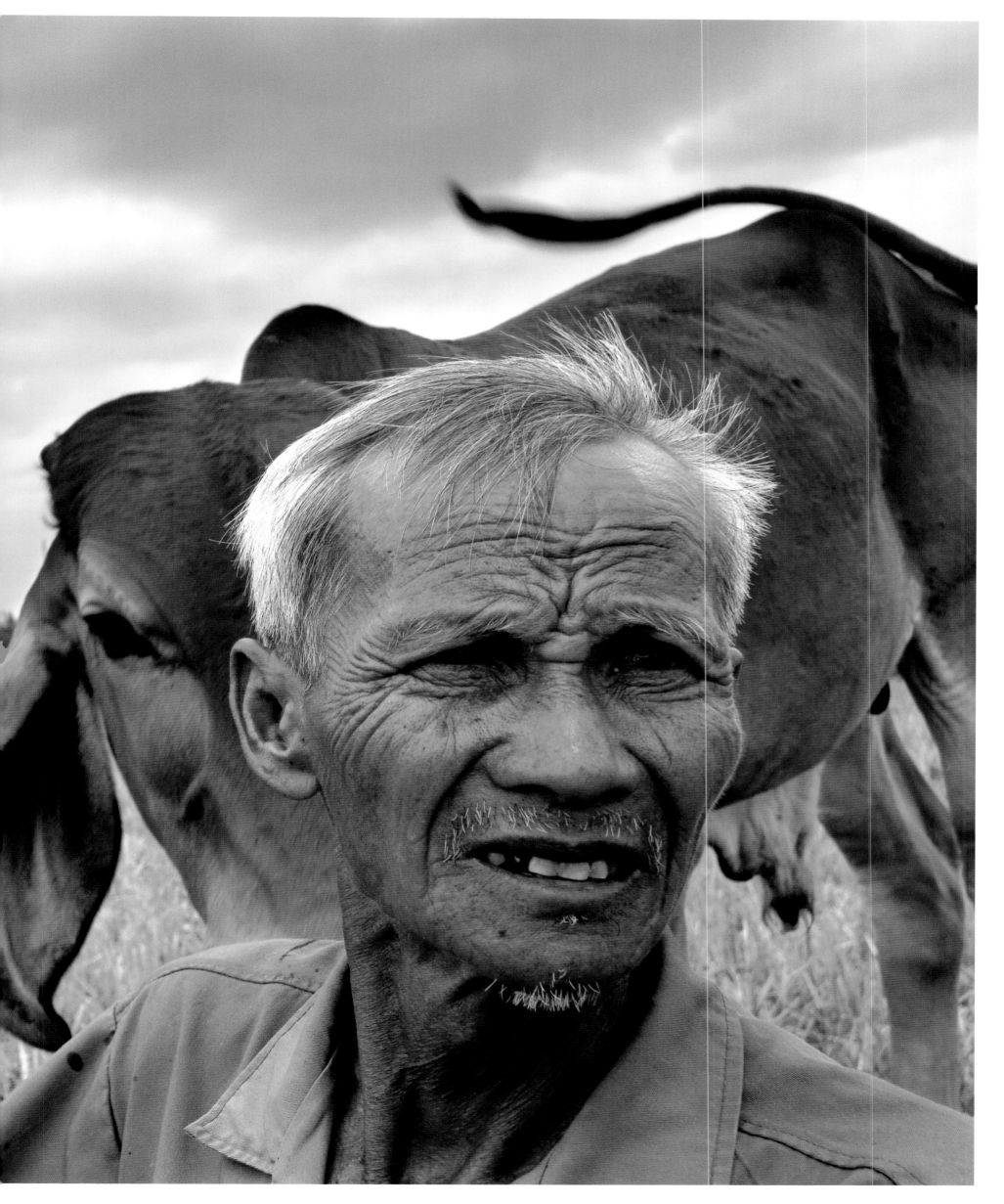

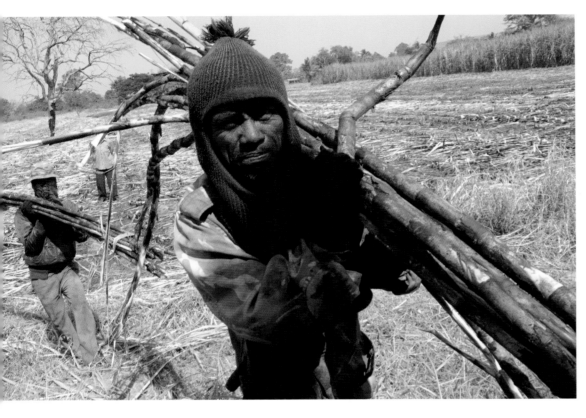

ABOVE: A labourer hauls away sugar cane from a field in Khorat province.

Hans Hoefer, Germany

RIGHT: Farmers in Ayutthaya province prepare the rice field for the next season by spreading hay over the water. The women cover themselves from head to toe to protect themselves from the sun.

Kaku Suzuki, Japan

FOLLOWING PAGES: Farmers harvest a rice field in Chiang Rai province in northern Thailand. Rice plantations dominate much of the country's landscape. Rice is often harvested in small family farms in the traditional manner: it is beaten by hand in the fields before it is carried into the villages, where it is stored and then sold.

Yann Arthus-Bertrand, France

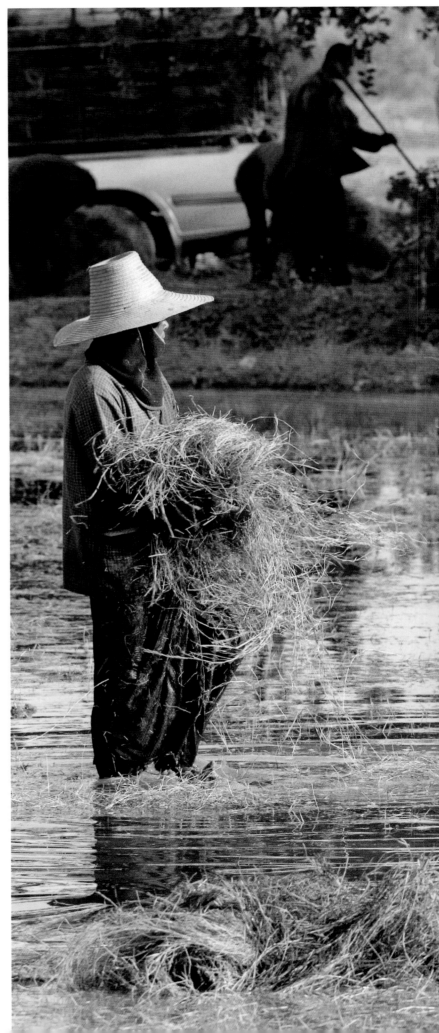

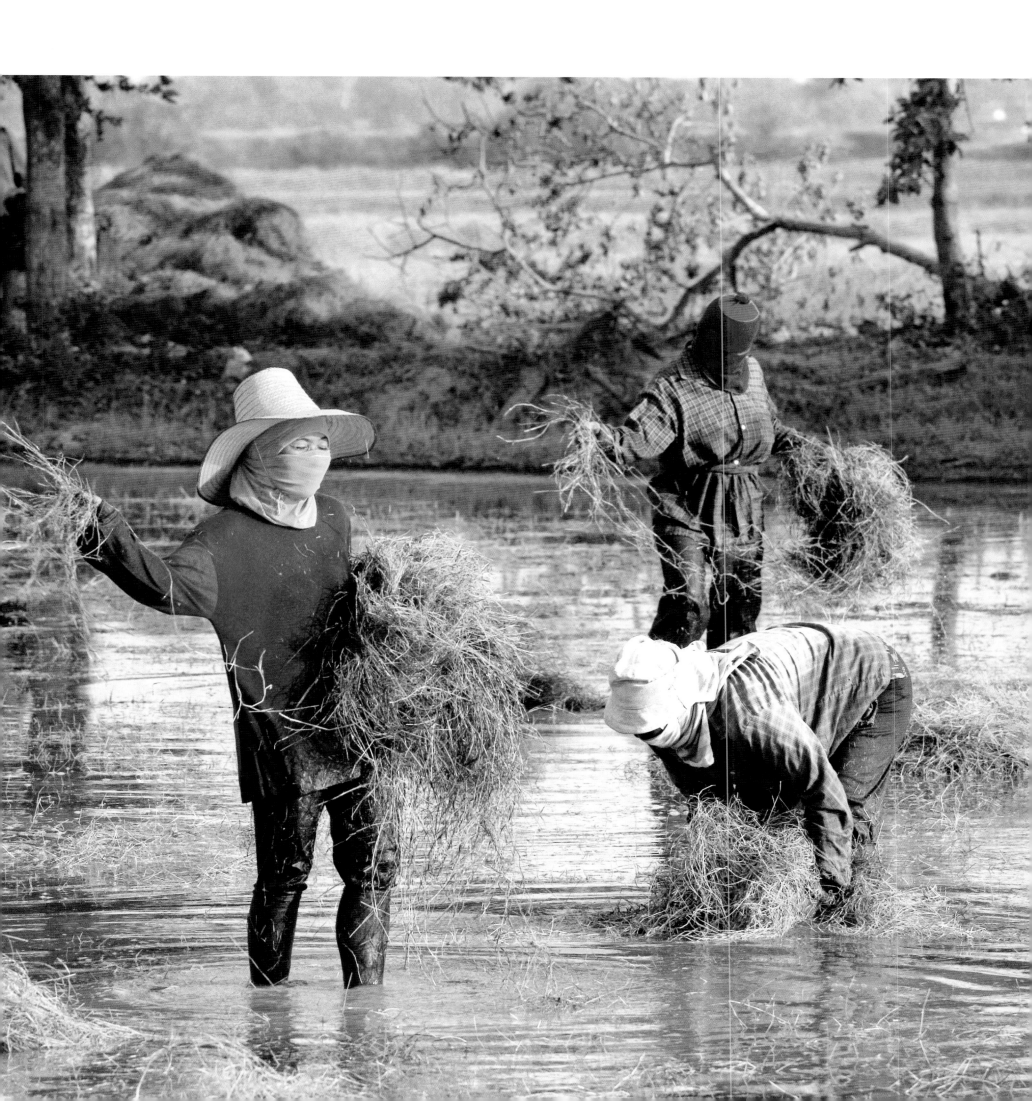

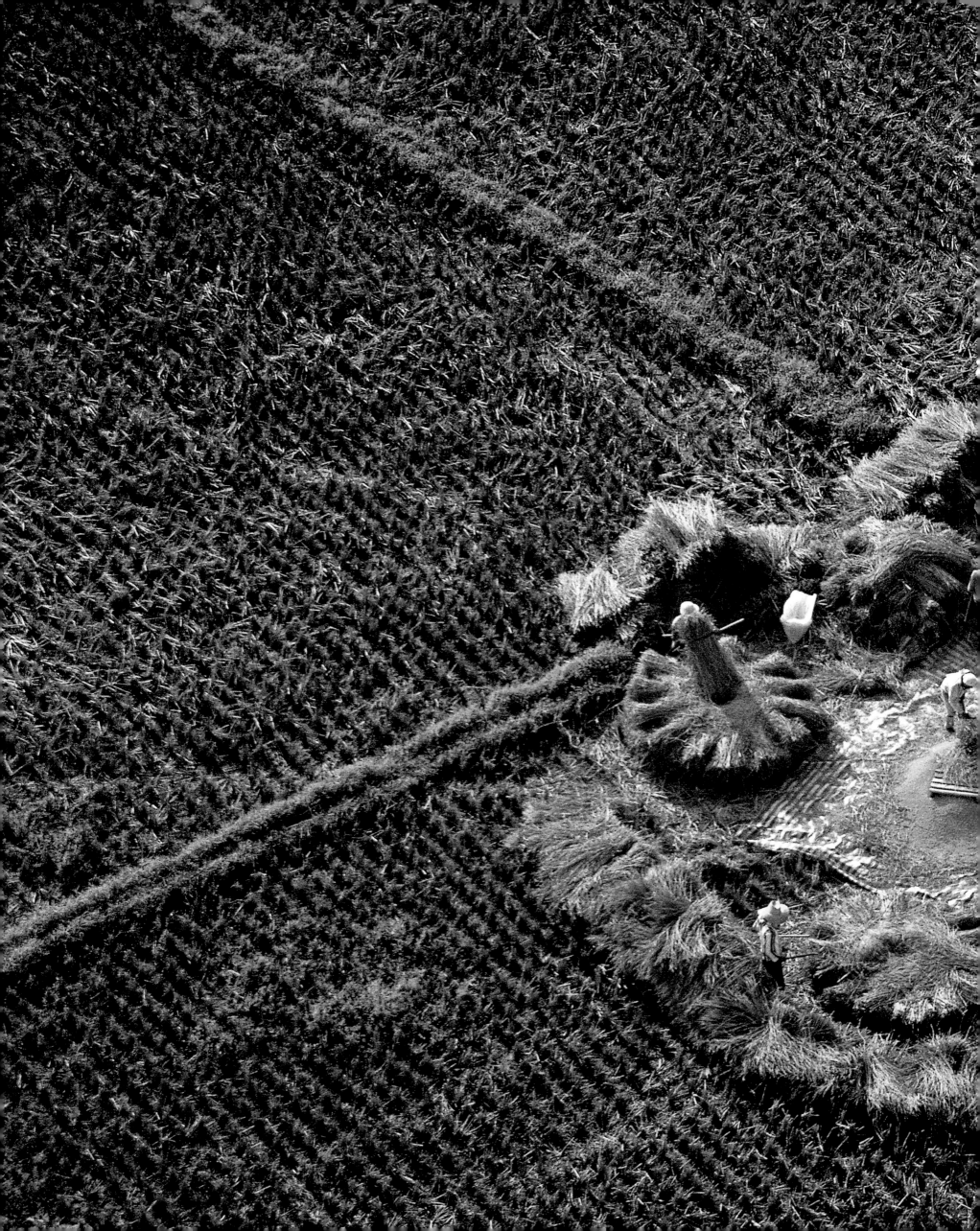

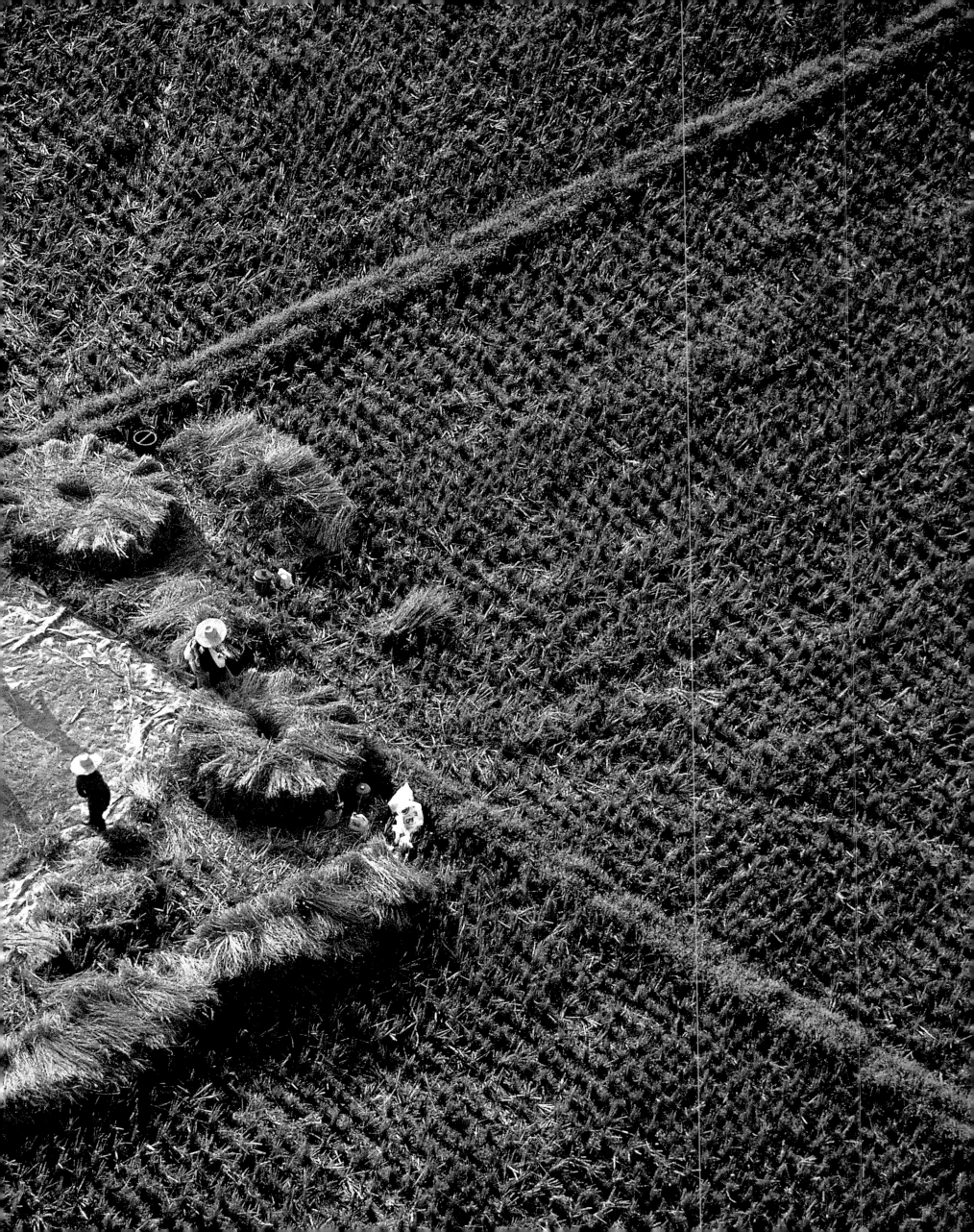

ABOVE: A worker at a Mitsubishi car factory in Laemchabang, just outside of Bangkok. Thailand, the self-proclaimed 'Detroit of Asia', is becoming a major manufacturer of automobiles. There are nine major companies with production facilities in the country.

RIGHT: A Mitsubishi employee inspects a vehicle on the assembly line at the plant.

Photos by Jeff Hutchens, USA

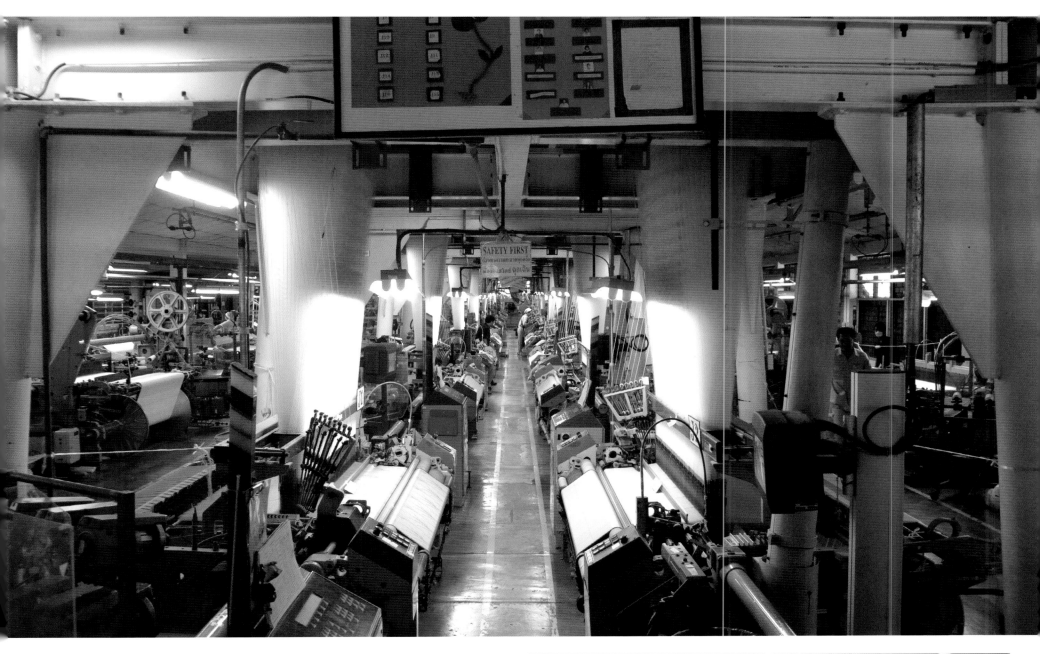

ABOVE: Inside the Jim Thompson Thai Silk Company's factory in Khorat province. During the 1950s and 1960s, the company's founder, American Jim Thompson, revitalised the cottage silk industry. Thompson employed thousands of home weavers to create Thai silk's signature bright colour combinations, giving birth to what is now a major textile industry.

RIGHT: While the company has modernised in order to meet worldwide demand, traditional methods are also still employed.

Photos by Hans Hoefer, Germany

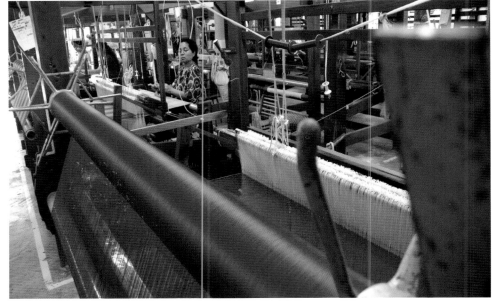

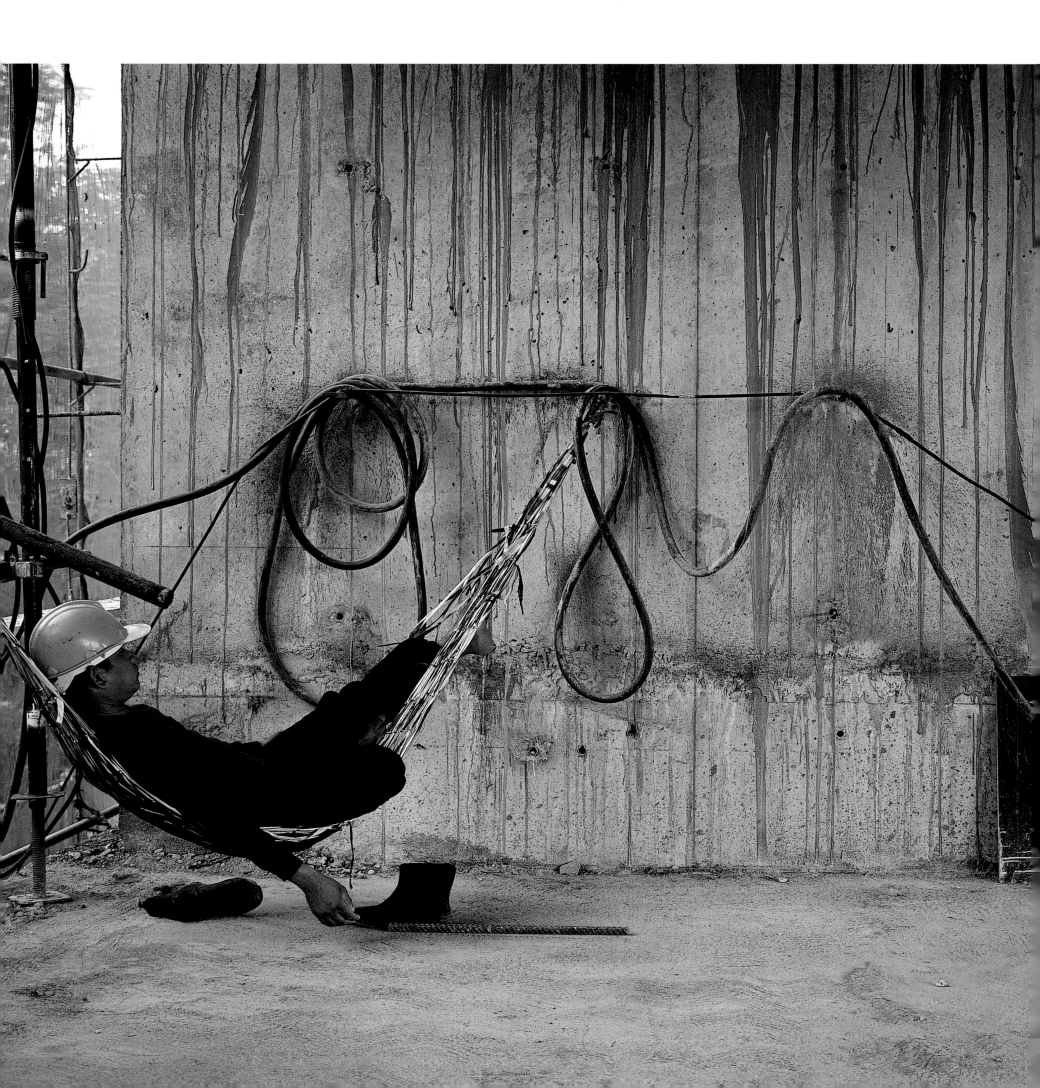

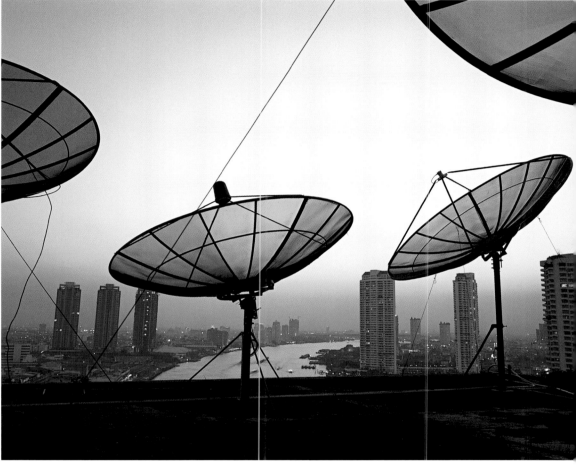

LEFT: At a Bangkok construction site, a labourer takes a nap on a hammock which is rigged to the building he's helping to build. Most construction workers come from Thailand's northeast and live on the site itself. Earning around US$5 per day, they typically work for a few months before returning to their villages for the harvest.

ABOVE: Satellite dishes on top of a hotel located on the banks of the Chao Phraya River.

Photos by
Chien-Chi Chang, USA

Construction workers in Bangkok are in the early stages of building a new luxury condominium. Condominiums are developed not only for the Thai market but for expatriates and wealthy executives from international companies with operations in the city.

Chien-Chi Chang, USA

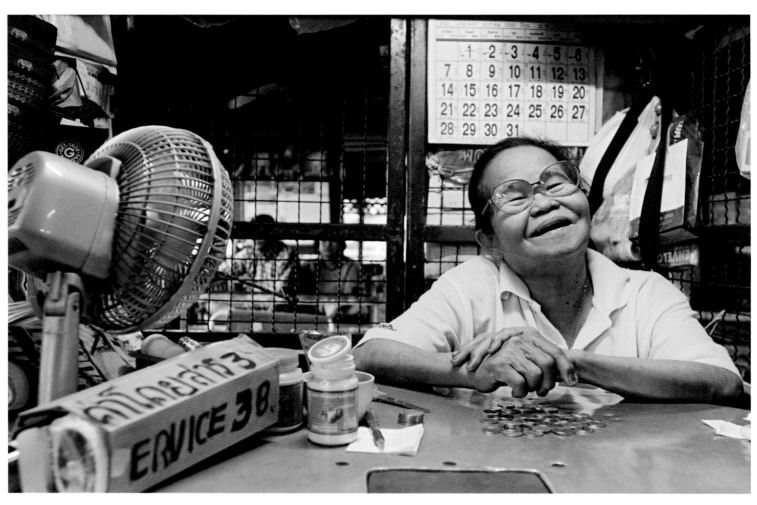

ABOVE: A woman sells tickets for the ferry at a pier on the Chao Phraya River.
Dominic Sansoni, Sri Lanka

BELOW: An artisan welds an alms bowl in the small Bangkok alley known as Ban Baht ('Monk's Bowl Village'). This 'village', which was established during the reign of Rama I, consists of a handful of families who still make the bowls by hand.
Raghu Rai, India

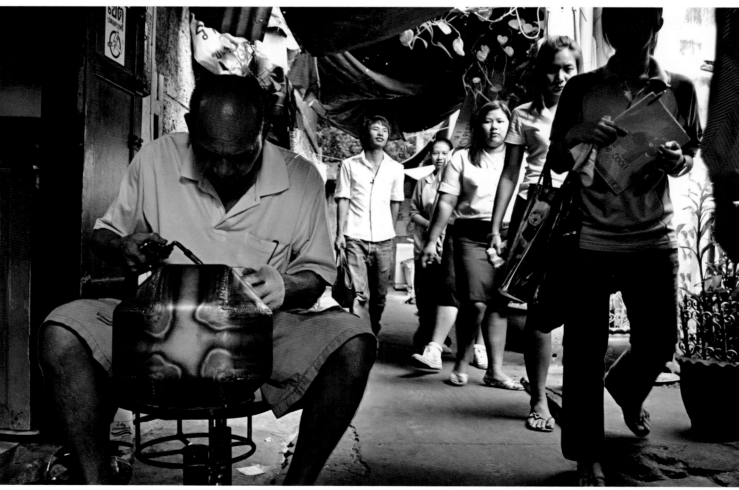

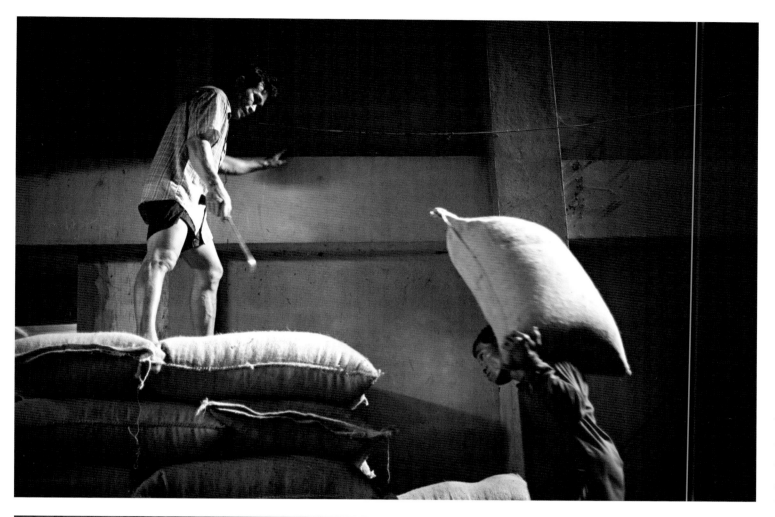

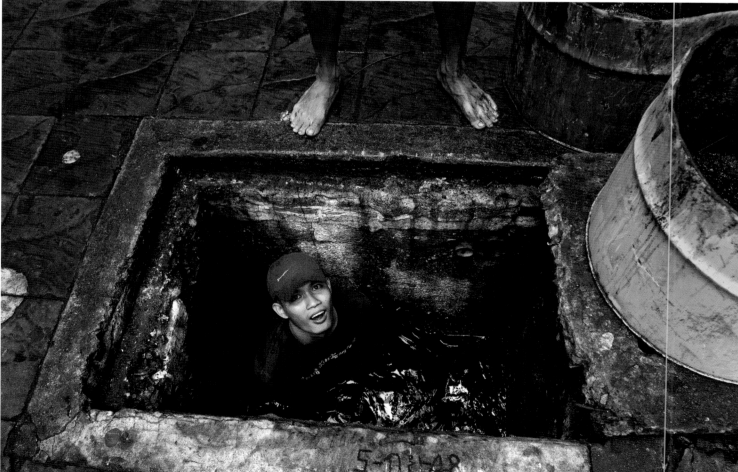

ABOVE: In Chinatown, labourers load sacks of peanuts in the early morning.

Jeff Hutchens, USA

BELOW: Along Silom Road, located in the heart of Bangkok, a municipal worker stands almost chin-deep in reeking muck—all part of a day's work cleaning sewers.

S. C. Shekar, Malaysia

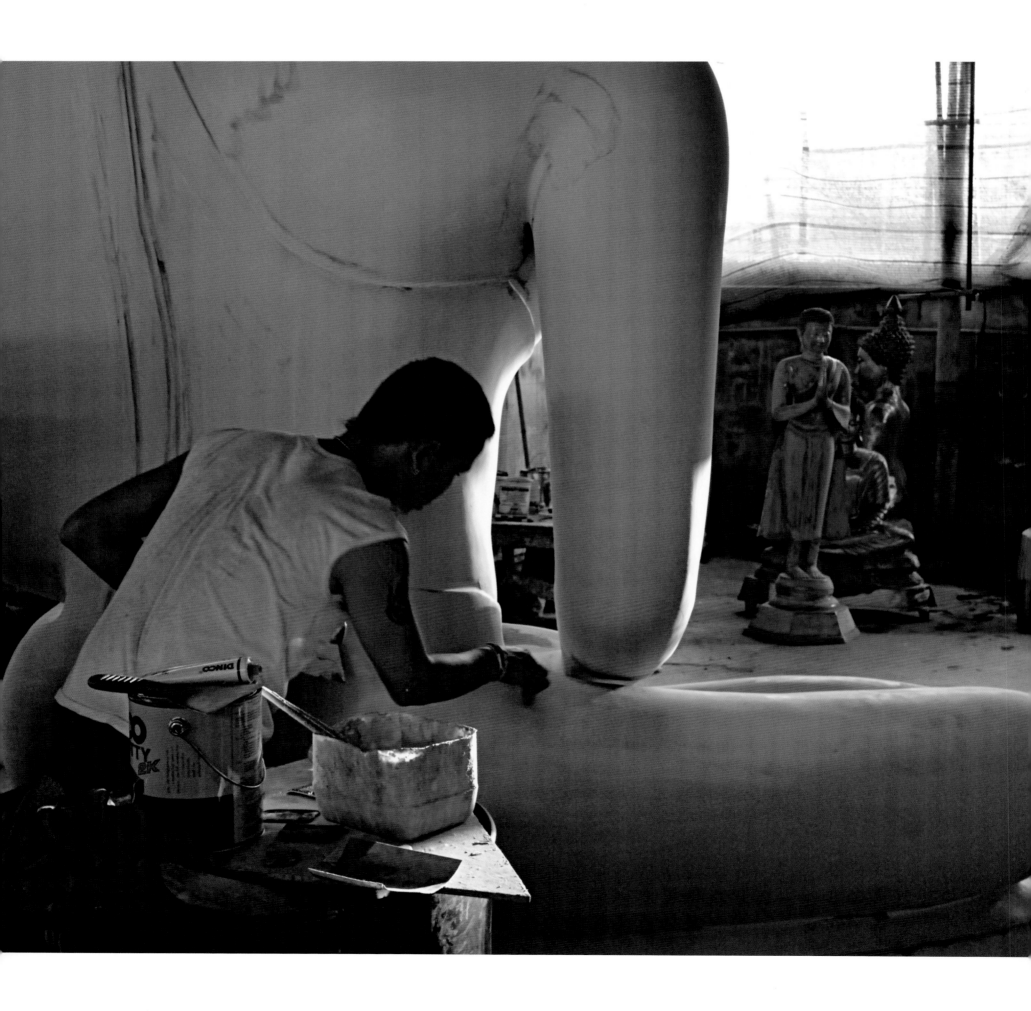

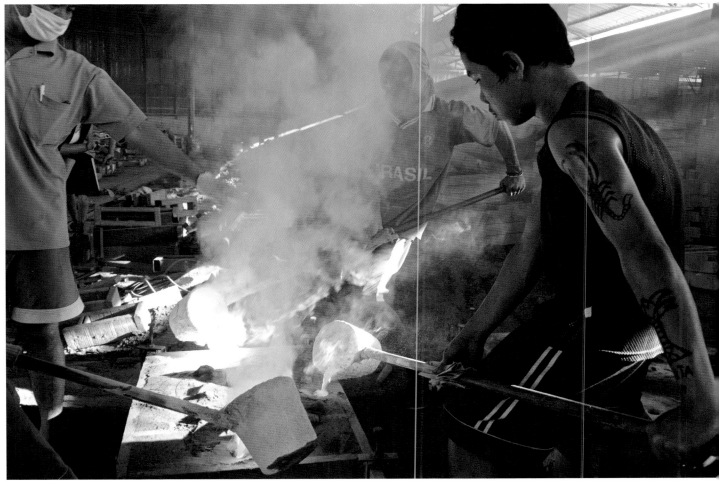

Sculptors and metalworkers cast Buddha statues using the lost wax method in the province of Ratchaburi.

Raghu Rai, India

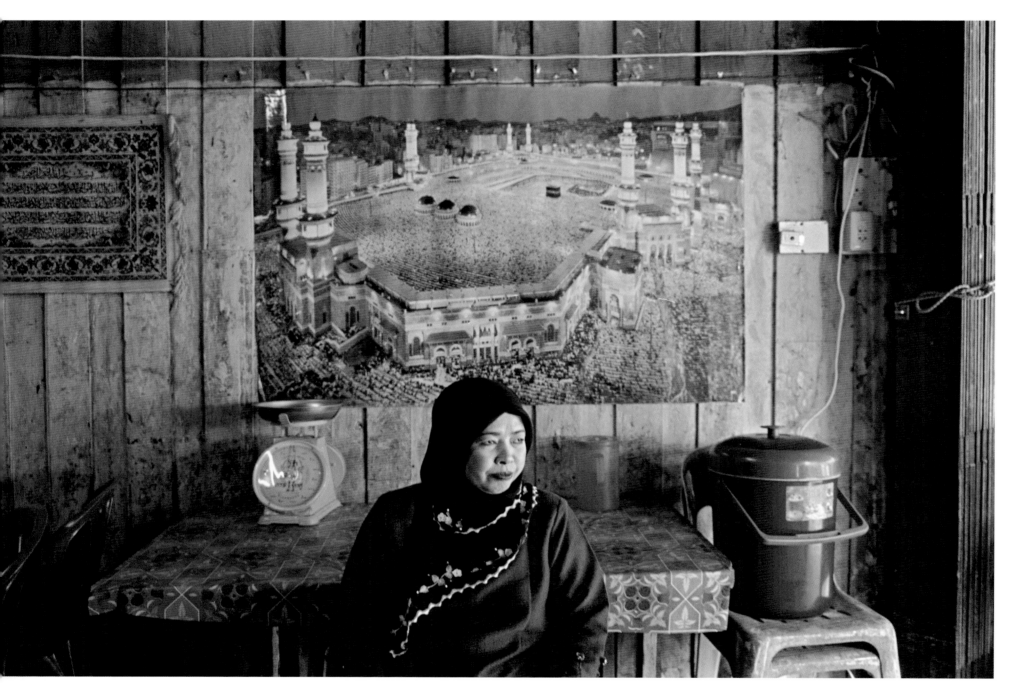

In Saiburi, Pattani province,
a Muslim woman sits in front
of a poster of Mecca in the
restaurant where she works.

Abbas, France

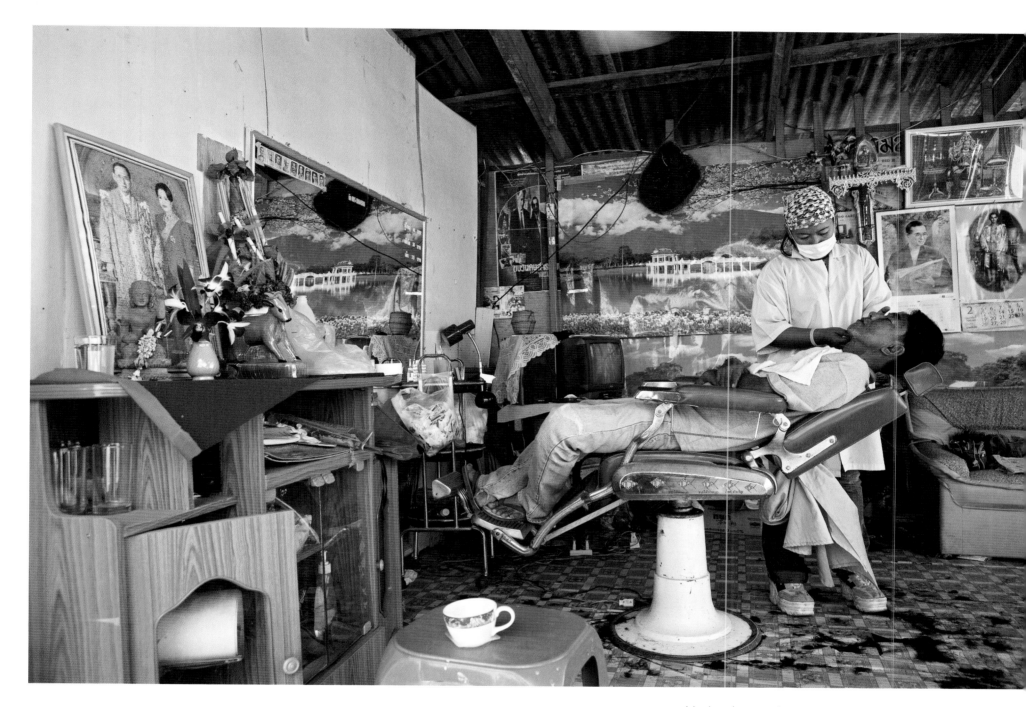

A barber gives a customer a shave in his shop in Chong Mek, Ubon Ratchathani. The barber has adorned his shop with pictures of His Majesty the King and wears a yellow bracelet in his honour. The bracelets became popular during the Diamond Jubilee celebrations of 2006.

Bohnchang Koo, South Korea

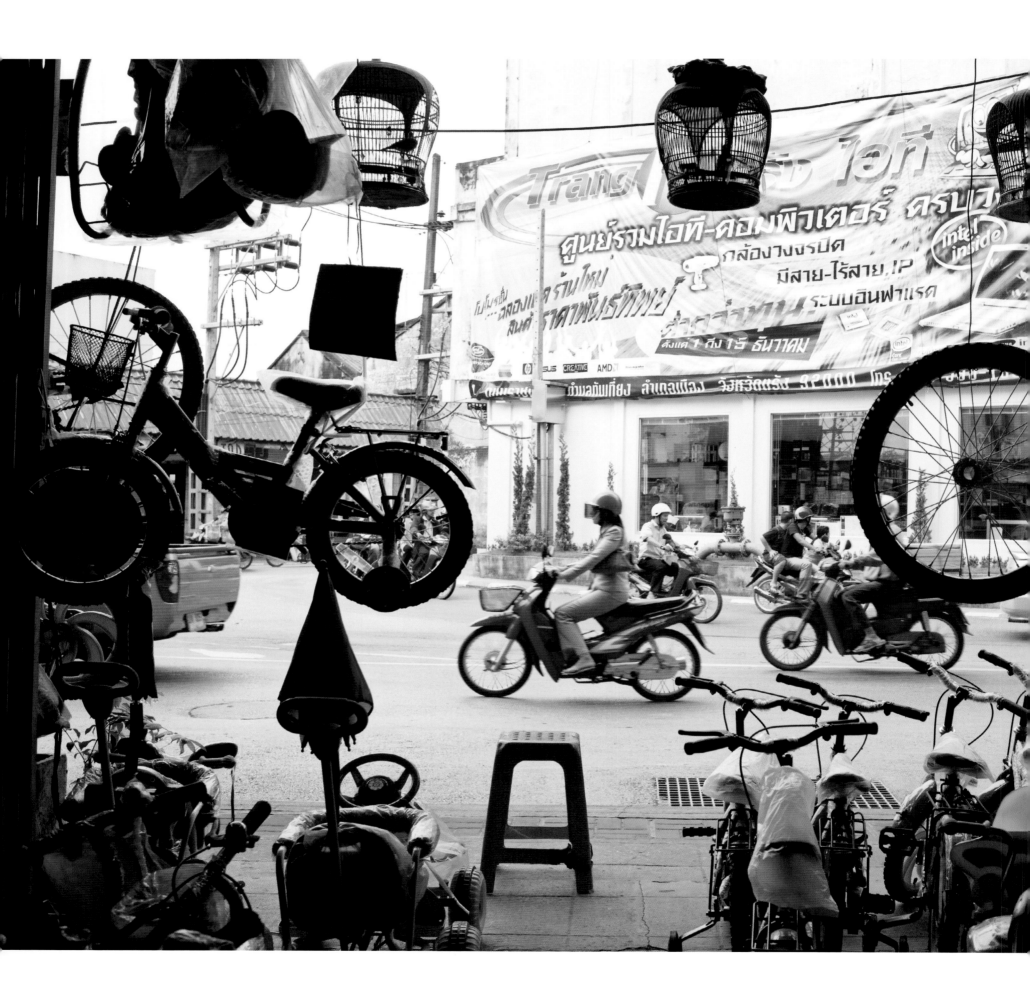

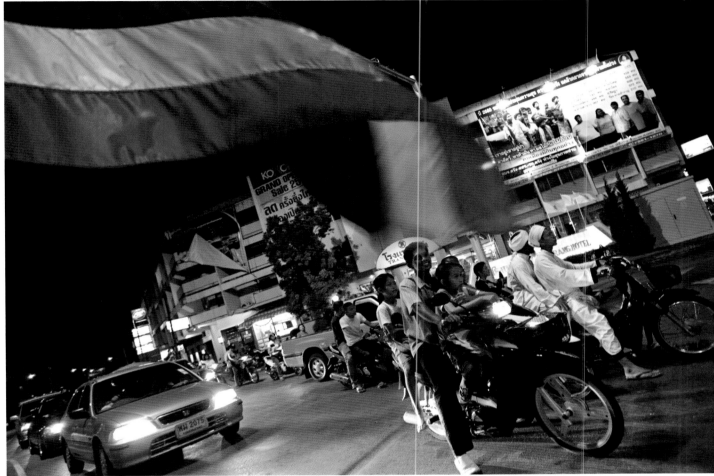

LEFT: A typical shop in Trang, southern Thailand, offers a variety of bicycles. As rural areas have urbanised, the motorcycle has replaced the bicycle as the main mode of transportation.

ABOVE: Motorcyclists wait for the green light at an intersection in Trang. More than 50 per cent of Thais now live in urban areas, with many leaving the countryside to take up work and residence in provincial centres.

**Photos by
Ernest Goh**, Singapore

Elusive Peace

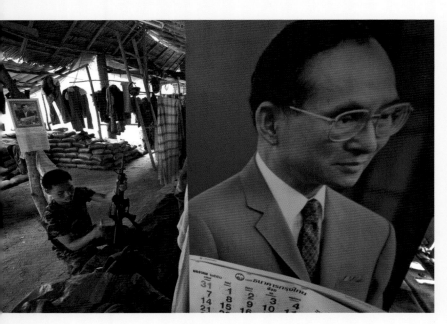

Home to 1.3 million ethnic Malay Muslims, the provinces of Yala, Pattani and Narathiwat are distinct from the rest of Thailand in terms of their culture, language and topography.

Palm-fringed lanes connect a network of small villages, which are signposted in Arabic script. Men, young and old, sit in the shade during hot, tropical afternoons, sipping strong local tea and smoking hand-rolled cigarettes at small roadside tea shops. And, in stark contrast to the rest of Buddhist-majority Thailand, understated mosques, adjacent to centuries-old Islamic *pondok* schools, vastly outnumber the dazzling Buddhist temples.

Unfortunately, this existence on the fringes of mainstream Thai society has been blighted for decades by a bloody separatist insurgency, one that has resurfaced with a vengeance since January 2004. In recent years, daily drive-by assassinations, roadside bombings and arson attacks have left more then 2,300 people dead, thousands more injured, and there is no sign of the violence abating any time soon.

Since the late 1960s, armed separatist groups have been waging a low-level insurgency against Bangkok rule in the hope of reviving the independent Islamic state of Pattani, which was formally annexed by Thailand in 1902. The origins of the conflict lie in historical grievances from more than 100 years of perceived discrimination against the largely Malay-speaking peoples of this far-flung region.

The resurgence of violence in 2004 is thought to be a result of the disbanding of key government security networks in the region and increasing resentment due to persistent allegations of human rights abuses and a lack of access to justice for the Malay Muslim population. The heavy-handed policies of former Prime Minister Thaksin Shinawatra's administration were often blamed for further aggravating the conflict, but any hopes that the situation would begin to settle down following Thaksin's removal in the 19 September 2006 coup were quickly dashed.

The year 2007 saw the violence steadily escalate, with growing numbers of Thai security forces and both Muslim and Buddhist civilians killed by an increasingly organised and brutal rebel force. Government forces, holed up in Buddhist temples and makeshift army bases, remain unable to rein in their unknown enemy. The spiralling violence has increased fears that Thailand's internal problems may escalate further with the involvement of regional and global Islamic terror groups such as Jemaah Islamiya.

While Thais across the kingdom and the vast majority of local villagers want a peaceful resolution, the situation is far from straightforward. In the rubber plantations and tea shops of the deep south, the people both fear the militants and remain mistrustful of the Thai authorities: accusations of kidnapping, assassination and torture of local Muslims at the hands of Thai security forces remain persistent and unresolved. And with no sign of security forces and intelligence units infiltrating the shadowy networks of separatists hidden amongst the jungles and villages of this otherwise charming region, it seems peace will remain elusive for the foreseeable future.

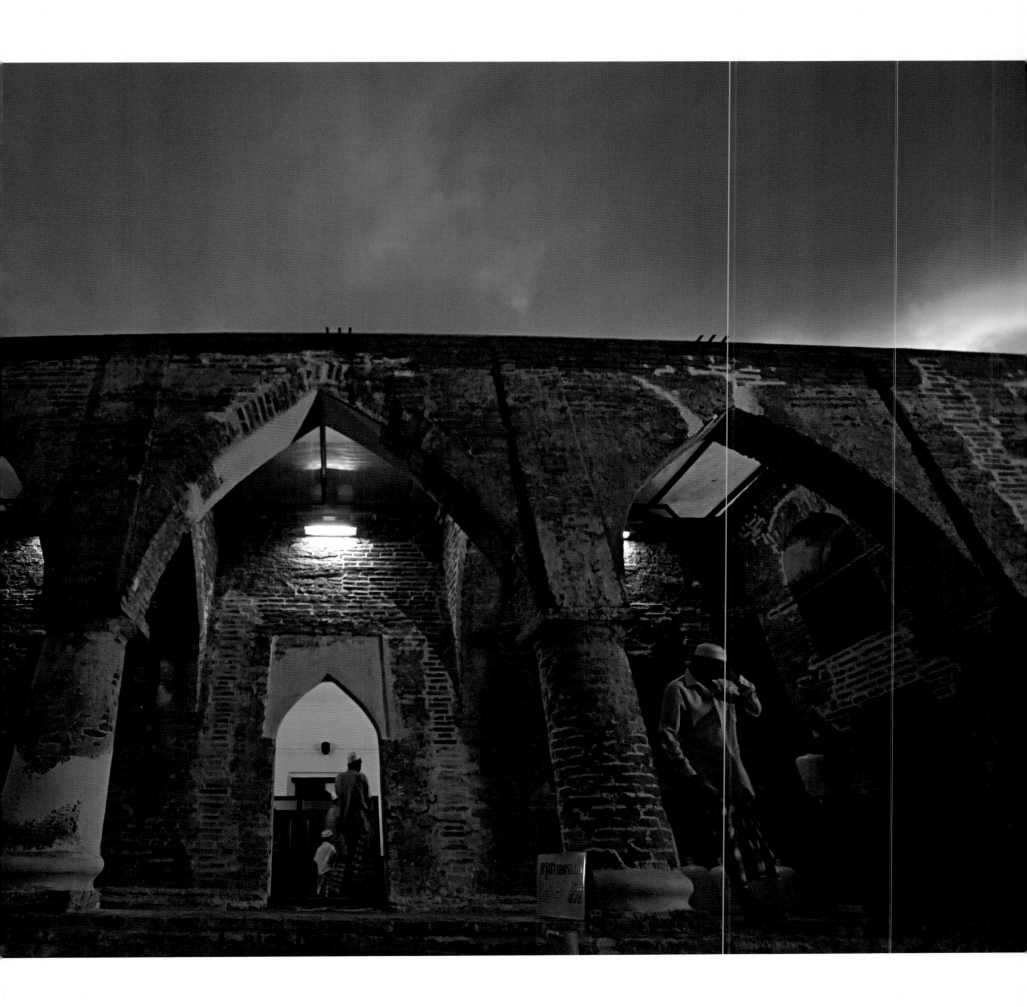

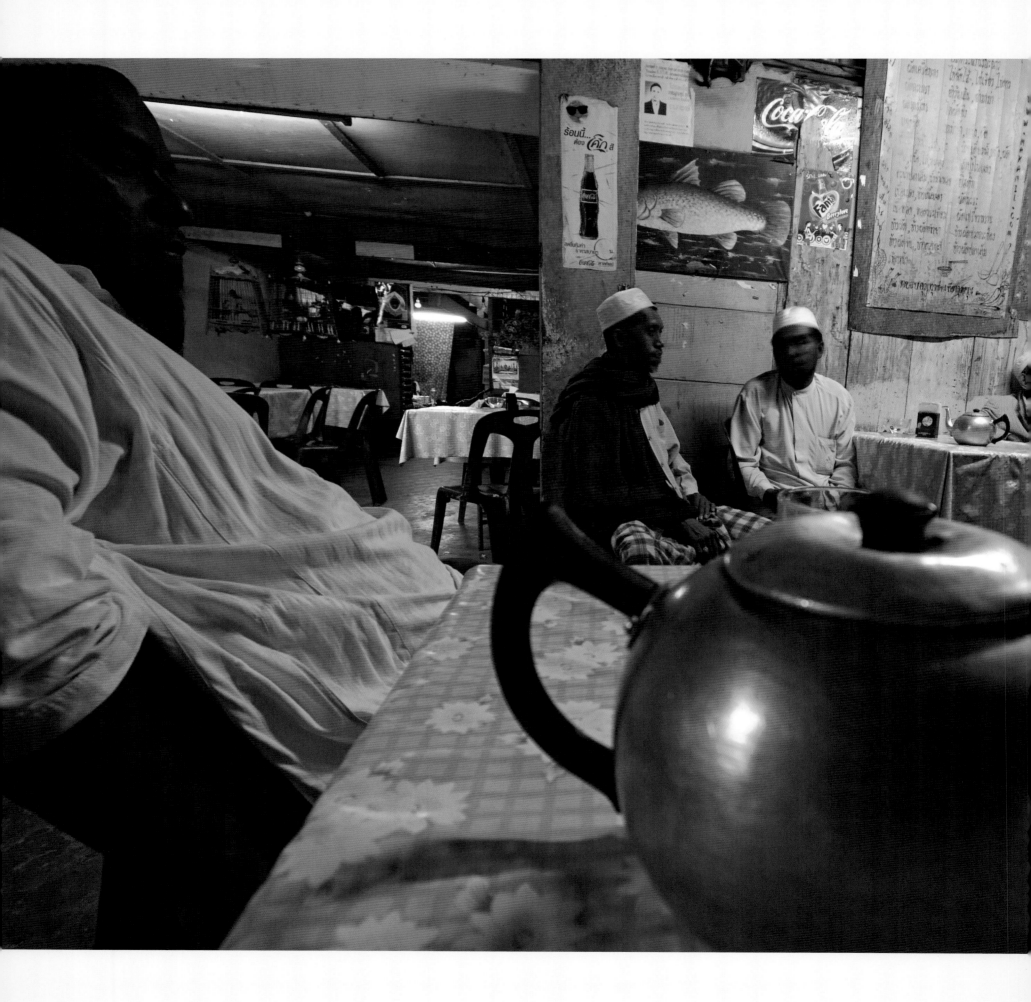

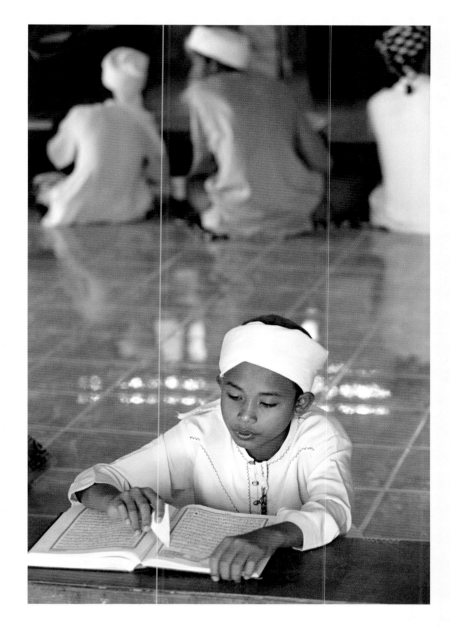

PRECEDING PAGES (FROM LEFT): A soldier cleans his rifle in the living quarters of the resources development and reservation troop at Ban Joh Ka Po in Ka Po district, Pattani. This troop is stationed inside a so-called 'red zone', where separatist violence is common.

Charoon Thongnual, Thailand

Krue Se mosque is the holiest site in Pattani and has also become a reluctant symbol of the violence that plagues the region. On 28 April 2004, 32 militants hid in the ancient mosque after attacking police outposts and checkpoints across the deep south. After a tense stand-off with the army, all of the militants were killed in a raid by soldiers.

Charoon Thongnual, Thailand

LEFT: Inside a tea shop near Krue Se mosque in Tonyong Luloh. The shop is a meeting point for local people before and after the salat (prayer).

Charoon Thongnual, Thailand

RIGHT: In the Dalawiya pondok (Islamic school) in Dalo, the Quran is memorised by rote by students who do not speak Arabic.

Abbas, France

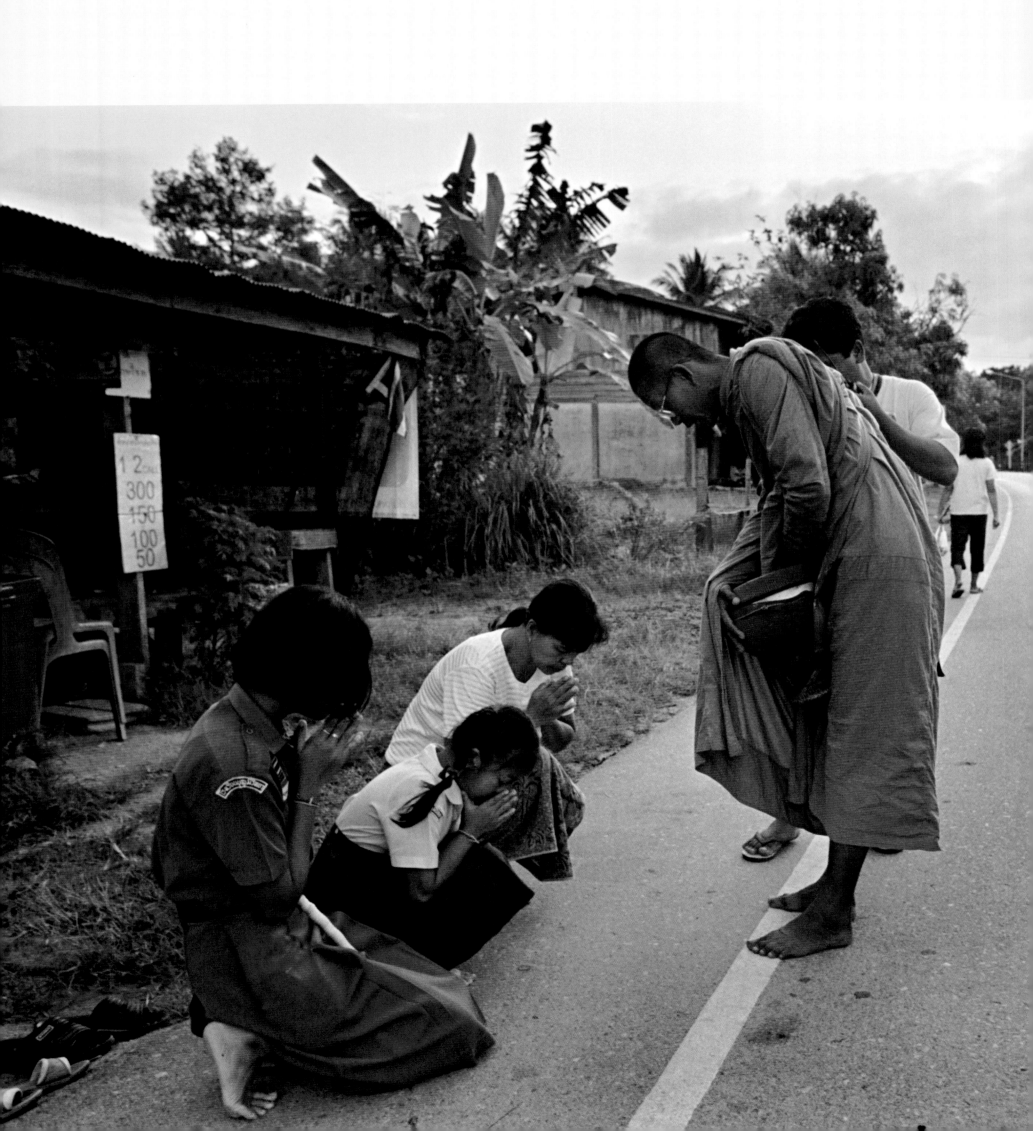

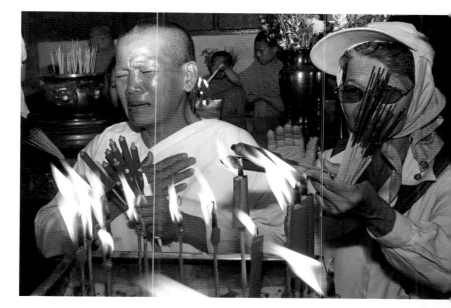

LEFT: In Songh Kai village, Pattani, Buddhist monk Phra Rung Rudang is given alms by villagers at dawn. He is protected by an armed militia man as even monks have not been spared from the violence.

Abbas, France

RIGHT (TOP): This joss house in Pattani, home to the goddess Chao Mae Lim Ko Niao, used to be a popular pilgrimage site among Thai-Chinese as well as overseas tourists. Due to the unrest, it sees far fewer visitors today.

Charoon Thongnual, Thailand

RIGHT (CENTRE): In Pattani's Wat Sathitchonlathan, Buddhist monk Phra Dang tattoos a soldier. Believing the tattoos will protect them from injury, soldiers commonly request them from local monks.

Abbas, France

RIGHT (BELOW): In Wat Yuparam, Yala province, family members attend a Buddhist ceremony in memory of a female relative killed by separatists.

Abbas, France

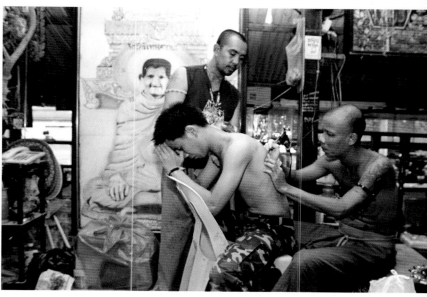

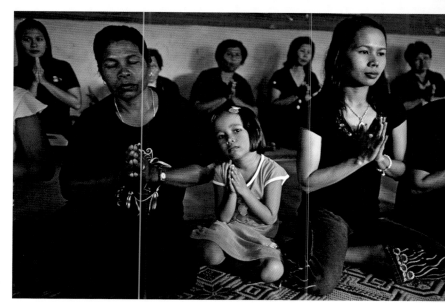

Her Royal Highness Princess
Maha Chakri Sirindhorn
makes a royal visit to observe
and offer support to the
education system in the south.
In this picture, she is at the
Muslim Pittayakhom School
in Pattani province. Due to
language barriers and cultural
differences, many ethnic
Malay families have struggled
to adapt to the Thai school
system. In order to disrupt civic
life and wage war on state-
related institutions, separatists
also target schools, frequently
burning them to the ground.

Kraipit Phanvut, Thailand

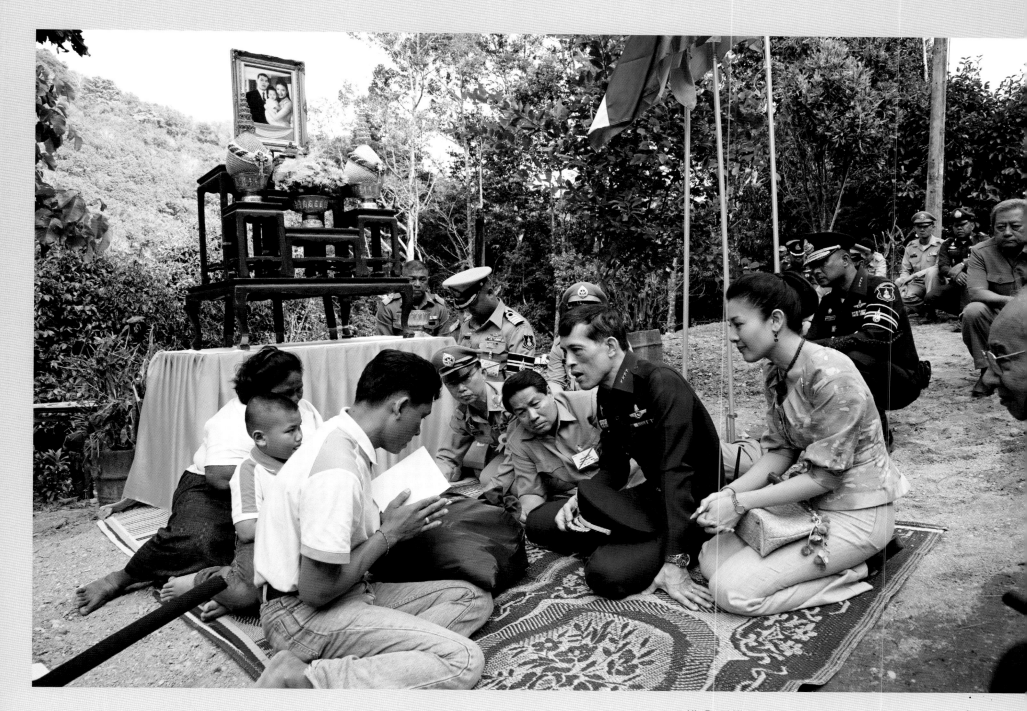

His Royal Highness Crown Prince Maha Vajiralongkorn and Her Royal Highness Princess Srirasmi listen attentively to the problems facing their subjects in Yala's Tarntoe district. The Thai-Muslim villagers there are facing problems developing their land. The deep south has traditionally suffered more from poverty than other areas of the country.

Kraipit Phanvut, Thailand

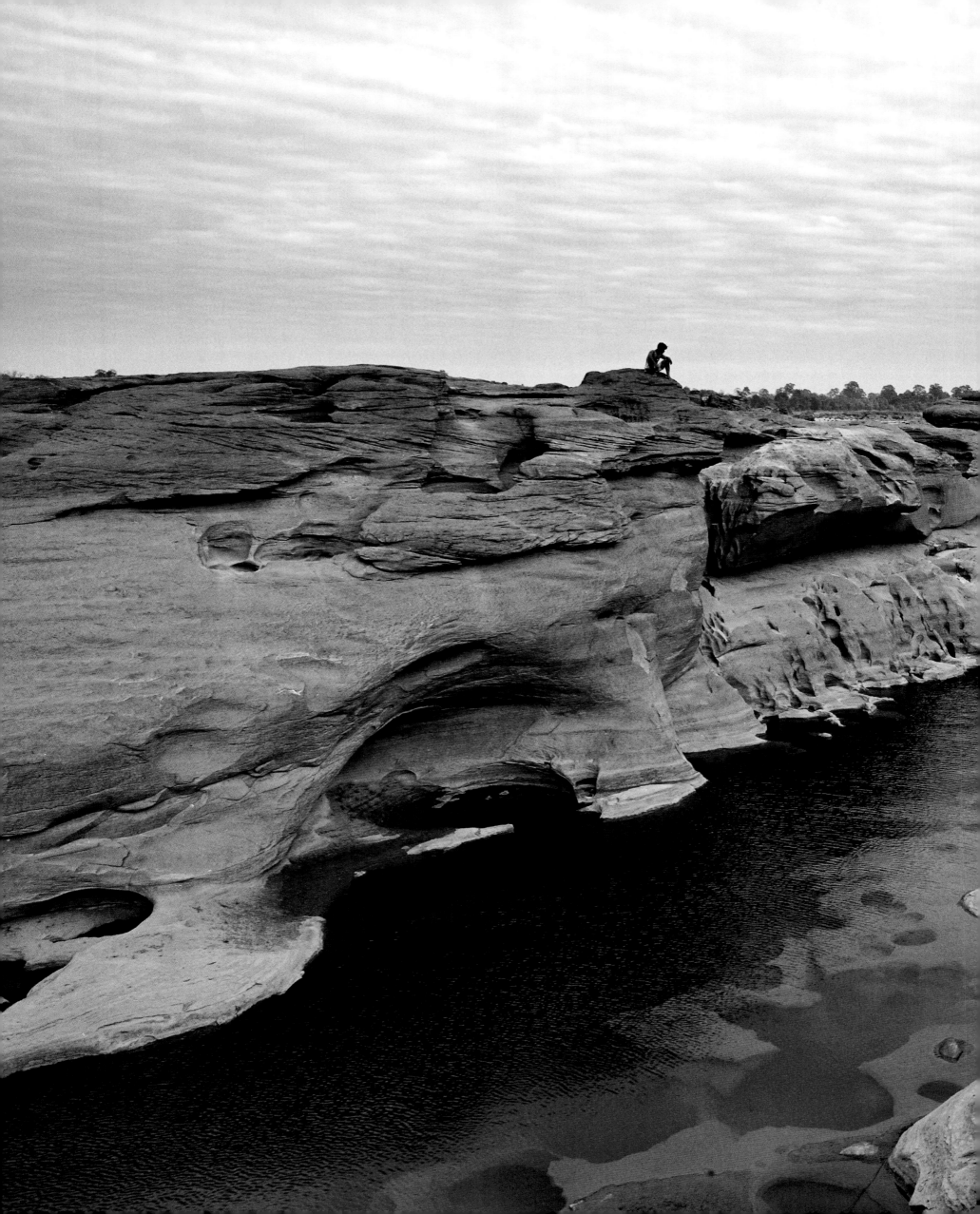

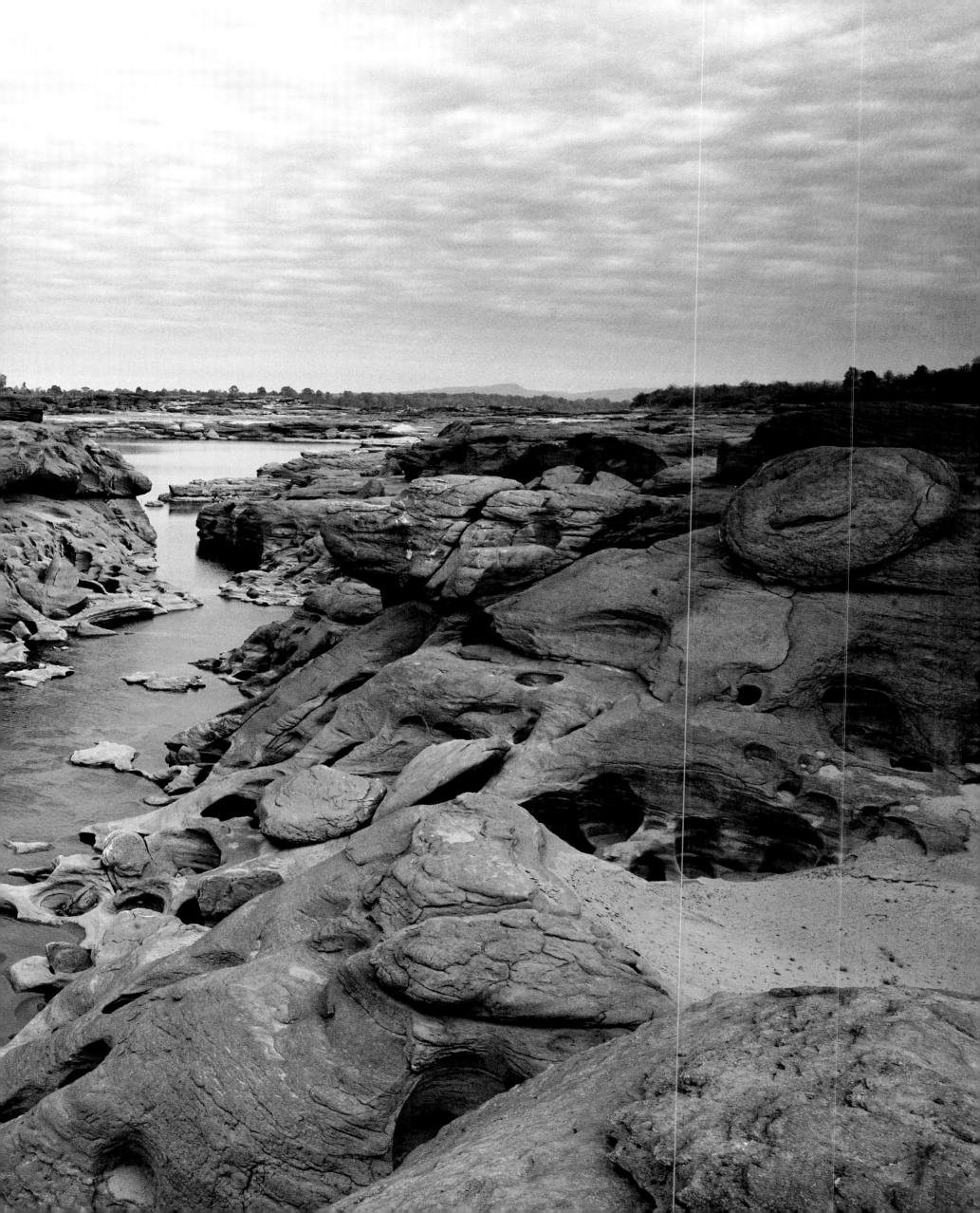

PRECEDING PAGES: The Mekong River has carved its sandstone banks into interesting formations in Kaeng Tana National Park in Ubon Ratchathani province. The area also features prehistoric cave paintings which reveal it was inhabited by humans many thousands of years ago. Sitting near the junction of Laos and Cambodia, the province today has a mix of Khmer, Laotian and Thai people and cultures.

Bohnchang Koo, South Korea

ABOVE: A standing Buddha statue in Wat Phra Si Iriyabot in Kamphaeng Phet.

Yann Arthus-Bertrand, France

RIGHT: An aerial shot of Kamphaeng Phet Historical Park, which is a UNESCO World Heritage Site. Located on the banks of the Ping River in the lower north of Thailand, the city was part of the Sukhothai kingdom and acted as a front line of defence against invaders.

Yann Arthus-Bertrand, France

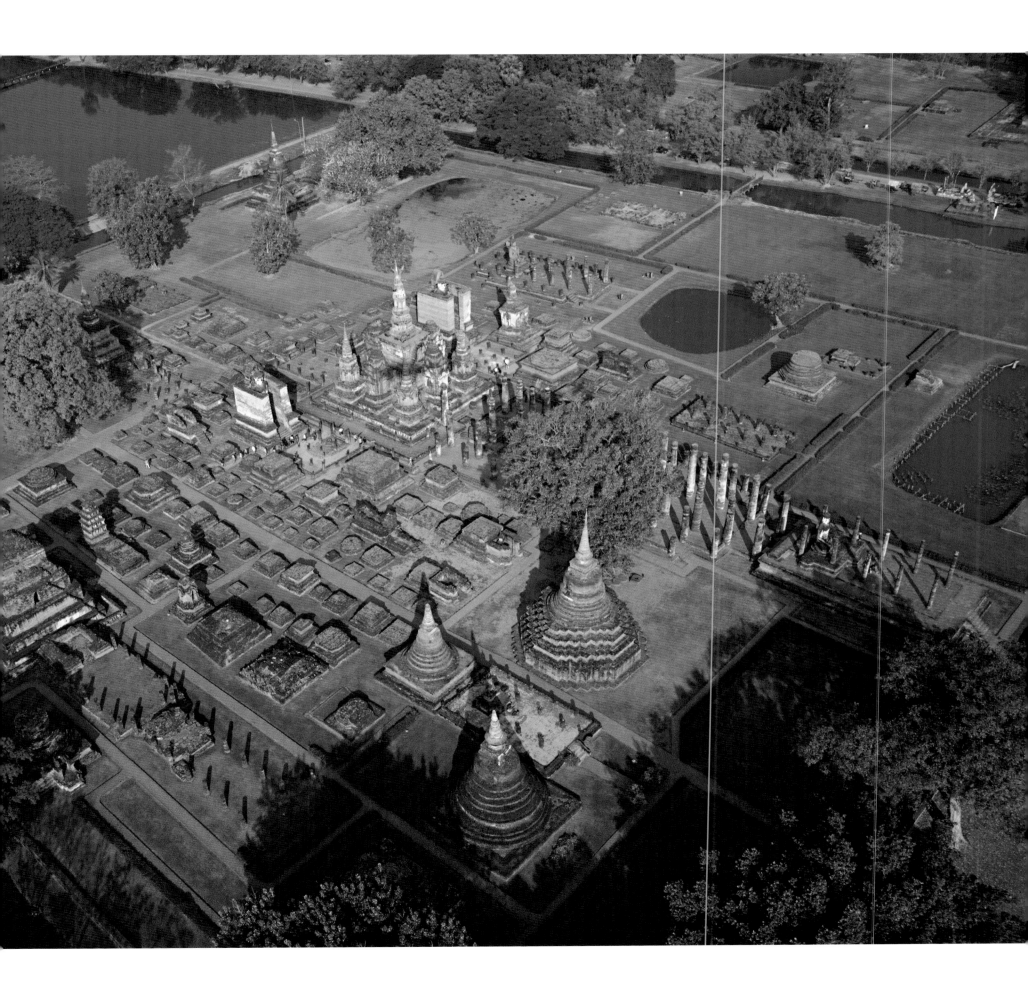

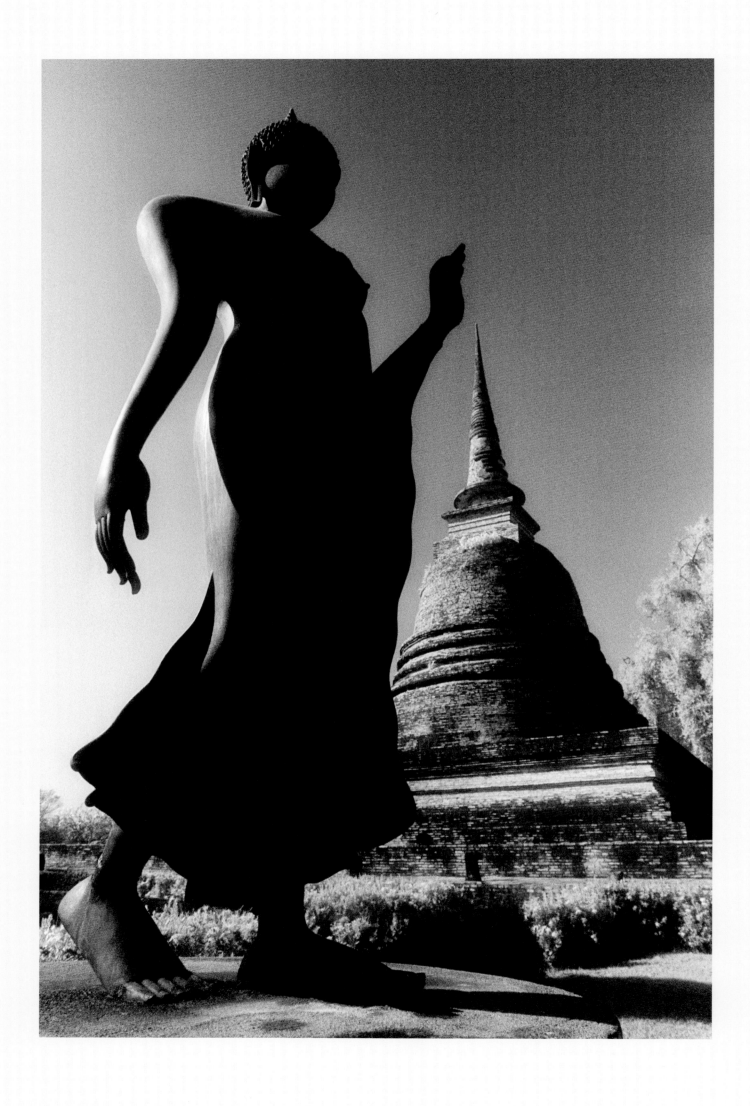

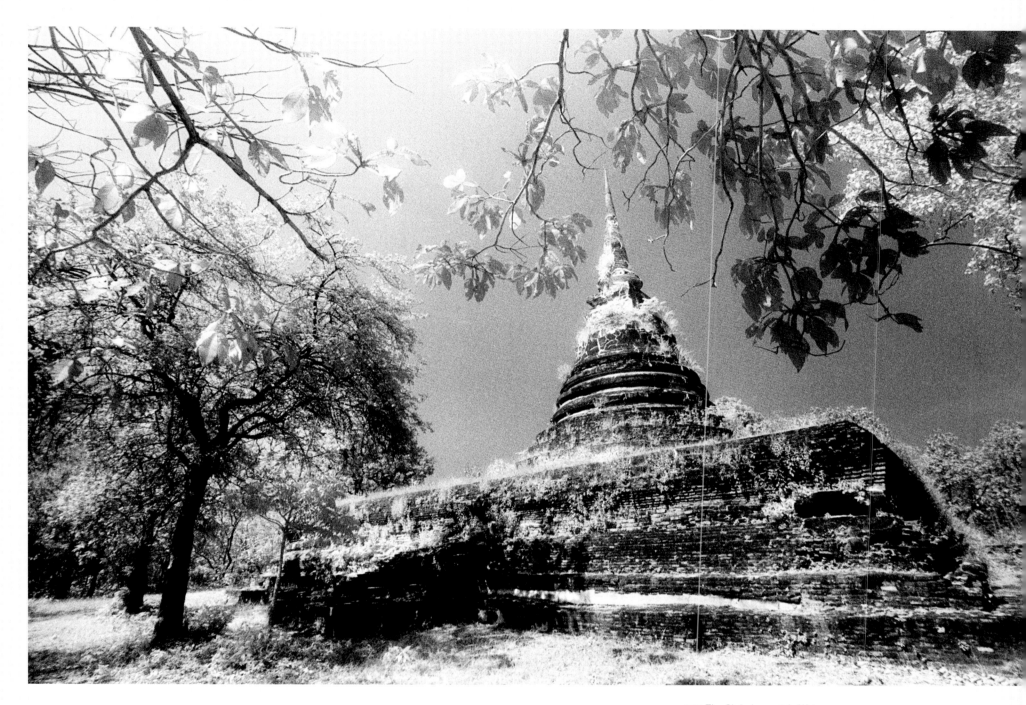

LEFT: The Sinhalese-style Wat Sa Si *chedi* (stupa) and bronze walking Buddha statue at Sukhothai Historical Park. The Sukhothai era is considered a golden age of Thai Buddhist imagery and architecture.

ABOVE: Wat Chedi Ngam, or 'Beautiful Stupa', is located on a hill and reached by a pathway of slate slabs. The Sinhalese-style *chedi* that has been left slightly unrestored gives the impression of a lost kingdom emerging from the jungle.

Photos by Martin Reeves, UK

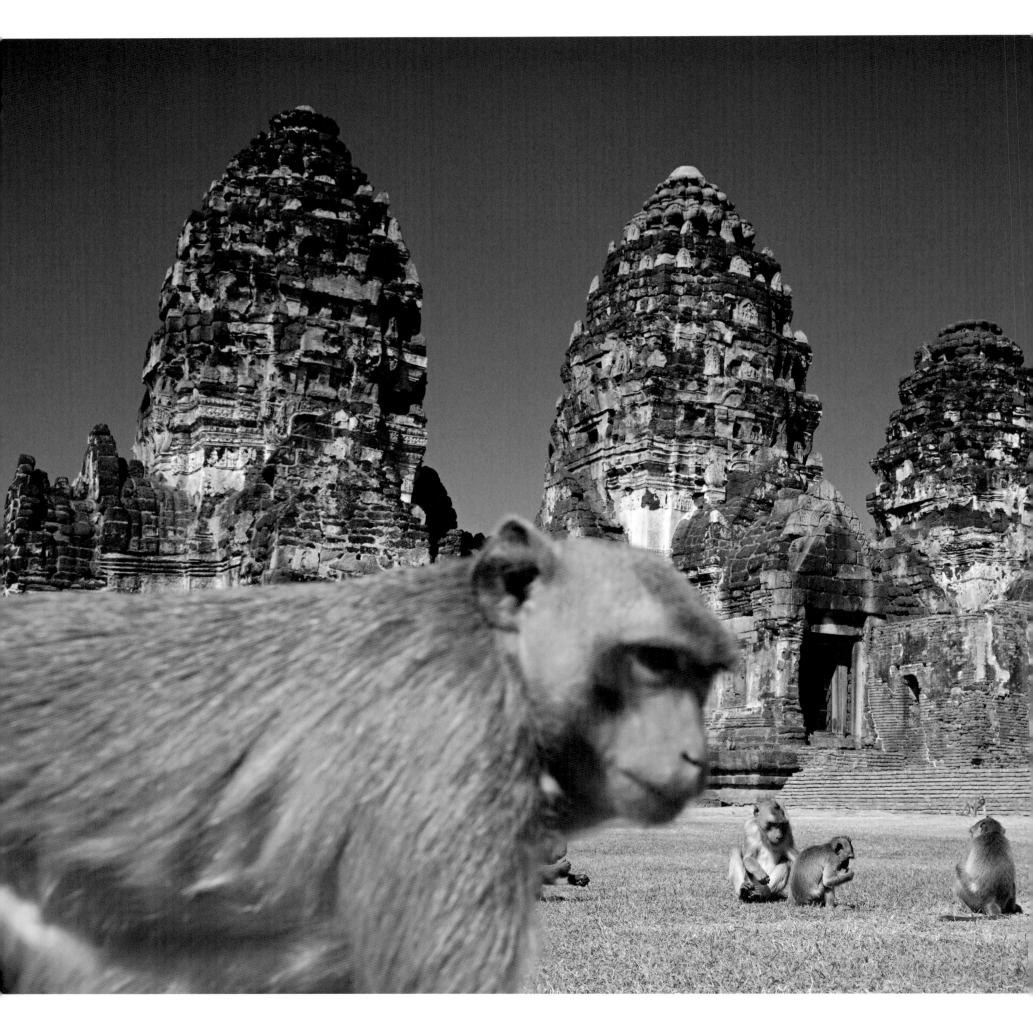

LEFT: Phra Prang Sam Yot in Lop Buri, like the entire town of Lop Buri, is overrun with macaques. The mischievous monkeys have become a tourist attraction themselves and, every year at this Khmer temple, a festival complete with a banquet of bananas, cabbage, boiled eggs and more, is held in their honour.

Kaku Suzuki, Japan

RIGHT: An Estonian tourist with a tattoo of Jesus on his back videotapes the gleaming *chedi* of the Temple of the Emerald Buddha, which houses Thailand's most important Buddha image. The site, with its fantastically ornate Buddhist architecture, is the first stop for many visitors to the kingdom.

Dow Wasiksiri, Thailand

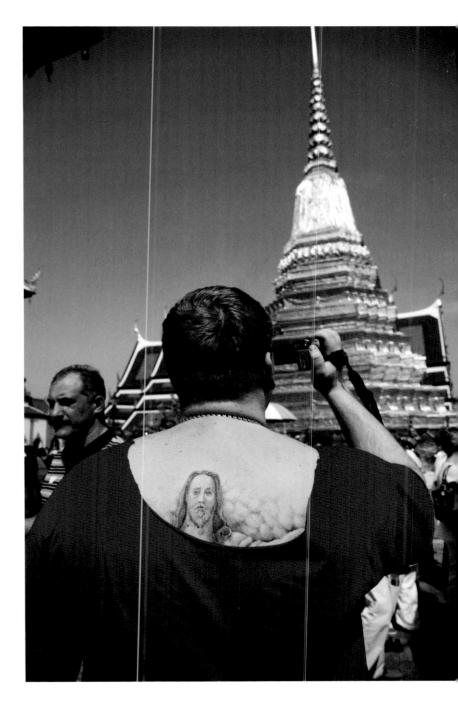

LEFT: Inside Wat Sri Chum in Sukhothai, one-year-old and less than a metre tall Pinthong 'Yok' Thipree gazes up at an over 700-year-old, 15-metre-high Buddha statue. Accompanied by her mother and aunt, she holds an offering of lotus flowers.

Laura El-Tantawy, Egypt/UK

RIGHT: Scaffolding covers the hand of a Buddha statue under construction at Wat Muang in Ang Thong province. The statue has taken more than 10 years to build.

Romeo Gacad, Philippines

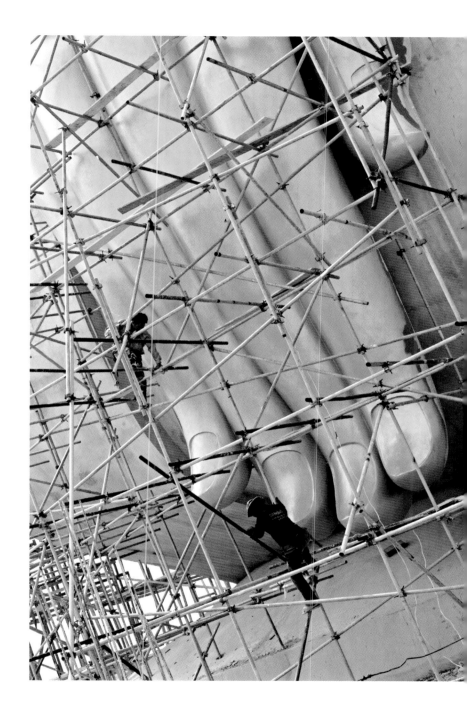

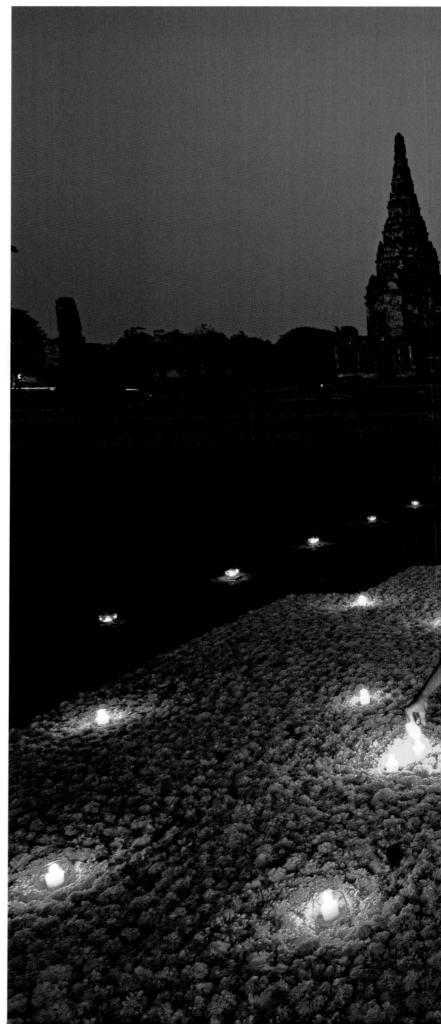

ABOVE: Inside the Grand Palace, the government's Fine Arts Department is painstakingly restoring the magnificent murals that line its walls. Here, an artisan is carefully resurrecting a scene from the *Ramakien*, Thailand's national epic, which is based on the Indian *Ramayana*.

S. C. Shekar, Malaysia

RIGHT: In front of Wat Chaiwattanaram in Ayutthaya, Sakul Intakul, Thailand's premier flower designer, creates an installation that pays homage to one of the kingdom's most treasured temples. He arranges yellow marigolds to form the same shape as a traditional Thai temple floor plan.

Catherine Karnow, USA

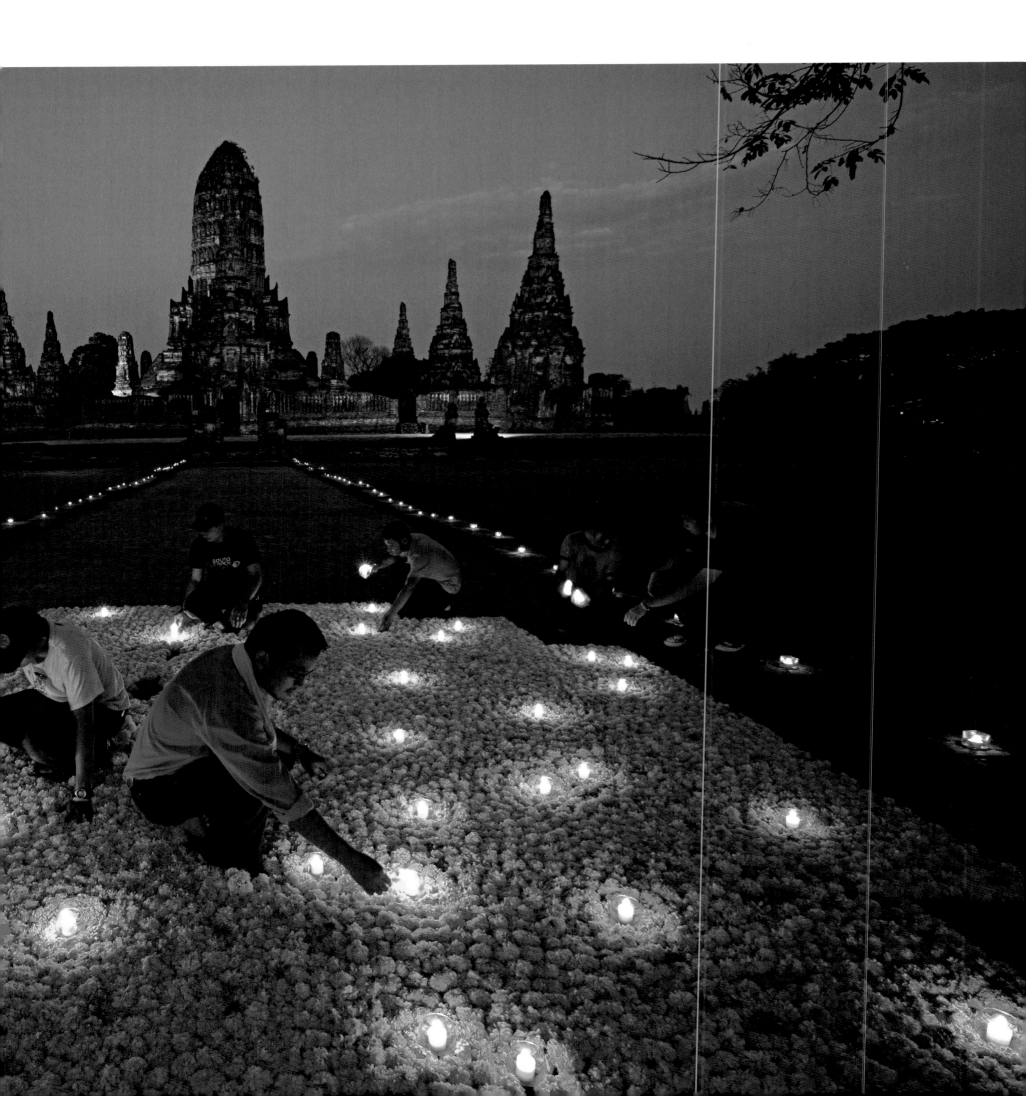

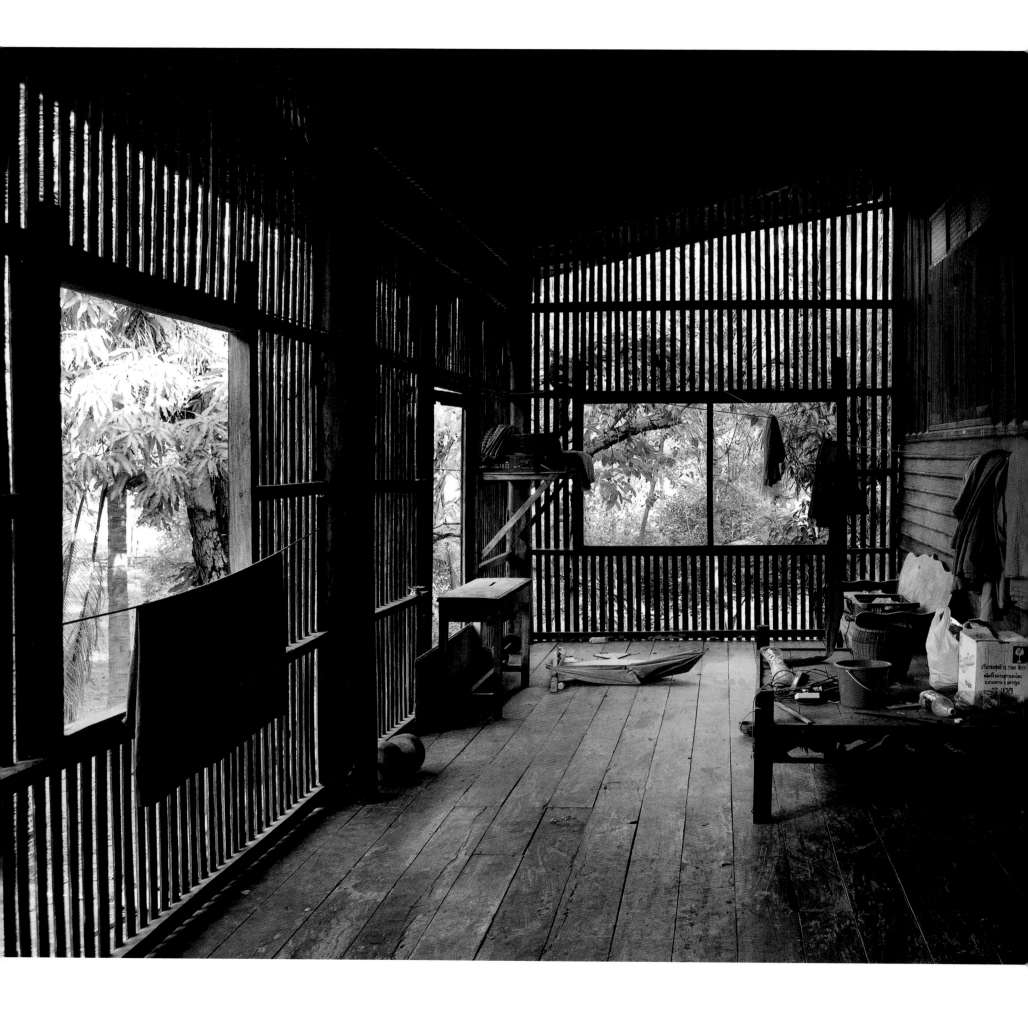

LEFT: Monks have hung their robes out to dry on the porch of their simple quarters at Wat Burapa Pa Ao Nue in Pa Ao village in Ubon Ratchathani. The residents of Pa Ao, one of the oldest villages in the province, make traditional bronzeware and silk.

RIGHT: A detail from a rest stop on the way to Sirindhorn Dam in Ubon Ratchathani.

FOLLOWING PAGES: Seen through the window of Wat Burapa Pa Ao Nue's small, adjoining museum, are giant pink paper lotuses which have been left in the garden after an event held earlier at the temple.

**Photos by
Bohnchang Koo**, South Korea

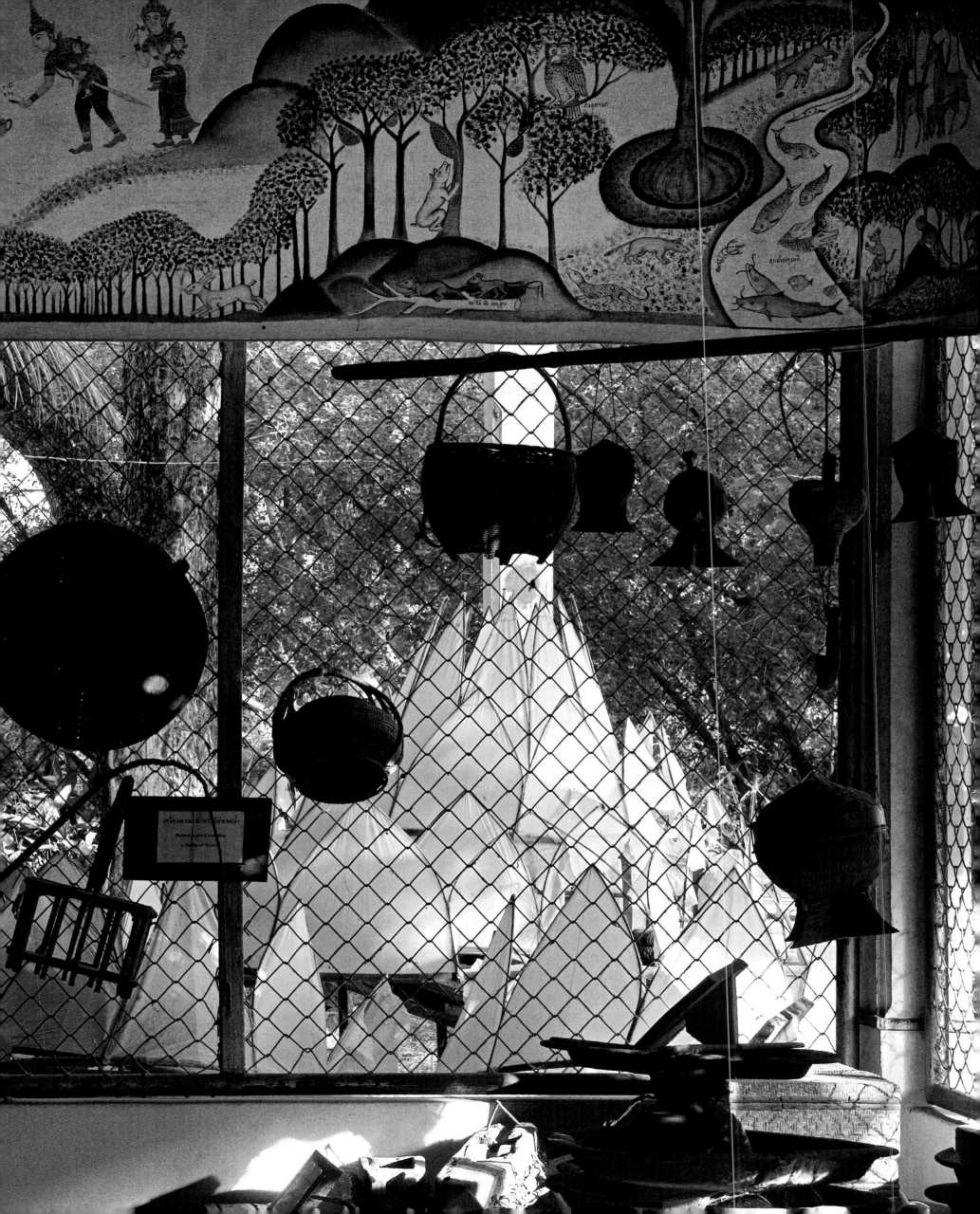

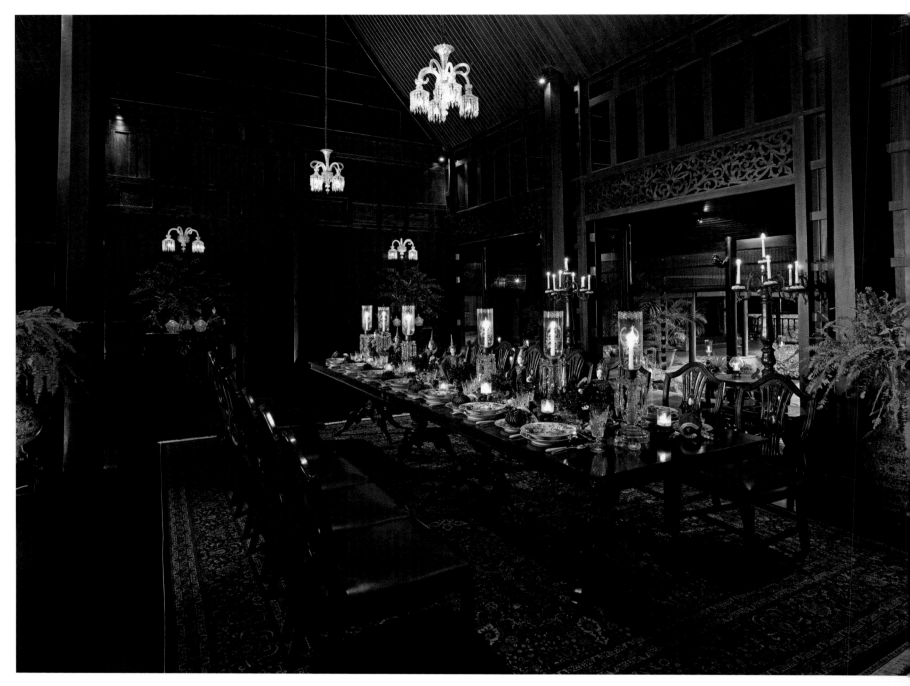

THIS PAGE (ABOVE): The dining room at M. L. Poomchai Chumbala's house in Bangkok. The house was constructed in a 'Y'-shape from four large traditional teak houses transported to the city from the northern province of Tak.

Robert McLeod, UK

Details revealing the artistry of traditional Thai arts and craftwork.
THIS PAGE (RIGHT):
Bohnchang Koo, South Korea

OPPOSITE PAGE
(CLOCKWISE FROM TOP LEFT):
Robert McLeod, UK
Dominic Sansoni, Sri Lanka
Vicente Wolf, USA
Bohnchang Koo, South Korea
Bohnchang Koo, South Korea
Bohnchang Koo, South Korea
Jörg Sundermann, Germany

OPPOSITE (BELOW RIGHT): Models Sinjai Plengpanich, Bussakorn Pornwannasirivej and Janjira Jujang pose in traditional silk dresses known as *sabai*. They were popular in central Thailand during the middle of the 19th century, before more Western styles and touches were popularised during the reign of Rama V.

Nat Prakobsantisuk, Thailand

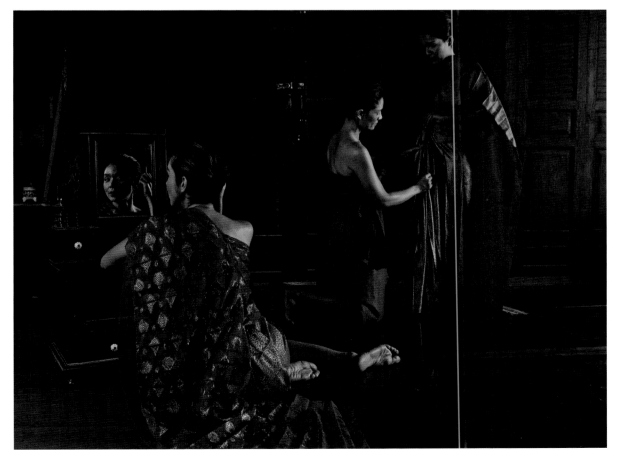

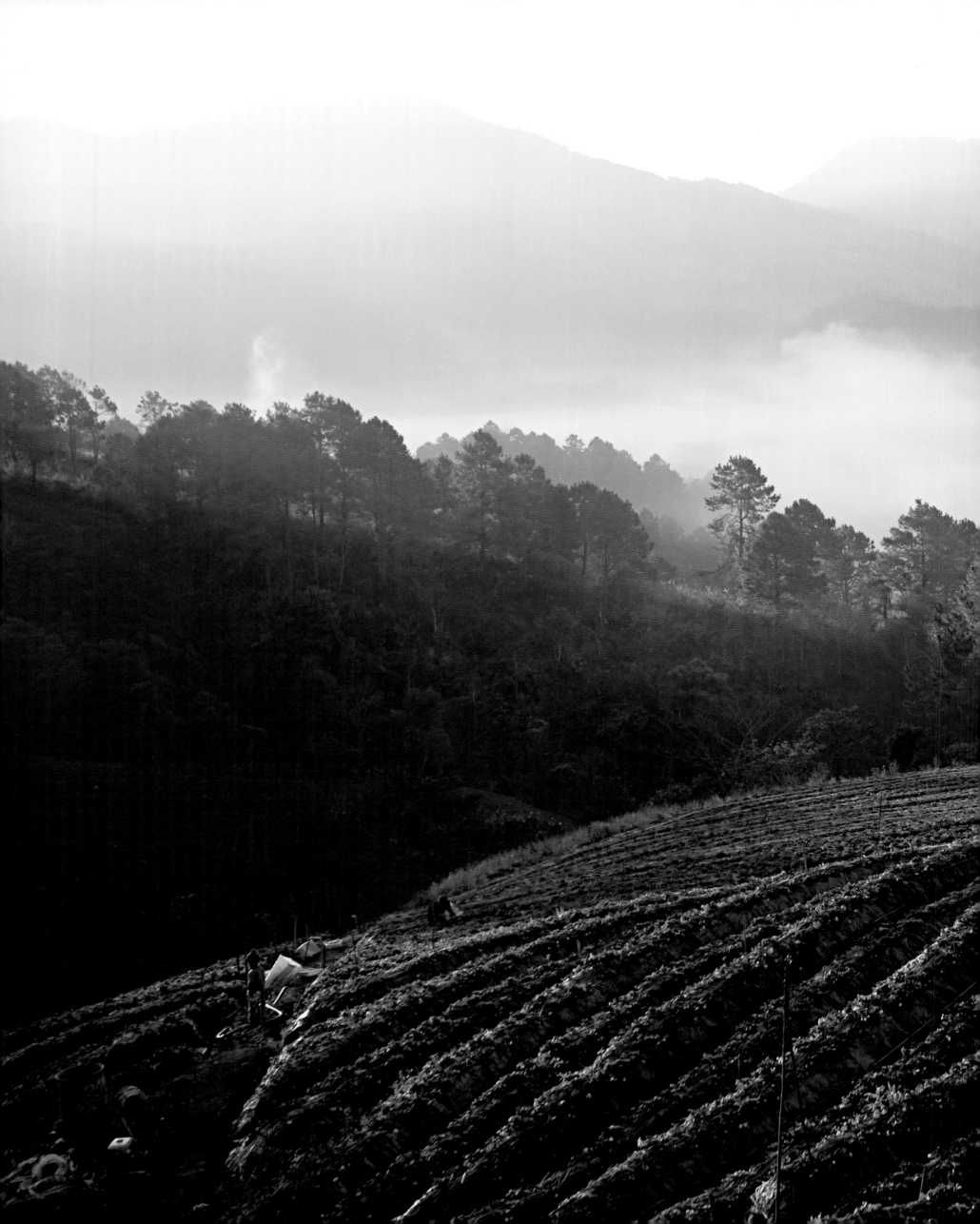

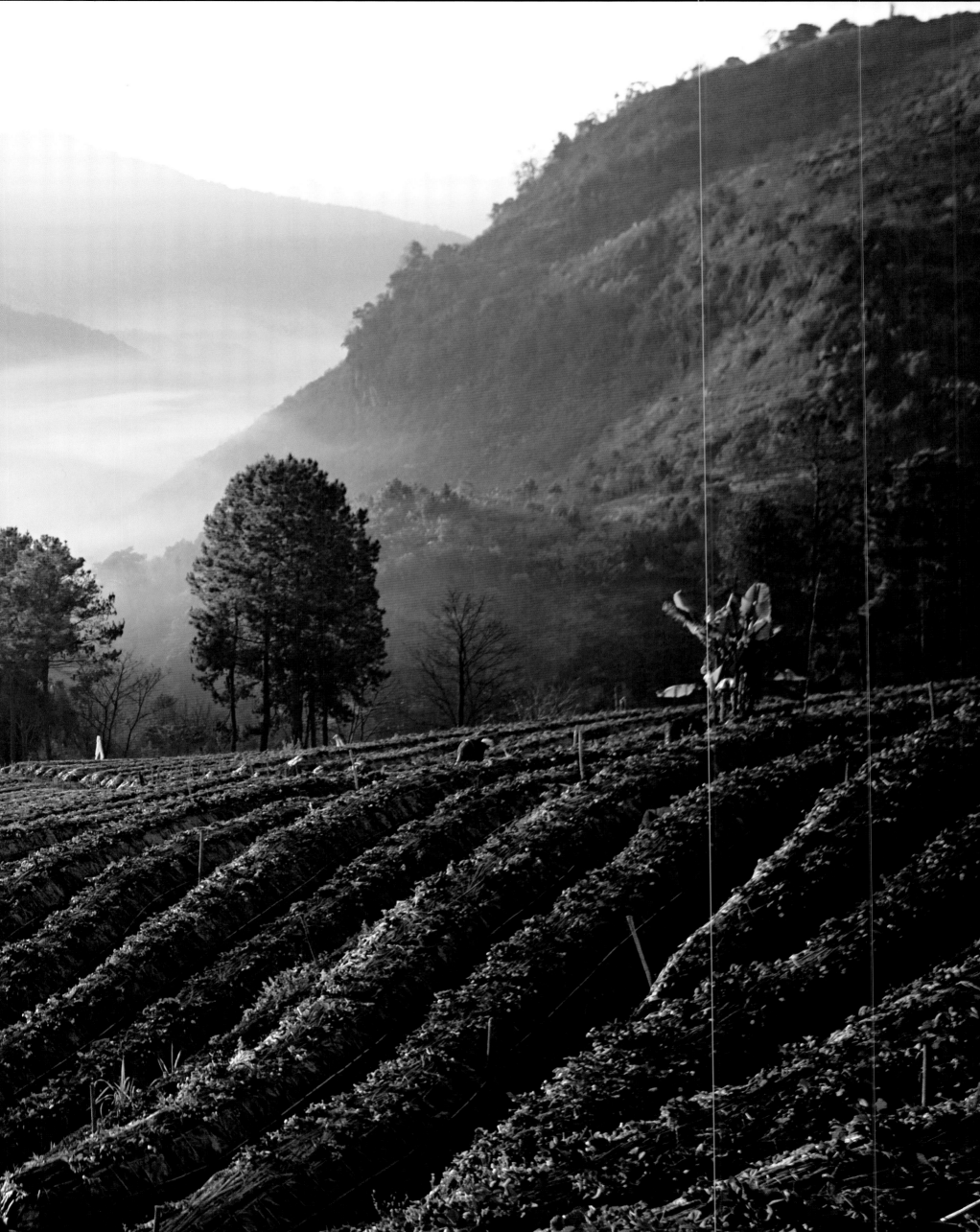

PRECEDING PAGES: Strawberry beds cultivated by Pa Lhong hill tribe farmers at the Royal Ang Khang Agricultural Research Station in Chiang Mai. The station, established in 1969, was the first of thousands of royal projects initiated by His Majesty to aid Thailand's development and the poor. The destitute hill tribe farmers in this area were traditionally dependent on growing opium, until research financed through royal patronage developed alternative marketable crops for them to harvest.

Duangdao Suwunarungsi, Thailand

LEFT: A young novice monk from the remote Wat Phra Archa Thong ('Golden Horse Monastery') in Chiang Rai rides his horse most mornings to collect alms. Many novices learn how to look after horses at this monastery.

Martin Reeves, UK

RIGHT: Sisters Fah, Fon and Ann Huapar are Lisu girls. They are picking Oolong tea at the Ban Cha Gow plantation near Mae Salong in Chiang Rai province. Their traditional Lisu hats double as sunshades. Originally inspired by His Majesty the King as an alternative crop to opium, tea plantations also offer work opportunities for many hill tribes in the north of Thailand.

Martin Reeves, UK

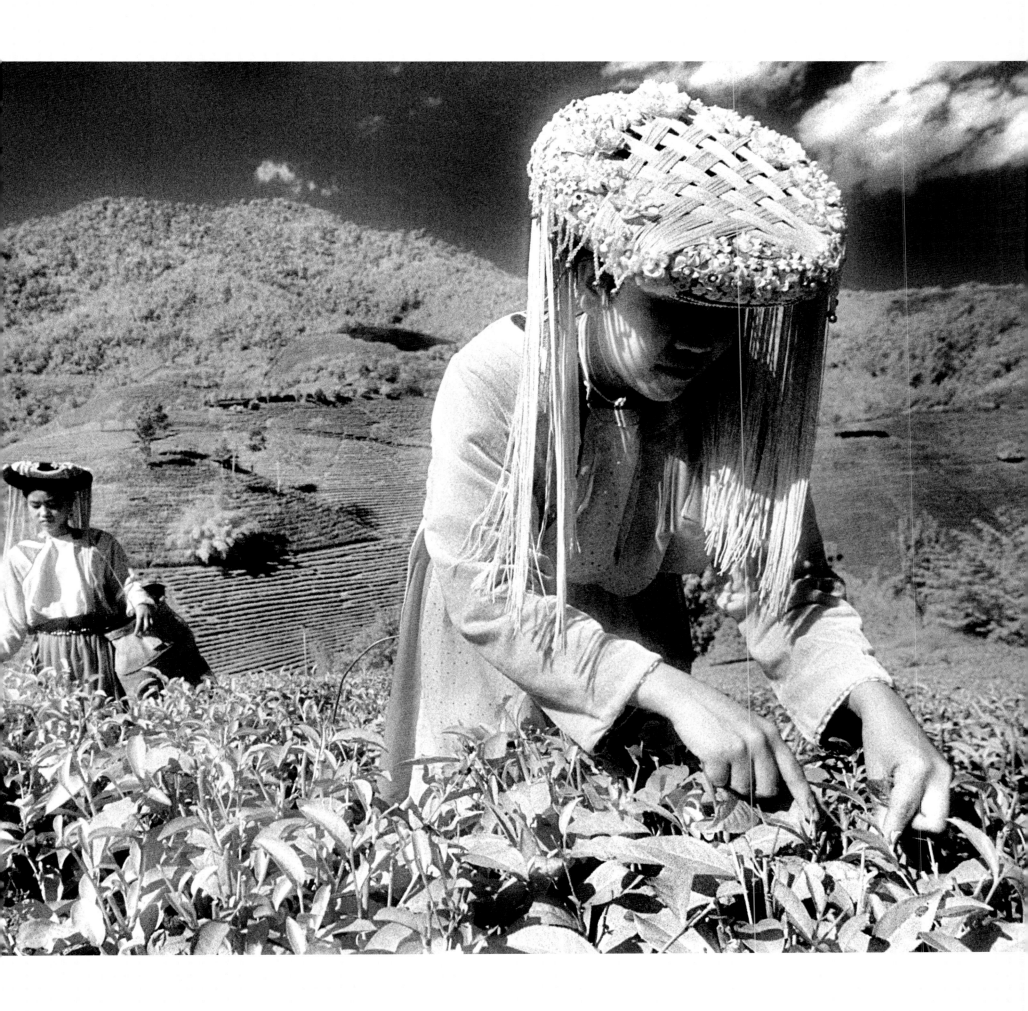

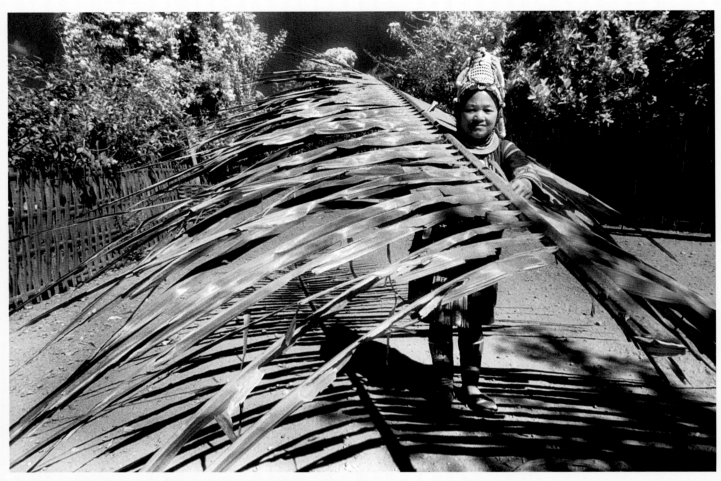

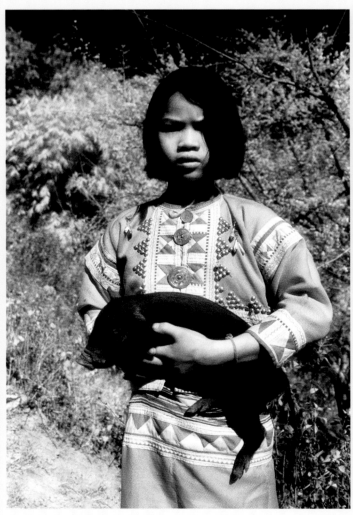

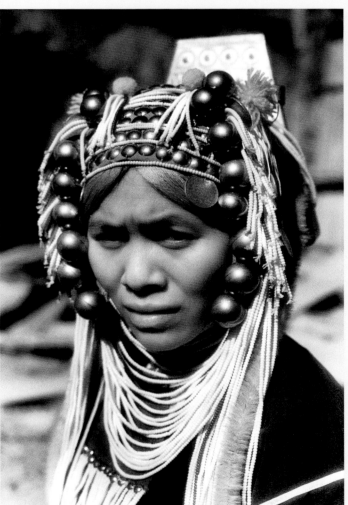

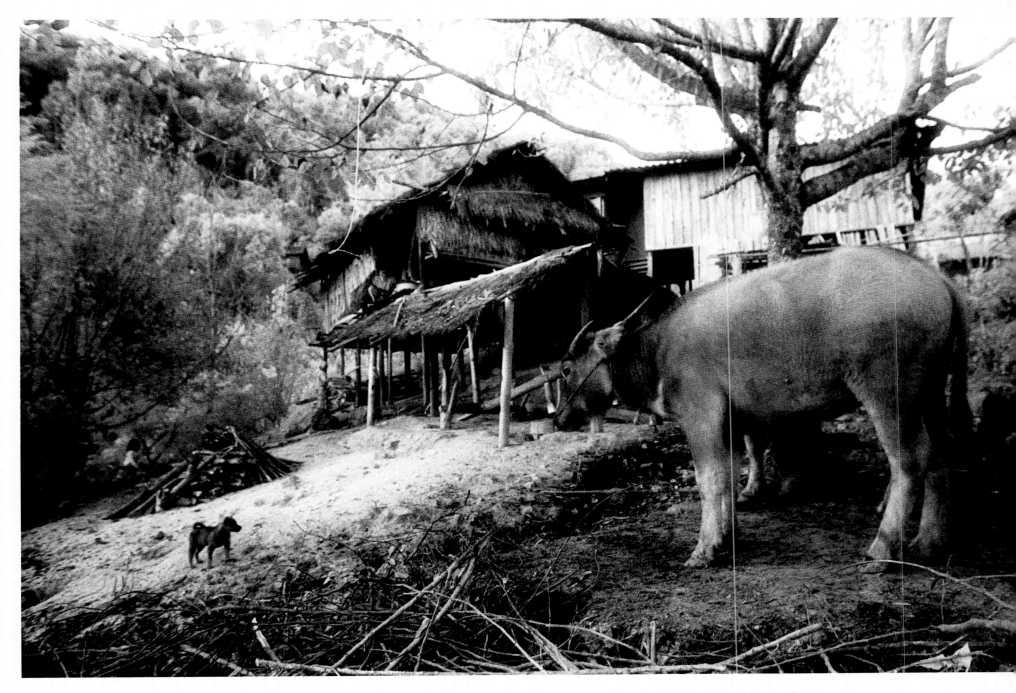

LEFT (CLOCKWISE FROM TOP):
Me-Su Jupoe, an Akha lady, carries a large palm leaf into the hill tribe village of Ban Saen Charoen, where it is to be used as decoration in a wedding ceremony the next day.

Me-Sue R-Mor comes from Ban Leepa Akha village, near Chiang Rai. Akha women are never seen without their silver headdresses. They wear them to festivals, when working in the fields and even to bed.

Nalor Jajue, a Musir girl from the Ban Sann-Mai hill tribe village, holds a piglet that is only a few weeks old. Musir girls and women are experts at embroidery and making Musir clothes.

ABOVE: A tiny puppy taunts a rather large (but tethered) buffalo in the Musir hill tribe village of Ban Sann-Mai in Chiang Rai, very close to the Myanmar border.
Photos by Martin Reeves, UK

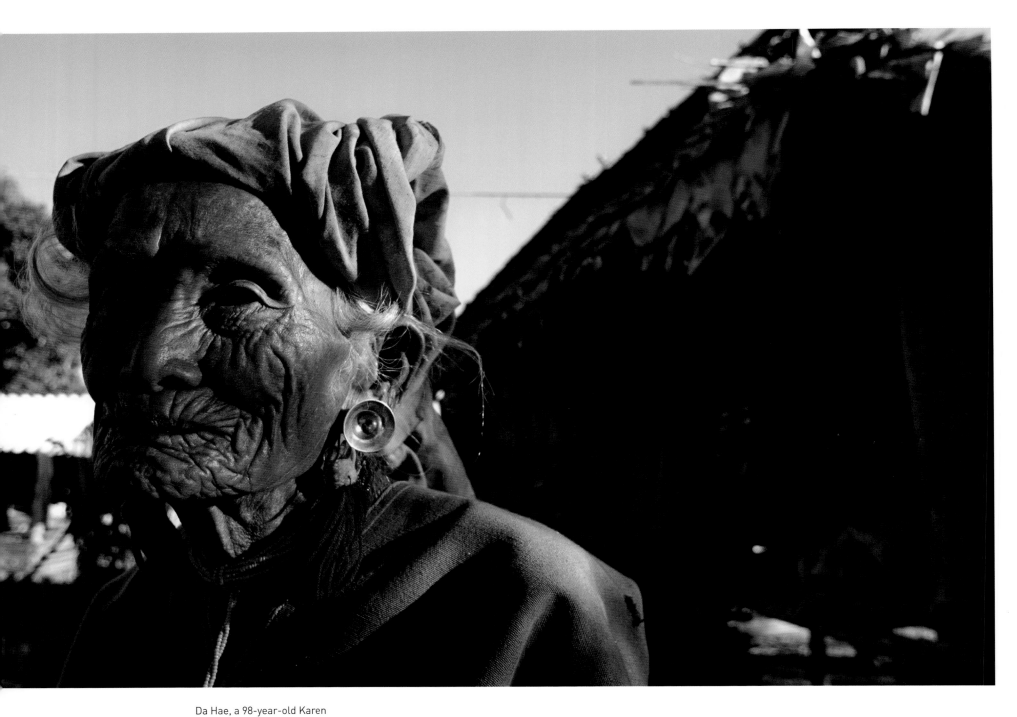

Da Hae, a 98-year-old Karen woman, has 11 children and grandchildren. She is pictured here in her village, Ban Mae La Noi, which is located by Inthanon National Park in Chiang Mai. The Karen, who originated in Myanmar, form the largest hill tribe in Thailand, with an estimated population of more than 300,000. Many Karen migrate to Thailand to escape persecution in Myanmar.

Peter Turnley, USA

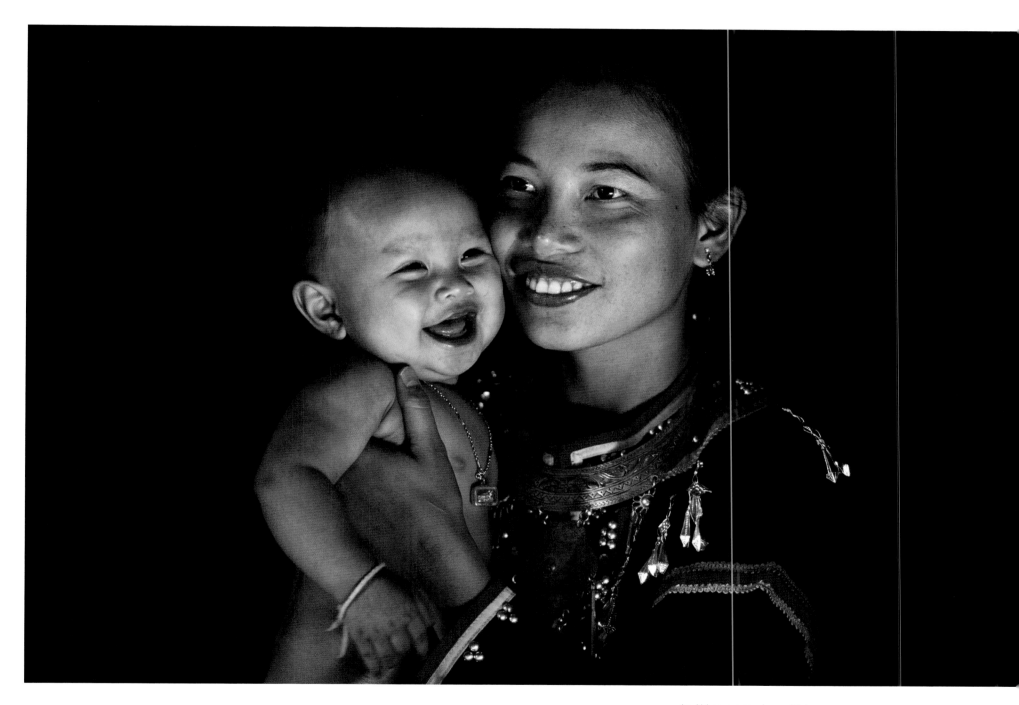

An Akha woman plays with her baby in a village in Chiang Rai province. Now that many hill tribe people have been issued identity cards or citizenship (if they are born in the country), there is more opportunity for future generations to take advantage of state benefits.

Olivier Föllmi, France

A Pwo Karen woman in the early morning in Mae To La village, Mae Hong Son province. This tribe does not have a written language, but their tattoos tell about their lives.

Helen Kudrich, Australia

Dinner is prepared inside a house in Mae To La village. For the estimated 550,000 hill tribe people in Thailand from up to 20 different tribes, language barriers and a lack of economic opportunities typically prevent them from realising a higher standard of living.

Helen Kudrich, Australia

LEFT: A performer finishes her song with a flourish at Tiffany's Show, billed as 'The Original Transvestite Cabaret Show'. The musical revue is a popular tourist attraction in the resort town of Pattaya.
Jeff Hutchens, USA

RIGHT: Backstage at a Chinese opera in Bangkok's Chinatown. The art form, brought to Thailand by Chinese migrants, has undergone a revival in recent times, with many Thai-Chinese troupes performing throughout the country.
Gueorgui Pinkhassov, France

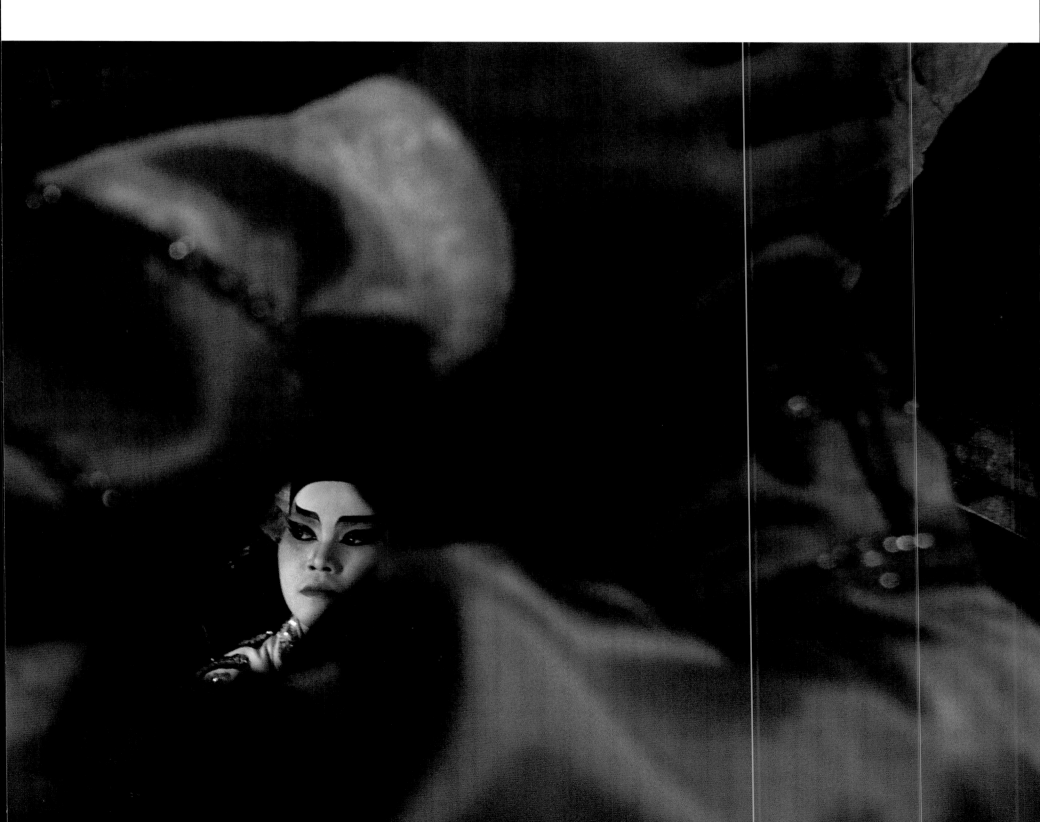

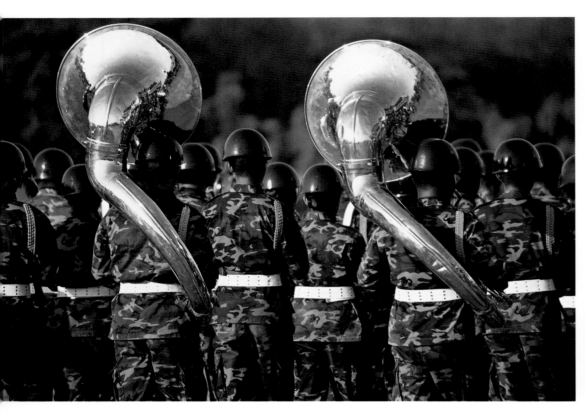

ABOVE: On National Armed Forces Day, a Royal Thai military marching band provides some fanfare during an oath-taking ceremony held for the 11th Infantry, a unit of the Royal Guards, in Bang Khen, Bangkok.

Guido Alberto Rossi, Italy

RIGHT: The trombone section lets it rip during a school parade put on by Angthong Patthamarot Witthayakhom in Ang Thong province.

Romeo Gacad, Philippines

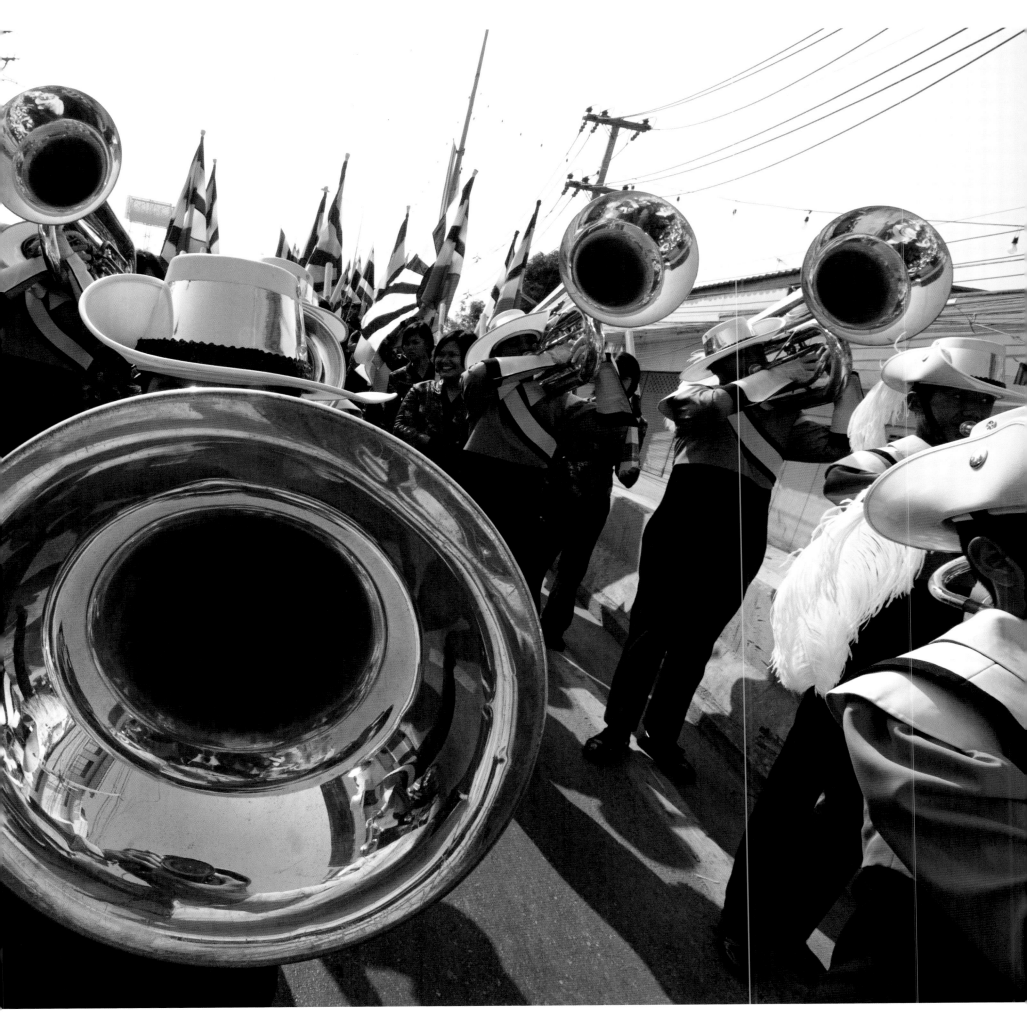

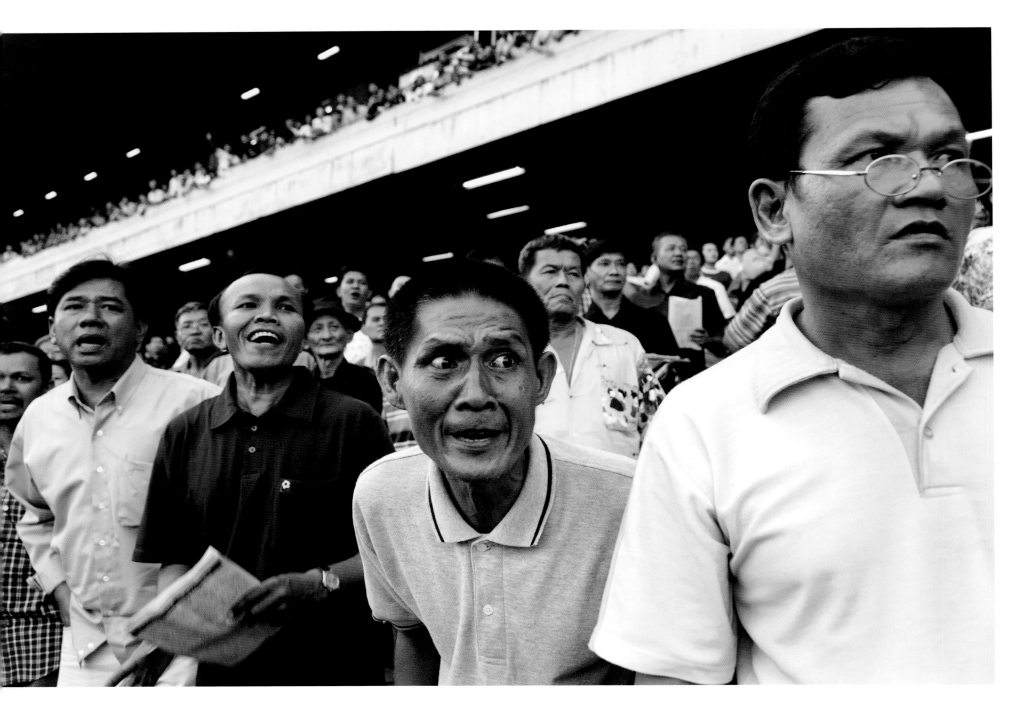

ABOVE: Horse-racing enthusiasts react to a race at the Royal Bangkok Sports Club. The public Sunday races attract people from all walks of life to the grounds of the posh club, many of whom are hoping to revive sinking fortunes.

Richard Kalvar, USA

RIGHT: After an early-morning party, neighbours, friends and family walk, dance and stumble their way to the temple during the ordination procession of a young man from Klong Toey in Bangkok. Most men are ordained as monks at least once during their lives, during a period of time that is commonly determined, via astrology, to be fortuitous.

S. C. Shekar, Malaysia

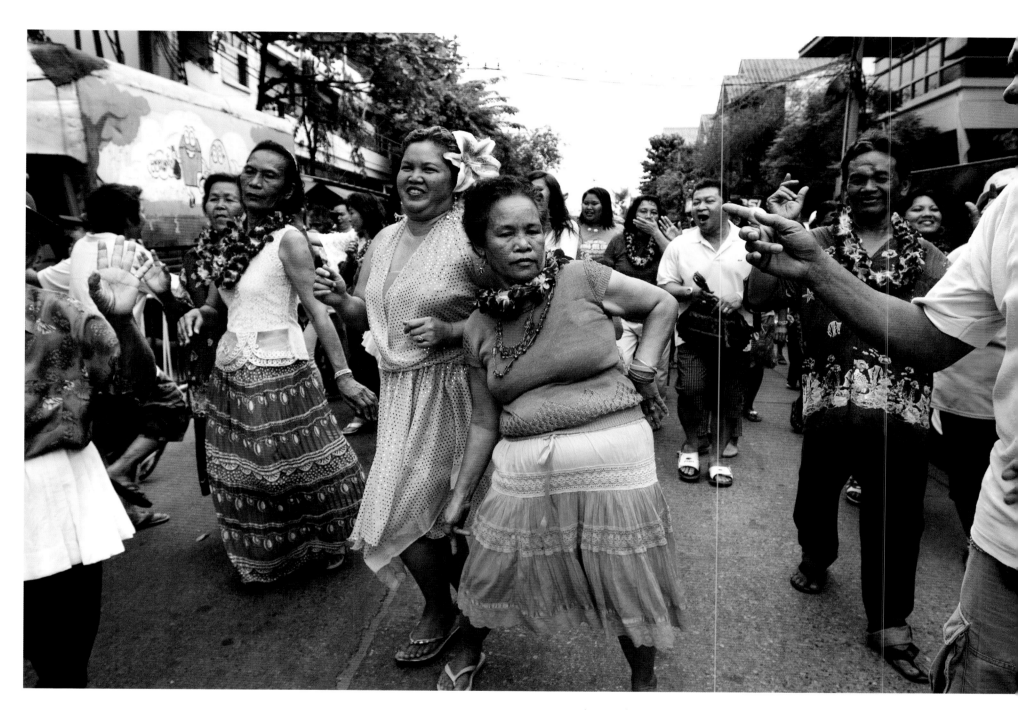

FOLLOWING PAGES (FROM LEFT): A fan reaches out to touch one of his favourite singers at a *luuk thung* concert in Samut Prakan. *Luuk thung* is country music that fuses folk singing with eclectic instrumentation and cabaret flair. Its sentimental lyrics about romance, hardship and tragedy comfort millions of rural migrants.

A young dancer participates in a *luuk thung* show. The performances have evolved into extravaganzas featuring stand-up comedy and dancers in colourful outfits.

PAGES 254–255: Young dancers exit the stage during a concert by *luuk thung* superstar Nok Noi Urai Phon in Bangkok. The most popular genre of music in Thailand, *luuk thung* has grown into an industry, with radio and television stations, record labels, and tours of rural fairs and urban venues.

**Photos by
Surat Osathanugrah**, Thailand

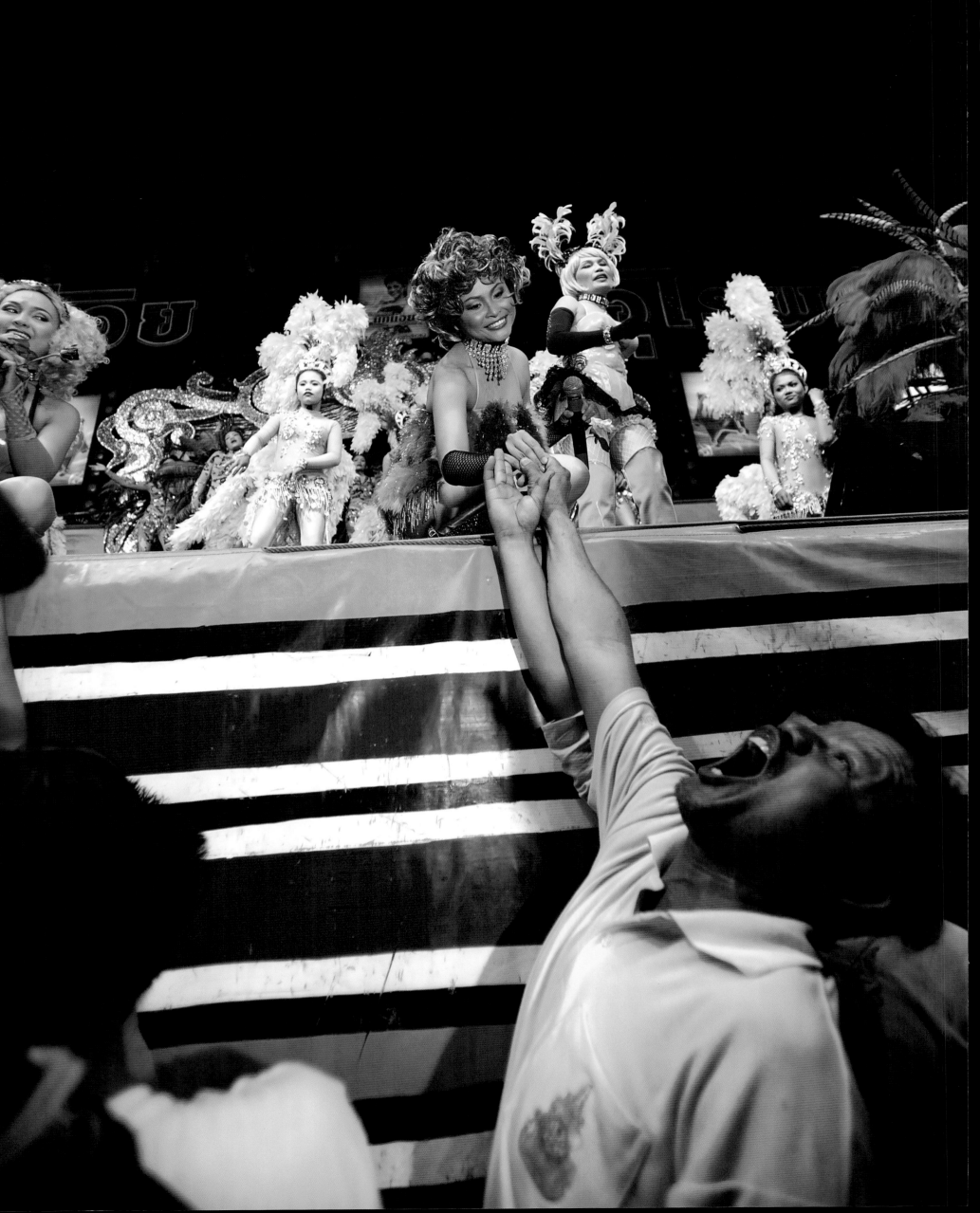

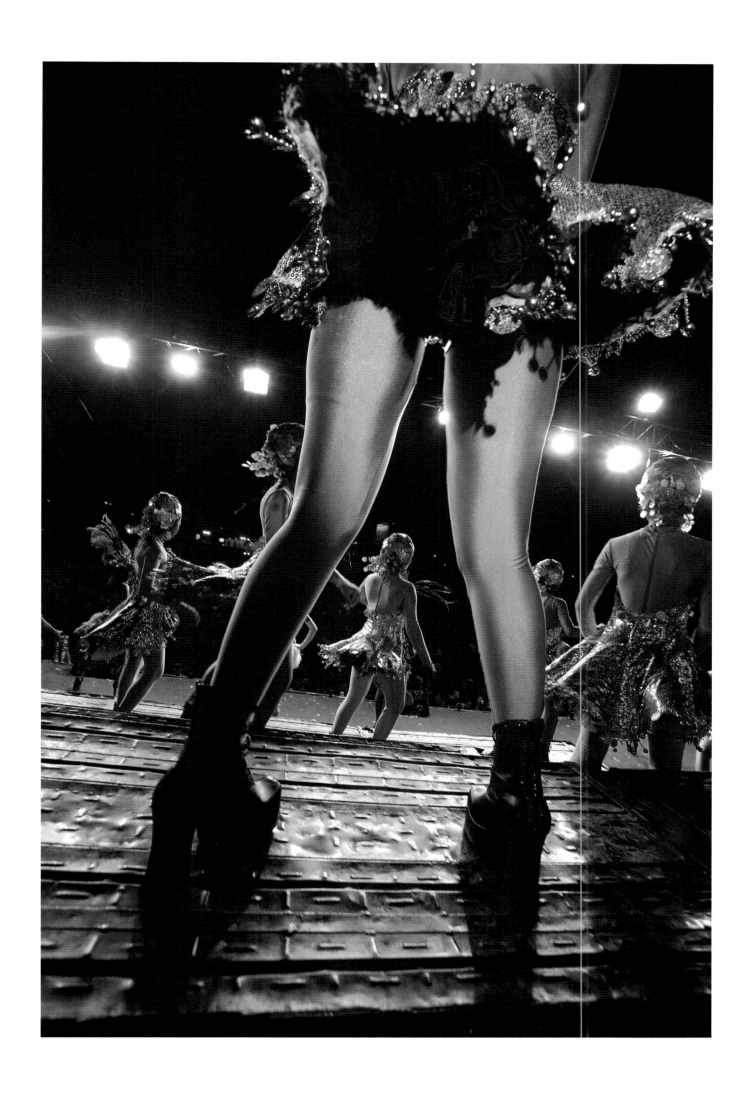

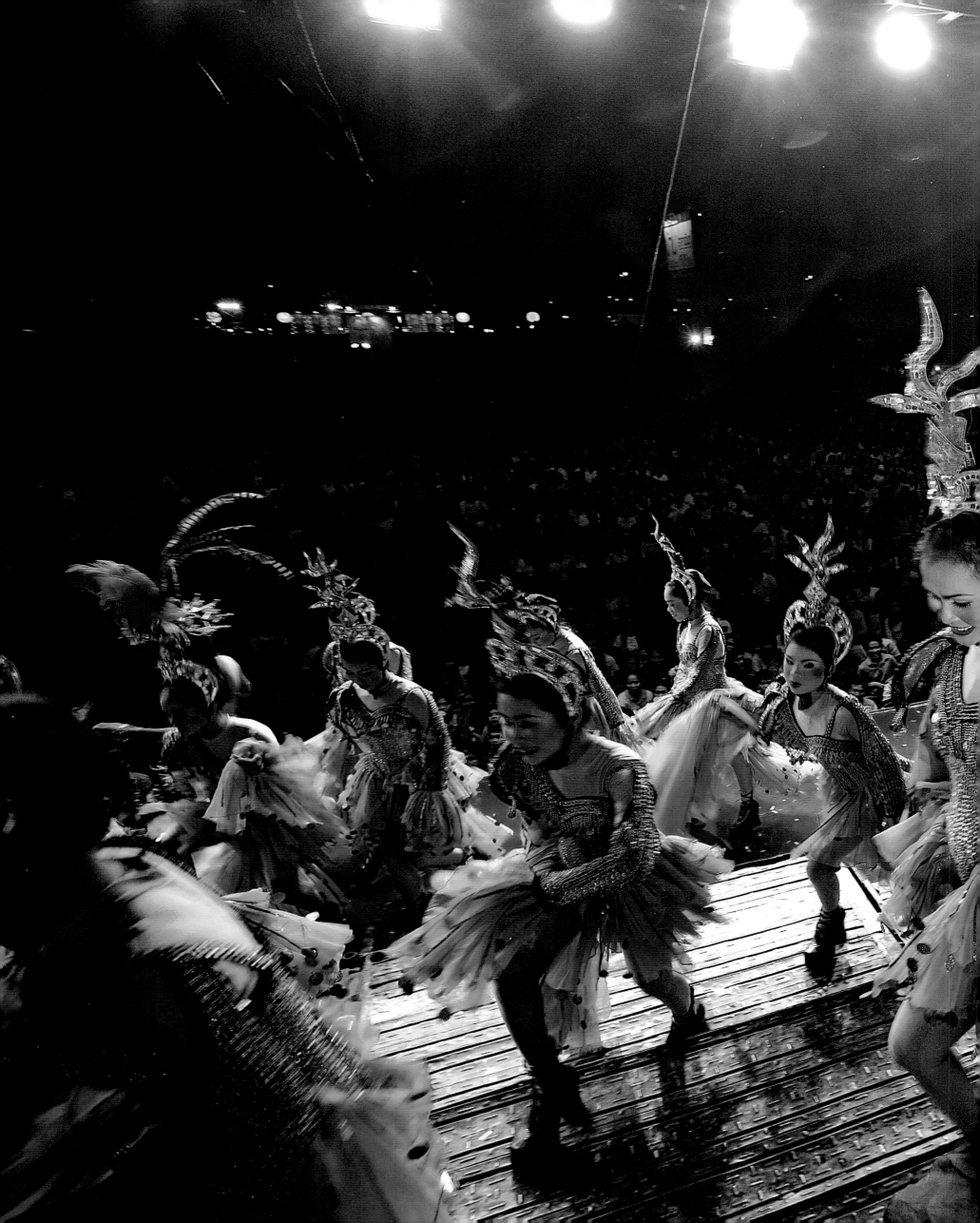

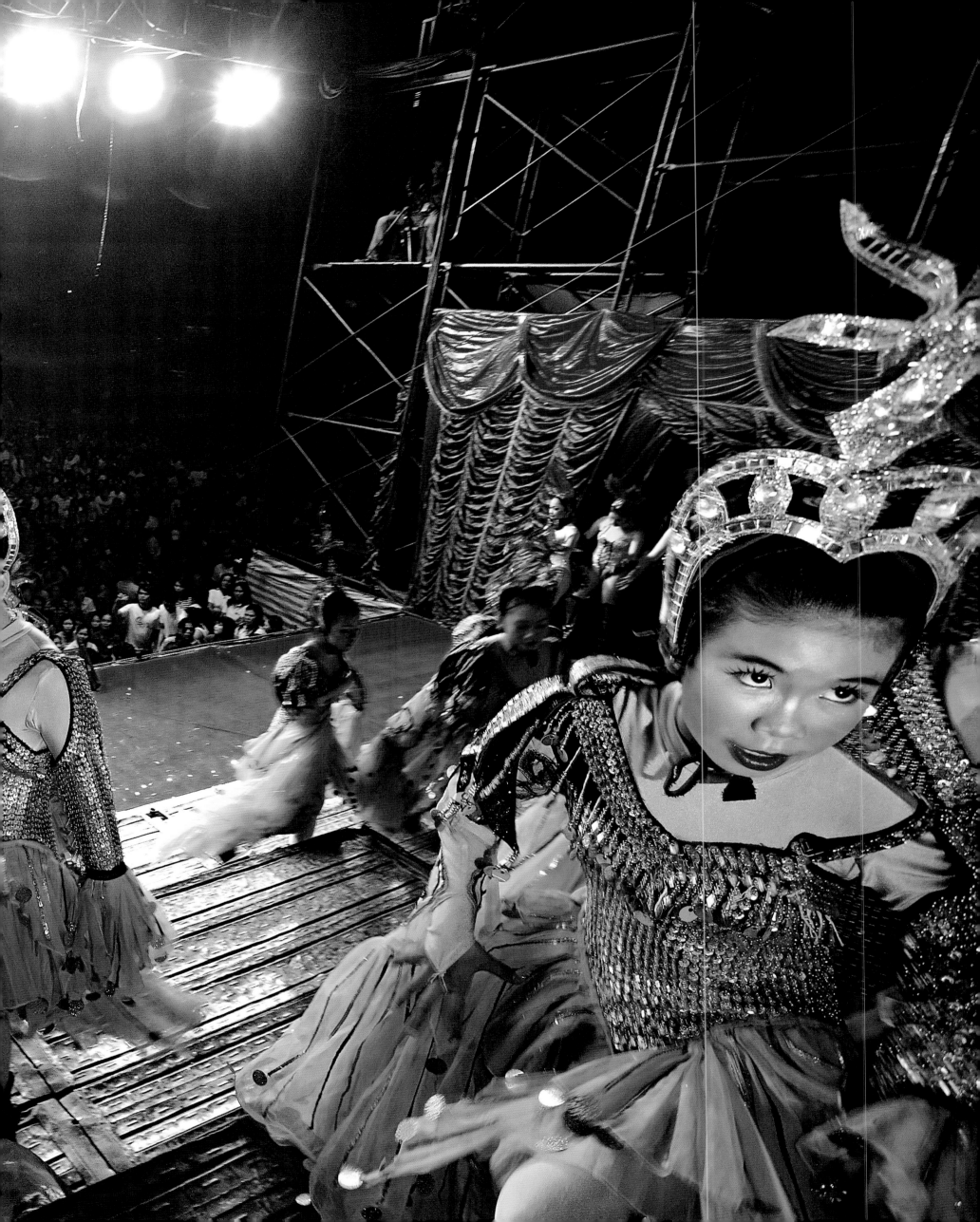

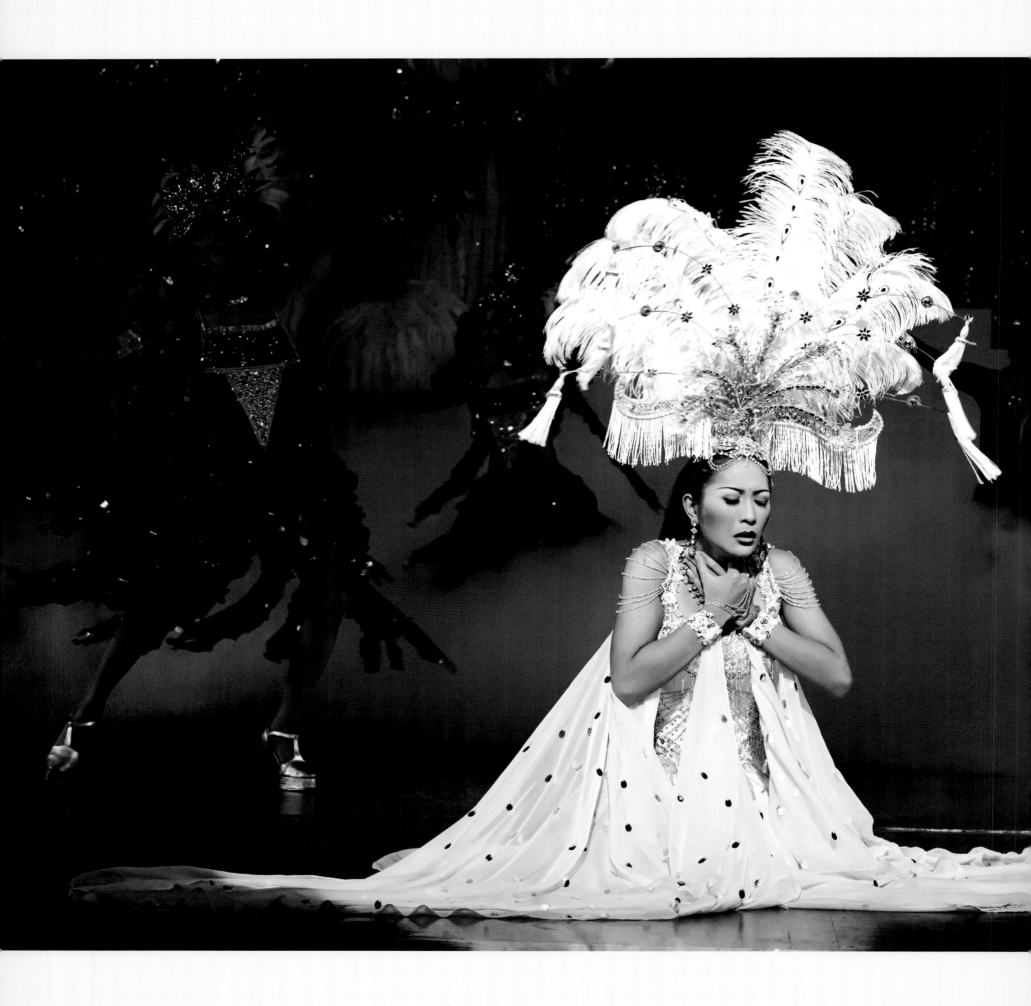

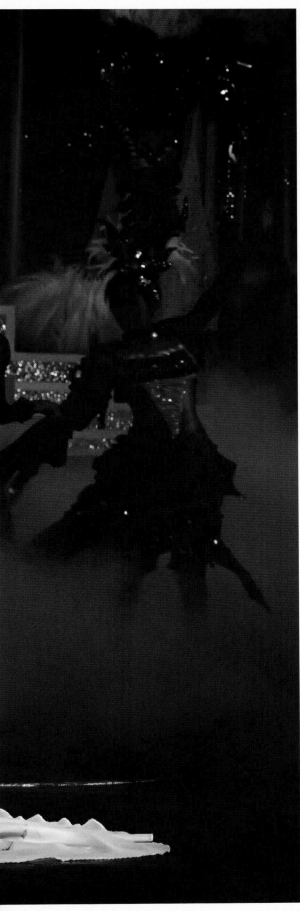

Showgirls

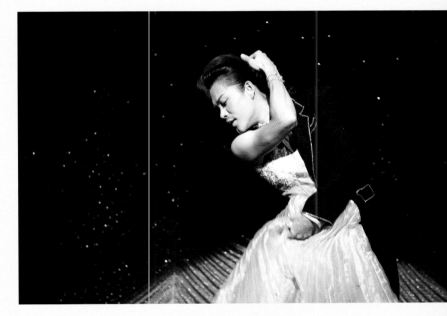

Backstage at the Mambo Cabaret, the atmosphere before the show is typical of any theatre in the world. There's a sense of quiet anticipation. The performers are carefully applying their make-up, putting on accessories and shimmying into dresses. One stands to the side dragging on a last cigarette. But this is not your standard dressing room. Almost all of the cast members here are men who have become women—not for show, but for real. The spectacular they are preparing to put on is, in part, to show that they are for real.

Thailand's third sex has always engendered fascination and curiosity, not only within the country itself but also internationally. This interest does not stem simply from the frequently stunning results of their sexual transformations. What is remarkable to many is their apparent acceptance and visibility in Thai society.

Kathoey, or 'ladyboys' as they are called in English, can be seen working not only as dancers but also in retail shops, hair salons and restaurants. Occasionally, some become celebrities in their own right, gaining prominent roles in films and other entertainment productions. A team of *kathoey* won a national volleyball competition, competing as women; and another became a champion Muay Thai boxer.

Kathoey generally strive to take on all the trappings of being a woman. This is not confined to simply a physical transformation, fuelled by hormones and completed with surgeries. When *kathoey* speak Thai, which is a gendered language, they speak as women. When they look for lifelong partners, they are typically attracted to heterosexual men—and they increasingly demand and get the respect owed to women in a rather patriarchal society.

This respect, however, is often given with a coy smile and has limits. *Kathoey* are generally seen as curiosities and, while not ostracised, they are not always taken seriously. Only in recent years, for example, has the idea of giving legal protection explicitly to *kathoey*, such as in cases of targeted rape, gained momentum.

Photographer Greg Gorman photographed one aspect of *kathoey* culture: their famed cabarets. To dance in a cabaret is an achievement for a *kathoey*. More than just a source of steady income, it is a positive public reaffirmation, a celebration of their status as women. These shows, popular mostly with tourists, are not only spectacles, but also demonstrate their genuine talents—and challenge audiences.

As Gorman recounted, 'Watching the show left me wondering how many in the audience realised they were looking basically at all men. I am sure not only the children but many of the adults got lost in the moment, which presents an excellent argument for allowing all of us to exist in this universe as the person inside ourselves that we most closely identify with.'

Photos by Greg Gorman, USA

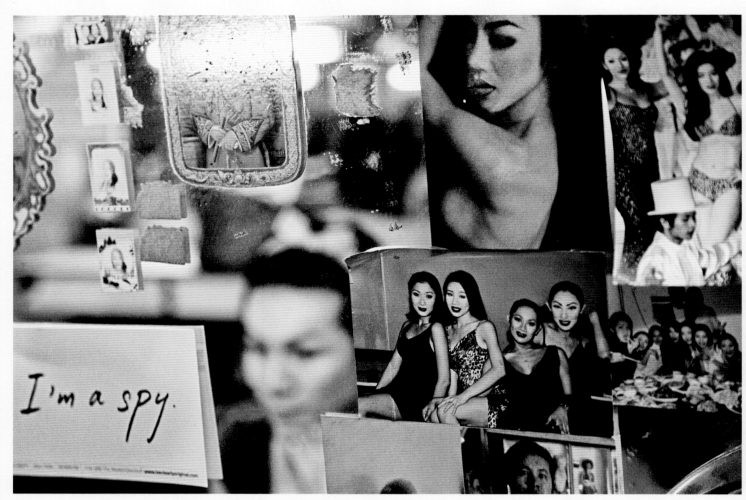

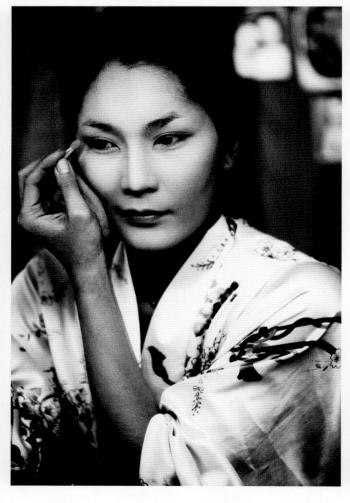
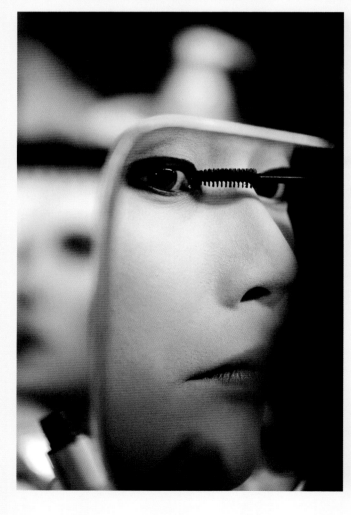

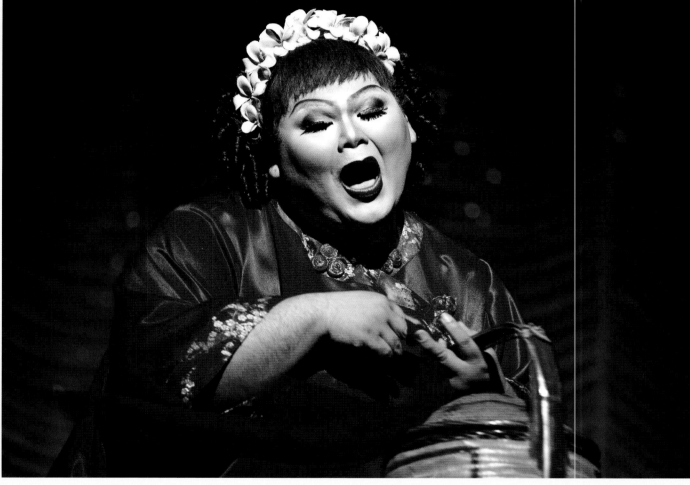

PRECEDING PAGES (FROM LEFT): At Club Alcazar, superb lighting, outrageous costumes and detailed choreography create an energetic spectacular. The performers put on a genre- and gender-bending revue of pop songs, Broadway classics and performance art pieces.

A performer at Club Alcazar dresses as a half-man and half-woman, with hairstyles to match.

OPPOSITE: Backstage at Club Alcazar in Pattaya and Mambo Cabaret in Bangkok, the performers put on make-up and prepare themselves for the opening curtain.

THIS PAGE: All cabarets involve a dose of comic relief. This is frequently offered by a larger, extremely effeminate *kathoey*.

FOLLOWING PAGES: After the show at Club Alcazar, the performers greet the crowd and pose for pictures for tips. Some tourists are excited by the opportunity; others are still awe-struck as the *kathoey* move from the stage to the street.

Photos by Greg Gorman, USA

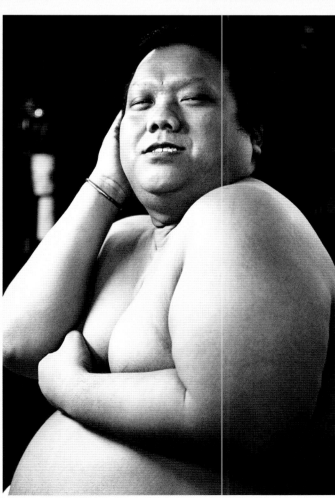

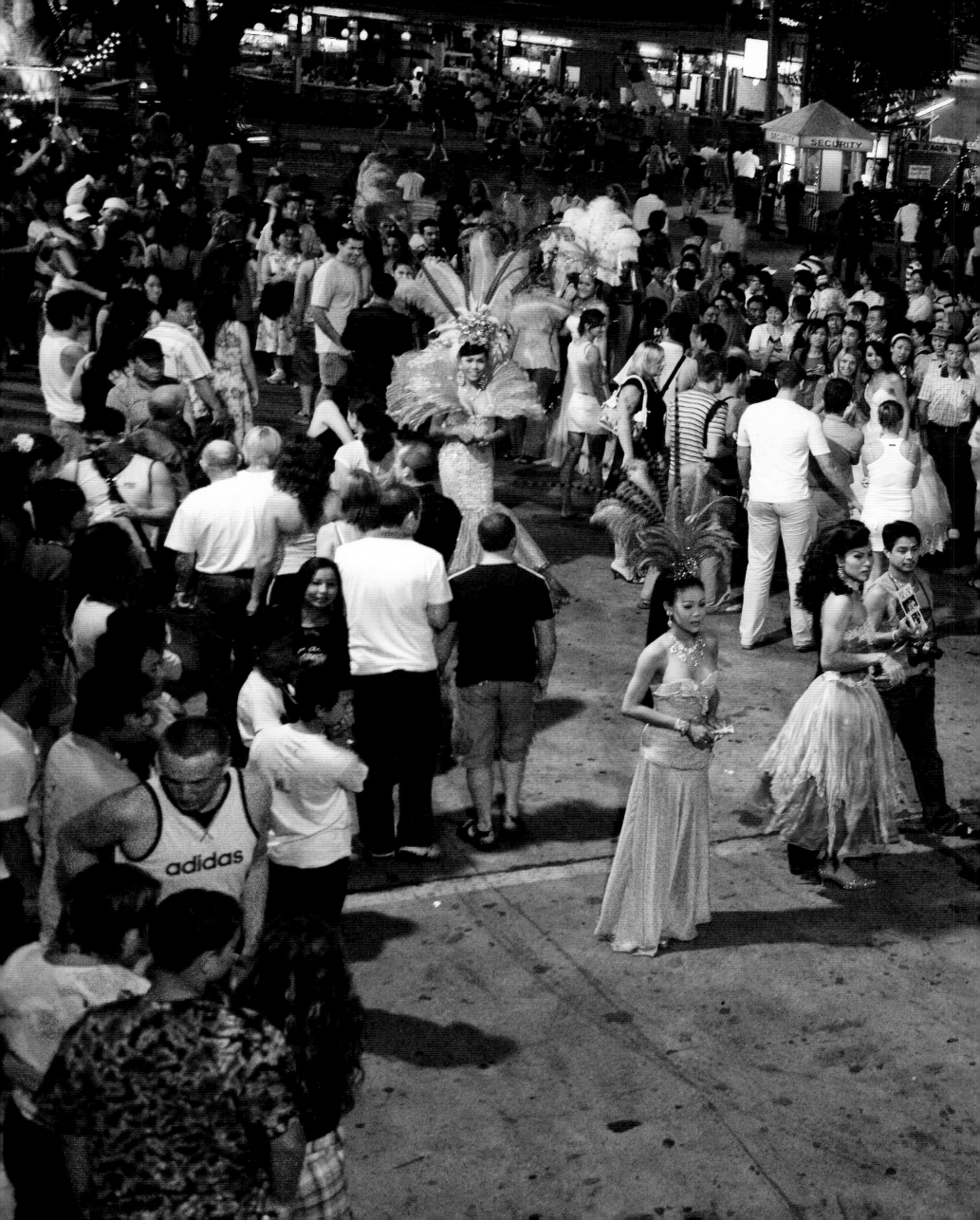

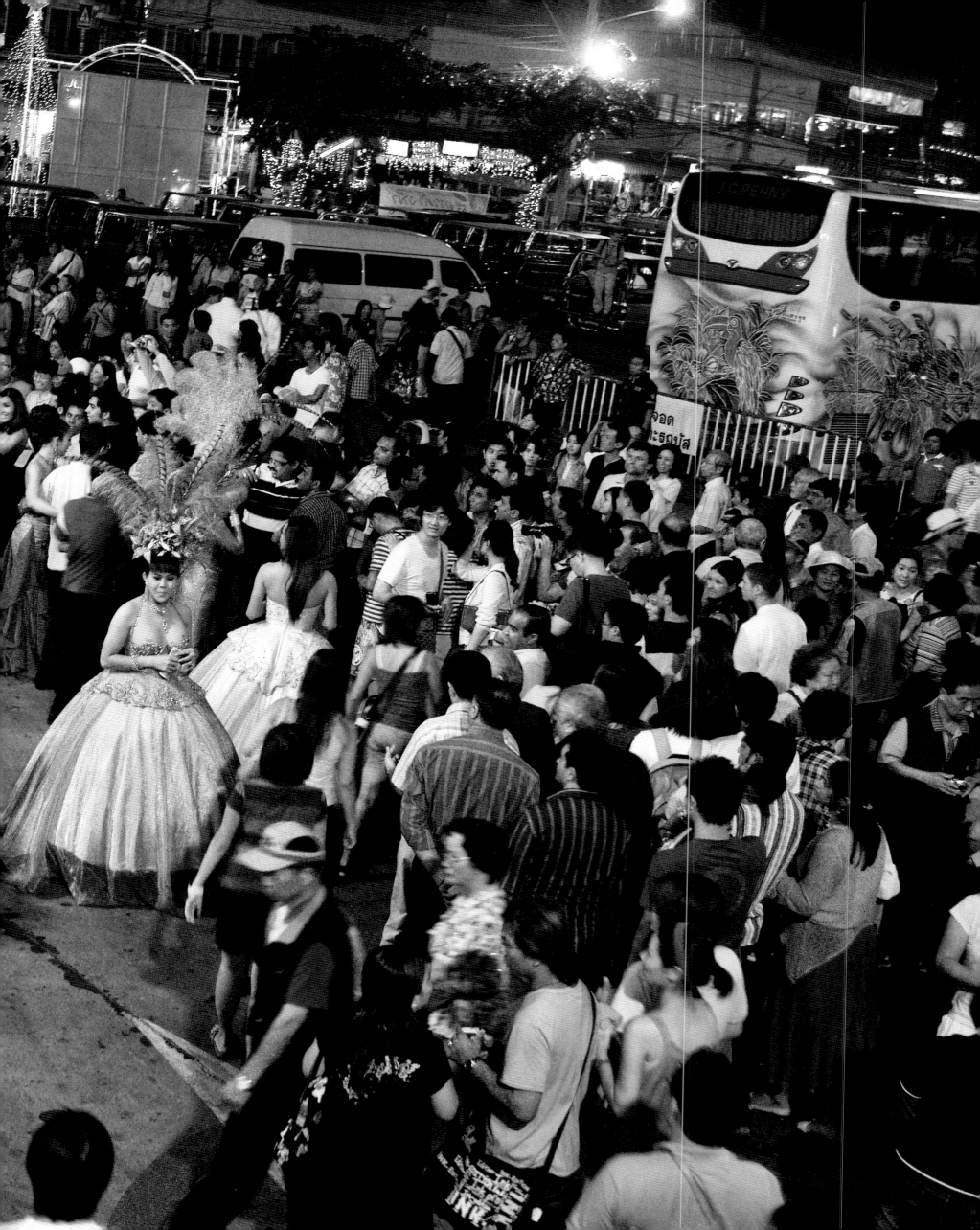

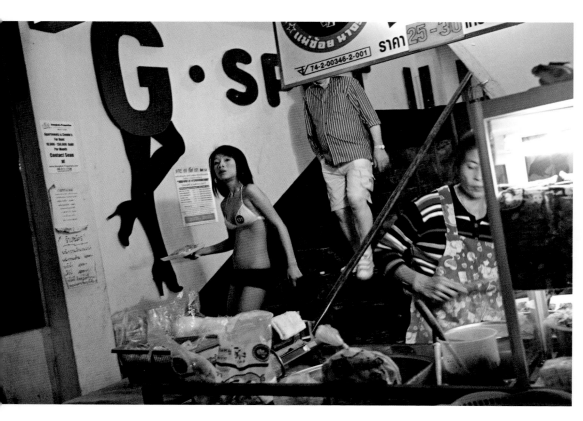

ABOVE: A dancer at Nana Entertainment Plaza takes a break from work. Nana Plaza is one of Bangkok's most famous go-go bar areas, a triple-decker of neon-lit bars which are frequented mainly by tourists and expatriates.

RIGHT: Inside a dressing room at Nana Entertainment Plaza, two women apply make-up before starting work.

Photos by David Alan Harvey, USA

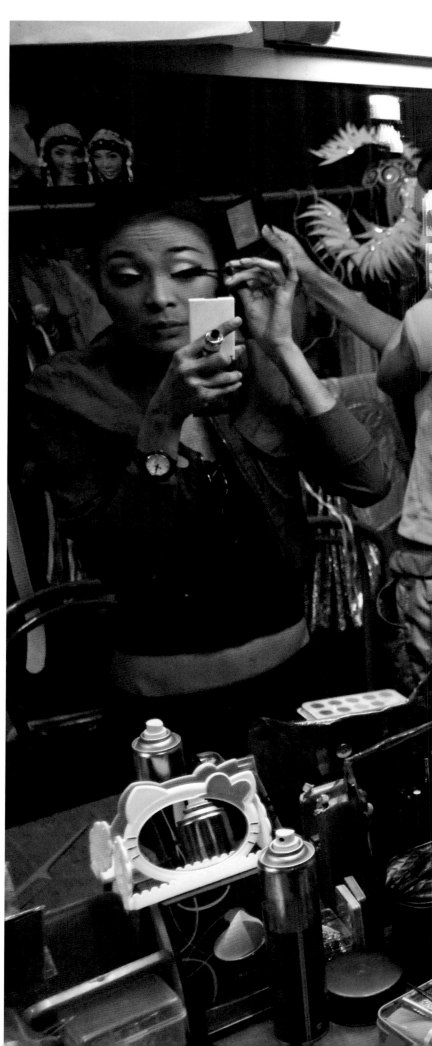

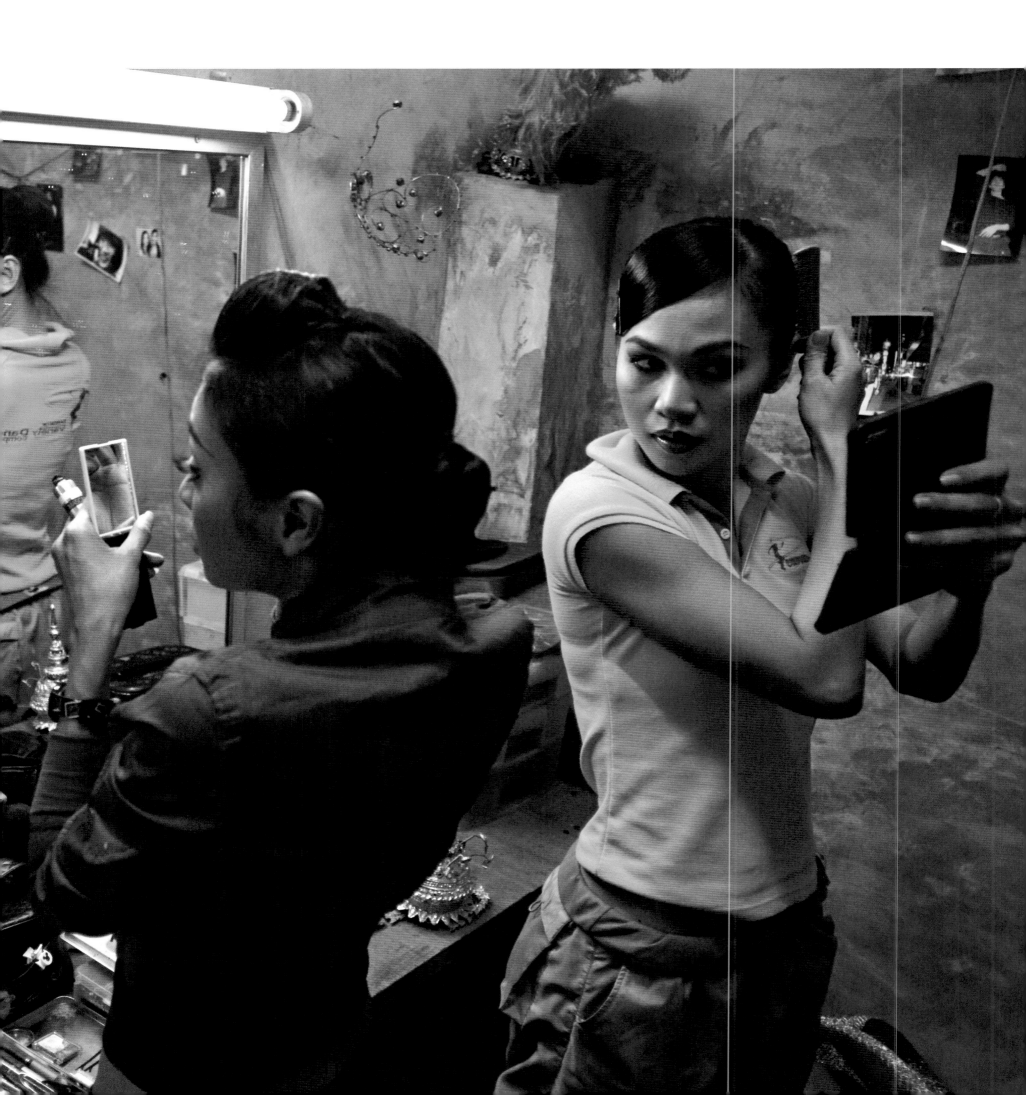

At Tiffany's Show in Pattaya,
billed as 'The Original
Transvestite Cabaret
Show', ladyboys perform
a musical revue.

Jeff Hutchens, USA

A dancer at Nana Entertainment Plaza. While prostitution is technically illegal in Thailand, go-go bars allow patrons to watch women, men or, in this case, ladyboys dance. If a customer is interested in a dancer, he or she can pay the bar a 'fine' in order to take the dancer out of the bar.

David Alan Harvey, USA

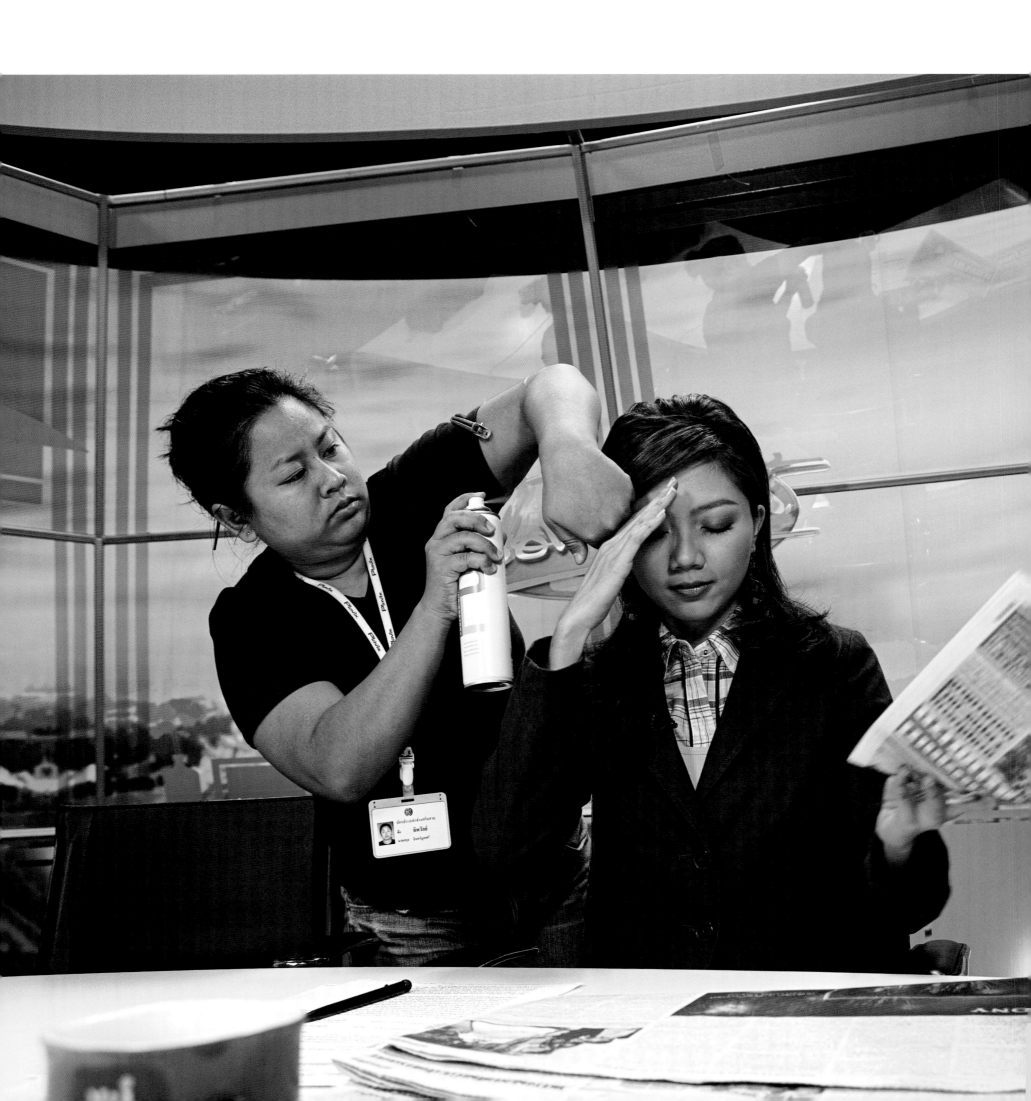

LEFT: A stylist attends to Channel 3 morning news anchor Krittika Sakmanee. During the popular news show, the hosts review the morning headlines. More than three-quarters of Thais are believed to receive their news from television shows.

Catherine Karnow, USA

RIGHT (TOP): M. C. Chatrichalerm Yukol, also known as Tan Mui, is surrounded by the press at the gala opening of his blockbuster film trilogy *The Legend of King Naresuan*. The director is also a member of the Royal Family. The opening two films of the trilogy, which share narrative and stylistic similarities to *The Lord of the Rings* trilogy, have been box office smashes.

Tara Sosrowardoyo, Indonesia

RIGHT (BELOW): Host Prapas Cholsaranon Todsagun stands with a contestant during the filming of his popular quiz show. The grand prize is 100 million baht, awarded to any contestant who can win 10 consecutive times. Game shows are a staple of the Thai television diet.

Tara Sosrowardoyo, Indonesia

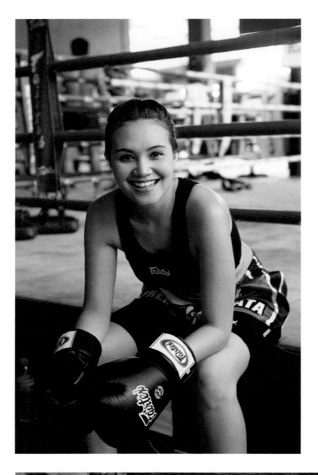

TOP ROW (FROM LEFT): Pop superstar Tata Young takes a break from a boxing lesson. The talented *luuk khreung* (mixed blood) singer's albums, which include songs in English and Thai, are popular all over Asia.

Catherine Karnow, USA

Veteran actors and couple Somchai Samipakde (left) and Juree Osiri (right) at their home in Bangkok.

Tara Sosrowardoyo, Indonesia

Photographer Manit Sriwanichpoom dons the pink suit that is the signature of his 'Pink Man' pictures. Manit first created and photographed the character (played by performance artist Sompong Thawee) in 1997 as a comment on rampant consumerism in Thai society. He uses pink to call attention to the materialism of life in Thailand.

Tara Sosrowardoyo, Indonesia

Ad Carabao in concert in Chiang Mai. The folk singer is also a passionate defender of cockfighting and has used part of his fortune to launch an energy drink line.

Shahidul Alam, Bangladesh

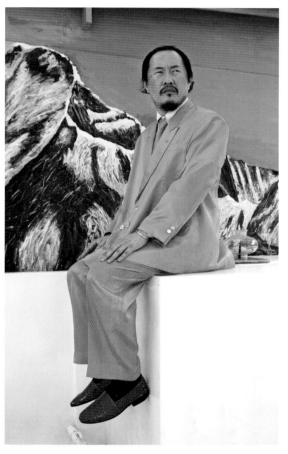

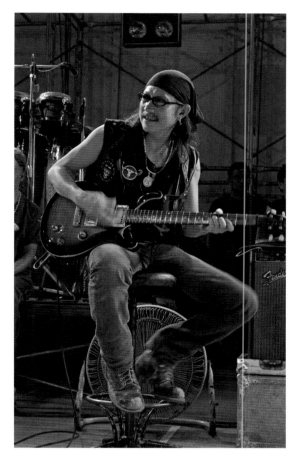

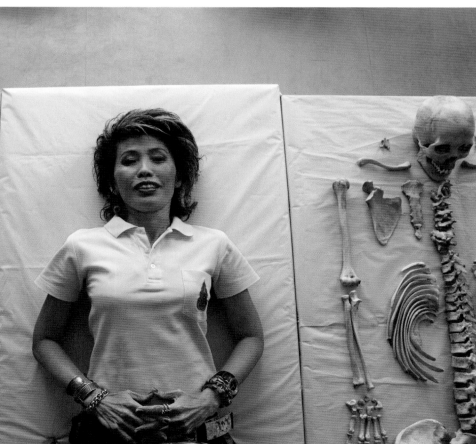

BOTTOM ROW (FROM LEFT): Modern Dog lead singer Thanachai 'Pod' Ujjin performs at Exotica Exclusive Club, a very unusual venue for the band that shook the pop-driven Thai music scene in the mid-1990s with its alternative, independent sound.

Tara Sosrowardoyo, Indonesia

Khunying Pornthip Rojanasunan at her forensic lab in Bangkok. Over the past decade, the crime scene expert has become famous for standing up to the police.

Shahidul Alam, Bangladesh

Perhaps Thailand's most famous *kathoey*, Nong Toom rose to fame as a brilliant Muay Thai boxer in the 1990s, winning fights in order to raise money for a sex change. Her story was portrayed in the film *Beautiful Boxer*.

Greg Gorman, USA

269

THIS PAGE: Khon master Rakop Pothiwes. *Khon* is a form of formal dance theatre involving highly stylised postures and elaborate costumes and masks. Originally it was exclusively a court dance but it is now performed for public audiences. Here, Rakop is teaching *khon* at the College of Dramatic Arts. He was recognised as a National Artist in Performing Arts (Thai Dance) in 2004.

OPPOSITE (CLOCKWISE FROM TOP): Dancer Manop Meejamrat is pictured here at Patravadi Theatre in Bangkok, where he is the director and choreographer. Manop, who has performed around the world, received the Silpathorn National Award for Performing Arts in 2005.

Actress, playwright and director Patravadi Mejudhon, pictured with a bust of her mother, Khunying Supatra Singholaka—her inspiration. Patravadi's television and theatre productions and performances often broke new ground in Thai arts. By injecting contemporary flair into classic Thai stories and forms, she has become an arts icon.

Classical Thai dancer, choreographer and director Pichet Klunchun, posing in Chiang Mai, where he was performing in his production 'I am a Demon'. Pichet is a young master of both traditional *khon* and contemporary dance. He received the Silpathorn National Award for Performing Arts in 2006.

Artist Pratuang Emjaroen. The self-taught artist's semi-abstract paintings apply Buddhist imagery and principles. He is pictured standing in front of a circular stone door at his home. He was named a National Artist in Visual Art (Fine Art) in 2005.

Photos by Carlos Freire, France

OPPOSITE (CLOCKWISE FROM TOP):
Actor and musician Narongrit Tosa-nga. His starring role as a musical genius in the hit film *The Overture* inspired a wave of renewed interest in classical Thai instruments such as the Thai xylophone (seen here).

Avant-garde film-maker Apichatpong Weerasethakul. His film *Tropical Malady* won a Jury Prize at the 2004 Cannes Film Festival. This picture was taken in the editing room, where he was completing his follow-up film, *Syndromes and a Century*. Apichatpong received the Silpathorn National Award for Film in 2005.

Known for his witty prose, one of Thailand's most famous writers, Rong Wongsawan, was named a National Artist in Literature in 1995.

Surapol Fuensilpa of the Chang Sip Moo ('Ten Crafts Bureau'). The organisation researches, conserves, fixes and recreates traditional craftwork and cultural artefacts. Here, he is painting a *khon* mask.

ABOVE: Dancer Phiramon Chomthawat, founder of the Arphorn-Ngam Theatre Group, is famous for recreating ancient *khon* costumes. Phiramon also teaches at the College of Dramatic Arts.

RIGHT: Poet Naowarat Pongpaiboon. Known as 'The Great Poet of Siam', Naowarat was named a National Artist in Literature in 1993. Here, he is pictured at Silpakorn University.

Photos by Carlos Freire, France

273

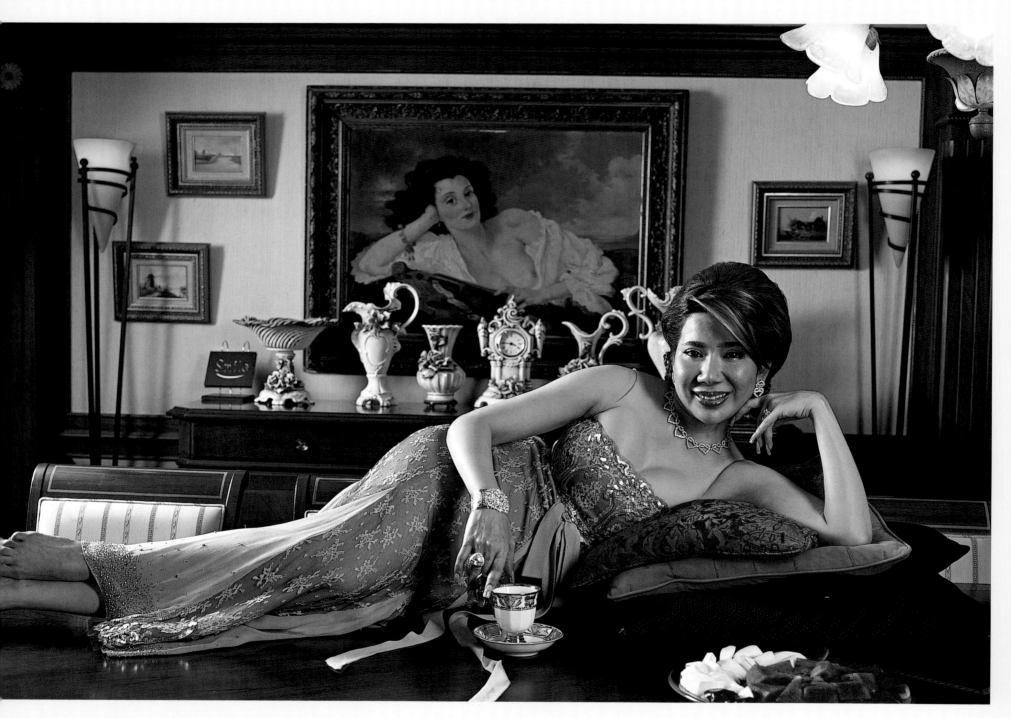

THE MEMBERS OF BANGKOK'S HIGH-SOCIETY, popularly called 'hi-so', do not consist entirely of the country's wealthiest citizens, nor its most famous families. Instead, some hi-sos are a class unto themselves, a modern subculture whose prominent figures make their reputations by attending fancy parties and product launches, displaying a lavish—often dizzying—sense of style, and never shying away from the camera. By making sure their names are on every party list and garnering mass media attention, these hi-sos have created a special role for themselves in status-driven Thai society. Photographer Manit Sriwanichpoom chose to photograph some hi-sos in their homes while dressed in their best clothes.

ABOVE: Romanee Thienprasiddhi, 46. The leading Thai luxury lifestyle magazine *Thailand Tatler* once wrote of her: 'She is able to attend seven parties per day if required.' The owner of Plengprasiddhi Silom Kindergarten is also known for her work on children's issues.

RIGHT: Suriyon Sriorathaikul, 33. Managing director of Beauty Gems and a former chairman of the Thai Diamond Club, the boyish-looking Suriyon is not only a regular face at parties around town, but is also active in the Boy Scouts.

**Photos by
Manit Sriwanichpoom,**
Thailand

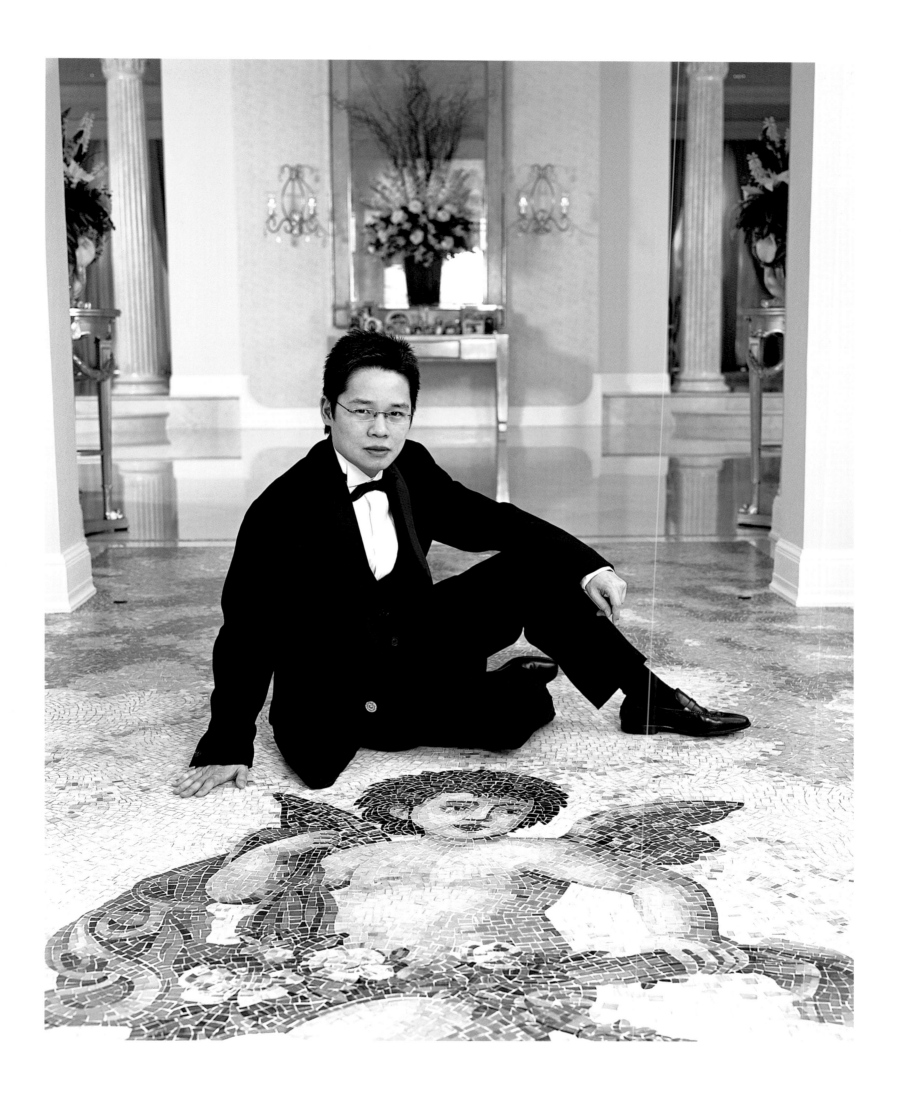

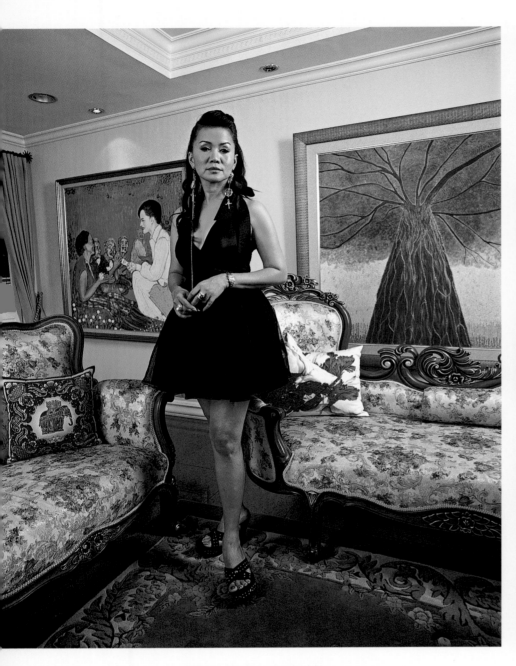

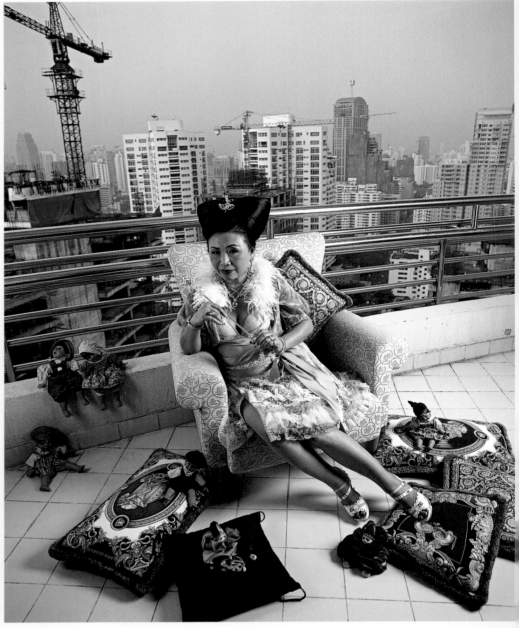

Marissa Mahavongtrakul, 44.
The youthful-looking Marissa
is the managing director of
Bhodhi Leaf Co. Ltd, a purveyor
of religious paraphernalia.

Darunee Kritboonyalai, 58.
Her fortune is based on many
businesses, including Oishi,
a sushi chain and green tea
drink producer. Darunee has
transformed her notoriety into
acting roles. The talented dame
of the hi-sos has appeared in
many soap operas and movies.

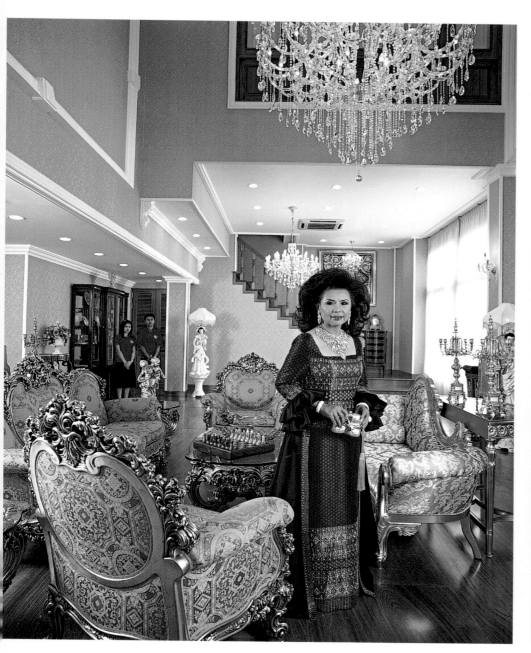

Lee Puengboonpra, 54. She is
known to wear conspicuous
jewellery and to travel to
parties with an entourage of
attendants. A frequent face
in magazines, she decided to
launch her own and is now the
managing director of *Hi!*.

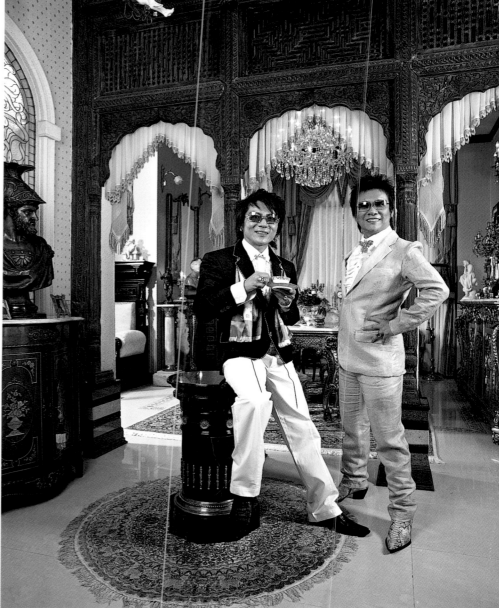

Chuchai Chairitthilerd (left),
45, owner and designer of Gem
Peace by Chuchai, and Somsak
Chalachol, 50, a celebrity
hairstylist, are famous for
their outrageous outfits
and being the 'lives' of the
party. Somsak has started a
charitable foundation called
Somsak for Somsak, which
helps less-fortunate Thais
named 'Somsak'.

**Photos by
Manit Sriwanichpoom**,
Thailand

Photographing Thailand

JUST BEFORE DUSK, Gueorgui Pinkhassov emerges like a mosquito. He is drawn out of his hotel room by the setting sun. 'This light is good,' he tells his assistant in Russian-accented English. 'We go?'

Pinkhassov says he wants to see a slum. More specifically, a slum on the water. He clearly has an image in his head. Like many of his pictures, it involves reflections, which add abstraction and depth to his pictures.

Five minutes later, they have left the hotel and are riding on motorcycles through downtown Bangkok. By this time, the capital's traffic is peaking, which means it has come to a standstill. Their 'moto' drivers, wearing sleeveless, bright orange vests, weave through cars, squeezing down the narrow zigzagging lanes formed by this city-wide parking lot.

When they reach the train tracks, they hop off the bikes. In Bangkok, slums often form along the railroad or near water. The river, too, is not far away. After walking for a minute, Pinkhassov freezes in his tracks. He looks ahead as if he has spotted an old friend in the distance and waves his assistant over. He says, 'We stop here. This light, it is very good. It is very special.'

For the next 20 minutes, he focuses his camera on the sidewalk's activity—kids playing after school and vendors selling snacks among emerging twilight shadows. He constantly stops to change the settings on his camera and to look at his pictures on the digital screen.

The locals become curious. Who is this foreign man dressed all in black working so intensely? What about this typical patch of concrete jungle could have inspired such a frenzy? They smile and a few edge closer. Pinkhassov pauses and, through body language, invites them to take a look. They peer over his shoulder and laugh, appearing somewhat bewildered by what they see. Is he mad?

Gueorgui Pinkhassov was possessed by a mission. Over the course of nine days in January 2007, he and 54 other leading photographers created a unique piece of reportage—a simultaneous visual record of Thailand. Given assignments and detailed itineraries, photographers from 18 nations each covered a piece of the country's physical and cultural landscape. They produced images that would collectively form a visual time capsule, a kaleidoscopic view of Thailand's distinctive mix of East and West, ancient cities and new urbanism, deep-rooted traditions and 21st-century challenges—and surprises too.

For who could predict what Pinkhassov would put in this time capsule after nine days of manic work? Although his assignment was rather conventional—to photograph life on the street at night—he rarely focused on conventional subjects. For him, if it was 'too obvious', as he says, it was not interesting. He existed, instead, in a state of constant reaction, bouncing between interesting sources of light, building himself into the irrational state which he says he needs in order to create his highly original compositions.

Thailand has been an exciting destination for photographers and tourists alike for many decades now. In 2007, up to 15 million visitors are expected to pass through its gates. Between them, they will create hundreds of millions of images of the country. How would the pictures from these 55 photographers be any different?

To begin, months of planning ensured that over just nine days their views of Thailand spanned not only the entire landscape, but that the country's environment was also seen from above (in a helicopter), below (underwater) and in relative darkness (inside a cave).

Through special access to locations few, if any, travellers visit, the photographers created a more comprehensive portrait of the kingdom. While the white-sand beaches and temples that form the Thailand of the popular imagination were not ignored, the photographers also toured military bases, entered an area of violent conflict and covered an HIV/AIDS hospital.

Making an effort to capture Thailand through its people, photographers visited hill tribes in remote villages and, from city to sea, aimed their cameras at the everyday people who form the lifeblood of the nation. Meanwhile, a handful of others met its most famous artists, entertainers, celebrities and socialites.

Finally, the photographers, in the hopes of revealing the cultural and religious fabric which unites Thailand, witnessed the events from which the Thai identity could be distilled. They attended Buddhist ordinations and funerals, rural festivals and television game shows, boxing matches and cabarets.

Ultimately, the photographers' own approaches, choices and styles made the difference, transforming the book, like a photograph, into a single slice of time that uniquely captures the life of this modern kingdom.

The conditions between 16 and 22 January 2007 were ideal. January is one of Thailand's driest months and also one of its coolest, meaning it only hits 32°C (90°F). At any other time, monsoon rains or crippling heat would have scuttled many plans or simply exhausted the photographers into submission. Mother Nature didn't accommodate all of them all of the time though. Sitting in the open doorway of a military helicopter, hovering about 1,000 metres above the ground, aerial photographer Yann Arthus-Bertrand was often disappointed to find a haze had settled across his spectacular view.

Yann Arthus-Bertrand (centre) and Sasion Kam-on (left).

Arthus-Bertrand's window for success was narrow. He had only seven days, just two flights per day (within two hours of sunrise and sunset) and a few hours' worth of fuel per flight. In addition, the terrain he was expected to cover was vast. After taking in the cityscapes of Bangkok, his itinerary took him over the ancient cities and rice fields of central Thailand to the northern capital of Chiang Mai. From there, he caught a commercial airliner which was headed in the opposite direction, to the southern island of Phuket, where he joined a separate military crew to fly over the Andaman coast.

Fortunately, Arthus-Bertrand, who has taken more than 500,000 pictures in more than 100 countries to date and sold more than three million copies of his ground-breaking portrait of our planet, *Earth From Above*, had the support of the entire Royal Thai Armed Forces and the sponsorship of Eurocopter to lift his spirit (and clear his way). In coastal areas, in particular, where the haze was less of a factor, he created some of the stunning graphic and landscape images which are his signature, offering an angle on Thailand's environment which is rarely seen.

Underwater photographer Nat Sumanatemeya, whose work relies on visibility and chance encounters with marine life, was also susceptible to the whims of Mother Nature. That was one reason the Thai took his 16 years of experience 90 kilometres off the southern coast to the undisturbed waters of the Surin and Similan islands. There, he could be confident that the conditions would favour him.

Above one of the most spectacular coral reefs in Asia, Nat and his assistant stayed on a 'liveaboard', a special boat designed for divers. Each day they took four one-hour dives. Then, lying motionless at the bottom of the Andaman Sea, they waited. 'Life in the coral reef,' Nat explains, 'is like daily life in the city. The fish interact, they eat, they might need to kill. The goal as a photographer is to make them comfortable with you. You need to get to know them and they need to get to know you.'

Nat was inspired to take up underwater photography in a rather unlikely way. When he was little, he would go spear-fishing with his father. Spear gun in hand, he would swim into the waters off the coastal town of Pattaya and dive down, looking for grouper and barracuda to snare. Now, Pattaya is a bustling resort and its waters host jet skis and banana boats. The best place to find fish there? In the local aquarium.

Nat still prefers the sea. During his shoot, rather than lose time changing a lens underwater, he brought two cameras on each dive: one fitted with a wide-angle lens and the other with a macro lens. This proved especially useful when six enormous manta rays glided overhead. Nat switched to the camera with the wide-angle lens and, for the rest of the dive, took pictures of the majestic fish using the reflexes he honed as a kid in Pattaya to catch them.

Frenchman Éric Valli knew beforehand that the conditions would be against him. In the massive caves on the southern coast of Thailand, confronting treacherous ascents and descents, humidity and avalanches of bird excrement would just be part of the job. Seventeen years

Nat Sumanatemeya and one of his underwater subjects.

earlier Valli had achieved in those same caverns what many thought was impossible: photographing, in near total darkness, the agile climbers who collect the edible nests of the caves' resident swiftlets.

Hoping to replicate the feat for this project and prove he still had the fitness for such an adventure, Valli started training in France before he arrived in Thailand. Even if he had failed (which he didn't), no one would question his heart. The assignment he was undertaking was dangerous and mentally exhausting.

Valli and his assistant set out before dawn every day in a longtail boat. From the foot of the island, they faced a 40-minute hike up to the mouth of the cave. From there,

Éric Valli returned to the bird's nest caves of the south, which are protected by armed guards.

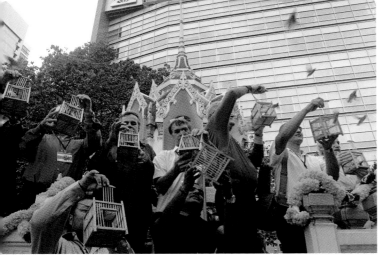

LEFT: In an effort to ensure good luck and good weather during the shoot, a merit-making ceremony was held at the Dusit Thani's spirit house, during which the team released birds.

RIGHT: Meeting old friends and making new ones at the welcome party.

Raghu Rai, India

Photos by Spa Advertising

they first lowered their equipment in protective Pelican cases before rappelling down themselves. Once inside, they scouted exciting angles from which to photograph the nest collectors at work. Typically this meant climbing the bamboo scaffolding and vines like the birds' nests collectors themselves and then perching on a ledge. So precarious was their position that they frequently strapped both themselves and the tripod to the cave's walls.

Such 'extreme' photography was, of course, not the norm. On the other hand, it was not abnormal for photographers to go to unusual lengths and take risks to get the shot. By gaining access to angles and locations that defy the most common views of Thailand, the book would gain scope and depth.

A few photographers, for example, expressed interest in following the Royal Thai Armed Forces. Because its top brass had led a coup against the popularly elected Prime Minister Thaksin Shinawatra only four months earlier, the Thai armed forces were very much in the international spotlight in January of 2007. In the end, Guido Alberto Rossi was awarded the tour of duty. Waking up by 5 am every day, Rossi was escorted through some of the military's main bases and led to exercises and scenes that were often orchestrated for his sake.

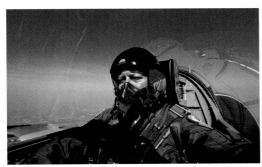

Guido Alberto Rossi in an L-39 jet.

Towards the end of his boot camp-like schedule, it was clear the Italian was exhausted, so his military entourage decided to give him a final boost—a rocket boost. The Air Force offered Rossi a rare opportunity: the chance to take pictures at 450 kilometres per hour. For most photographers, that would be an intimidating prospect, but Rossi, who has logged 1,600 hours as an amateur pilot, was pumped. For 90 minutes he flew in an L-39

aircraft and, for 10 minutes, manned the plane. When two F-16 fighter jets settled alongside Rossi's wing, leading to one of the book's most dramatic shots, the Italian said the scene was just like 'a still life'.

As the Royal Thai Armed Forces was eager to present its traditional role of serving His Majesty the King and protecting his people, it had no plans to embed Rossi in the conflict zone deep within its own territory. The editors of this book, however, felt it was important to depict the ongoing insurgency in the three southernmost provinces of Thailand—Yala, Narathiwat and Pattani.

For nearly four years now, as part of their non-stop sabotage of daily and civic life there, Muslim separatists in the deep south have burned schools, ambushed military outposts, murdered farmers, teachers and informants, or set off small bombs. These ethnic-Malay Thai citizens want to re-establish the independent Pattani state, which was annexed by Bangkok nearly a century ago. Thai photographer Charoon Thongnual, from the English-language daily *The Nation*, and Abbas, a veteran of many conflicts, from the Iranian Revolution to the Vietnam War, were given the task of recording this sensitive situation.

The key challenge among photographers working in conflict zones is to gain the trust of the local people. Without the help of a network of contacts, it is extremely difficult to overcome physical and cultural barriers. Fortunately, both photographers had experience taking pictures in the Muslim-majority area. Charoon, who grew up in and lives in the neighbouring province of Songkhla, has covered the conflict since its resurgence four years ago. Abbas was returning for the second time in three years. He brought prints from his previous trip, and handing them out to familiar faces at the places he revisited allowed him to quickly establish himself again.

Knowing that the region boasts a rich cultural and religious history as well as traditional lifestyles that are disappearing elsewhere in Thailand, Charoon and Abbas also emphasised scenes outside of the tension and destruction that plague its daily life. Charoon planned one particular picture months in advance. He wanted to locate a woman being attended to by a midwife in her home, a practice preferred to hospital care in the deep south.

Locating such a scenario unfolding within the nine days, however, would be difficult, but Charoon, effectively using his connections, secured an invitation to a home. There, a midwife who had delivered more than 1,000 babies in over 25 years of service to her village, was attending to a mother who had just given birth to her fourth child, a

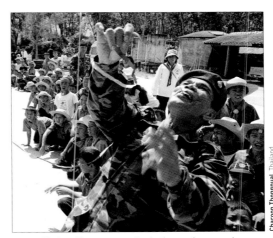

Charoon Thongnual, Thailand

Reconciliation efforts are ongoing in the southern provinces of Thailand.

daughter. In order to respect their privacy and the sleeping newborn, Charoon worked quickly and without a flash. The baby was only two days old.

In some cases, the desire for balance and depth in this book required portraying aspects of Thailand that exist largely on the margins. For all of Thailand's tremendous progress, the kingdom, like any 21st-century society,

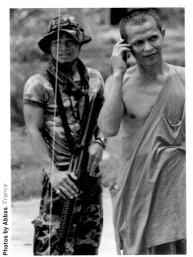
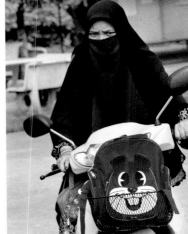

Photos by Abbas, France

When sending photographers into conflict zones, it is essential that they gain the trust of the locals.

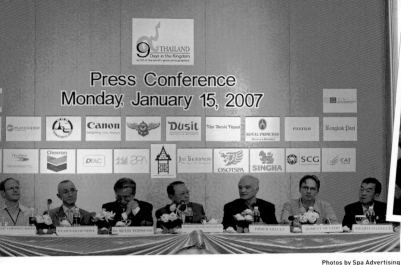

Photos by Spa Advertising

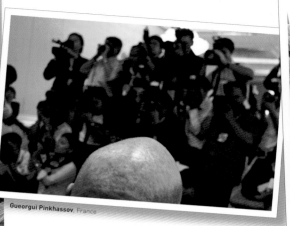

Gueorgui Pinkhassov, France

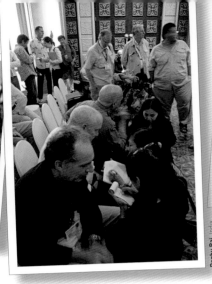

Raghu Rai, India

faces serious challenges: poverty, alcoholism and HIV/AIDS among them. The story of those who are often out of sight could not be left untold. Enter James Nachtwey, a photographer who has spent more than 25 years exposing the struggles faced by people throughout the world.

For his assignment, he chose to continue his ongoing project on the global HIV/AIDS epidemic. Thailand, which has effectively curbed the spread of HIV/AIDS since the mid-1990s, has often been referred to as a model for other developing nations to follow. But while today the issue has fallen largely out of public and political discourses, HIV/AIDS certainly has not disappeared.

Following Catholic priest Father Mike on his daily visits to an HIV/AIDS hospital in Lop Buri, Nachtwey showed how the greatest suffering can be intertwined with the greatest compassion. His pictures of Father Mike caring for HIV/AIDS patients in their last stages of life are not easy to look at, but they inspire. Getting so close to his subjects, the American brings what might be called a 'human touch' to his images. Fittingly, many of his photos contain a literal 'human touch' between two bodies: Father Mike and the patient he comforts.

A different type of human drama was the subject of Michael Freeman's focus. For a single night, Freeman chased bad luck in the back of a pick-up truck on Bangkok's streets. Saturday night, he was told by the Por Tek Tung emergency response team, was the best time to do that.

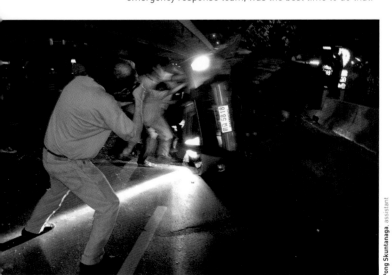

Pong Skuntanaga, assistant

Michael Freeman at the scene of a fatal car accident.

Por Tek Tung is a volunteer network that, due to Bangkok's poor emergency services and bad traffic, is often the first on the scene of an accident. If the victim is killed, Por Tek Tung will deliver the body to the nearest morgue. Freeman, who, a couple of nights earlier, had spent the night on a squid boat, was excited about some high drama on the open road.

Freeman's assistant, however, was not completely enthused by the idea: he did not want to see a dead body. Later that night, after sitting with the emergency crew at their headquarters, listening to the police radio and waiting for a call, the assistant's worst fears came true. An off-duty police officer had driven into a concrete pylon. The initial collision did not kill him, the police said, but the one-tonne transformer held by the pylon did. Dislodged by the impact of the crash, it fell 20 metres and through his windshield, ending his life instantly.

Freeman's pick-up was the first on the scene, followed closely by the Thai tabloids. The following day the crash was splashed across the front page of two Bangkok dailies. The newspapers' pictures of the accident also featured a curious detail: a strange foreigner taking pictures of the crash. Freeman had made page one.

Altogether, 21 photographers were sent out into the chaos of the capital. Because the 'City of Angels', with its population of more than 13 million people, is the centre of commerce, wealth, architecture, entertainment and the media, not to mention the focal point of the hopes and dreams of rural migrants, a large group of photographers representing a diverse mix of styles and interests was required. Together, could they comprehensively frame the beast that is Bangkok?

Sizing up the city from every angle, Ben Simmons made a superb effort. The American expatriate from Japan was entrusted with presenting the dramatic transformation in Bangkok's infrastructure and architecture, from the new airport to the glitzy shopping centres. He was also asked to keep an eye out for the idiosyncratic contrasts of old and new, East and West, that the Thai capital is famous for.

Simmons knew from past assignments in Bangkok that simply moving about the city was a challenge. In fact, his sharpest memories of the sprawling, polluted,

hyperventilating capital were of haggling over taxi fares in the blazing heat. 'And you'd better have a good book for the ride,' he jokes. The city's notorious gridlock inevitably froze even his shortest journey for long periods of time and the photographer's only views were of cars on all sides.

Simmons's test, therefore, was a common one for the urban landscape photographer. He needed to find the best angle from which to present Bangkok's crunch of office buildings, shopping centres, temples and commuters, allowing the elements to breathe—or not to breathe, if that is the desire—within the frame.

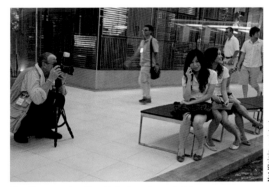

Nat Klainin, assistant

Ben Simmons in a Bangkok shopping complex.

This time, Simmons was offered a solution in the form of the new infrastructure itself. Before he started shooting, he hopped onto Bangkok's slick, elevated commuter rail, known as the Skytrain. Smoothly snaking its way through downtown, the air-conditioned train cruised over the congested roads below. From this parallel plane Simmons was able to scout positions, and he was inspired by what he saw. 'I love the mix, that little bit of what's left of the traditional up to the cutting-edge architecture that's part fantasy, part modernist,' he says. 'Now I have an entirely new perspective on the city.' A new perspective which he translated into his pictures.

Chien-Chi Chang, meanwhile, approached Bangkok from the ground up. Stationing himself on two construction sites, Chang focused on just these groups of workers. This allowed him to indulge two of his personal interests: working slowly and photographing marginal communities.

Few of Bangkok's urban labourers grew up in the city. Some are Burmese and Cambodian immigrants while

The Dusit Thani's Vimarn
Suriya Room was the venue for
the press conference launching
the project on 15 January
2007. Local and international
media gathered to meet the
photographers, snap photos
and interview them. The
event was organised by one
of our media partners,
Spa Advertising.

the majority are migrant labourers from the northeast of the country. They typically work for a few months before returning for the harvest, earning around US$5 a day, and sleeping and eating on the site itself. Through their labour, hundreds of skyscrapers, condominiums and overpasses have sprouted in Bangkok in the last 20 years.

Leading real estate developer Raimon Land gave Chang permission to take pictures at two of its building sites. At both, the workers were constructing luxury condominium complexes. Chang's assistant was slightly anxious about the locations. He was not worried about Chang's safety—the workers were hospitable and the photographer was given a hard hat—but he was concerned about Chang's stomach. Rural Thais often load their dishes with hot chillies. What would Chang eat? The Taiwanese-American photographer, for his part, was more concerned about immersing himself in the small community of workers. Chang knew that to create the intimate portraits he is known for, he would need the workers to be comfortable with his presence. The best way to take the edge off the dynamic, a staff member told him as he headed out on his first day, was simple: if they offer you food, eat it.

Chief photographer Robert McLeod's approach to the city, like Chang's, was deliberate, but it was also very different. The Bangkok-based photographer set up what he called 'a production line', a temporary studio in the middle of Bangkok's central shopping district. There, he recruited subjects and, placing them against a simple backdrop, took their pictures in less than a minute.

A similar concept had been applied on the border for *Thailand: Seven Days in the Kingdom*. McLeod's innovation was to move the studio idea from the countryside to the heart of the city centre, known as Siam Square, and to focus exclusively on pairs. 'If you shot Siam Square 20 years ago, everyone would be wearing jeans and t-shirts,' he explains, 'but as Thailand has become more prosperous and modernised, what it's lost in the countryside, in terms of diversity, it's gained in the city.'

For nine days McLeod ran his temporary studio in the back room of a Siam Square parking garage. Through a team of assistants, he recruited 186 pairs of Thais. His portraits capture a cross-section of Bangkok's prevailing

fashions, attitudes and hairstyles. Why pairs? McLeod had noticed that pairs—of friends, couples and co-workers—often have a visual connection between them. And who would visit the back room of a parking garage alone?

Greg Gorman, on the other hand, came to Thailand to intentionally remove himself from the parameters of the studio. The Californian, who is famous for his brilliant portraits of Hollywood stars, wanted to see if he could retain his style, using natural light, 'in unfamiliar surroundings with unfamiliar subjects.' On his first visit to Thailand, Gorman would tackle Muay Thai boxing and the country's colourful cabarets, which are largely performed by members of its *kathoey*, or 'ladyboy', population. 'My challenge,' he says, 'was to capture imagery that not only worked for the assignment but represented who I am as a photographer.'

On the last day of his shoot, Gorman certainly found himself in unfamiliar surroundings with unfamiliar subjects. In the women's restroom of the Dusit Thani's French restaurant, Gorman was taking pictures of five gorgeous ladyboys. For more than an hour, the girls never stopped smiling. Gorman wouldn't let them. As his camera

clicked every few seconds, he kept up a running dialogue of jokes, compliments and suggestions for poses. With make-up expertly applied, the women, who form a pop group known as Venus Butterfly, looked completely at ease.

The restroom had not been Gorman's first choice. He had preferred the rooftop restaurant of a nearby hotel. But his clever spur-of-the-moment idea wasn't such a step down: glass windows provided views of the city and there was a luxurious divan for the women to sit on. Somehow it was all very fitting: five stunning ladyboys in shimmering gold dresses in the women's restroom of a five-star hotel— only in Thailand.

Highlighting the sheer diversity of Thai life, many photographers, besides Robert McLeod and Greg Gorman, took portraits during the project. To capture the spirit of the times, an effort was made to present leading artists, entertainers and athletes. Icons were chosen not simply for their status, but because they represented larger cultural trends. There was avant-garde film-maker Apichatpong Weerasethakul, whose films have received rave reviews at the Cannes Film Festival but are rarely watched at home: in 2007, after rejecting minor cuts suggested by increasingly

Greg Gorman (left) photographing Venus Butterfly in the women's restroom of the Dusit Thani's French restaurant.

Catherine Karnow, USA

picky Thai censors, he said he would not show the film in Thailand at all. There was half-American, half-Thai pop idol Tata Young, a singer whose albums include songs in both English and Thai and are popular across Asia: she is what Thais call a *luuk khreung*, someone of mixed Western and Thai blood. Due to the conspicuous number of *luuk khreung* models and pop entertainers, this ethnic group enjoys a somewhat special status in Thailand. And there was female Olympic gold-medal winner Pawina Thongsuk, who defies traditional stereotypes of the Thai woman. She is a weightlifter...with a beautiful smile.

Catherine Karnow (right) with pop star Tata Young.

Across Asia, the countryside, with its rural traditions and distinctive pace of life, stands in sharp contrast to the city. Thailand is no exception. While the countryside has urbanised significantly in the last 20 years, it is still home to the kingdom's ancient cities, wildlife and many of its key industries, from rice farms to textile factories. And while Thailand's beach-fringed south, known primarily for its rubber production and fishing fleets, has been heavily influenced by its massive tourism industry, the vast swathes of countryside to the north of Bangkok are well known for preserving the more traditional ways of Thai life.

Thirty-three photographers dedicated their entire nine days to recording life in the provinces—visiting farms and remote villages, searching for elephants in the bush and attending rural festivals, among other activities. Far from the conveniences of the city and with long drives and treks often required, the countryside posed its own set of challenges for these photographers, as Filipino photographer Romeo Gacad found out.

Gacad, who has covered both USA–Iraq wars as well as the American invasion of Afghanistan for Agence France-Presse (AFP), had looked forward to a change of environment and a return to his roots. The 46-year-old's grandparents on both sides of his family were farmers north of Manila, and Gacad describes himself as a 'farm boy', with fond memories of riding buffaloes as a child. His assignment was, simply, farming. During his nine-day shoot, he drove through the country's agricultural basin, situated appropriately in the heart of the country. His emphasis would be on rice, of which Thailand is the world's leading exporter.

So what happens when a war photographer goes to the countryside to take pictures of rice? He gets injured, of course. While standing on a ladder in the middle of a paddy field, his right foot slipped and Gacad sliced his leg on the ladder's frame. Unfazed at first and immersed in the surrounding landscape, Gacad did what any war photographer would do: he continued taking pictures.

Only when his assistant returned from an errand did Gacad discover the extent of his injury and decide to go to a hospital. Although his leg was extremely swollen, he had suffered only a haematoma; so he got it bandaged and moved on to his next location, a chicken farm.

For the provincial photographers such as Gacad, it was not always easy to make contact with subjects and locate outstanding picture situations. Few could communicate in Thai and strong images in the countryside depend heavily on good light for their impact. Frequently it was their invaluable assistants and guides who opened the windows of opportunity.

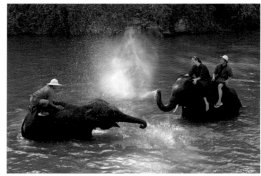

Palani Mohan's (not pictured) fascination with elephants led him deep into the jungle, to the river's edge.

Michael Yamashita, for example, who photographed around the Mekong River, learned through his guide that hundreds of monks were gathering at a nearby temple for a special slice of winter activities. Arriving at the temple at the crack of dawn the next day, Yamashita went to work. At this point, it is the demeanour of the photographer

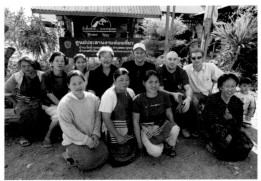

Michael Yamashita (back row, centre) in the far north.

and his or her method which often becomes significant. Yamashita approaches every scenario with an easy-going smile, allowing the situations to develop naturally around him. Regardless of his subjects—gatherings of monks, river fishermen or villagers—he almost never intervenes directly, remaining instead an intent observer. Yet at the same time, his pictures frequently put the viewer right in the thick of the scene. In one of his pictures of the monks, included here in the book, you can almost taste the food the monks are blessing.

Among the wildlife photographers, a relaxed nature can also be a virtue; but patience is not always rewarded. Although Jan Matthysen and Suthep Kritsanavarin both knew the trails of Khao Yai National Park and Huay Khwang Wildlife Sanctuary like the backs of their hands, that did not lead to the many encounters with rare game that they had hoped for. Palani Mohan, whose special affection is for the elephant, found a way to guarantee a meeting with the gentle beast: follow the mahouts. Heading deep into the bush, Mohan sought the elephants' keepers. Finding a new angle to present the much photographed Thai icon was another challenge. Getting down on his knees as a mahout guided his elephant down a hill towards its daily bath, Mohan captured one shot that gives a sense of the elephant's awesome size.

The project's farewell party was held at Jim Thompson House. Here, it was time for the photographers to step in front of the camera for a change, and it was also time to let loose and have some fun. Delicious street food was served from stalls set up in the garden and wine flowed freely all night. Entertainment was provided by the Joe Louis Puppet Theatre.

While the Thai countryside retains a sense of purity compared to Bangkok, it is certainly not beyond the reach of modernity. The hill tribe villages of northern Thailand and the ancient royal cities have, like the elephant, been influenced by tourism. The former Thai capital of Sukhothai, for example, is now a 'historical park' as well as a UNESCO World Heritage Site, and many hill tribe villagers welcome *Lonely Planet*-wielding trekkers with bottles of Coca-Cola. While in reality their appeal is not that diminished, the problem from a photographic standpoint is that they have become symbols of Thailand's charm. Pictures of hill tribe villages and Sukhothai's stunning Buddha statues are plastered on the walls of travel agents all over the world.

For many photographers, it would be an unenviable task to be asked to present these locations in a fresh way. That's why a man with special powers was called in, a man who, according to chief photographer McLeod, 'sees in infrared.' Since 1983, Bangkok-based British expatriate Martin Reeves has been using infrared film, which picks up light that is invisible to the naked eye. 'It's the same as dogs can hear sounds we can't,' explains Reeves.

Reeves first encountered this unconventional style of photography in a Brighton record shop on the cover of the U2 album *The Unforgettable Fire*. The rest is history. More than 20 years later, Reeves has become a prominent specialist who is an expert at finding the clouds, foliage and stones which, glowing with infrared reflections, will have a magical effect when captured using a 'Red 25' filter over the lens.

Because Reeves likes to use the film to recreate the mystical ambience of bygone eras, he does not appreciate modern intervention in his pictures, a situation, he learned during this project, cannot always be prevented in Thailand today. Visiting a remote Akha hill tribe village in Chiang Rai, Reeves was invited to attend a traditional wedding ceremony between two young Akha. Midway through the ceremony, a mobile phone rang. It belonged to the groom. 'He didn't bat an eye,' recounts Reeves. 'He answered the call, even put on a headset and then chatted for the next five minutes in the middle of his own wedding.'

While modernity has certainly changed the Thai countryside—farmers, too, call their families from the fields on mobile phones and even monks can be seen using the technology—the area still remains the guardian of traditional forms of Thai culture. Rural festivals, known as temple fairs, for example, are hugely popular. Often featuring generations-old country singing known as *luuk thung*, ensembles of classical Thai musicians, beauty pageants and Muay Thai boxing matches, they encapsulate the concept of *sanook* (fun) that still exists in the hearts of the Thai people.

Assignment editor Korakot Punlopruksa (Nym).

Gueorgui Pinkhassov, France

These fairs, like an American Independence Day parade, distil some of the essence of the country's character. Many photographers attended such emblematic events, hoping to catch the Thai spirit. Some happened upon them by accident, while others made plans well in advance to attend them. Gilles Sabrié, for example, travelled on a train with a *norha* dance troupe all the way from Hat Yai in the far south of Thailand to their performance in Bangkok, recording the preparations and lives behind the masks. Meanwhile, Surat Osathanugrah stood backstage and mingled with the crowd at a series of concerts by a *luuk thung* singer. Gorman and Pinkhassov attended cabarets while Shahidul Alam witnessed Thailand's most famous folk singer and motorcycle enthusiast lead a procession of Harley Davidsons, accompanied by a pair of elephants. Early one morning, S. C. Shekar happened upon a young man being lifted through the streets of Bangkok by a procession of drunken neighbours and family. The man was on his way to being ordained as a monk. Such serendipitous moments provided not only many memorable shots for the book, but, more often than not, left the photographers feeling captivated themselves by Thailand's charisma. *Sanook*, they quickly learned, is infectious.

After nine days, the photographers, too, could finally give themselves over to the pleasure of the moment. Flying back to Bangkok from locations all over the country, they reunited, exhausted but clearly exhilarated by the experience. With the more than 100,000 pictures downloaded and safely stored in six hard drives, there was nothing more they could do, except unwind. At a farewell party held at Jim Thompson House on the final night of the project, they celebrated. Putting their cameras aside, they traded stories and toasts and reflected on nine days of hard work. Except for one photographer.

Gueorgui Pinkhassov was still taking pictures. Then he vanished. Had he found some interesting light? After a while, his whereabouts became a topic of passing discussion, and then his disappearance became a cause for concern. His flight back to Paris was leaving soon. Finally, a member of the staff found him wandering alone on the second floor of a nearby building and corralled him into a van. All the way to the airport, he took pictures through the van's windows.

No doubt, as he moved towards the check-in counter, passed through immigration and waited to board, his camera rarely left his eye. When his plane left the ground and soared over the country's illuminated new airport, was he attracted by the luminous glow? And as midnight on the ninth day approached and the kingdom below became just a twinkle of lights in the darkness, did he take one last picture?

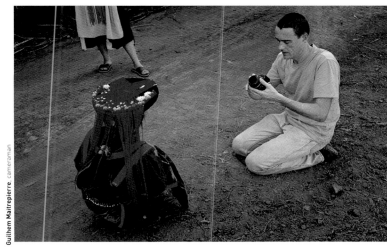

Guilhem Maitrepierre, cameraman

Martin Reeves photographing a member of the Lisu hill tribe in Chiang Rai.

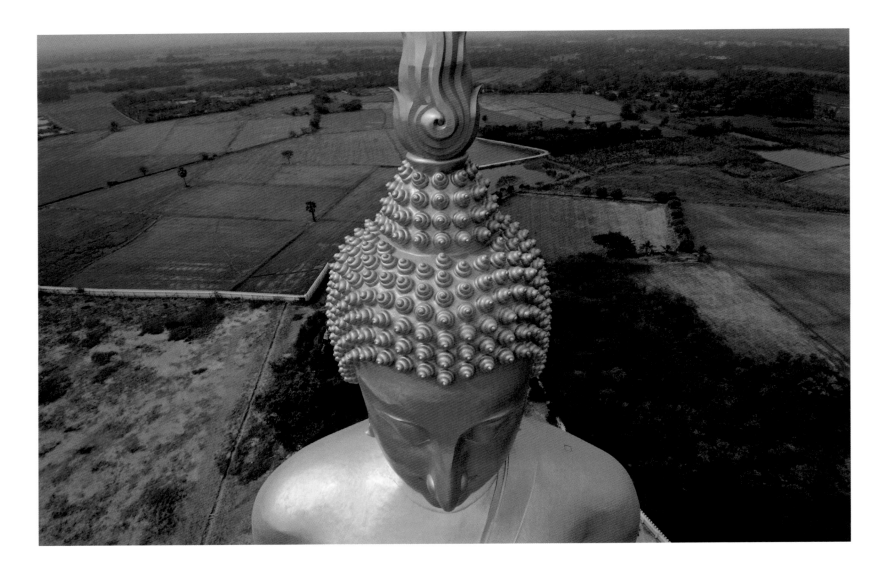

Behind the Pictures

BEHIND EVERY PICTURE there is a story that is rarely told—the story of how that picture came to be. This book, then, is not only a collection of hundreds of photographs, but also of many untold tales.

Sometimes, the story behind a picture is simple. There was a fleeting moment of visual magic and the photographer, like an expert hunter, snared it. Other times, a picture is

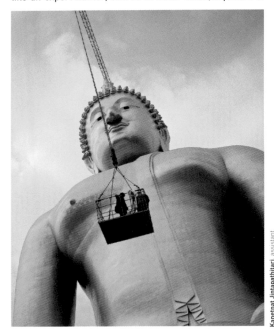

Kanetnat Jintapathitari, assistant

the result of patience and persistence. Even a split-second reaction can involve hours of waiting. More often than not, a meaningful photograph is a mixture of factors—preparation, instinct and serendipity—as these two stories reveal.

Filipino news photographer Romeo Gacad was assigned to cover rice farming. Driving through Ang Thong province in central Thailand, Gacad noticed an enormous statue of the Buddha. 'It struck me,' he said, 'it was sitting in a carpet of green, surrounded by rice. It was a landscape of serenity.' Realising that the light was wrong, he decided to return at sunrise the following day. The next morning, Gacad started taking pictures approximately one kilometre from the Buddha image. Hoping to put the Buddha's size in perspective, he waited patiently until a flock of birds passed by.

As he took the pictures from a distance, Gacad could see a crane and the tiny silhouettes of people working on the statue. Deciding he wanted a closer look, he and his assistant drove to the temple where the statue was located. The Buddha, as it turns out, was in the very last stages of construction and workers were in the process of applying shimmering gold paint to the statue. With the help of his assistant, Kanetnat 'Big' Jintapathitari, Gacad received permission from the temple's head monk to ride in the crane with the site's engineer. 'I told him I wanted to go eye to eye,' said Gacad.

Gacad and the engineer were winched to the top in a small iron box and, using hand signals, Gacad was able to get the crane to position him for shots. Dangling precariously nearly 100 metres off the ground, Gacad stood face to face with the Buddha image and also had a 360-degree panorama of the rice fields below. Using his Leica, he experimented with different angles and shots for the next half-hour.

Kanetnat Jintapathitari, assistant

In the end, Gacad decided to split the composition, allowing the rice fields and half of the Buddha's face to share the frame. The picture thus neatly combines two aspects of Thailand that have remained at its heart since its inception: Buddhism and rice. As Gacad was brought back down to earth, he thought he had a good shot for the book: in fact he had many.

While Gacad was using a crane to scale a statue among rice fields, an entirely different story was unfolding

in downtown Bangkok. Photographer and *9 Days* chairman Surat Osathanugrah had set his sights on an ambitious family portrait of one of Thailand's wealthiest and most successful families—the Chirathivat clan.

Having turned a small roadside store into a retail empire comprising malls, hotels, hypermarkets and more, the Chirathivats and their Central Group symbolise Bangkok's own transformation over the last century from humble beginnings to a global metropolis.

The clan also illustrates the traditional family-style business model popular among the country's thriving ethnic Chinese community. As the business empire has expanded, so has the family. There are now nearly 200 family members spanning only four generations, all direct descendants of family patriarch and Central founder Tiang Chirathivat.

To make a portrait of the Chirathivats, a bit of luck and the inspiration of His Majesty the King were needed. After initial attempts to secure the family's interest failed, it was discovered that a Chirathivat—Pong Skuntanaga—was, in fact, participating in *9 Days*. A photography lover, the young executive from the retail arm of the company had taken time off work to volunteer as an assistant.

In short, as might be expected in such a tightly knit family, it took one of their own to bring them together. 'We are very close so it is easy for us to communicate with each other,' explained Pong, 'and because this picture was for the King, everyone was inspired to come.' And come they did, almost entirely in luxury cars of course, which began rolling into the parking garage of the family's CentralWorld before opening hours. The massive shopping complex was a fitting location for the picture and, by 9.30 am, more than 100

The Digital Divide

Siwarak Daosuparoch, *assistant*

FOUR DAYS INTO THE SHOOT, Richard Kalvar holes up in his dimly lit hotel room. It is late evening and he's done taking pictures for the day, but his work is hardly finished. 'With digital, the photographer has so much more work,' he says. Having hunted for pictures in crowded markets since sunrise, Kalvar, like most of his colleagues, returns to his room to download, organise and review his shots, a process which can take hours.

Other photographers have found a way to avoid overtime on the computer—they stick to film. Their reasons or justifications for doing so range from the practical to the philosophical. Some are purists who believe that digital photography is taking the art out of photography. Others simply feel it's too late for an old dog to learn new tricks. Yet, most photographers, even those who rose to fame before the digital age, have switched, although not exclusively, to digital cameras.

On this project, 44 of the 55 photographers used digital cameras. Michael Freeman, who worked on both *Thailand: Seven Days in the Kingdom* and this book, and whose 'evening job' is writing books on digital photography, says that the digital age has opened new doors for photographers. 'It has taken over far faster than anyone imagined. It has also extended the range of human activity and situations we can cover. More of life can be tackled and that can only be good.'

From a publishing standpoint, the advantages of digital photography are clear-cut. It is cost- and time-efficient, if it is organised properly. EDM prepared for the digital avalanche by purchasing 10 hard drives with five terabytes of storage (5,000 gigabytes) and hiring a team of technicians to help the photographers, headed by Freeman. His task was to create a system that would allow EDM to collect and organise the more than 100,000 images of all different sizes and formats before the photographers scattered around the world again.

The benefits of this system became most apparent in the production stage. Instead of scanning contact sheets with magnifying glasses, the photo selection team collectively considered the pictures on 30-inch Apple computer monitors. They could also use software features to expedite the selection, organisation and layout process. Picture editor Marie Claude Millet, a veteran of such committees, marvelled at how much more productive and effective the system now is.

Among the photographers, however, there remains ambivalence towards digital technology. For them the goal is, as it always has been, to establish a comfortable relationship with the equipment they use. For war photographer James Nachtwey that means using only black and white film and spending hours in the dark room with his staff, perfecting prints. For purist Chien-Chi Chang that means slowing down while others speed up: 'I am trying to make every frame count, just as in t'ai chi every breath counts.' And for Abbas, well, technology is beside the point. 'I don't use a camera,' he says, speaking figuratively, 'I use my eye.'

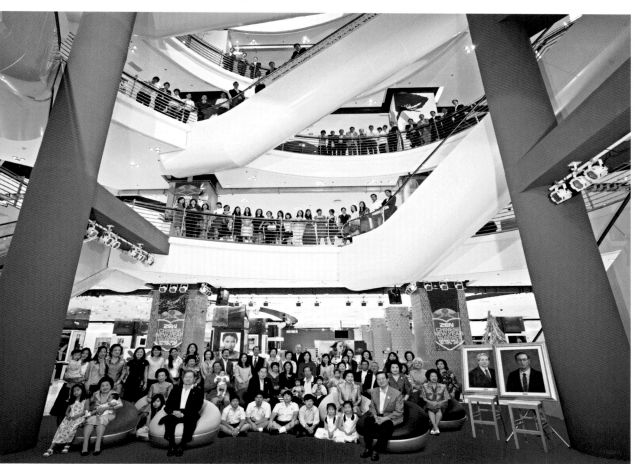

family members had gathered. For some, who were studying abroad and returned to Bangkok especially for the occasion, the journey had begun as far away as America.

Waiting to greet them was a team from the *9 Days* project. Family portraits are notoriously problematic affairs and, given the scope of this one, Surat knew he would have his hands full. Enlisting the technical expertise of *9 Days* chief photographer Robert McLeod and the lighting skills of Anuchai Secharunputong, as well as a platoon of assistants, Surat ensured a smooth operation in the short time frame provided. Then, using a 39-million-megapixel camera and with minutes to spare before CentralWorld was opened to the public, Surat got his shot.

Nicholas Grossman

OPPOSITE: Romeo Gacad, who frequently photographs wars, went to great heights to capture a memorable picture for the *9 Days* project. In Ang Thong province, he scaled a statue of the Buddha by hitching a ride with a construction crew.

LEFT: The Chirathivat clan is one of Thailand's wealthiest and most successful families. Here, more than 100 family members from four generations are pictured at the family-owned CentralWorld, Southeast Asia's largest retail complex. The family's patriarch, Tiang, and his eldest son, Samrit, who established the family's retail empire, are featured in paintings.

Pairin Kankaew, *assistant*

Ernest Goh

Peerapong Prasutr, assistant

Manit Sriwanichpoom (seated)

Tara Sosrowardoyo, Indonesia

Bruno Barbey and his son, Igor

Olarn Nateharn, assistant

Nicolas Millet

Pong Skuntanaga, assistant

Gerhard Jörén

Ruben Toral, Bumrungrad Hospital

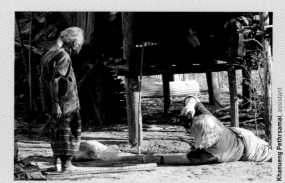

Peter Turnley

Khanueng Pethrsamai, assistant

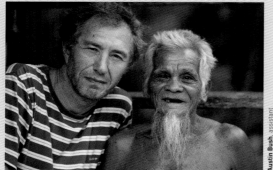

Éric Valli (left)

Austin Bush, assistant

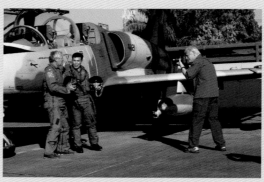

Guido Alberto Rossi (far left) and Yann Arthus-Bertrand (right)

Guilhem Maitrepierre

Yann Arthus-Bertrand, France

Dow Wasiksiri

Spa Advertising

Raghu Rai

Royjerm Vithakamontri, assistant

Richard Kalvar

Natthachai Wittayawongruji, assistant

FROM LEFT: Yien Li Yap and Laura Jeanne Gobal

Ben Simmons, USA

Egbert Brehm

Somjade Srimahachota, assistant

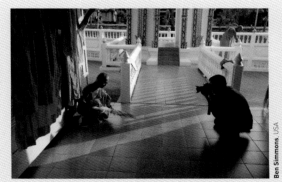

Kraipit Phanvut

Ben Simmons, USA

FROM LEFT: Carlos Freire and Michael Freeman

Pong Skuntanaga, assistant

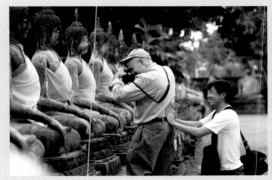

Steve McCurry

Papon Kecharananta, assistant

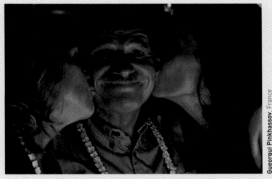

FROM LEFT: Marie Claude Millet, Yann Arthus-Bertrand and Melisa Teo

Gueorgui Pinkhassov, France

Jörg Sundermann

Tara Sosrowardoyo, Indonesia

Jeff Hutchens

Kija Pruchyathamkorn, assistant

FROM LEFT: Nicholas Grossman and Korakot Punlopruksa (Nym)

Gueorgui Pinkhassov, France

Shahidul Alam

Catherine Karnow, USA

Charoon Thongnual

The Thai Silk Company (Jim Thompson)

Puchara Sandford (Am)

Jeremy Horner, UK

Palani Mohan

Tara Sosrowardoyo, Indonesia

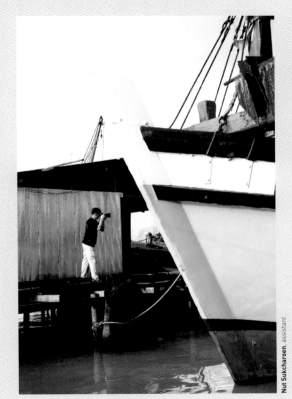

Jeremy Horner

Nut Sukcharoen, assistant

Tanya Asavatenasuphab (Bee)

Bruno Barbey, France

Rio Helmi

Pong Skuntanaga, assistant

FROM LEFT: Melisa Teo, David Alan Harvey and Hans Hoefer

Catherine Karnow, USA

Olivier Föllmi

Melisa Teo

FROM LEFT: Waranun Chutchawantipakorn and Duangdao Suwunarungsi

Pong Skuntanaga, assistant

Kaku Suzuki

Pong Skuntanaga, assistant

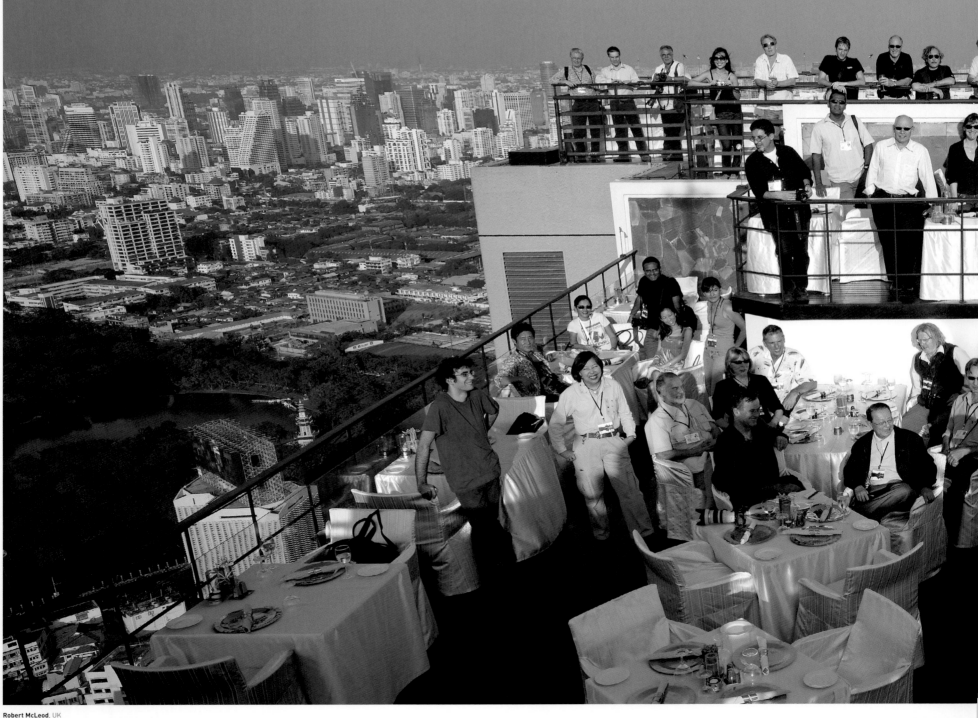

9 Days Numerology

18 nationalities participating

26 the age of the youngest photographer

78 the age of the oldest photographer

12 modes of transportation*
*passenger airline, jet, helicopter, canal boat, fishing boat, longtail boat, powerboat, bus, car, motorcycle, paraglider and rope.

44 photographers shooting digital

Robert McLeod, UK

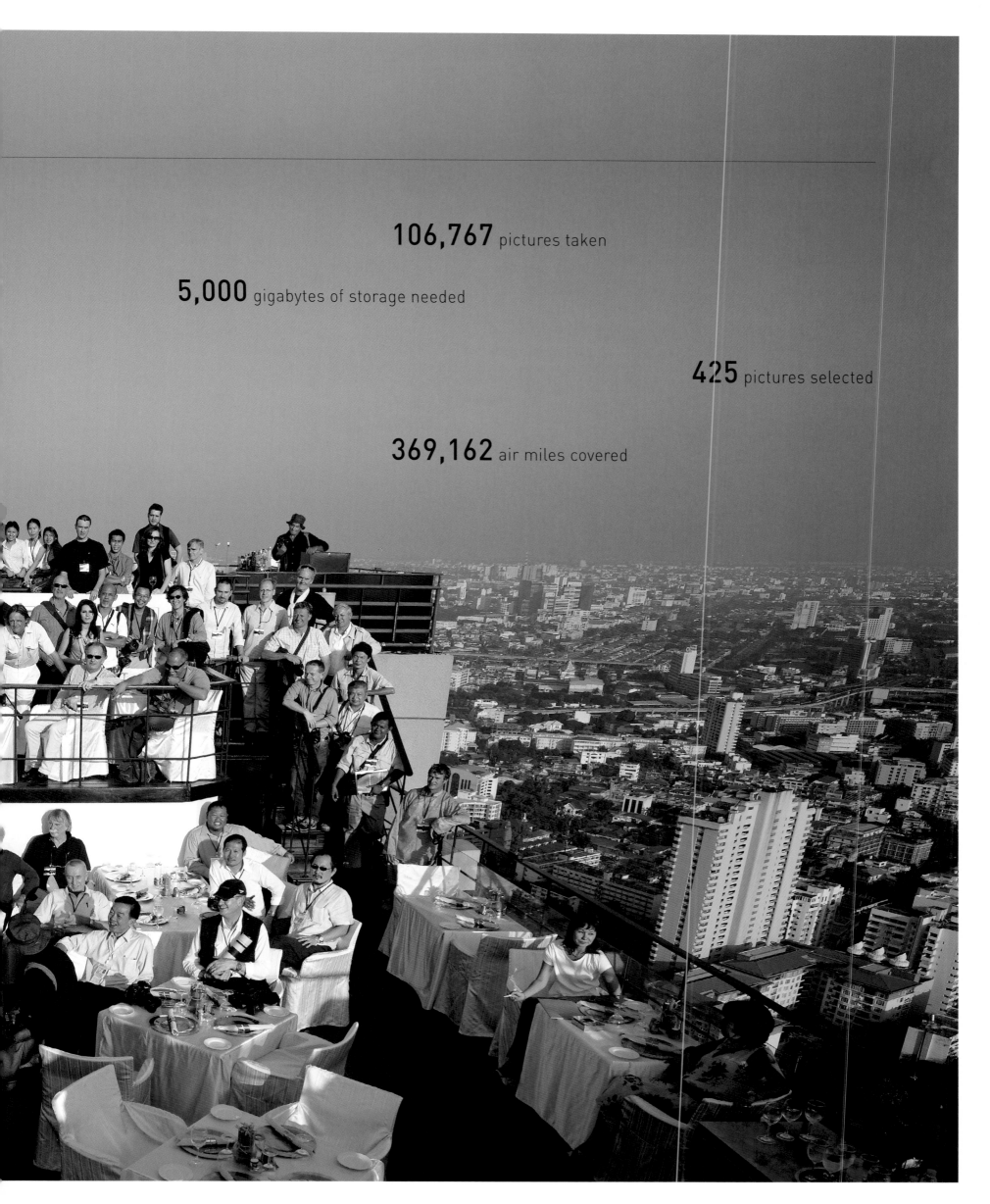

106,767 pictures taken

5,000 gigabytes of storage needed

425 pictures selected

369,162 air miles covered

Capturing the Kingdom

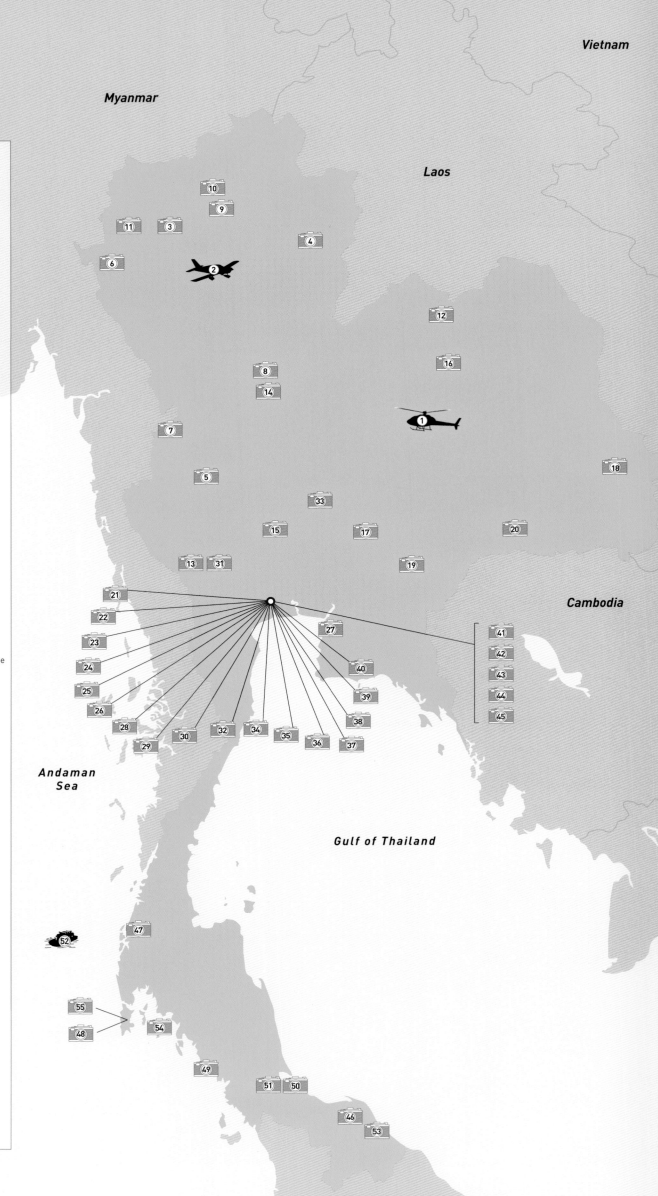

The assignments and locations of the 55 photographers

1 Yann Arthus-Bertrand — aerial photography of the countryside, cities and islands
2 Guido Alberto Rossi — the Royal Thai Armed Forces (Bangkok, Phrachuap Khiri Khan and Chiang Mai)

North

3 Shahidul Alam — celebrity portraits (Chiang Mai, Bangkok and Sukhothai)
4 Olivier Föllmi — eastern Lanna culture (Nan and Chiang Rai)
5 Suthep Kritsanavarin — wildlife (Huay Kha Khang Wildlife Sanctuary)
6 Helen Kudrich — the Karen way of life (Mae Hong Son)
7 Palani Mohan — elephants (Umphang and Lampang)
8 Martin Reeves — hill tribes and Sukhothai Historical Park (Chiang Rai and Sukhothai)
9 Jörg Sundermann — contemporary design and architecture (Chiang Mai)
10 Duangdao Suwunarungsi — nature (Chiang Dao, Doi Inthanon and Doi Angkhong)
11 Peter Turnley — people and northern culture (upper Mae Hong Son loop)
12 Michael Yamashita — landscapes and life along the Mekong River (Nong Khai)

Central/Northeast

13 Waranun Chutchawantipakorn — western Thailand (Kanchanaburi and Sangkhla Buri)
14 Laura El-Tantawy — festivals (Suphan Buri and Sukhothai)
15 Romeo Gacad — rice farming (Ang Thong and Pathum Thani)
16 Rio Helmi — Isaan heartland and provincial urban life (Khon Kaen)
17 Hans Hoefer — industries and activities of Isaan (Khorat)
18 Bohnchang Koo — Isaan culture, markets and food (Ubon Ratchathani)
19 Jan Matthysen — wildlife (Khao Yai National Park)
20 Kaku Suzuki — heritage sites (Ayutthaya, Lop Buri, Phimai and Surin)

Bangkok and vicinity

21 Egbert Brehm — historic sites and landmarks
22 Chien-Chi Chang — construction sites
23 Michael Freeman — transportation and fishing (Bangkok and Rayong)
24 Carlos Freire — portraits of famous artists
25 Greg Gorman — Muay Thai boxing and cabaret
26 David Alan Harvey — Bangkok's nightlife
27 Jeff Hutchens — street life in Pattaya and Bangkok
28 Gerhard Jörén — the blind community and modern and traditional medicine
29 Richard Kalvar — Bangkok's street life
30 Catherine Karnow — cultural diversity
31 Steve McCurry — Buddhism (Bangkok, Ayutthaya and vicinity)
32 Robert McLeod — Siam Square portraits and interiors
33 James Nachtwey — caring for HIV/AIDS patients
34 Surat Osathanugrah — popular entertainment
35 Kraipit Phanvut — the Royal Family
36 Gueorgui Pinkhassov — Bangkok at night
37 Nat Prakobsantisuk — fashion
38 Raghu Rai — religious diversity
39 Dominic Sansoni — river life
40 Anuchai Secharunputong — reverence for His Majesty the King
41 S. C. Shekar — exteriors and architecture
42 Ben Simmons — modern infrastructure and culture
43 Tara Sosrowardoyo — film and television industries
44 Manit Sriwanichpoom — high society
45 Dow Wasiksiri — children, youth and education

South

46 Abbas — culture, industry and conflict in the deep south (Pattani, Narathiwat and Yala)
47 Bruno Barbey — tsunami recovery and life along the Andaman coast (Khao Lak and Ranong)
48 John Everingham — tourism (Phuket and Krabi)
49 Ernest Goh — southern culture and islands (Trang and Tarutao National Park)
50 Jeremy Horner — the unique character and culture of Songkhla province
51 Gilles Sabrié — life under the bridge and *norha* arts troupe (Hat Yai to Bangkok)
52 Nat Sumanatemeya — underwater photography (Surin and Similan islands)
53 Charoon Thongnual — culture, industry and conflict in the deep south (Pattani, Narathiwat and Yala)
54 Éric Valli — bird's nest gathering (Phang-Nga Bay)
55 Vicente Wolf — interiors and exteriors, from markets to hotels (Bangkok and Phuket)

About the Photographers

ABBAS, France

Abbas, an Iranian living in Paris, has found some of his greatest inspiration in photographing societies in conflict. Between 1987 and 1994, from Xinjiang to Morocco, he covered the resurgence of Islam, exposing the internal tensions within Muslim societies torn between the past and a desire for modernisation and democracy. Later, Christianity became his focus as a political, ritual and spiritual phenomenon, and from 2000 to 2002 he explored animism. His work has been published in two books, *Allah O Akbar, a journey through militant Islam* and *IranDiary 1971–2002*. Abbas is a member of Magnum Photos.
www.magnumphotos.com

SHAHIDUL ALAM, Bangladesh

Photographer, writer and activist Shahidul Alam studied and taught chemistry at London University before shifting his focus to photography. In 1984, he returned to his hometown of Dhaka, Bangladesh, where he captured the country's democratic struggle. Alam set up Drik Picture Library, Pathshala: The South Asian Institute of Photography and Chobi Mela, the festival of photography in Asia. He is also an honorary fellow of the Royal Photographic Society, an advisory board member of the National Geographic Society and a visiting professor at Sunderland University (UK).
http://shahidul.wordpress.com

YANN ARTHUS-BERTRAND, France

French photographer Yann Arthus-Bertrand has always had a love of nature. It led him one day to Kenya, where he was to study the lions, and while there, he realised that the best way to capture the beauty of his surroundings was by flying over the landscape in a balloon. Since then, Arthus-Bertrand has produced 60 books of landscape photographs taken from helicopters and balloons. His most acclaimed project is *Earth From Above*, a book which led to the similarly named travelling exhibition of stunning aerial views.
www.yannarthusbertrand.org

BRUNO BARBEY, France

Morocco-born Bruno Barbey studied photography and graphic arts at the Ecole des arts et métiers in Vevey, Switzerland. He is a prolific author, often choosing to express himself in book form and exhibitions, and is known for his free use of colour, as shown in his books on the country of his childhood—*Fès, My Morocco* and *Essaouira*. Barbey is the recipient of many awards, including the French National Order of Merit, the Overseas Press Club Award and the University of Missouri Photojournalism Award. He is a member of Magnum Photos.
www.brunobarbey.com

EGBERT BREHM, Germany

German photographer Egbert Brehm's signature style is one which he calls 'photo painting', a technique similar to the style of the Impressionist painters at the beginning of the 20th century. This unfamiliar way of shooting photographs shows the viewer an imaginary, fleeting moment which, Brehm feels, allows one an 'inner' view rather than an 'objective' view. Brehm has held exhibitions in Germany and at Bangkok's Sofitel Central Plaza and Goethe-Institut.

CHIEN-CHI CHANG, USA

Alienation and connection are the subjects of much of Chien-Chi Chang's work. His investigation of the ties that bind one person to another and to society draws on his own immigrant experience. Born in Taiwan, Chang studied at Soochow University and Indiana University. His work is best reflected in *The Chain*, a collection of portraits taken in a mental institution in Taiwan; and *Double Happiness*, an examination of arranged marriages between Vietnamese country girls and older Taiwanese men. Chang is a member of Magnum Photos.
www.magnumphotos.com

WARANUN CHUTCHAWANTIPAKORN, Thailand

Bangkok-native Waranun Chutchawantipakorn is an honorary advisor to The Royal Photographic Society of Thailand and a member of the Fellowship of the Royal Photographic Society of Great Britain. He actively participates in contests organised by photographic societies internationally and his entries have been ranked in the world's top 10 for the past 20 years and have been awarded first place 15 times in the Photo Travel Division. His work has also been published in such books as *The Royal Barge* and *Images of Shanghai*.

LAURA EL-TANTAWY, Egypt/UK

Laura El-Tantawy was born in Worcestershire, England. She grew up in Cairo, Egypt and spent her early teenage years in Dammam, Saudi Arabia. She graduated with a degree in political science and journalism from the University of Georgia in the USA. El-Tantawy discovered photography by surprise and fell in love with it as an artistic form of expression of limitless boundaries. She started her career as a newspaper photographer with the *Milwaukee Journal Sentinel* and *Sarasota Herald-Tribune*. She is currently a freelancer based in Cairo.
www.lauraeltantawy.com

JOHN EVERINGHAM, Australia

John Everingham first took up a camera as an 18-year-old tourist in Vietnam in 1968. During the war years he based himself in Laos to cover the events of that period. Following the communist victory he was the only Western journalist in 'liberated' Indo-China for two years before being expelled from Laos in 1977. From a new base in Bangkok he then focused on Asian stories for international magazines, working on his first *National Geographic* story in 1979. He remains a resident of Thailand, where he runs his own magazine publishing business.
www.aapress.net

OLIVIER FÖLLMI, France

Olivier Föllmi discovered the Himalayas at the age of 17 thanks to his love of mountaineering, and he spent the next 25 years hiking through its hidden valleys. He became a specialist in Tibetan village culture, travelled the length and breadth of French-speaking Europe as a lecturer and co-directed two films for Canal+ in the Himalayas. Föllmi is the author of 18 photography books and two adventure stories. His work has been featured in magazines such as *Life*, *Paris-Match* and *National Geographic*, among others.
www.follmi.com

MICHAEL FREEMAN, UK

London-based Michael Freeman, with more than 80 photographic books to his credit, is a veteran photographer of Southeast Asia, a region he has covered for clients such as *Smithsonian*, *The Sunday Times Magazine*, Time Life, Thames and Hudson and many others. His latest book, *Sudan: The Land and the People*, represents a widening of geographical coverage. Freeman is also the author of over 30 books on digital photography, including the best-selling *Complete Guide to Digital Photography*.
www.michaelfreemanphoto.com

CARLOS FREIRE, France

A black and white specialist, Brazilian-born Carlos Freire has lived in Paris since 1973. His well-known photographs of artists and intellectuals are held in important private collections and museums around the world. Freire has photographed Francis Bacon, Marguerite Yourcenar, Rudolf Nureyev, the Dalai Lama and many others. Among the recent books he has been involved in are *Carnets de Route* (with Marc Fumaroli, Paris, 2005), *Genoa* (with Renzo Piano, Paris, 2006) and *Amazigh of Morocco* (with Driss Benzekri, Paris, 2006).
www.photo12.com

ROMEO GACAD, Philippines

Born in Manila, Romeo Gacad majored in visual communication at the College of Fine Arts of the University of the Philippines. He joined Agence France-Presse in 1985 and covered three US wars for them: the 1991 Gulf War, the 2001 war in Afghanistan and the 2003 invasion of Iraq, where he spent 41 days as an embedded photographer in the US Army 3rd Infantry Division. Gacad spends his personal time documenting farm life and nature. His first book, *Retrato at Recuerdos*, which covered life in a peasant village in the central plains of Luzon island, was published in 1983. Gacad's photographs have graced the covers of *Newsweek* and *Time*.
www.editorial.gettyimages.com

ERNEST GOH, Singapore

An education in graphic design and the influence of journalism while working at *The Straits Times* led to Ernest Goh's belief in using striking images to highlight issues relating to the human condition and the environment. Goh was commissioned by the Singapore Disability Sports Council in 1999 to work on *Laughter In The Rain*, a book covering sports for the disabled in Singapore. In 2003, at the height of the SARS outbreak, Goh documented the dire situation from inside the hospitals for *Beyond Mask*. Goh also captured the aftermath in post-tsunami Aceh, Indonesia, for Mercy Relief, an NGO. He now works on photographic projects across Asia.
www.ernestgoh.com

GREG GORMAN, USA

Greg Gorman graduated from the University of Kansas in 1969 with a major in photojournalism. He completed his studies at the University of Southern California, graduating with a Master of Fine Arts degree in cinematography in 1972. His work documents that peculiar obsession of the 20th century—celebrity. His photography has a timeless nature and each picture is a testament to the subject's character. For over two decades, Gorman has continued to master his art. From personality portraits and advertising campaigns to magazine layouts and fine art work, he has developed and showcased a discriminating and unique style in his profession.
www.gormanphotography.com

DAVID ALAN HARVEY, USA

Born in San Francisco and raised in Virginia, David Alan Harvey discovered photography at the age of 11. He purchased a used Leica with savings from his newspaper route and began photographing his family and neighbourhood in 1956. When he was 20, Harvey lived with and documented the life of a black family in Norfolk, Virginia. With these photographs he published *Tell It Like It Is* in 1966. Harvey has shot over 40 essays for *National Geographic* and has published two major books, *Cuba* and *Divided Soul*, based on his extensive work on the Spanish cultural migration into the Americas. Harvey is a member of Magnum Photos.
www.magnumphotos.com

RIO HELMI, Indonesia

Indonesian Rio Helmi has been capturing images of Asia since 1978, constantly adding to a richly textured portfolio that celebrates the region's people, places and lifestyles. From 1978 to 1983, Helmi worked with the Indonesian media and, from 1983, he freelanced for many regional and international magazines, including *Asiaweek*, *The New York Times* and *Vogue*. He has also provided commercial material for clients such as the Aman Group, Bulgari, John Hardy, Hyatt International and The Ritz-Carlton, to name but a few. Helmi has a gallery in Ubud, Bali, which exhibits his private work. His images were also featured in *Over Indonesia*, *Bali Style* and *River of Gems*.
www.riohelmi.com

HANS HOEFER, Germany

Hans Hoefer has worked as a commercial photographer based in Singapore since the 1970s, covering studio, media, fashion and corporate assignments for airlines and the travel industry in most Asian countries. He created and published a series of travel guidebooks—*Insight Guides*—using his own photography, an effort which spanned over 120 countries. In 1997, he sold his publishing company to concentrate on his art and personal interests.
www.apavilla.com

JEREMY HORNER, UK

Jeremy Horner began a six-year stay in South America in 1991, where he published several books, including *Living Incas*, *The Life of Colombia*, *Fiestas, Celebrations and Rituals of Colombia* and *Bogota From The Air*. More than 70 countries later, he is still documenting daily life in all its richness of colour for leading international magazines such as *GEO*, *Terre Sauvage* and *Meridiani*, and clients ranging from BP and UNICEF to the United Arab Emirates government. His most recent book, *Island Dreams Mediterranean*, was published by Thames and Hudson in November 2004.
www.jeremyhorner.com

JEFF HUTCHENS, USA

Jeff Hutchens was born in Lansing, Michigan. The son of an American diplomat, he spent his childhood in locations all over the USA and across China, South Africa and the Philippines. After two years as the sole staff photographer for the National Geographic Channel, Hutchens decided to freelance, allowing him to spend more time pursuing personal projects. He has shot professionally on five continents, capturing the fascinating in the mundane with a graphic and often humorous eye. He is represented by Getty Images.
www.jeffhutchens.com

GERHARD JÖRÉN, Sweden

Born and raised in Sweden, Gerhard Jörén moved to New York in 1982, where he launched a career as an editorial and corporate photographer. In 1987, drawn by the sights and colours of Asia, he moved to Hong Kong. From 2001 to 2005, he was based in Bangkok, where he worked for a host of international publications and a number of major corporate clients, with assignments ranging from a brothel in Manila, to coal mining in Borneo and Giorgio Armani in Shanghai. Among his most recent photographic projects was the relaunch of Bumrungrad Hospital, one of the region's leading hospitals.
www.gerhardjoren.com

RICHARD KALVAR, USA

New York-native Richard Kalvar moved to Paris in 1970. Since then, he has worked extensively in Europe, the USA and Asia. He was one of the founders of the Viva photo agency and has been a member of Magnum Photos for over 30 years, serving as president and vice president several times. His personal photographs are marked by a certain dark and mysterious humour. In 2007, a major retrospective exhibition of his work was held in Paris at the Maison européenne de la photographie, and a book called *Earthlings* in English and *Terriens* in French was published by Flammarion.
www.magnumphotos.com

CATHERINE KARNOW, USA

Born and raised in Hong Kong, the daughter of an American journalist, San Francisco-based photographer Catherine Karnow was the only non-Vietnamese photojournalist to accompany General Giap on his historic first return to the forest encampment in the northern Vietnam highlands from which he plotted the battle of Dien Bien Phu, in 1994. She also gained unprecedented access to H. R. H. The Prince of Wales for her 2006 *National Geographic* feature, 'Not Your Typical Radical'. Her work has appeared in *National Geographic Traveler*, *GEO* and other publications. Karnow is known for her vibrant and sensitive style of photographing people.
www.nationalgeographic.com

BOHNCHANG KOO, South Korea

In 1985, South Korean Bohnchang Koo left the secure comforts of employment in a German conglomerate to begin a career in photography. He made his way to Germany and enrolled in the Fachhochschule in Hamburg, where he studied photography. Later, upon returning home, he became a lecturer and professor of the subject. Koo has held over 20 solo exhibitions worldwide and has also participated in multi-photographer projects such as *A Day in the Life of Japan* and *Toshodaiji 2010 Project*. His own books include *Revealed Personas*, *Portraits of Time* and *Vessel*.
www.bckoo.com

SUTHEP KRITSANAVARIN, Thailand

Suthep Kritsanavarin is among the most exceptional photojournalists to emerge from Thailand in recent years. His images of life in China's Xinjiang province were widely exhibited in Thailand to critical acclaim. His work has been published in a wide range of international magazines, including *Far Eastern Economic Review*, *The New York Times*, *International Herald Tribune* and *CNN Traveler*. Suthep is currently engaged in a project documenting life along the Mekong River.
www.onasia.com

HELEN KUDRICH, Australia

Australian Helen Kudrich has been based in Bangkok since 1999. Originally trained as a graphic designer, she began working as a photographer upon moving to Thailand and has been involved with both commercial assignments and personal projects in Asia. Her photography often focuses on outwardly ordinary moments which subtly suggest less apparent narratives, as can be seen in her series on western China and her project on the Indian Ocean tsunami. Kudrich's work has been exhibited at photography festivals and galleries in Europe, Asia and Australia and has been published in magazines worldwide, including *Granta*, *Stern*, *Time* and *Global Knowledge*.
www.helenkudrich.com

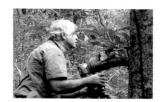

JAN MATTHYSEN, Belgium

Jan Matthysen, a Belgian diplomat and amateur wildlife photographer, has been living in Thailand for two years. With his wife Agnes, he has spent many weekends exploring the dense jungles of Thailand in search of wildlife. Hunting for that ultimate picture—the bloodless hunting trophy—sharpens the eye for the country. Wildlife photography is a tribute to the beauty of our natural heritage, and by showing the public the hidden treasures of nature, Matthysen hopes to generate more awareness.

STEVE MCCURRY, USA

Steve McCurry's career was launched when, disguised in native clothes, he crossed the Pakistan border into Afghanistan just before the Russian invasion. When he emerged, rolls of film were sewn into his clothes, containing images that would be published around the world as among the first to show the conflict there. A high point in his career was the rediscovery of the previously unidentified Afghan refugee girl that many have described as the most recognisable photograph in the world. McCurry has published many books, his latest being *Looking East* (2006), and his work is frequently featured in *National Geographic*. He is a member of Magnum Photos.
www.stevemccurry.com

ROBERT MCLEOD, UK

Robert McLeod started photographing underground theatre in Japan in the mid-1980s. In 1992 he moved to Thailand and, shortly thereafter, founded Lantern Photography, which provides architectural and interior photography to the hospitality and property industries. He is also a contributor to *Architectural Digest*. His black and white images have been exhibited in Bangkok, Tokyo, Sydney and New York. He is the great-great-grandson of Victorian photographer Robert French, with whom he hopes to hold a joint exhibition some day.
www.robertmcleod.com

PALANI MOHAN, Australia

Palani Mohan was born in Chennai, India, and moved to Australia as a child. His career began with the *Sydney Morning Herald* and, since then, he has been based in London, Hong Kong, Bangkok and now Malaysia. Mohan's work is regularly featured in leading magazines and newspapers. He has published two photographic books: *Hong Kong Lives—an intimate portrait*, is a black and white reportage-style look at life in Hong Kong; and *Hidden Faces of India* is a collection of photographic essays covering the length and breadth of the country. He is currently working on a book on Asian elephants.
www.palanimohan.com

JAMES NACHTWEY, USA

James Nachtwey's career as a war photographer began in 1981 when he covered civil unrest in Northern Ireland. Since then he has photographed more than 25 armed conflicts and dozens of critical social issues. A recipient of the TED Prize, Nachtwey has been named Magazine Photographer of the Year and received the Robert Capa Gold Medal, World Press Award and I. C. P. Infinity Award multiple times. *war photographer*, a documentary about his work, was nominated for an Academy Award. Nachtwey has been a contract photographer with *Time* since 1984 and is a founding member of the photo agency VII.
www.jamesnachtwey.com

SURAT OSATHANUGRAH, Thailand

Surat Osathanugrah is the president of The Royal Photographic Society of Thailand. As a photographer, he has had his work exhibited at numerous galleries in Thailand and around the world, such as the Leica Shop Gallery in Vienna and Auditorium Parco della Musica in Rome. Surat has also published a number of books, including *Vanishing Bangkok*, *Luang Phrabang* and *Goodbye Bangkok*. When not taking photographs, Surat is the chairman of the Osotspa Group of Companies.
www.suratosathanugrah.com

KRAIPIT PHANVUT, Thailand

Kraipit Phanvut spent 12 years as a chief photographer for United Press International in Bangkok, covering the Asia-Pacific region. He was also a chief photographer for Agence France-Presse for eight years. His work has been published in major magazines such as *Fortune*, *Paris-Match* and *Newsweek*. Throughout his career, he has taken photographs of the King and Queen of Thailand and the Royal Family. At present he runs his own studio and gallery in Bangkok—Kraipit Photography Inc. and Kraipit Gallery.

GUEORGUI PINKHASSOV, France

Gueorgui Pinkhassov's interest in photography began when he was in school at VGIK in Moscow, where he studied cinematography. Between 1971 and 1980, he worked for Mosfilm as a cameraman, but always made time for his own creative work and photographic research. In 1978, Pinkhassov joined the Moscow Union of Graphic Arts, which gave him the status needed to participate freely in exhibitions. In 1985, he moved to Paris and, three years later, joined Magnum Photos. Magazines have commissioned various reports which allow him to see the world from different angles, but it is not events alone which intrigue him, but using photographic elements to hone his craft.
www.magnumphotos.com

NAT PRAKOBSANTISUK, Thailand

Nat Prakobsantisuk is a Bangkok native and former fashion stylist who left the business in the early 1990s to take up photography at the London College of Printing. His background in fashion, firm grasp of style and willingness to give his all to every shoot have made him a favourite of fashion magazine editors across Asia. In Thailand, his work has appeared in magazines such as *Elle*, *Wallpaper* and *Harper's Bazaar*, among others. Nat also served as the visual director of the Bangkok Fashion City Project's *Bangkok Fashion Now & Tomorrow* book series.
www.natprakobsantisuk.com

RAGHU RAI, India

Raghu Rai began his career in photography with India's *The Statesman* in 1966 and later took over as picture editor–visualiser–photographer of *India Today*, where he contributed picture essays on social, political and cultural themes of the decade. A recipient of the Padmashree, one of India's highest civilian awards, Rai has specialised in India and has produced many books on the country, including *Khajuraho* and *Taj Mahal*. His coverage of the 1984 Bhopal Gas Tragedy has travelled the world. Rai's work has been featured in *The New York Times* and *Newsweek*, among others. He is an associate of Magnum Photos.
www.magnumphotos.com

MARTIN REEVES, UK

Asia has held Martin Reeves in a spell for two decades. Being a passionate photographer, he sought a film that could portray Asia how he envisioned it—enchanted, mysterious. His quest began in India in 1986 when he tried infrared black and white film. The resulting images revealed a hidden realm and he became captivated, bewitched and intrigued by the notion of infrared light, invisible to the naked eye, manifesting in photographs with a dream-like quality. In 2006, four of Reeves's images of Angkor were chosen by H. R. H. Norodom Sihamoni, the King of Cambodia, as official gifts. Reeves's images of Angkor are also captured in *Angkor: Into The Hidden Realm*.
www.thehiddenrealms.com

GUIDO ALBERTO ROSSI, Italy

Italian Guido Alberto Rossi did not take long to decide that he wanted to be a photographer and, in 1966, his first images were published in *Sport Illustrato*, a feature on the Formula 1 Grand Prix at Monza. By 1967 he was in the Middle East as a war photographer, a job which also took him to Africa, Cambodia and Vietnam. Over the years he has specialised in aerial photography, combining his love of photography with another passion, flying. Rossi's photos are published almost daily in important Italian and foreign magazines and his work is featured in 35 books. In 2004, he started his own photo agency, TIPS Images.
www.tipsimages.com

GILLES SABRIÉ, France

Gilles Sabrié is a freelance photographer based in Beijing, China. After years spent working in television, he switched careers to embrace his passion—documentary photography. Since then, he has focused on news and social issues in China. He spent months documenting the life of China's migrant workers as well as the fate of the inhabitants of the Three Gorges area. Sabrié's images have been featured in numerous publications, including *Newsweek*, *Time*, *The New York Times*, *L'Express* and more.
www.gsabrie.com

DOMINIC SANSONI, Sri Lanka

Dominic Sansoni lives and works in Sri Lanka. What he likes doing best is travelling around the world with no agenda. In addition to an extensive portfolio on Sri Lanka, where he has photographed the many years of conflict, Sansoni's collection includes photos of India, the Maldives, Thailand, Yemen, Cambodia, Nepal and Singapore.
www.dominicsansoni.com

ANUCHAI SECHARUNPUTONG, Thailand

Thai fine art photographer Anuchai Secharunputong runs Remix Studio Bangkok, specialising in photography and design services for advertising. He has sat on various committees and juries in Thailand and the region, including the Bangkok Art Directors' Awards (Bangkok, Thailand) and the Asia-Pacific Advertising Festival (Pattaya, Thailand), and is an honorary consultant to The Royal Photographic Society of Thailand. In 2005, he was voted by *Archive* magazine as one of the world's best photographers and, in 2006, he was named as a special photographer assigned to cover the 60th-anniversary celebrations of King Bhumibol Adulyadej's accession to the throne.
www.remixstudiobangkok.com

S. C. SHEKAR, Malaysia

S. C. Shekar began his career with *The Star* newspaper in the early 1980s, where his work won many awards. In 1989 he started Reds Studio Inc., specialising in editorial, architecture, food as well as hotel and resort photography. Shekar has also been commissioned for work on a number of coffee-table books, among them *The Architecture of Malaysia*, *Beyond Fusion— A Trans-Ethnic Journey* and *Daughters of Asia*. More recently, he worked on *Straits Chinese Porcelain*. Shekar is also recognised in the Asia-Pacific's hotel circuit. His trendsetting work for Shangri-La Hotels & Resorts and Four Seasons Hotels and Resorts has won him much acclaim.
www.redsstudio.com

BEN SIMMONS, USA

Ben Simmons was born in Columbus, Georgia, and studied photography at the State University of New York. As a professional photographer, Simmons concentrates on photo-essay features and photography books. His book *Tokyo Desire* is a personal collection of colour images taken over a 10-year period. Simmons's photos appear worldwide in leading publications such as *Le Monde*, *Time*, *Vogue* and *Vanity Fair*. He is a long-time photo-correspondent representing SIPA Press, an international agency headquartered in Paris. His company, Ben Simmons Photography Inc. is based in Momo-An Studio, a classic Japanese retreat that he restored, just south of Tokyo on the mountainous Miura Peninsula coast.
www.bensimmonsphoto.com.

TARA SOSROWARDOYO, Indonesia

Tara Sosrowardoyo started his professional career in 1977 as a stills photographer in the Indonesian film industry. His work and interests have since encompassed a wide array of photographic disciplines, from advertising to fashion, portraiture, aerial, corporate and editorial photography. Sosrowardoyo's work has been featured in publications such as *Fortune*, *Paris-Match*, *BusinessWeek* and *Asiaweek*, among others. He is credited with having shot seven *Time* covers. Sosrowardoyo has held solo exhibitions at the Victorian Arts Centre in Melbourne, Australia in 1995; at Gedung 28 in Jakarta, Indonesia in 2002; and at Valentine Willie Fine Art gallery in Kuala Lumpur, Malaysia in June 2003.

MANIT SRIWANICHPOOM, Thailand

Manit Sriwanichpoom is one of Thailand's leading photographers and its best known in the international art world. His solo shows include 'Bangkok in Pink' at the Yokohama Museum of Art (Japan); 'Pink Man in Paradise' at Monash University (Australia) and Valentine Willie Fine Art (Malaysia); 'Repertoire of the Innermost' at the Plum Blossom Gallery (Singapore); and 'Beijing Pink' at the Highland Gallery (China). His works are held by the Maison européenne de la photographie (Paris), the Fukuoka Asian Art Museum (Japan), the Singapore Art Museum and private collectors. In 2002, he was named one of the world's 100 most interesting emerging photographers by Phaidon Press in their book *BLINK*. In 2007 he was awarded the Higashikawa Overseas Photographer Prize.
www.rama9art.org

NAT SUMANATEMEYA, Thailand

Bangkok-born Nat Sumanatemeya graduated from Thammasat University with a degree in film and journalism in 1992. From 1993 to 2000, he was a staff writer and photographer for the Tourism Authority of Thailand. Specialising in marine life photography, his images have been published in leading dive magazines such as *Rodale's Scuba Diving*, *Marine Photo* (Japan) and *Asian Diver* (Singapore). In 2002, Nat was presented with the David Doubilet award for international underwater photography. The following year, he assisted Nicolas Reynards with a story on the Moken (sea gypsies) for *National Geographic*. In 2005, Nat won the Epson photography competition held in Japan in the category of black and white digital prints.

JÖRG SUNDERMANN, Germany

Jörg Sundermann has been a professional photographer for more than 20 years. Over this period, his technical understanding of the perfect shot and his endless enthusiasm for finding it has led him to work for various world-class advertising, design and publishing companies. With each shoot he brings with him a unique creative insight, and his warm and approachable manner ensures the best results. Based in Scotland, Sundermann has worked on many books with Editions Didier Millet, including *French Classics Modern Kitchen*, *Chiva-Som's Thai Spa Cuisine* and *Food Art*.
www.jorgsundermann.com

DUANGDAO SUWUNARUNGSI, Thailand

Duangdao Suwunarungsi is one of Thailand's top nature and landscape photographers. She set up the monthly magazine *Nature Explorer*, of which she is the executive editor, and has published several travel books, including *Explore the World: The 50 Greatest Trips* and *Passage to the Himalayas: From Shangri-la to the roof of the world*. Currently she is working on a number of other book projects, including *Japan For All Seasons*. Duangdao is a veteran of other multi-photographer books such as *Thailand: Seven Days in the Kingdom* and *Brunei: Abode of Peace*.

KAKU SUZUKI, Japan

Japanese photographer Kaku Suzuki specialises in photographing nature and the world's ancient ruins. Suzuki has crossed the Kalahari on his own with just a four-wheel-drive vehicle and a GPS device, and has trekked through the jungle on horseback to reach the Mayan ruins. In 1994 and between 1999 and 2000, he held two exhibitions in Japan—'Jakkou' and 'Jakkou II'—to showcase his photographs. Suzuki's work has been published in many Japanese magazines and books, including *Monthly Newton* and *JICA*. His photographs were also used on Japan Post's stamps in 2002 and 2003.
http://kakusuzu.web.infoseek.co.jp

CHAROON THONGNUAL, Thailand

Thai photographer Charoon Thongnual, from the kingdom's southern province of Songkhla, moved to Bangkok in 1989 to work as a photographer for *Matichon*, the leading political newspaper. In 1993, he joined the Nation Group, where he was given the opportunity to do more feature work. He became a photojournalist, travelling nationwide for his work. Early in 2004, during the period of unrest in the south, he was assigned to Pattani, Yala and Narathiwat. Charoon was the runner-up in the Thai Journalists Association's 2002 photo contest, the winner of its 2003 competition and the runner-up of the ASEAN Press Federation's 2004 photo contest.

PETER TURNLEY, USA

Peter Turnley is a contributing editor/photographer for *Harper's Magazine* and creates multi-page photo-essays regularly for the magazine. His work is published and exhibited worldwide and his images have been on the cover of *Newsweek* 43 times. He has covered nearly every major news event of international significance over the past 20 years and has won many awards, including the Overseas Press Club Award for Best Photographic Reporting from Abroad. Turnley has published five books: *Beijing Spring*, *Moments of Revolution*, *In Times of War and Peace*, *Parisians* and *McClellan Street*.
www.peterturnley.com, *www.corbis.com*

ÉRIC VALLI, France

Frenchman Éric Valli lived for many years in the Himalayas and is one of the region's best-known photographers. He is a regular contributor to *GEO*, *Paris-Match* and *National Geographic*, and is the author of numerous books, including *Caravans of the Himalaya* and *Shadow Hunters: The Nest Gatherers of Tiger Cave*. Valli has also produced award-winning documentaries and, his first feature-length film, the Academy Award-nominated *Himalaya* (1997), was an international success.
www.ericvalli.com

DOW WASIKSIRI, Thailand

Dow Wasiksiri studied film and photography at Los Angeles City College and later graduated with a degree in radio and television broadcasting from California State University, Los Angeles. As a photographer, Dow began his career shooting for many well-known fashion magazines in Thailand. In 1983 he set up his own photography studio, Persona, and concentrated on commercial photography. Since then, Dow has been in demand, shooting both for local and international clients. But he still finds time to create fine art and street photography. Today, his work is in private and public collections around the globe.

VICENTE WOLF, USA

In the world of contemporary design, Vicente Wolf has been at the top for 30 years. He heads his own company, Vicente Wolf Associates, and his VW Home showroom carries everything for the home, including antique furniture, accessories and bedlinen that he handpicked while travelling the globe. Over the last few years, Wolf has become known for his other passion—photography. His work is regularly featured in every major design magazine including *Architectural Digest*, *Elle Décor*, *House & Garden* and *Interior Design*. Wolf's latest book, *Crossing Boundaries: A Global Vision of Design*, focuses on the many design inspirations found internationally from the perspective of an observant traveller.
www.vicentewolfassociates.com

MICHAEL YAMASHITA, USA

Michael Yamashita has combined his dual passions of photography and travel for over 25 years as a photographer for *National Geographic*. His most recent story on the legendary Ming Dynasty admiral and explorer, Zheng He, first appeared in the July 2005 issue of *National Geographic* and was released as a documentary feature film in 2006. The film, *The Ghost Fleet*, was named Best Historical Documentary at the 2006 New York International Film Festival. Yamashita's book *Zheng He* was released in 2006. A lecturer and teacher at workshops around the world, he has received numerous awards from the National Press Photographers Association, the New York Art Directors Club and the Asian-American Journalists Association.
www.michaelyamashita.com

About the Authors

WILLIAM WARREN

Resident in Bangkok now for over 40 years, William Warren is the author of more than 50 books, the most recent being *Asia's Legendary Hotels*. He has written extensively about Thailand, most notably for *Jim Thompson: An Unsolved Mystery*, *The House on the Klong*, *Thailand: Seven Days in the Kingdom* and *Thai Style*.

NICHOLAS GROSSMAN

Bangkok-based journalist Nicholas Grossman wrote the captions and text accompanying the photographs in this book. After graduating from Harvard University with a degree in history and literature, the Bostonian travelled to Thailand to write a travel guide for Let's Go Publications. He unexpectedly fell in love with the country and has since worked for the *Bangkok Post* and *ThaiDay*.

GOLD SPONSORS

 BANGKOK BANK is Thailand's largest bank, with a complete range of personal and business banking services. The bank is a friend and financial partner, giving lifelong support to its valued customers. The bank has more than 750 branches and 250 business centres or business desks, and its extensive self-service network includes more than 3,500 ATMs and cash deposit machines, phone banking, and a convenient easy-to-use Internet banking service available through its website. Bangkok Bank is one of the leading regional banks in Southeast Asia and has 21 branches or representative offices strategically located among Thailand's major trading partners.
www.bangkokbank.com

 BOONRAWD BREWERY, Thailand's first and largest brewery, was founded by Phraya Bhirom Bhakdi in **SINGHA** 1933. The privately owned company has expanded and diversified under the innovative management of its founder into a renowned beer producer with an annual production capacity of 1,200 million litres. Boonrawd's extensive product line includes beer, soda water, drinking water and ready-to-drink green tea and coffee. It produces and markets its products under the brand names Singha, Leo, Thai Beer, B-ing and Moshi. As an integral part of Thai society, Boonrawd actively participates in environmental support programmes, educational scholarship programmes, cultural events, traditional festivals and sports sponsorships.
www.singha.com

Canon
Delighting You Always CANON MARKETING (THAILAND) CO. LTD, a subsidiary of Canon Inc. Japan, was established in 1994. Its mission is to make Canon's quality products and services more accessible to Thais. The company is a leader in importing and distributing imaging products and office equipment. Canon is dedicated to meeting customer satisfaction by offering high-quality products and five-star service with a team of direct sales personnel and more than 160 dealers and authorised service centres nationwide. Canon also believes success requires good corporate citizenship and strives to work together with its employees, customers and society for the common good.
www.canon.co.th

Chevron CHEVRON THAILAND EXPLORATION AND PRODUCTION, LTD is the country's top oil and gas producer. The company operates more than 180 platforms in the Gulf of Thailand and most of its produced natural gas is used for electricity generation, satisfying one-third of the country's demand. Local natural gas has also played a vital role in the development of Thailand's petrochemical industry over the past decades. As demand for energy continues to rise, Chevron poses a clear challenge to develop new and better ways to deliver that required energy. The company remains committed to providing clean, efficient and indigenous energy to reduce Thailand's dependence on imported petroleum, while also improving the lives of the Thai people.
www.chevron.com

 DKSH DKSH is the leading Market Expansion Services Group in and for Asia. It enables and supports companies in expanding their businesses in existing markets and launching into new ones. DKSH offers sourcing, marketing, sales, distribution and after-sales services, and provides its partners with fundamental expertise and on-the-ground logistics, covering the world's most complex and demanding growth markets. Diethelm Limited is the Thailand-based operation of DKSH Group. Established in 1906 on the banks of the Chao Phraya River, the company today is one of Thailand's leading business organisations, with annual sales of US$3,000 million and 10,000 employees. Diethelm Limited operates four distinct and highly specialised Business Units—Consumer Goods, Healthcare, Technology and Specialty Raw Materials—and serves its business partners through a comprehensive network of 160 branches all across the country.
www.dksh.com

JIM THOMPSON
The Thai Silk Company
THE JAMES H. W. THOMPSON FOUNDATION Jim Thompson and a group of his Thai friends founded The Thai Silk Company in 1951 primarily to give Thai people employment, and in doing so, revived the dying craft of hand-woven Thai silk. What was initially a small Bangkok retailer of Thai silk fabrics now has a brand name and reputation that is known and respected worldwide. THE THAI SILK COMPANY LIMITED (JIM THOMPSON) today employs over 3,000 people in Thailand and has wholly owned subsidiaries in Singapore, Malaysia, Dubai and Brunei Darussalam. It has distributors and showrooms in over 30 countries worldwide for its home furnishing fabric collections.
www.jimthompson.com

 OSOTSPA CO. LTD is very proud to be a part of this special publication, *Thailand: 9 Days in the Kingdom*. Osotspa is a **OSOTSPA** 115-year-old company which is still owned and operated by the same family, now in its fourth generation. The company started out in pharmaceuticals and expanded into various consumer products, but is now most recognised through its leading brand of energy drink, M150. As the first producer of energy drinks in Thailand and having 45 years of experience, Osotspa now commands a 65 per cent share of the Thai energy drink market. Its products are present in more than 70 countries. Osotspa is very much an integral part of all aspects of the nation's life today through its commercial activities.
www.osotspa.com

 RAIMON LAND PLC focuses on developing lifestyle-oriented, luxury residential projects in Bangkok and **RAIMON LAND** *developing a better environment* in major resort destinations around Thailand. Today, the company is renowned for its exacting standards and successful track record. Raimon Land PLC has combined a diverse group of core shareholders and directors providing a valuable blend of property, investment, fund-raising, finance and management skills with an experienced executive management team, and is positioned as one of Thailand's leading property development companies. Its current projects include The Heights in Phuket; The River, The Lofts Yennakart and 185 Rajadamri in Bangkok; and Northpoint in Pattaya.
www.raimonland.com

 SCG SIAM CEMENT GROUP (SCG) was founded under the Royal Decree of His Majesty King Rama VI in 1913 as the nation's first cement producer, a construction material critical to national development. The company has expanded continuously since that time, becoming the largest and most advanced industrial conglomerate in Thailand, with five strategic business units: chemicals, paper, cement, building products and distribution. All SCG businesses operate under the principles of good corporate governance and promote innovation in products/services, processes and business models to delight customers. The group constantly rejuvenates itself to sustain business leadership in Thailand and in the region, and to remain internationally competitive.
www.siamcement.com

 Established by Royal Charter in 1906, SIAM COMMERCIAL BANK was the first Thai bank. Over the last century, it has played a leading role in both the development of Thailand's economy and in the provision of modern financial and banking services to its residents. Today, the bank has the largest market capitalisation in the Thai financial services sector, and the largest branch and ATM network. It provides the full spectrum of financial services across all market segments. Over the past few years, the bank has transformed its business model in response to a rapidly evolving financial-services landscape. It is committed to world-class customer service and generating above-average returns for its shareholders. The bank and its employees have a shared mission to be recognised as the kingdom's best universal bank.
www.scb.co.th

ThaiBev THAI BEVERAGE PUBLIC COMPANY LIMITED (THAIBEV) was incorporated in 2003. It is Thailand's leading producer and distributor of beer and spirits by sales and production volume and one of the largest brewers and distillers in Southeast Asia. It owns well-known brands such as Chang and Archa beers as well as Sangsom and Mekhong rums. The company was listed on the Singapore Exchange on 30 May 2006, where it is one of the largest private companies listed, with market capitalisation of approximately US$4.4 billion. ThaiBev plays a role in Thai society by focusing its contributions in sports, education, public health and arts and culture, and by assisting those in need. The distribution of blankets to poor villagers during the cold season and the ThaiBev corporate sports development programme are the company's flagship social programmes.
www.thaibev.com

SILVER SPONSORS

 GSB GOVERNMENT SAVINGS BANK (GSB) was established in 1907 by King Rama VI as a small bank called Leefotia, to study and promote the habit of saving among Thais. With the promulgation of the Savings Act by King Rama VI on 1 April 1913, the Savings Office was established within the Royal Treasury. It was a state enterprise administered by a board of directors, who were designated by the Minister of Finance. GSB is now a state-owned bank under the supervision of the Ministry of Finance. It has developed and upgraded its operating systems and services to meet a fast-changing banking environment and to match and surpass its competition. Today, GSB offers a wide variety of products to customers. It has 592 branches nationwide, 165 service outlets, 12 mobile units, 18 community bank outlets, 881 ATMs and four foreign exchange booths serving nearly 30 million customers.
www.gsb.or.th

Julius Bär THE JULIUS BAER GROUP is the leading dedicated wealth manager in Switzerland. The group concentrates exclusively on private banking and asset management for private and institutional clients. GAM, a leading global active asset manager, has been part of the Julius Baer Group since 2005. With more than 3,800 employees worldwide, the group manages client assets in excess of CHF 400 billion. The group's global presence comprises more than 30 locations in Europe, North America, Latin America and Asia, including Zurich (head office), Buenos Aires, Dubai, Frankfurt, Geneva, Hong Kong, London, Lugano, New York, Singapore and Tokyo. Bank Julius Baer & Co. Ltd, the group's key company, has an Aa3 rating from Moody's. Julius Baer Holding Ltd is listed on the SWX Swiss Exchange.
www.juliusbaer.com

 THE STOCK EXCHANGE OF THAILAND (SET) **The Stock Exchange of Thailand** is a juristic entity set up under the Securities Exchange of Thailand Act and began operations on 30 April 1975. Its mandate is to be a market for the trading of listed securities, a promoter of personal financial planning and a provider of related services, as a not-for-profit organisation. The SET's main operations include securities listing, the supervision of listed companies, information disclosure, trading, market surveillance, the supervision of members, international capital market networking, information dissemination and investor education. The SET is a member of the Asian and Oceania Stock Exchanges Federation, the International Organisation of Securities Commissions (affiliate) and the World Federation of Exchanges.
www.set.or.th

The TOURISM AUTHORITY OF THAILAND (TAT) was established on 18 March 1960. It is responsible for the promotion of the tourism industry and its related sectors. TAT supplies information on tourist areas to the public and also publicises and promotes Thailand in various ways to attract travellers. For more than 45 years, TAT has been involved in national tourism, encouraging Thai and international tourists to travel in this beautiful country. The organisation has 22 local and 21 overseas offices that disseminate information and wonderful images of the country, as well as extend a cordial invitation to everyone to come and experience the real beauty of Thailand.
www.tourismthailand.org

LOGISTICAL SPONSORS

CAT TELECOM PUBLIC COMPANY LIMITED (CAT TELECOM) is one of the leading telecommunications providers, closely connected to the Thai people through state-of-the-art communication technologies and responsive customer-centric services, to raise quality of living by bringing communications power to the people. CAT TELECOM implements cutting-edge business policies to expand and develop innovative services and respond to consumers' needs. Its aim is to develop strategic business functions that contribute to the company's main revenue streams by focusing on four core business units: International Telephone, Data Communication and Internet, e-Business and CDMA Multimedia.
www.cattelecom.com

dtac TOTAL ACCESS COMMUNICATIONS PUBLIC COMPANY LIMITED (DTAC) is one of Thailand's leading telecommunications service providers, offering a comprehensive portfolio of voice and data services nationwide. DTAC has over 14.5 million subscribers and was the first operator in Thailand to deploy high-speed EDGE technologies on its entire network. DTAC's international roaming service covers 139 countries through 345 operators worldwide.
www.dtac.co.th

Dusit INTERNATIONAL DUSIT INTERNATIONAL offers five distinct experiences all inspired by the 'wondrous utopian kingdom' called Dusit Thani envisioned by King Rama VI of Thailand in the 1900s: Dusit Thani Hotels & Resorts offers guests the wonder of 'heaven on earth' through Thai perfection, style and taste; Dusit Devarana Hotels & Resorts provides a perfect respite for those who seek the balance between 'having' (success) and 'being' (quality in their lives); dusitD2 hotels & resorts is a new generation of hotels and resorts delivering an experience of delightful surprises through style with substance; Dusit Princess Hotels & Resorts offers relaxed comfort, warm, helpful service, great locations and an approach that is designed to help you make the most of your journey; and Dusit Residence Service Apartments is a long-stay base for business or leisure that offers the quality of Dusit hospitality with the privacy and independence of your own residence.
www.dusit.com

 Dusit Thani HOTELS & RESORTS A member of The Leading Hotels of the World, the Dusit Thani, Bangkok is the flagship property of DUSIT THANI HOTELS & RESORTS. Dusit Thani is one of Bangkok's leading luxury hotels and a popular venue for conferences, meetings, incentive tours and conventions. Centrally located in the heart of Bangkok, overlooking Lumpini Park, the Dusit Thani is a short walk from the city's main business, shopping and entertainment districts and offers quick access to the subway terminal right in front of the hotel and the Skytrain terminal, a short walk away. This deluxe five-star property offers 517 tastefully decorated guestrooms, including Dusit Club and Grand rooms, eight restaurants and four bars/lounges.
http://bangkok.dusit.com

 eurocopter an EADS Company EUROCOPTER SOUTH EAST ASIA (ESEA) is the regional headquarters of Eurocopter, the world's leading helicopter manufacturer. Established in 1977 in Singapore, ESEA is responsible for the sales and customer support activities of the entire range of Eurocopter helicopters. ESEA has sold and delivered more than 250 new aircraft to customers in 25 countries. It serves a diverse range of customers and purposes, such as the armed forces, commercial oil and gas operators, VVIP transport for corporate flights, helicopter flying schools and charter flights.
www.eurocopter.com

The MINISTRY OF DEFENCE was founded on 8 April 1887 by His Majesty King Chulalongkorn upon his royal vision that the military would be a leading institution to safeguard the nation, religion and the throne in the future, all of which are considered the three essential pillars of the country. With His Majesty's determination and a solid foundation, the Ministry of Defence was then established. Thailand's military has been continuously developed in line with other leading nations, but maintains the philisophy of 'self sustainability' with which it was founded.
www.mod.go.th

THAI THAI AIRWAYS INTERNATIONAL PUBLIC COMPANY LIMITED (THAI) is the national carrier of the kingdom of Thailand. Founded in 1960, it operates domestic, regional and intercontinental flights. THAI flies to 73 destinations (including domestic destinations) in 35 countries around the world. THAI has over 25,000 employees and a total of 83 aircraft in its fleet. THAI aims to provide full service to premium passengers, while maintaining its standard of service for leisure travellers. THAI aims to be the 'First Choice Carrier with Touches of Thai'. The success of THAI is apparent in numerous customer surveys conducted by well-known institutions both within and outside Thailand, which have resulted in awards such as the Skytrax Award for Cabin Staff Service Excellence 2006 and Skytrax Award for Best First Class Lounge 2007.
www.thaiairways.com

MEDIA PARTNERS

Bangkok Post On 1 August 1946, BANGKOK POST, a four-page English-language newspaper, hit the Thai streets and proved it was here to stay. Today, it is the number one English-language newspaper as well as the oldest existing newspaper in Thailand. Post Publishing has expanded into other newspaper and magazine ventures—the most recent being the launch of *Post Today* in 2003, now the fastest-growing Thai-language business daily. *Bangkok Post* has been Thailand's witness to joy and sorrow, the highs and lows of the last 60 years. The *Bangkok Post* always tried to report these with accuracy, integrity and fairness and it pledges to continue following the same principles into the future.
www.bangkokpost.com

MCOT MCOT PUBLIC COMPANY LIMITED owns and operates 62 radio stations across Thailand. It also operates the Thai News Agency (TNA), supplying MCOT's Modernine TV and its affiliated radio networks with up-to-date news and current events. TNA works with over 50 leading news agencies, including the Organisation of Asia-Pacific News Agencies (OANA), AsiaVision, CNN, BBC, CCTV, NHK, TV5 Monde, ABC and Deutsche Welle. In 2003, MCOT set up a subsidiary, Panorama Worldwide Company Limited, to serve as a production centre with a focus on documentaries. MCOT has also developed joint operations with Bangkok Entertainment Company Limited to run Channel 3 and True Visions Public Company Limited.
www.mcot.net

 SPA ADVERTISING SPA ADVERTISING, a flagship 'Top 10' advertising agency in Thailand, is a subsidiary of Future Marketing/Media Communications Group, which is part of Osotspa Holding Co. Ltd. Osotspa is a successful 115-year-old family-owned, leading Thai conglomerate. The Future group and her 14 subsidiaries consist of marketing and creative agencies, a media company, design academy, research house, production house and a public relations company, which extend across other countries in the region, including Myanmar, Cambodia and Malaysia. Spa Advertising's major clients include Nokia, Toyota, PTT, Singha Corporation, Sun Microsystems, AOT, Toshiba, Epson, Yamaha and the Thai Government House.
www.spa.co.th

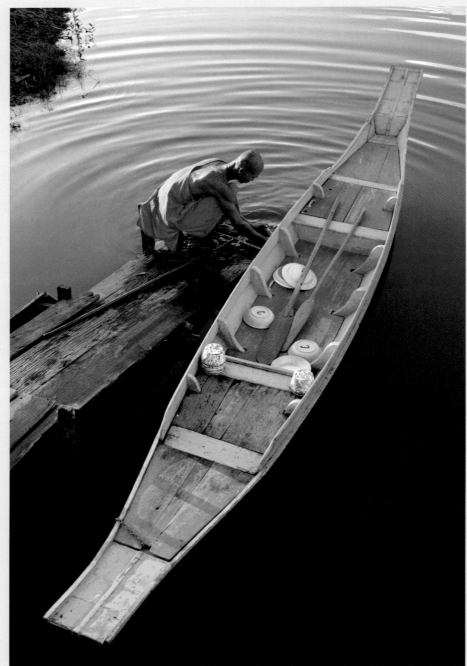

Kraipit Phanvut, Thailand

Acknowledgements

The publisher and team behind *Thailand: 9 Days in the Kingdom* would like to extend our deepest gratitude to the many companies and individuals without whom this project would not have succeeded. We apologise if anyone has been accidently excluded from this list.

First and foremost, we would like to thank the illustrious members of our Editorial Advisory Board.

Dr Chirayu Isarangkun na Ayuthaya (Honorary Chairman) • Mr Surat Osathanugrah (Chairman) • Mr Tej Bunnag • Ms Kannikar Chalitaporn • Mr Somchainuk Engtrakul • Mr Staporn Kavitanon • Mr Sakthip Krairiksh • Ms Phornsiri Manoharn • General Winai Phattiyakul • Mr Apinan Sumanaseni • Mr Khwankeo Vajarodaya • Dr Suvit Yodmani

We are also indebted to our many sponsors, who were the financial and logistical backbone of this project.

Bangkok Bank • Bangkok Post • Boonrawd Brewery • Canon Marketing (Thailand) Co. Ltd • CAT Telecom Public Company Limited • Chevron Thailand Exploration and Production, Ltd • DKSH and Diethelm Limited • Dusit International • Dusit Thani Hotels & Resorts • Eurocopter South East Asia • Government Savings Bank • The James H. W. Thompson Foundation/The Thai Silk Company Limited (Jim Thompson) • The Julius Baer Group • MCOT Public Company Limited • Ministry of Defence • Osotspa Co. Ltd • Raimon Land PLC • Siam Cement Group • Siam Commercial Bank • The Stock Exchange of Thailand • SPA Advertising • Thai Airways International Public Company Limited • Thai Beverage Public Company Limited • Total Access Communications Public Company Limited (DTAC) • Tourism Authority of Thailand

Our thanks also go to the many assistants who gave their time to help our photographers navigate the country with ease.

Mr Igor Barbey • Mr Will Baxter • Mr Austin Bush • Mr Wutthinun Chantori • Mr Wutthichai Chermsrijan • Mr Wirot Chouyjaroen • Ms Phittaya Chuailua • Mr Sophon Chueaicham • Ms Vannee Chutchawantipakorn • Mr Siwarak Daosuparoch • Colonel Kornwipa Jaroenpol • Ms Kanetnat Jintapathitari • Mr Ampol Jiramahapoka • Ms Kanya Julapongvanich • Mr Sang-arun Jumpawan • Ms Ing K • Ms Prapawadee Kajornboom • Ms Sasion Kam-on • Ms Pairin Kankaew • Mr Chumsak Kanoknan • Mr Papon Kecharananta • Mr Nat Klainin • Mr Mongkolsasawat Luengvorapant • Mr Wachira Muniganont • Mr Olarn Nateharn • Mr Surasak Sae Ngow • Mr Yuenyong Ophakul • Mr Kittisak

Panmanee • Mr Panu • Mr Kamthorn Paowattanasuk • Mr Khanueng Pethrsamai • Lieutenant Colonel Kajorn Pimkasem • Ms Pilai Poonswad • Mr Vonlop Pornprasertthavorn • Mr Peerapong Prasutr • Mr Poj Prommetta • Mr Kijja Pruchyathamkorn • Ms Takawan Reingkrit • Mr Kittinun Rodsupan • Ms Rungcheewan Rungruangwong • Mr Chawalit Sagindra • Mr Jatupat Sarikaputra • Mr Saran Sematong • Ms Wajanan Silpawornwiwat • Ms Lalita Siripaiboon • Ms Varunee Skaosang • Mr Pong Skuntanaga • Mr Joshua Smith • Ms Supreeya Somaporn • Mr Thomas Sorrentino • Mr Pitipat Srichairat • Mr Somjade Srimahachota • Ms Arunee Srisuk • Mr Chumphol Suckaseam • Mr Nut Sukcharoen • Mr Nophorn Sumranjai • Ms Pitchaya Supasiriluk • Ms Siwaporn Supharattanadilok • Mr Rungson Suwanvichit • Mr Akom Taweesaranpong • Mr Thongkan Thamngern • Mr Natchapol Thongnok • Mr Kittipong Tipmanee • Ms Pattarajitr Trankarnkate • Ms Kanwee Vatrasresth • Ms Royjerm Vithakamontri • Mr Gun Werawut • Mr Natthachai Wittayawongruji • Mr Niti Yimsukpaitoon

The following individuals offered their time, support and knowledge to help us get this project in top shape.

Ms Sirirat Akranirankul • Ms Piriyaporn Antong • Mr David Armstrong • Ms Sukanya Asavapooreekorn • Mr Goanpot Asvinvichit • Mr Santi Bhirom Bhakdi • Mr Wallop Bhukkanasut • Dr Nitipong Boon-Long • Mr Eric Booth • Mr Patrick Booth • Mr William Booth • Mr Suthichai Bunnag • Mr Marut Buranasetkul • Mr Ad Carabao • Mr Pratharn Chaiprasit • Mr Kitti Chambundabongse • Mr Padhanaseth Changkasiri • Major General Chaichan Changmongkol • Ms Larich Chavapong • Mr Rawin Chompunuchtanin • Ms Pipatra Choomkamol • Mr Paul Choong • Mr Chaisong Churitt • Mr Nigel J. Cornick • Lieutenant Colonel Anu Dechmuangpak • Mr Michael de Santiesteban • Ms Wongvipa Devahastin na Ayudhya • Mr Olivier Dubos • Mr Yos Euarchukiati • Group Captain Tosanop Gajajiva • Mr Bruce Gaston • Mr Sompob Gingngern • Mr Raymond Hall • Mr Reinhard J. Heermann • Mr Richard Hermes • Ms Ladawan Kantawong • Ms Supitcha Katanyoo • Mr Daniel Ten Kate • Mr William J. Klausner • Mr Parames Krairiksh • Ms Kitiya Lacharoj • Mr Kenny Leck • Ms Ratanawalee Loharjun • Mr Rungsrid Luxsitanonda • Ms Siriorn Mamanee • Ms Kwanrudee Maneewongwatthana • Mr Danny McCafferty • Mr Hisahiro Minokawa • Mr Takeshi Mizutani • Mr Allan Namchaisiri • Mr Chatchawan Napawan • Ms Palarp Natrujirote • Ms Chotip Ngawpithaktham • Mr Renato Petruzzi • Mr Martin

Petty • Mr Serm Phenjati • Mr Woraphol Phutjoye • Ms Vanida Pitaksonggrarn • Mr Somboon Prasitjutrakul • Air Chief Marshal Thares Punsri • Mr Masato Saito • Mr Wansit Jeremy Saiyawan • Group Captain Tanit Samitsombat • Ms Lalana Santos • Ms Ar-tara Satraroj • Mr Michael Selby • Ms Valeerat Singkivibul • Mr Piti Sithi-Amnuai • Mr Chatri Sophonpanich • Mr Khampi Suwanarat • Ms Chadaduang Suwannadat • Group Captain Suttipun Taithong • Mr Warin Tantipongpanich • Ms Pavina Thongsuk • Ms Jiwassa Tipayanon • Mr Tara Tiradnakorn • Mr Kan Trakulhoon • Mr Bordin Unakul • Mr Supakorn Vejjajiva • M. L. Dhanavisuth Visuthi • Ms Karen Wai • Ms Srisuda Wanapinyosak • Mr Ismail Wolff • Major General Patcharavudth Wongpet • Ms Nongram Wongwanich • Ms Sommai Yocapajorn • Mr Henri Young

And finally, we would like to thank the following companies/ institutions for their help in gaining us access to various places and for their support.

Airports of Thailand (AOT) • Alcatraz Cabaret • Amanpuri Resort • APB Company Limited • Association of Astrology • Bangkok Mass Transit System Ltd (BTS) • Banyan Tree Bangkok • Bed Supperclub • Books Actually • Central Department Store Limited • CentralWorld • Chaiyo Production • Chatuchak Weekend Market • Command A • Delphys Hakuhodo (Thailand) Co. Ltd • Doi Phu Kha National Park • Fairtex Resort Hotel and Sports Centre • Farm Chok Chai • Fivestar Production • Grammy Duck Bar • Gurdwara Siri Guru Singh Sabha • Headquarters of the Supreme Commander • Huay Kha Khang Wildlife Sanctuary • King Naresuan Project • Klong Sarm School • Le Bua/The Dome at State Tower • Mambo Cabaret • Mandarin Oriental Dhara Dhevi • Mass Rapid Transit Authority of Thailand (MRTA) • The Mercy Centre and Human Development Foundation • Miss Tiffany • Mitsubishi • National Park, Wildlife and Plant Conservation Department • Office of the Permanent Secretary, Ministry of Defence • Oriental Hotel • Pangkae School • PB Vineyard • Phase One • Phichit Thai Livestock Company Limited • Por Tek Tung Foundation • Q Bar • The Racha Hotel • Royal Bangkok Sports Club • Royal Project Foundation • Royal Thai Air Force • Royal Thai Army • Royal Thai Navy • Royal Thai Police • Siam Centre • Siam Ocean World • Siam Paragon • Six Senses Resorts & Spas • Suvarnabhumi Airport • Tawandang Brew House Co. Ltd • *Thailand Tatler* • Thepwittaya School • Trisara Resort • Wat Bang Phra • Wat Bowonniwet Vihara • Wat Muang Temple • Wat Nong Bua • Wat Pa Luangta Bua Yannasampanno • Wat Phrabat Nam Po • Wat Sathitchonlathan • Wat Suan Mokh • Wat Suthat • Wat Yuparam • Workpoint Entertainment

Bruno Barbey, France